HER ARGUMENT

epiphanies, theories, confessions

ELLARY EDDY

Printed in the United States of America

First printing, 2020

Cover photo by David Schalit
Present day photos of author – Ken Locker Photography
Vladimir Nabokov – Phillipe Halsman, Magnum Photos
Book design by David Provolo

ISBN: 978-1-7324708-0-4 (paper)
ISBN: 978-1-7324708-1-1 (ebook)

Darling Media Press
Los Angeles, CA 90048

www.darlingmedia.com

To my darling Daughter —
from whom I still have so much to learn.

TABLE OF CONTENTS

AGE LIKE A MOTHERFUCKER

BONUS: L'IL LEXIVORE

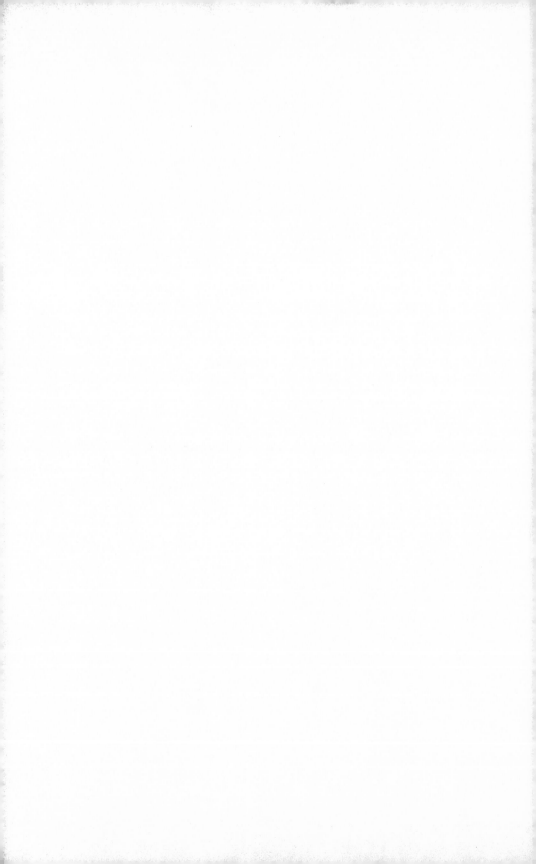

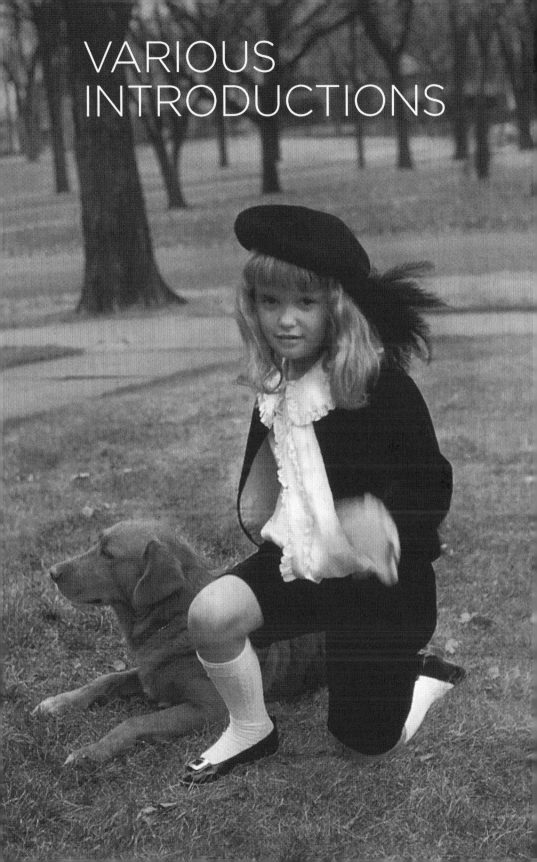

VARIOUS INTRODUCTIONS

HER ARGUMENT

This is not an argument *against* anything but rather an argument *for* something, such as scientists and philosophers make — an argument in the sense of a 'process of reasoning' in support of a theory, in this case for a certain approach to life.

(Argument: from Old French *arguere* "make clear, make known, prove" *(13ᵗʰ century)*, from Latin *argumentum* "a logical argument; evidence, ground, support, proof".)*

This is not to say that I am not a sometimes querulous, defensive, or argumentative individual, prone to stoutly held opinions, and not always entirely reasonable. (My father once said to me, after listening to an exhaustive bit of reasoning, "You seem to be able to rationalize anything." Now he may not have meant it to be, but I found it highly flattering — you know, of my logical capabilities.)

In fact, Her (My) Argument is in support of a way of thinking about the world, being in it, engaging with it in a way that enhances the likelihood of finding joy, or fun, or deeper layers of 'reality'. My sincere hope is that I offer a novel perspective on surviving, despite the odds, the absurdity, and the flawed ego. To position myself as author, most of the essays upfront are personal, subjective, even diaristic in nature, but I try to use them as springboards for some humorous analyses. As the book progresses, the essays become a bit meatier, more philosophical, (which of course in no way reduces the subjectivity!) before they finally swing around in a lighthearted direction. Feel free to lark about amongst them all.

*You will notice the occasional asterisk denoting one of my current 100 favorite words; the definition, etymology, and usage — many invented by myself — will be listed at the end of each essay.

BUT WhoTF IS SHE?

Funny you should ask, because in fact she's spent an inordinate amount of time here on earth trying to answer that question herself, to corral the diverse elements of her psyche, explore the contours of the self she inhabits at any given moment and, ideally, learn how to run with the particular body/ mind continuum she's been given.

This has often boiled down to a daemon hunt. Not a snark — a daemon (or daimon) is an ancient Greek concept that encompasses, depending who you're reading, one's animating spirit, one's soul, or one's true character. An illusion, an hallucination, an idea… whatever it is, her daemon has continued to beckon to her, and given her no surcease from the chase. (Actually, the damn thing still drags her out of bed in the morning and badgers her through 'til midnight…)

Now given my lack of talent in the sciences, this sort of quest left me little choice but to become an artist. Although I've often tried to intervene in this trajectory, it just seems to be my nature. (Wait, who is the 'I' here? And who is the mysterious figure lurking behind 'my nature'? This is just the sort of quandary one winds up in when exploring the nature of identity and the location of the self — one of the primary vectors of this book.)

Somewhere along the way, through the surprising number of decades I've managed to traverse, I began to find myself sort of laughable, to feel I had donned the mantle of Tigger — the goofball, quick-change artist buddy of Winnie-the-Pooh. (I think I like acorns, but no it's honey, then nope, I'd rather eat thistles… actually not.) But this allusion to cartoon tigers is only one half of a circus metaphor; the other half is pulling back the curtain on the Big Top, meaning what we consider 'reality'. And, to mix metaphors, that *is* a snark hunt.

In the end, I'm not driven by money or success (although I'd love more of both and therefore might consider being so) because I'm inter-

ested in exploration, expression, and authenticity. In this strange, often solitary, sometimes egotistical, mostly existentialist pursuit, I've leapt from medium to medium, from painting monkeys in armored helmets to shooting idiosyncratic art videos, from interviewing neuroscientists to juggling ideas in this book. Every genre I've worked with, however, is just another means of wondering about life, in all its manifold mysteries, and is an attempt to unearth meaning, to discover my true self and, while I'm at it, to be able to *play*. Hence my Tigger daemon, or in my case, that would be Tigger *Redux* (Latin for *revived*).

At this advanced age, I feel I can say I'm doing fairly well with this project, although for some vexing reason I still feel the need to legitimize my chosen existence, to formulate The Argument. Being an artist, and neither an academic nor a scholar, my proofs may be a tad shaggy, like my little dog. Her Argument is built from a collection of anecdotes, confessions, disquisitions, theories, questions, and epiphanies. My thinking can be circuitous, wayward and even fantastical. Which is probably why the title of this book has morphed so many times, from the facetious "How To Do It" to "Wayward, An Artist's Search for Liberation" to "Age Like a Motherf****r". (Although the topic of aging is not spelled out as such in much of this book, this last title, which gained a few fans amongst my friends, was meant to define the book as a case study for anyone looking to be a card-carrying mofo too. Along the way I do scatter ideas designed to counteract any premature aging of one's mindset. And my hope is that my underlying philosophy, My Argument, fosters a sense of agency in my readers when it comes to their own life trajectory.)

For some reason I've always been a bit of a philosopher — not an academic type, because those folks are into some serious drilling down into minutiae (often leaving life gasping under the drill), but an amateur sort, as in Plato's definition of the word, which is 'one who wonders'. I wonder all the time, and that may be because I was born that way, or because circumstances made me that way.

Certainly growing up female in the 1950's would set any active girl-child brain to wondering. Why this? Why that? Why do they act that way? *Why is there something rather than nothing?* Why, why, why? There were simply not enough good answers, so I had to set out and find them myself. This quest eventually led me to read, however naively, various philosophers. (Since I graduated with a BFA, with more art than academics, I became an *autodidact*. Sounds vaguely libidinous, right? And in some ways it is, because I lust for knowledge. Even when I was young, what I really wanted was to *know everything.*) In this pursuit, I was especially drawn to the ancient Greeks (I'll explain why later on). Below is a phrase I've always loved from Heraclitus, but as I look at it now, I wonder if the word hope is an active enough one, so I've altered the quote slightly:

"If a man does not hope, he will not find the unhoped for, since there is no trail leading to it and no path." — Heraclitus.

"If we do not imagine, we will not find the unimagined, for there is no trail leading to it but the one we blaze ourselves." — Eddy

Ultimately, this book aims to present the argument that we *create* meaning in our lives. We chisel meaning out of the raw material life hands us.

"The interest in life does not lie in what people do, nor even in their relations to each other, but largely in the power to communicate with a third party, antagonistic, enigmatic, yet perhaps persuadable, which one may call life in general." — Virginia Wolff, The Common Reader

Can we persuade it? What a concept. But after all — why *are* we humans here? Indeed it is infinitely curious that we find ourselves embodied and experiencing it all. Meanwhile, the damned world just

keeps being reborn and wailing to have its story told. Which is why there are so many trillions of stories and why I thought, having reached my seventh decade, I'd add my own. Her Argument is a chronicle of my inquiry into this wild chaotic spectacle of 'life in general'. It relates my ongoing process of discovery — one that I've only lately learned how to guide. (There are still many glitches to be worked out and by the time I do I'll be fucking dead. Ha!)

Caveat: As you may have deduced, these essays swerve between the silly, the sincere, and the serious (in any combination), which basically reinforces my approach to life as a highly important topic which usually merits a huge dose of humor. I want to radicalize life, continue to open it up to deeper scrutiny, *play* with it. And I want you to join me. Throw off the shackles of everyday reality, of all the categories we stuff ourselves into, and Tigger-like, bounce free, stripes rippling, into the frabjous wilderness of being.

— Ellary Eddy

LOS ANGELES, 2018

Principal character - The Author, Her
Secondary characters - Various Selves, Her Parents, Several Men, Some Philosophers, a Daemon, an Eidolon and a small creature dubbed the Enigmapoo.
Location - Here, There, and Everywhere.

The French describe the setting of a scene, when shooting a film or staging a play, as the 'mise-en-scene'. Literally, a *putting in the scene*. This can include everything from sets and props to actors. There is another French word — 'decor' which can apply here too, although in the original sense of the term as *background*, which can also mean a natural setting or landscape. Since the actual action begins in the author's lair, it is that we will describe here.

Like most people, the author has eschewed decorators (due to lack of financing and general uninterest) and lives in a habitat of her own design. In effect, she inhabits her own history — her home being essentially a small museum filled with unusual objects, many of which are natural specimens, like a taxidermied Oryx, the dried, ghostly inflorescence of local palm trees, and delicate branches of seaweed from Florida. A few skulls, not human. Many books. Vintage cameras. A child mannequin. Sundry busts of classical women. A PeeWee Herman doll.

Enter: The Author. She's still in her robe, a mammoth black cotton velour hooded affair that gives her the aspect of a monk. A monk from some whacked monastery, a gender-neutral monastery. Her mind in the morning is typically phantasmagorical. She *dwells* in a phantasmagoria. She would probably say she is one.

But let's see what she says herself.

Oh wait, this is herself speaking. I mean, myself. Oh dear… herein lies the nub and quiddity of her lifelong research (or is it *my* research): What the fuck is the Self? Following the zigzagging trail of this

amorphous beast will be all sorts of other disquisitions on topics
such as:

Play, The idea of Freedom
Solitude, Synchronicity
Motherhood, Water - swimming in it
Polar bears, Dildos, Dating
Being, The possible meaning of it all, Death!
Style, Art, Soundtracks
Places, Schnittpunkts and the English Language
My Dog, Love
Aging like a Motherfucker
Eudaemonia (The Good Life)

OH, THE MAGIC OF SELFHOOD :)*?!

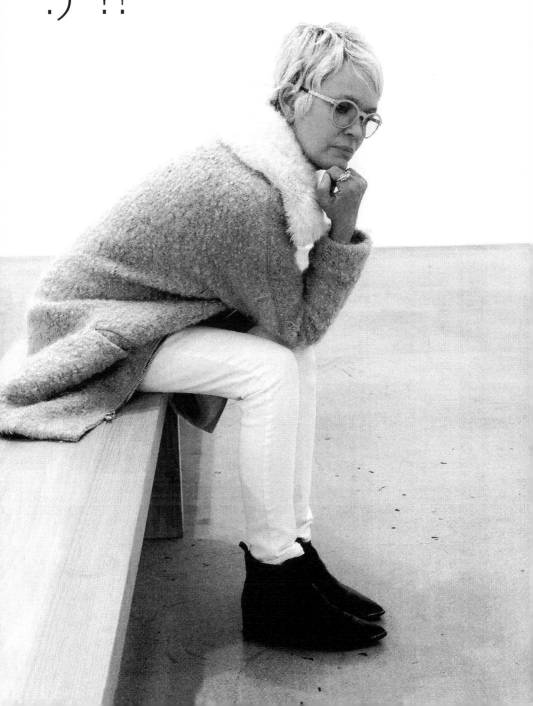

TWINKLE TWINKLE LITTLE SELF

Assembling and Reassembling a Self

Each morning as I awaken
I meander through the state called hypnopompia.
Marvel at the mere fact that minutes ago
I was truly elsewhere
Not in this bed
Not in this city
Just barely in this body.

In a world I created, or rather that my mind built around me.
But is my mind my self?
(It certainly tells me so…)

Millions of days pile up in my wake
Swirl into an ocean full of them
And as I transect this sea in a little craft I call my self,
They splash against my gunwales
Spray into the air, creating shimmering chimera of the past,
Or could it be the future?
They wet my body.
They haze my vision momentarily.
They anoint me and renew me.

Every drop of water different from the next.
Each containing in its secret core
A vast array of information
Coded infinitesimally.

Therein lies the key.
I reach to grasp a drop
And it slips through my hand
Splashes on the deck
And burns back into the sky.

Day after day
Hopefully so hopefully
I steer my little boat toward the horizon.

And sing, as I lay me down to sleep
For my self my soul to keep.
Twinkle Twinkle little self,
Twinkle Twinkle little star.

Or maybe I'm a constellation –
Little Dipper I am,
Little Bear pointing to the Big.
Embracing Polaris,
My own true North,
I need no other chart.

NICKNAME: DOLPHIN

But how does one come to know oneself, after all?
Not just the bundled patches of identity that walk the earth with one's
name, but one's purest being?

I can define myself any number of ways, but always, at the core of it all — I am a swimmer. I began this life as a guppy in my mother's womb, a star child in a universe of living liquid — and I have a bone-deep urge to reclaim my former paradise.

When I have bad dreams, they are most often about anticipating and preparing to swim but then finding myself before an empty pool. Or a half-filled one. Or a polluted one. Or one that an absurd array of circumstances prevents me from diving into. These are very bad dreams.

What is the meaning of this obsession? In short, it is about a form of ecstasy I taste with my entire self, a higher state I can achieve if I find myself with a body of water to traverse. It can be a dark silken lake, a wavy stretch of ocean, or a glittering turquoise pool. Over the years, I've swum in indoor and outdoor pools all over Europe — in London, in Lugano, in Milan, Paris, and Vienna. And in lakes from Maine to Wisconsin to California. In the Mediterranean, the Atlantic, the Caribbean, both sides of the Pacific and in the Red Sea. And I mean swim — not dip, not paddle, not soak.

Swimming for me is a holistic enterprise, engaging every part of me, from my muscles to my mind. In the water I elongate, I unfurl a body compressed by stress. I unkink my psyche and enter timelessness. I meditate, I luxuriate. I fully comprehend the miracle of the human body, that it can exist both on land and in water. As I pull myself, in my local pool, through the brilliant, apparently aqua substance, and observe my shadow glide across the bottom of the pool, I realize — I am weightless, I am flying. I am a djinn of the subaqueous.

Humans are amphibians...half spirit and half animal...as spirits they belong to the eternal world, but as animals they inhabit time. This means that while their spirit can be directed to an eternal object, their bodies, passions, and imaginations are in continual change, for to be in time, means to change. Their nearest approach to constancy, therefore, is undulation—-the repeated return to a level from which they repeatedly fall back, a series of troughs and peaks. — C.S. Lewis

Somehow C.S. Lewis has captured something about the ineffable experience of swimming, except it is that very undulation, those troughs and peaks of the stroke, that yield the liberation of the spirit, a spirit directed back toward the divinity within the sensual, within the immediate.

Since I most often swim in pools, I will rhapsodize from that realm. I think first of the sweet repetition of laps, the juicy sound of splashing, the rhythm of my breath... but all else is in constant flux: the myriad patterns created as my body transects water, a halo of concentric circles flying forth across the surface as my hands part the water before me, the arc of bubbles I sweep to the side with each stroke, the fragments of light skittering like sprites across the pool's floor, the infinite array of diamonds I may possess simply by turning on my back, flinging a hand overhead, and watching them sprinkle across my face. They are mine, all mine.

There is for me, as a painter, the inexpressible delight at seeing the hot deep blue of a California sky slashed and scattered into the aquamarine blue of the water. I turn somersaults again and again just to see the ripples mix my two favorite colors. My body conducts a wild visual symphony, a phantasmagoria glorious and alive. There is as well that moment when mid-lap, head submerged, I watch my hand pull down through what seems an underbelly of mercury and, as the last bubble

pops, realize there is nothing but the vague sense of the pool walls to tell me that there is *any* substance surrounding me, that I am not airborne.

Of course there is the advantage of winding up with muscles that are, unlike those of tennis players or runners, *long*. And there is the definite advantage, for an older body, of a much-reduced set of opportunities for injury. Yes, one can damage a rotator cuff if one overdoes the crawl, but shin splints, twisted knees or ankles, and hernias? Not in the water. In fact my habit of mixing laps with somersaults, loop-de-loops, and barrel rolls has given my entire body a flexibility I couldn't achieve any other way. Guess that's why my fellow swimmers have given me the nickname of Dolphin.

Speaking of the physical virtues leads me to add that swimming has another distinct appeal — observing other bodies as they appear at the pool's edge or from underwater as they transform into projectiles. All sorts of bodies, of course, and bless each one as it seeks release in the water, but occasionally one glimpses a body that approaches perfection. Gleaming upon leaving the pool, muscles rippling... but back to the transcendental:

Water to me embodies aspects of the sublime; it harbors all the secrets of being and is one of the deepest miracles of the universe. Essential to all life, it is somehow yet unknowable. How can such a fluid exist? How does the mere combination of atoms yield this slippery, vital balm? To me, the arc of clear water springing from a swimmer's airborne hand is one of the most beautiful sights on earth.

I look at water as I would a lover; it beckons for my body, for my soul. And it knows how to slake my thirst for oblivion.

NANCY DREW HAD NOTHING ON ME

I was a wee thing, just turned 6, in first grade in an ostensibly normal town in Wisconsin. It was a day in late spring. I usually walked to school with my older brother, but he must have been sick that day, because I was sent off by myself, and late enough that the streets were empty. Janesville was a placid, honest place, where everyone felt completely safe letting children walk to school alone. I even remember getting the local milkman to let me ride along with him as he did his rounds one day.

As I set out that morning, I walked down the street parallel to the edge of the small park we lived on, and then noticed an odd fellow coming down along the park side toward me. Tall and lumpy, hunched under a big blue nylon jacket, he was unlike any man I'd ever seen in the neighborhood. He was an outsider, I could tell. The dead giveaway he didn't belong on this street? His hair. It was bright and pale, like the color of my doll's hair. No, more orange — the color of Circus Peanuts — those icky marshmallow candies that looked like blown up peanuts and that I hated. I even knew the color came from a bad job of peroxiding it, because my babysitter once explained it to me.

He spotted me as I spotted him, or maybe minutes before. We passed each other, still on separate sides of the street. I was as alert as an animal to his trajectory, which now was angling toward my side of the street.

And then he was walking directly behind me. Electricity flew up the hairs on my neck. I began to walk faster. His pace increased as well until he was right behind me. I felt his breath.

"Would you like some candy, little girl?"

I knew taking candy from strangers was a pretty bad idea and that he was not a nice man to try it. I started to run. He sped up, awkwardly propelling his hulk toward me. Still ahead of him, I looked to my right

to see if anyone was home, on their porch or in their driveway. Then, through a screened porch, I saw an open door. I bolted up the steps, threw open the screen door, tore into the house and yelled.

An older woman appeared and I slammed the door shut. "Call the police. There's a man chasing me!" Alarmed, she locked the door and shakily dialed. By the time the police arrived there was nobody on the streets. My mother turned up and drove me to school, all the while trying to make it seem like a minor incident. "He was probably just a lonely man. Maybe he never had a child and wanted a friend." Later that evening, when my father came home, his response was approximately the same, an attempt to allay my fears by sweeping the whole event under the rug. But later that night they got a call. The man had been caught — leaving town with a little girl, eating candy beside him in his car.

That night, when I got into bed, I was sure one day he would appear under it, when he got out of jail, and drag me away with him. The next morning my Dad was reading the morning paper. I asked if I was in it. After all, wasn't I just like Nancy Drew? But there had been no mention. I was crestfallen; my act of bravery, which actually saved a girl's life, went completely unrecognized.

If I felt like doing psychoanalysis here, I suppose I could see how my little life took a wild detour from the ordinary that day, alerting me at a young age to the true danger of the world and to the fact that the apparent normalcy of everyday life was just a veneer. Oddly, somewhere along the way to my adolescence, I completely blocked out this event and only in meeting with a therapist after a difficult breakup in my twenties did it suddenly come flooding back. Regardless, I can't help but wonder if it didn't subconsciously set me on a determined path to prove my bravery to the world at large, since my small hometown paid no attention. But that would be way too simple an explanation of everything that has happened since...

1958

You wake up one morning and realize you're a Girl, and that this means something not entirely appealing, which is that you grow up to be a Woman. On the horizon you see a pink and gray kitchen, maybe avocado green. Stockings, curlers, nail polish, novels. Two kids, probably more. And what would you be talking about with the other women? PTA, bridge, and gardening, all that domestic stuff? Your breathing accelerates and you don't want to get out of bed.

What I didn't know, of course, was that if a woman *had* a job, the discussions would probably be a series of complaints about her 'superior' not recognizing her genius or landing an 'affectionate' slap on her behind just because he could. Quite a comedown from the war days when women were welding the nose cones of fighter planes. But the young ladies in my era weren't told about all that, nor about all those superwomen who defied convention and influenced history.

So no, I didn't want to be a woman, at least not the suburban version that I grew up with. I came to the subconscious conclusion I would have to refute that premise of what a woman could and could not be. I would not be subjugated. I would have to prove that I could do anything, maybe even better than boys could.

I was lucky though; my mother was feisty and had a strong creative streak. She had done some painting in her one year of college. I remember a small canvas of an African-American couple dancing joyously, which gave me a fleeting glimpse of the possibility of hidden passion. Then, when my younger brother was 7 or so, she took up painting again. At first influenced by Giacometti and Picasso, later by Bonnard and Diebenkorn, she was soon winning art fairs. It was natural that I saw art as the only door into another world. Although by the time I turned 16, I thought poetry could open doors as well, and then if everything went to hell you could always open the oven door and stick your head in like Sylvia Plath. (Yeah, well by that time my family had moved

to New York City and I was now ensconced, after having spent a few years in the nation's biggest high school, in a tiny private girls' school on the East River and discussing suicide in French with my professor.)

Bookended as I was, in my youth, by two casually malicious brothers, my animus got a serious kick-start. I learned not to get caught with my guard down and to excel in school, thereby arming myself with a weapon not in their arsenal. I came to marvel at why they got away with certain behaviors I was told wouldn't be 'appropriate' for me. It became clear to my family early on that I wouldn't take no for an answer, so when I demanded, I was allowed to play football with my older brother, until I myself came to the conclusion that getting upended on a cold, hard field held absolutely no appeal, no matter my gender. An activity that seemed thoroughly daft, it led me to believe boys were as well. In retrospect, this was a clear presage that I was one who would only learn the hard way.

But I did all the other sporty things boys did. I basically lived on my bike, wore boy's saddle shoes, and competed fiercely in hide and seek. I learned to skip a sailboat with the same ferocity. In these early days, such abilities felt like major wins. It seems I found another identity to express part of my soul — the Tomboy. I still love that aspect of myself, the cut-up, boisterous and naughty, irreverent and obstinate. It's terribly apt that the name of the little sailboat I had as an adolescent got named *Cattywampus**. My mother's idea, but I leapt at the name and it has entered my current lexicon of favorite words.

As a girl, I was pretty-ish but was never truly fascinated with my looks. Of course there were no selfies and all of us just thought a lot less about our image. I proceeded through my life ignoring my looks for the most part, or just taking them for granted and often being surprised when they were noticed. Sure, I would use them if it seemed like an advantage in social situations, and would turn them on for cute boys. As I grew older, I tried to ignore my appearance in professional situations, but by the time I hit my twenties that appearance became a

liability because it seemed the only thing people cared about, or rather the people in power, who were of course men.

This ultimately led me to rely too much on my charm and not on the one thing I wanted to be known for — my mind. I think the driving factor, as I grew through life, remained a determination to prove that I could do *anything*. (An ongoing competition with the boys?) Now, however, at this late date I find that I have *not* proved I could knock it out of the park in any one endeavor, just maybe to center field. Oh well, I tell myself, merely another obstacle. Yes, perhaps a more fearsome one, but I do love a challenge. I like to fight, and ideally to win. At any rate, it always seemed like a stout ally in my ongoing campaign.

Even the use of that word *campaign* positions me as a warrior, right? And aligns with the concept of an argument as seeking proof, or establishing prowess or independence. Oddly, I *am* an Aries. Not that my rational self gives astrology any credence and yet, Golly, I do seem to match up with a lot of the markers of the Ram, that first headstrong sign of the zodiac that prefers to ideate more than most anything else. And with both Sun and Rising Sign in Aries, I've got a whole lot of old Mars, God of War, running through my psyche.

In the dawning era of liberated identities, even if we're not part of the more obvious shift, we need to look at our own little personae and see if they haven't also been shoved in a closet along with our mother's high heels, our dad's suits, and numerous skeletons.

On my refrigerator is a photograph of Queen Elizabeth. Slightly doctored by a puckish artist, at first glance she appears to be meditating; possibly even at peace. But on second glance, there is a desperation beneath her composure, evoked by the way her lips seem pressed together as if to keep it all out, or to keep it all in. As if she is imagining a world in which she is not Queen, in which she is free. Perhaps the look is really one of forbearance. *"If I press my lips together tightly enough, I can maintain this illusion."*

Elizabeth, as The Queen, is the paramount example of the classically

projected ideal of the feminine. This ideal acknowledges her power to symbolize but then makes sure to confine it strictly to the world of symbol. Saddle her poor head with a crown and prance her around her corral. Take her out for a decorous trot but keep her bridled. Dress her up as a woman, with a different suit for every color of the spectrum and pill box hat to match and give her orders to wave.

My refrigerator Elizabeth reminds me that, unlike her, I *am* free. It has taken me decades to maximize that freedom and it would take minutes to forfeit it. Whether or not this is a constructive metaphor, I walk a razor's edge of either/or. Either I seize the day or I let it slip from my hands. Writing this book seems the culmination of that; I'm taking a stand, testing the limits of that freedom. I could say it's my Hail Mary pass, or my fish-or-cut-bait or do-or-die moment (look how I pile on the male metaphors here), but then what is the end game? Maybe I'll just come out of the closet as the slightly philosophical clown I've always been and start doing stand-up…

* **Cattywampus** - (Cattiewhompus, Caddwampus, Catawampus, etc.) 1) diagonally, obliquely, askew, awry, in disarray or disorder. 2) across diagonally from; "catty cornered". Origin uncertain. But there are other, completely different definitions; from the Dictionary of American Slang, by Eric Partridge : Catawampus (Catawamptious) : 1) Avid: fierce, eager: violently destructive. 2) Vermin and insects, esp. the stingers and biters… 1870. Some opine that the word references the Wampus cat of Tennessee folklore which is derived from Cherokee legend about a half woman, half cat who spies on the male elders after hunting expeditions.

The professors were smoking and expelling considerable hot air when she blew into the room and, with glittering eyes and explosive theories, scattered their thoughts, leaving them all entirely cattywampus.

WHY AM I ME?

Great God! Why am I me? — Stendhal, Le Rouge et le Noir

Can one have an identity crisis at the age of 63? Apparently one can. One is. I am. I am having a bloody identity crisis at the age of 62 and 11 months. In preparation for yet another g-d birthday.

I sit at my desk and can see it — like a dismembered hulk, it's piled up in various corners of my room, in drawers and on shelves — paper and more paper, yellowing xeroxes and originals, notebooks and binders — the novel I wrote in my thirties, and all the orbiting bit players — poems and lyrics, the occasional short story the writing of which I have no recollection, the 'book' for a musical… lots of doggerel. My former self…

I can barely stand to look at it. It terrorizes me. The damned weight of it all, the density of verbiage, the rush of self. But I cannot put it away again. I've done that already so many times; fiddled with and prodded at it so wantonly that all context, all chronology, has been forfeited. Part of the horror. It's like entering a room with an unmade bed, clothes on the floor, shoes strewn all over. A vortex ready to suck me in and then make me cry because I never pushed hard enough to finish it.

It shortens my breath just to be surrounded by it and yet I let it lie. Some sort of self-flagellation routine I guess. My shrink says to either do it or put it away for some other time. But here is the final metaphor: it is a shuffled deck of cards, and the game demands to be played.

<p style="text-align:center">※</p>

So now I sit before these piles stacked all over the floor of my study. Every morning I glance at a few pages. Often I yelp out loud as I encounter a younger self whose sometimes painfully accurate prose records her thought processes. *Who is this creature?* Where has she fled? This is a self I only distantly remember. A post-war, post-punk, pre-marital,

pre-maternal, artistic soul who gave way too much thought to her own predicament as such in an increasingly commodified world.

There is anger here, and doubt, and fear, and a pulsing desire to make manifest a vision of beauty and harmony and destruction and a Self beyond self. The writings are filled with starkly solitary moments. My response is visceral, humid, an ache. I am filled with tenderness for this girl, admiration for her struggle. But then I blunder into the sadness that she shared it with no one, that all this thinking and articulation, poetry and madness, ecstasy and doubt, had no witness. It seems a tragedy of romanticist proportions, an extraordinary waste, a grand futility, or maybe simply grandiose (is that an oxymoron)? Ahhh, but there is that cliché — it's all about the path. Well, it's been one hell of a rocky Sisyphean stroll.

Better to write for yourself and have no public, than to write for the public and have no self. — Cyril Connolly

One might take solace in those words, but I know I cannot let the work languish any longer. I dive into an editorial frenzy, a forensic exhumation. As I read, the shade of my younger self begins to coalesce before my eyes. With a scent of musk and cold earth to complete the metaphor, that younger self incarnates. So interrogatory. Back then every move I made provoked a question, every thought produced another thought, every word a query as to its origin. I came to life in these words — my earlier I — so on edge, fighting for something, I knew not precisely what.

As I'm reading, it begins to dawn on me how blurred my current perspective has become. As if along the way I just shrugged and said, what the hell — it's all inscrutable, because even if there is a momentary glimpse of meaning, it gets swallowed by the onslaught of moments rushing beyond it. But the question was — had my sight become so etched, cross-hatched and scribbled upon that its original clarity could not be summoned?

Back then *everything*, and it *was* Everything (including myself —
an Alice-like figure who grew and shrank at will), everything was riding
on the back of some winged creature (maybe angelic, maybe demonic,
or merely mundane); could be a bat, could be a hawk or a humming-
bird, could be a careening sparrow upon which I rode across the plain
of my own existence... So what terminated that flight? What quelled
that urgent need to define, to realize, to transcend?

Of course events transpired, demanding full attention of the con-
scious brain. Important stuff like marriage and motherhood. The ju-
venile onanistic meandering came to a halt. One loses track of one-
self while fielding life's numerous absurd and arbitrary curve balls. But
when those years were navigated, and in many ways successfully, and
you arrive one day back on that earlier path, what then? Do you find
the same questions looming before you? Like a bear standing on the
path between you and the uphill journey? A bear who plays gatekeeper,
asking the same questions as always. Who are you? What is the mean-
ing of your life? Why should I let you pass? And anyhow, where do you
think you'll get to? Do you really think there is something beyond me?
How do you know I am not the terminus of your quest?

Perhaps if I were a Native American, I would bow before this bear,
knowing I could either walk through her, or head back downhill to
civilization, or extend my claws and do battle with her. And of course
she would laugh, no matter what I did. What dream bear would not?
For she knew that the night before I *had* dreamt of claws emerging from
my furry paws.

So now, nearly 63, why would I cower before the standard outline of
mortality? I owe it to my younger self, not to dive back into her quandary
but to charge back up the path with the same ferocity, the same blood
lust; do battle with the furred giant, fling open my sack of words, and
conjure, with the spinning alphabet, my best, most essential self.

There are those that need be born only once, and those that need to be born twice.
— William James

WTF IS THE SELF ANYHOW?

Who was I? Today's self, bewildered, yesterday's forgotten;
tomorrow's unpredictable.
— Jorge Luis Borges

What *is* the self?
Is my personhood an action or a reaction or a bruise?
Am I an agent, an object, a fiction, a victim?

What is the source of identity?
Is it a product of culture, a work of art?
How many are the tales you tell about yourself?
Or rather, what is the tale you *make* of yourself?

My spirit, playing as a horse escaped, begets in me so many extrava-
gant Chimerae, and fantastical monsters, so orderless, and without any
reason, one huddling upon another.
— Michel de Montaigne, Confessions

The modern self is so splintered and refracted by the endless stream
of what is Other. How do we isolate what is ours amidst that deluge,
that onslaught? Clearly the great physicist Richard Feynman saw the
self as dynamic:

The thing I call my individuality is only a pattern or dance... the
atoms come into my brain, dance a dance and then go out — there're always
new atoms, but always doing the same dance, remembering what the dance
was yesterday. — Richard Feynman

Contemporary Stoic philosopher Massimo Pigliucci states that the self *"is neither an illusion nor a static ruler of the mind."* This approach seems to be catching on in that confluence between the worlds of neuroscience and philosophy. David Galin, Neuroscientist at U.C.S.F., contrasts the nature of the Self, as conceived by Western theories as well as by our innate folk wisdom, to what Buddhism calls the 'correct view,' in which

"The Self is seen, not as an entity or as substance or essence, but as a dynamic process, a shifting web of relations among evanescent aspects of the person, such as perceptions, ideas, and desires…" For Westerners, he says, *"The erroneous view of self as an enduring entity is the cause of our suffering because we try to hold on to that which is in constant flux and has no existence outside of shifting contexts."*

Galin goes on as follows: *person, self, and 'I' are not synonymous, but are quite different things, with person including more than self, and self including more than 'I'.*

Galin relies on two of my favorite books, by linguists George Lakoff and Mark Johnson. The first, Metaphors to Live By, focuses on the way we use metaphors to construct 'reality'. The second, Philosophy in the Flesh (a brilliant book, part of which he summarizes here) turns that same diagnostic of metaphor to the way we think about *person, self, and I.* Given the tendency of the human brain *"to seek and find, or to project a simplifying pattern to approximate every complex field,"* we are bound to apply that to comprehending the nature of our selves.

We simplify in two nonconscious automatic ways: by lumping (ignoring some distinctions as negligible) and by splitting (ignoring some relations as negligible). Splitting into discrete entities is useful for manipulating, predicting, and controlling at the sensori-motor level, and at abstract levels too. — David Galin

But, while being highly adaptive, these two mental shortcuts used for pattern seeking can yield serious errors, especially *"in our experience of our own "inner life," and in our concepts of the structure of 'the person.' Thus we come to see the self as a bounded persisting entity, rather than as a dynamic open network of relations."* On the plus side, the lumping strategy, which simplifies by unifying and finding more relatedness, can compensate for the isolating tendencies of the splitting function. Galin goes on to theorize that the approximations that aggregate entities *"may be the seed of the Buddhist 'correct' view that all things are interdependent. Perhaps these Western ideas could add to Buddhist understanding of the difficulty of transforming the inborn view of self and person."*

That transformation is rendered even more difficult due to the fact that we operate, some neuroscientists believe, perhaps as much as 95% of the time, from our *nonconscious* (the advanced cognitive processing that occurs automatically without awareness) — the term most academics use now so as to distinguish it from the Freud's *unconscious,* with all its murky connotations. You see, whatever you think you believe, most of the facts you'll cite, memories you'll dredge up, or excuses for behavior you'll muster — they will all quite possibly be specious. In effect, we experience life through our nonconscious and then explain it all with our conscious minds, which are way more fallible than we think.

When you come up with an explanation for your feelings and behavior, your brain performs an action that would probably surprise you: it searches your mental database of cultural norms and picks something plausible… We tend to reply with descriptions or predictions that conform to a set of standard reasons, expectations, and cultural and societal explanations for a given feeling.
— Leonard Mlodinow, Subliminal

Our memories are card-indexes consulted and then returned in disorder by authorities who we do not control. — Cyril Connolly

Bit by bit, thanks to neuroscience, the old 'Central Command Center Self' is getting disassembled. What we, more-or-less all, actually are is a small crowd of selves, and we have scant control over them, too. I mean, put free will and the nonconscious in the ring? It will be a knockout, with free will left panting on the mat.

Some of us, interested in knowing ourselves more deeply—perhaps to make better life decisions, perhaps to live a richer life, perhaps out of curiosity—seek to get past our intuitive ideas of us. We can. We can use our conscious minds to study, to identify, and to pierce our cognitive illusions. By broadening our perspective to take into account how our minds operate, we can achieve a more enlightened view of who we are. But even as we grow to better understand ourselves, we should maintain our appreciation of the fact that, if our mind's natural view of the world is skewed, it is skewed for a reason. — Leonard Mlodinow, Subliminal

That reason being to survive and to flourish. So don't beat yourself (your selves) up over the whole thing. Let's face it — developing self-awareness, unraveling the various strands that have been woven into our identities — can be taxing work. And it really never ends. Since there is no static 'there' there inside of us, one has to constantly update the software on one's psychological GPS. We are all in flux, works in progress, and ideally en-route to higher, deeper, truer expressions of our potential. I consider this 'the work' (an idea that hearkens back to the Alchemists, who were tirelessly attempting to create gold from lead, which process, for them, stood as a metaphor for the transformation of Self).

But even earlier than the Alchemists were the seekers of Ancient Greece; their leading luminary, Socrates, was the first thinker who di-

vined that the quest for clarity and wisdom requires self-knowledge.

To comprehend the human mind is surely one of the hardest tasks any mind can face. The legend of the single self can only divert us from the target of that inquiry. — Marvin Minsky

In the process of pursuing these explorations, one can easily trip and fall down the rabbit hole. So let's start with the concept that we are Subjects, that we are functioning I's, and we have various relations with our various selves. Since *object control* is one of the first skills we learn as infants, because it distinguishes ourselves from external objects, there is a primary metaphor wherein self control looks like object control. Yes, that's right: my self is my object. In this paradigm, I, as subject, force a movement of the object, which is my self — for instance when I say, 'I knew I needed a swim, so I threw myself into the cold water.' In addition, I can hold various positions in relation to that object of myself: I can be adversarial with myself or 'be at war with myself.' I can be a parent to myself and 'wean myself from television.' I can be a buddy and enjoy 'just hanging out with myself.' I can fail to meet the obligations of my social self and 'disappoint myself.' I can act as a guardian and 'take care of myself, thank you very much.' And, hopefully, I can 'be true to myself.'

But according to what Lakoff and Johnson refer to as the *Folk Theory of Essences*, every entity has an essence or nature, a collection of attributes that makes it the kind of thing that it is and is the causal source of its natural behavior; and on this theory, there is within us, under this heap of selves, a true self at the core. Or I would interpret this as saying, 'There, behind it all, behind the potted palm, trying to blend in with the wall paper, is our authentic self.' But this, say Lakoff and Johnson, is yet another metaphor — the Essential Self metaphor — which in our minds is *"the locus of our consciousness, our thought, our judgement and will...and is our Essence that, ideally, should determine our natural behavior."*

Ideally. Since we all know that we frequently act in ways that feel discordant with our Essential self. And consider this:

What I am as a self, my identity, is essentially defined by the way things have significance for me… We are only selves insofar as we move in a certain space of questions, as we seek and find an orientation to the good… Because we cannot but orient ourselves to the good, and thus determine our place relative to it and hence determine the direction of our lives, we must inescapably understand our lives in narrative form as a 'quest'.
— Charles Taylor, Sources of Self

This statement has serious gravitas. And I do agree with it. But are we all only seeking virtue? Now wouldn't that be radical. I love the word *seeker* and I love the word *quest*; and what better thing to seek. However, many define themselves in contradistinction to the good, or at least the greater good. But let's go with the healthy self. To my mind, what becomes a critical precursor of seeking virtue is solitude. We need solitude, to know ourselves, to make ourselves, to plot, plan for, and ideally energize ourselves.

Consider the word 'retreat'. Although the primary connotation was to recognize defeat in war, here is an instance of a language process called *melioration*, where a word gains a more positive definition over time. These days we choose to head to a retreat to gather our senses back together. (Actually not far from the military retreat, which was a sensible thing to do in the face of imminent destruction.) But we can retreat at any point in our day. Maybe we meditate, maybe we swim, maybe we stare into space at the shoreline… all to get back to that primordial feeling of experiencing pure being. And from there, to wonder about the self.

It all goes back to Socrates really. Long before the multiplicity of the contemporary self had been postulated, he understood the following dictum to capture the essence of The Good Life — "Know thyself." (More on the The Good Life and virtue in a later chapter …)

❊

My own quest to understand my self, or the inner reality I experienced on a daily basis, began when I was in my late teens and was fueled by a desperate urge to understand my value in relation to the world. I sought an immediate answer as to why the hell I was here. And I railed against the absurdity of civilization and modern life, which seemed to offer absolutely no believable response.

Now, recognizing that there is no single answer, but multiple answers to my question, I have learned to relax into the search. Though I may never close in on the answers, I will never abandon the quest. It lends meaning to my life, this ongoing wonderment. And I have learned one essential thing: the quest is not simply a looking inward nor a seeking outward. To me, this searching has a shape, and it's something like a *Torus* (imagine an electrically charged Slinky closed into a tight circle). In fact the Earth's magnetic field is considered by some astrophysicists to be toroidal, to have the structure of a Torus, to be a sort of wildly fluxing, living cosmic donut, a form expressed by the energy perpetually flowing into the center and back out and again and again around Earth.

I think it's cool to imagine that consciousness is toroidal too, always moving inward and outward at once, getting pulled toward a center and as it arrives, getting fueled to express back outward, to manifest. An endless and productive rhythmic flow, in and out and on and on. Rather lovely really. And if we're lucky, we have a whole life to explore the nature of this flux that is us.

Character is characters. Our nature is a plural complexity, a multiphasic polysemous weave, a bundle, a tangle, a sleeve. That's why we need a long old age: to ravel out the snarls and set things straight. — James Hillman

In his autobiography, Memories, Dreams and Reflections, Carl Jung, of course, has much to say about the development of personality:

Personality... is an act of courage flung in the face of life, the absolute affirmation of all that constitutes the individual, the most successful adaptation to the universal conditions of existence coupled with the greatest possible freedom for self-determination. To educate a man to this seems to me no light matter. It is surely the hardest task the modern mind has set itself. And it is dangerous too... Yet the development of personality... means fidelity to the law of one's own being. For the word fidelity I should prefer in this context, the Greek word used in the New Testament... which is erroneously translated "faith". It really means "trust, trustful loyalty". Fidelity to the law of one's own being is a trust in this law, a loyal perseverance and confident hope; in short an attitude such as a religious man should have towards God.

Now Dr. Jung makes a claim that I, being a pusillanimous punk, would not have made. However, I agree with him. How can we be straight and true in our relations with others if we are not straight and true with ourselves, and how can we approximate that if we do not *know* ourselves? Socrates nailed it millennia ago, yet our stubborn refusal to follow his dictum has led to centuries of angst and acting out. How can we tweak the engine of our strength if we haven't learned how it runs? And why would we putt around at half-speed when we could blaze down the road by grabbing the wheel of that hot-rod which is human potential. This may not be such a bad metaphor when you consider how complicated a mechanism a race car is, how much awesome technology makes it run, and how critical is the way the driver handles it.

THE LEXIVORE BEATS HERSELF UP

I am a Lexivore, I devour words like bonbons...

The advantage of a nicely turned vocabulary is that while it may or may not actually define reality, it can sometimes put a lovely gloss on it. (Or in this case bang a drum to announce and 'make it real'.)

The quiddity of my existence, alas, was to be an oxymoron.
A divided soul. A victim of irony.
An existentialist demagogue by night, by day a simple malingerer.

Perhaps it is not altogether fair to label myself as an *ergophobe* (one who is afraid of work) or a *micawber* (after the Dickensian character who, though poor, lived in the optimistic expectation of great fortune), for I did work. Indeed I worked like a dog to unearth a bone, a bone whose scent was stirring me to madness, a bone I believed would deliver me from my hunger, from this gnawing feeling that there was something else to existence. But a dog can find justification enough in Olfacto Ergo Sum, so why not I?

That my labors and talents had come to seem non-negotiable in the marketplace, due to my own intransigent need to pounce from thing to thing, was a source of guilt. And I dutifully dubbed and castigated myself as a grasshopper — perennially leaping about as if summer were infinite, while all the rest were building their mounds for posterity. Had I made a fat mess out of all of it? Relentlessly staring into my navel, only to find lint? (Yes, I know grasshoppers don't have navels nor could they possibly look down at them. And if they could it probably would have been pollen they found. I am a mistress of mixed metaphor...) Or was I just a terminal decidophobe? Terrified to be categorized?

Regardless, all my works seemed to be locked in a general state of parataxis… paintings, songs, stories, movies, games, websites, each existing in its own little silo. (Parataxis: a literary device in which phrases and clauses are placed one after another independently, with conjunctions missing. The most famous example of which is this darling Dickens quote: *Dogs, undistinguishable in mire. Horses, scarcely better — splashed to their very blinkers. Foot passengers, jostling one another's umbrellas, in a general infection of ill-temper…*)

Self — a parataxis too. Occupational hazard of the coquette. Pretty head, turned qua-quaversally by all and sundry. So many turns. So many vistas winding up just snapshots. But where the locus? Where the schnittpunkt? (Ha! German for intersection or junction. See what farting around with words can do for you?)

As a wag I was once married to used to say, "It's tough being me." That's probably why we actually got along.

The tough thing about my me-ness is that for some reason I have wound up being a jittering nexus of numerous divergent streams of culture all in contraposition to one another… On the one hand a party girl, on the other a hermetic bookworm. On the one hand a punk modernist, on the other a romanticist. One hand a chill Cali girl, the other a wannabe dominatrix of culture. One a transcendentalist and the other an atheist. So for every step I take in one direction, I take another in the opposite. Maybe it all boils down to me being a weenie. For not taking a position.

Maybe I could retitle this book *Confessions of a Weenie or How Not to be a Weenie.*

Naturally, it is not easy to pull yourself out of your weenie-dom onto the cold bright stage of life. Self pep talks might be a start. Every morning look at yourself in the mirror and say, "I am not a weenie." Maybe get a little name tag to hang around your neck saying *I AM NOT A WEENIE.* At the very least this will provoke conversation, lead-

ing others to say "Really, you're not a weenie? How do I know?" Then you will just have to step up and prove it.

At any rate, just to show you how harsh one can be on oneself (and possibly present a vaccine for what you may feel you've encountered in this book, or even what you might encounter in your daily rounds):

<u>Heinous Charges I Have Brought Against Myself Over The Years</u>

Self-destructiveness, Self-doubt, Lack of Self Development

Pride, Vanity, Narcissism

Bad Faith (I am here only referring to the Existentialist term, meaning a refusal to confront facts or choices.)

Superfluity (Ah, this is a particularly sticky epithet as no matter what one's trajectory may be, one can always pull back and see how ultimately meaningless it is. Or is that just me?)

False Love (Teasing leading to seduction concealing opportunism. 'Crying wolf'. General dishonesty)

Indulging in Delusions and Fantasies (Soooo numerous.)

Solipsism (The theory that self is all that can be known to exist. Imagine the consequences!)

Laziness, Avoiding Responsibility

Being Bourgeois (The affected search for 'the Real', for 'Enlightenment')

Idle Curiosity (Hmmm, I'm not actually sure there is such a thing.)

Seeking Novelty (Well, okay, that one's genetic, right?)

Nihilism (Only the fashionable sort.)

Gluttony (Isn't that genetic too?)

Contingent Ethics (Pretty widespread condition after all.)

Akidia (I love this one: it's Greek for *slothful melancholy.*)

Sophistry (The use of fallacious arguments, especially with the intention of deceiving.)

Subconscious Lust for Power and Fame

Objectifying Self and Others

Seinsvergessenheit — the Forgetting of Being! (*"In what precise psychological and material ways does the condition of modern Western man, and of urban man especially, represent or act out the forgetting of being — seinsvergessenheit?"* — Martin Heidegger)

<u>The Names I Have Called Myself:</u>

Child (Idiot, Moron, Fuck-up... anyone feeling better?)

Flaneur (One who roams the avenues. Paris of course. Alas, very hard to simulate in New York or LA.)

Dilettante (I think I borrowed this epithet from my younger brother, who has rarely shown me any sympathy.)

Dandy (Oh well, this one I rather like since, really, I am.)

This name calling relates back to what Dr. David Galin (to whom I refer in the essay WTF is the Self) might consider a result of the brain's habit of shoving experiences into categories, of shaving off the untidy, complicated edges of the actual. This is how we maneuver in the world, according to these over-simplified maps. And it applies to the way we create our self-concepts, which masquerade as discrete entities, and whose outlines render them convenient for daily use. Of course, as Galin states, these "all-or-none rules break down over exceptions. But we stay blissfully unaware that we are constantly approximating… and we ignore the differences if possible."

All righty then!
I shall simply flip all those categories above and then halve the distance, just for the hell of it, or in honor of Zeno's Paradox. And now I can fall into these new, improved categories:

A Cocktail Philosopher
A bit of a Hermit, maybe even a Monk (however randy)
But also a Party Girl
A Hybrid. No, a Hyphenate!

Yes! I'm a Hyphenate. Quite accepted these days… Fucking A. Just plain did not exist when I *really* could have used it. But wait, now there's Poly-Hyphenate! I mean how many hyphens are too many or is this a moot question? For me it will have to be. Because, from now, I am just going to invent the categories to suit *myself*.

Wait, *which self???*

MAMAN AND THE WATER BEASTS

How many times can you lose your mother?

This phrase repeats itself in my head. It is not a metaphorical question. My mother had lived with Alzheimers for almost 15 years.

My own journey alongside her illness led me through strange territory. Mostly unguided, mostly alone. The one phrase I encountered in my occasional inquiry into the nature of the disease still resonates — that for those closest to the victim, there is a phenomenon akin to a succession of little deaths and, for each one, an attendant period of mourning.

My father, who insisted on caring for her up until he had a stroke and even after, lived this on a daily basis. I could see it in his face when it happened, when my mother, who seemed to have drifted farther and farther away, would suddenly reappear on the horizon, bright as a sunrise, with some intelligent, sensitive remark or bit of conversation. I could see it; a little flame of hope rekindled in his eyes... until, and there was always an until, her old self would be obscured again by a swift and mysterious cover of clouds. And he would fall under the same shadow — his lover of 65 years suddenly rendered mute, inaccessible once more.

When we first realized what was happening to her, after a long period of denial on my father's part, I was living on the East coast. They had just moved to California. Did my father move to get away from the friends who might realize what was happening to his bride? For me, a divorce and a new idea of my future brought me West and back into their orbit. And so began my own series of mournings. I know that for my father they were more poignant, as he harbored more hope that the Aricept and the Nemenda would return her to him. He sched-

uled a cruise to Alaska, only to find her wandering the decks late at
night. Back home, he valiantly set up her easel again, and bought new
paints — with the hope that she would revive her practice as a paint-
er. And there it all sat, gathering dust. And there too sat this once
glamorous, vivacious couple in the gathering gloom of my mother's
waning identity.

One day I pulled out her big box of Pantone color sheets. She used
to cut these into shapes, form collages and create compositions for her
abstract paintings. She had a sense of color like Bonnard — subtle in-
terplays of gold ochre, periwinkle and violet, pale butter yellows, sud-
den flashes of manganese blue. As I spread the sheets before her and
grabbed a pair of scissors, I asked if she'd like to play. She smiled wanly
and simply looked at the colors, breathing and looking. I bit my lip.
Where had the fire gone... where?!! But I knew my mind needed to back
off, to look again. Was she seeing color in an altogether different way?
Was she simply imbibing it... like a newborn? Color stripped of mean-
ing, color pure unto itself? I would never know, and now she could
never tell me.

And I began to see that other questions I'd never thought to ask
before would remain unanswered forever. This is one form of goodbye
that would continue to echo. A question would leap to mind, about her
childhood, about her thoughts as a painter, about her career as a galler-
ist but, encountering her smiling placid face, fall back into obscurity.

We got used to her, by her 80th birthday, living in her own world.
But suddenly, sitting in the back of a car, she would erupt with a funny
one liner and startle the shit out of us. And I wondered; *Where have you
been hiding, girl?* Then she would return to calling out the color of the
traffic lights. And again we would silently mourn.

I came to visit her at the group home she was living in; sitting
beside her wondering how to interact, I picked up a fashion magazine
and began to fan through the pages and point out unusual combina-
tions of color. My mother was always impeccably stylish, in my youth

rather Parisian, and then later following her own muse as a supporter of wearable art. Now, no longer able to dress herself, she has been reduced to odd assemblages of sweats and my Dad's old cashmere sweaters. Her eye rested on a particularly striking garment she herself might have worn. When I asked if she liked it, she slowly nodded and said, "Yes". But suddenly she blurted out "We can see the Temple from here..." I dropped the magazine. *Temple? Is she seeing heaven? Has she been reincarnated from a former life as a Jew, or is she envisioning her next incarnation as a Hindu? Mom?? Tell me! Please tell me more! What else do you see?* But there would be no further explanation. Her face returned to its former vacancy. Still I laughed at her wondrous words. And then, as I hit the street, mourned once more.

For her, there was no swoosh of scythe, cleaving life from itself, from her. No — death came as a miasma, malingering, malicious, coalescing into a phantom beast, licking, licking at her very core. Lapping up all the moments stored in her mind, all her history and the words used to string the tale together... with its big old tongue, tireless tongue, the ungodly creature, languid and lascivious, lured into its maw, one by one, the sugar-spun filaments of self, 'til she became naught but an outline. Hollowed out, scooped clean.

There is a famous painting by Marcel Duchamp, entitled *The Bride Laid Bare by The Bachelor*. Perhaps this is who the beast really was, The Bachelor... the one who taunts, who takes, who dines on our hearts, yet remains ever alone. Were waves of cognition in evidence anywhere in my mother's silent skull? If so they seemed to break on a shore of hard bone, ricochet dully against a cranium whose precious contents had been consumed by the Bachelor, who took her in gulps, like a drunk will caviar...

And yet even then, there was her sudden half smile, one that spoke to us of potential salvation. Though only a tiny flickering, it felt like the lamp of the Jews that burned for days. Only we weren't Jews and weren't Christians either... and could see only the slack jaw and eyes that stared into some nether world.

But she was my father's bride, and she haunted him, and led him with her into her purgatory, into the land of shades. He fell beneath her spell of death, and preceded her by four years.

But now — speaking about the loss of her — I wonder, did I ever really **have** my mother? Looking back through my youth, I remember a charming beauty, always willing to bestow a smile upon me, to lick her thumb and sweep a smudge away, to show me how to push the chocolate chip cookie dough from the spoon. But somehow, so little else. I found an old slide a few years back, of her changing my diapers... There was a look of such sweetness on her face. And yet I have no recollection of experiencing intimate moments like that. None.

She was an independent female, struggling in a suburban reality. A woman who could decorate a house with more imagination than anyone else on the block, who threw killer parties and sashayed through them like a Hollywood glamour puss. She looked like Norma Jean before she went platinum. She was a painter. My god, in early-sixties, suburban Chicago... she was a painter. She painted slightly awkward, lemon-colored nudes and dissolute, lavender odalisques; she even painted me — a somber portrait of a child unwilling to be captured.

One Halloween she made me a bat costume. It was my idea but she finessed it: somewhere found some mousy gray fur and stitched a little bat-girl cap and fabricated real wings of felt. That night she herself dressed as a demented ghost to hand out candy. She and my Dad had made a scary tape loop which they played when kids came to the door. I still have the big copper pitcher into which we dropped water then amped it way up along with creaking doors and moaning. Nobody else around did that.

Of course I think she really favored her first-born, my handsome and sarcastic older brother. And she had no choice but to continually monitor my younger brother, a cherubic boy with a satanic heart. Being the only girl, I expect she thought I would just toe the line. Like she had, despite her aesthetic deviations. And when it became clear, from an early

age, that this was not my style, I believe some sort of strange competition began. Here was a woman desperate to break free, to claim her right to a full-blown identity, and here was her girl-child, hellbent to do the same, but with a whole future ahead of her, and changing times that might mean she could actually swing it. I believe this advantage of mine, instead of being reason for hope and joy for her progeny, created a sense of injustice. And rather than rail against the world, or lend me a hand, she chose instead to watch me navigate a still-rocky road alone.

Maman, oh Maman, did you ever love me? (*Why Maman? Wasn't she Mom? Or Mommy, yes, when I was little. Mother — too icy a title. Mama — too warm. But Maman, as I write this, evokes just the right temperature, a French attitude — charming but aloof.*)

I assumed she loved me; that was the natural order of things, was it not? But they were not natural times. And she had her own tumultuous birth to attend to. Her own mother had spanked and fed her and spoken little of the monumental verities of existence, including her own divorce, and had said to my mother when she hinted at the hardship of marriage: "You made your bed, now lay in it." So my mother repeated the same to me when, after a disastrous first year of marriage (a child bride at 19, fumbling with a stupid decision and a stupid convention, adrift in the wastelands of Tucson, with no compass, winding up at midnight, 1969, in a vast vacant parking lot of a prototypical mall, begging to come home), she said "I *could* say what my mother said to me. You made your bed, now...."

I knew she brooked little sympathy for her wayward, headstrong daughter, but never before had I encountered this steely Kansas pragmatism. Who was she? Was she really my mother? Was I really her daughter? Was this what you said to a lost child? Could one ever be more alone than I was at that moment, surrounded by a sea of blacktop, illuminated by harsh neon, standing amidst a field of white lines whose only purpose was to guide the cars of the heedless into their allowed space for consumption?

I had read Kafka and Sartre and Dostoevsky, but these dark, heady males had nothing to say about female cruelty, neglect, obtuseness. And yet one must forgive the dead. One must have sympathy for the beautiful. One must understand history, and fate, to continue to love.

❉

Just as I never knew her, she never knew me.

The greater part of my sadness, now that she's gone, is that inconsolable hurt — that she never *sought* to know me, never found me worth the time, or just plain didn't know how to talk to me. *Or maybe was terrified of me?* Maybe that was it; I was poignantly and patently a logical extension of herself and possibly that freaked her out. So she refused to acknowledge it.

Well, I *was* a wild child; but it was all of her own pent-up wildness that had pooled inside of me. Inside it swam big, lovely, awkward water beasts that had business to conduct, of a sort, or rather play to conduct. They'd been penned up for centuries but now they could crawl ashore and see the sky for the first time in recorded history. Big she-things with thrashing tails and glinting eyes and teeth that could pierce. But they were unschooled. And Maman would not teach them. Maybe she hoped they would simply drown. But they wouldn't. I had to wiggle and squirm as they rose to the surface through my childhood sapience, as they crashed to the surface in primordial glee.

I had to learn what to feed them and what not to. Never did figure out the proper diet, and could never bear to discipline them. Eventually I had to name them. Myrrh Curious and Miranda Bang, Sylvere Flew and Clement Psychowitz, Georgia Spottiswode and Bunny Quatorze. And they are thriving still, swimming still, now somewhat languidly but not weakened, just waiting…

And all the while Maman spun in her glamour, in her muted ivory silk, in her crazed batiks, with her silver nails and frosted Peter Pan hair. I could never be her, thought I. I am a lumbering sea thing just

sprouted chubby legs. She cut my hair in a Buster Brown bob and I sulked. My lovely long golden-brown hair chopped. And then had to suffer a few years of rollered page boys making me look like a medieval kitchen churl. And so, churlish I became. Sulk, sulk, sulking I stood my ground. And developed thoughts. Critical thinking even. I could see the adult games being played around me and formed opinions.

So no, I never really *had* my mother. And that is why it was even more painful as she slipped away. At an age when old behaviors begin to drop away and parents are often more able to accord their children emotions long held back, and vice-versa, she was far beyond. I remember keenly coming home for a visit when I was in my thirties. After a precipitous and absurdly early marriage and divorce, I was hitting my stride as a girl about town in Manhattan. When I left to head back to the city, probably dressed for an evening out, I gave her a huge embrace, knowing I might not see her for some time. Her arms lightly encircled me but, after a split second, fell to my waist and pushed me gently away. My gut clenched. My mother literally pushed me away. Something dawned in me.

At some point in my youth I think I gave up trying to please, intrigue, or just plain interest her. I had had to borrow boy ways, try to seem like just one of the boys, to defend myself from her beauty and from her distance. No matter, now I wouldn't care what she thought. I would defy her. I would *become* her, only bigger and hotter and brighter and twice as sexy and much, much stronger, strong like my devil brothers.

So, early on, I headed off in the other direction. Blew through many a lover and a few marriages. Typical story really of the heady girls of my generation. And now, like many of them, I run solo. Which Maman always dreamed of for herself, I think. Willful thing she was (despite her concessions to societal norms) and yet, funny how it all works, that was the one definition she attached to me.

I broke free for her. Because of her. In spite of her. And now she is

gone, with only these wisps of memory clinging to the space she has now vacated. Not enough of them to give shape to her form. I will never know more of her now, nor she me. And this is the most incurable pain of all... the pain of those left in the silent wake of passing progenitors.

And yet, though she never held my hand as I stumbled and hacked my way through an urban jungle, my mother did one great thing for me. She showed me what one woman could do, with some grit and determination. In her late forties, she gathered a small group of women together and started a gallery of contemporary crafts in Greenwich, Connecticut, and later another in Manhattan — a gallery soon renowned for representing the best of American crafts, from potters to jewelers to woodworkers. She was considered a luminary in the field, genuinely loved and admired by her craftsmen. My mother was an entrepreneur.

And although I never really had her full attention in my youth, never really knew her in my adulthood, what I have now is an inheritance: of how to find my mojo, how to seize my moxie, how to use my voice. Maybe she knew that all along; that I wasn't the sort that wanted be coddled, that wanted to be 'understood', that would even accept her guidance. And so perhaps she decided to let me grow all on my own. And although I probably would have liked to have been offered all those things, maybe I wouldn't be the woman I am now if I had.

After all, I will never not feel her loss. I will always mourn the magnificent woman I never got to know, my mother.

DADDY'S GIRL

And then there was Daddy… delightful, equivocal, self-indulgent. If I appear to have been a heady child tugging angrily at my Mother's attention, the corollary would be that I was a pixie cajoling and performing to attract the attention of my father. Neither approach worked all that well.

A father is meant to be a guide, a pole-star, a demi-urge who shoves you into life. All while smelling of firewood, cold air, and spirits.

Or is he? My Dad was the only person I ever knew who could speak French with a Chinese accent. He was so handsome, so puckish, he could get away with stuff like that.

Did I have a crush on him? Maybe. A bit of an Electra complex? Probably. Even as a child, I could see that he was charming and benevolent, a man with a million dollar smile which, when bestowed upon you, quelled all pain. The moniker bon vivant didn't come 'til later when I myself learned French. But he was one — one who lived well. I also credit him with getting us the hell out of the Chicago suburbs and, because we wound up in New York, for being able to have discussions about things like suicide with Madame Smith in my French conversation class.

I adored my father, but growing up I would not have said I knew him any more than I knew my mother. He belonged almost exclusively to her, and she to him. He was infatuated with her, and she devoured his devotion, dwelled in it. It always seemed their progeny were just along for the ride.

By the time my mother reached her mid 80's, her Alzheimer's had rendered her increasingly distant and my father, who was a few years older, had become increasingly less able to cope. As the disease began blocking our paths to her, my mother receded like a figure in an early Renaissance perspective exercise. Her tiny form, at the far end of a cypress grove, was at the terminus of a host of rays, each one slowly breaking off, leaving the landscape in fragments, my father untethered and his dream collapsed.

At a certain point, I got drafted to become his helpmeet. Edit his four autobiographies (an overt and a covert clue to his persona), answer the endless tech questions about his Mac, and perform software duties as well. When in San Francisco, I also relieved my brother by buying his meds, his shaving cream and, despite my better judgment, his hits of *5-hour ENERGY.* Oh, and his bourbon. Not that he overindulged. He was just looking for that fumy buzz that would wash away the tedium of the day, that would clear the slate. For him it was the one act that provided him solace; it was the last vestige of civilization as he had once experienced it. The taste of alcohol on his tongue rehydrated, for a moment, the dream that had been his life, a life sweet as midwestern summer rain, sweet as a muted horn riff, sweet as a mint julep tinkling in a silver tumbler.

By the time my father turned 90, I realized that, though trying at times, these last years of his life were a gift. They had given me the chance to finally get to know him. As I edited the (often shaggy dog) tales of his years as a top Navy pilot, of his romancing my mother, his successes in publishing and victories as a sailor, it was I who prodded and cajoled him into getting more specific, to "include some sensory detail, man!"

One day, I pressed him to expand on his relationship with his own father, which he had only minimally addressed and had always described as very formal (bound as it was in the confines of the era, which consisted of his father instructing him in golf and sailing). Dad suddenly got very quiet and then related a brief vignette (he loved that word) that blew wide open the proverbial attic door. I had known for some time that it was on the day of Dad's 21st birthday that his father had died. What I did not know was that shortly afterward, passing a room where his mother and their lawyer were in discussion, Dad overheard the word *suicide.*

As he spoke, my father's face lost color; he looked out the window at a few hedges and a section of the McDonalds golden arch down the

hill from his assisted living complex. My heart sank, watching the scenery shift noisily on the stage of my father's play. *His father took his life on my father's 21ˢᵗ birthday.* This during the final year of the Depression when my Grandfather had been so buffeted by financial loss along the way that his prototypical American male ego simply splintered and fell apart. I can hear the tympani and the cymbals crashing, reverberating, and a whole edifice trembling. This was my father's deepest secret, one he never wrote about and only ever revealed to me. Though it was a startling revelation, our family history gained a whole new dimension and a darker significance which would otherwise have been engulfed by the shadows of time.

Considering this event, an alternative interpretation of my father's unquenchable thirst for life, and of his ready joy, sprang to light. I wondered if, looking at his repressed, commandeering father, he sought another path to a meaningful life beyond being a board member of the bank and stout pillar of Chicago society. If so, he found it, by staking out his own version of The Good Life. And what my father did write about, in his various memoirs, were all the goofy, serendipitous things of which his life was made:

Boy Scouts — And Two Special Merit Badges
This is serious stuff. It's the Hundredth Year of the Boy Scouts. On My Honor I Will Do My Best! When I was growing up, being a Boy Scout was part of the culture. At 13, I was the youngest Eagle Scout in Evanston's history, and I still treasure all of the experiences with my Cobra Patrol, Troop 17, Camp Wabaningo in Michigan, and later as Scoutmaster in Janesville, Wisconsin. I earned 27 merit badges; SEX was not one, but I earned it anyway. — George Eddy Jr.

For me, this excerpt combines his joie de vivre with his penchant for boasting and capacity to see life as magical. Penchants I just may have inherited. Although I debated including the following poem, I

somehow can't leave it out, perhaps because I see some of myself in his restless search:

The Boy Turns 90

A boy carries two buckets
full of sunshine.
His grin reflects it,
bounces it forward,
way forward into his life.

Scout of many badges,
(an Eagle angling for one from Eros...)
he learns fast how to game the system.
A player, a trickster.
Babes and derringers; life is sport.

The sun catches his laugh. Its beams lure him into the sky.
He flies among them,
a zephyr dressed in Navy blues,
charmed, despite the war.
Then through the light — a phantasmal goddess.
She appears before him, beckoning.
Her brunette waves glint, carry him forward along her rays.
Together they radiate.
They are America the Beautiful.
Doré as the Greeks say.
Golden, gifted. Luck flows in their veins.

Babies spill forth,
weed happy they bask in the glow.
And still he runs the course of his star,
rising and setting amidst the constellations of

Modern Man. Regular, reliable, jovial — always jovial.
But aching too, for something more —
for the sky, for flight,
for another permutation.
Apollo, Dionysus? The Gods wander through his soul,
disrupt him with their antics, intimations of glory.

Now he surges through canyons of glass,
restless as Odysseus,
until the tide drops him on the shores of his true home —
Memory, which is no land at all.

Setting sundogs nipping at his heels,
he saunters — no, ambles amidst the legend.
He confronts gods and demons alike
as he lunches with his silent bride.
Talks daily to Pluto, ruler of the underworld,
who has demanded an accounting.

So in defiance, he writes,
tracing a journey etched in light,
a journey propelled by joy…

And still, sometimes when hit with a pang of sadness and the wish he
could have seen how I have grown, I will get this feeling - that he does
see, somehow does know who I've become. Is it magical thinking or
some sort of intuition about the deep folds of the space-time continu-
um where our spirits meet again…?

FACE

A face is a dynamic thing.
A force. Mutable, eccentric.
Most days we can barely control the meaning it conveys.

Look into the mirror and wonder.
Can I find my true self in this countenance?
Read my future in my eyes?
Does my mouth tell the truth or lies?

Look longer and harder and soon the borders of the cheeks
soften and melt away,
All that lingers — the pith of the irises
hovering in space, questioning.
Who are you?
Why do you do what you do?
What does it mean to be alive?
What will you do today to help the world regain its strength?
What will your life have meant?

Refocus on the face again.
What does it express?
Does an aquiline nose lend you an aristocratic aspect and if so,
is that contrary to your nature?
Do full lips signify a luxurious sensuality you fight against
because it is a betrayal of your inner self?
When you consider all these elements of your face, are they you?
Aren't they arbitrary,
until you move them
and make them yours?

Minus long locks of licorice black,
minus shell pink ears,
minus gleaming chestnut skin,
or the midnight blue of your eyes,
Can you see your head as a skull?
Can you see how age will slowly erode
all those lovely accoutrements
and reveal the same solid structure we all bear on the tops
of our spines?
Can you imagine your brain no longer existing?

Look at your nose again, as pure function.
Marvel that this is the primary way you survive in the world.
One of the chief ways you interact with it, inhaling life itself.
Prana, life force, this is where you intake it day after glorious day.
Are you not a fucking miracle of aliveness?

Relax all the muscles.
Drop all expression and see
your face become a lifeless slab.
What others see when nobody's home.
When you're not present.

Now think something crazy wonderful.
Babble to yourself.
Put a smile on that face.
See how beauty has nothing to do with
the flesh but everything
to do with the self inhabiting it.

Now own that face, baby.

IN WHICH MY DOG LEADS ME INTO THERAPY

Oblivious of the diagnosis contained therein, I handed the letter to the airline clerk as part of the protocol to fly a small dog in the cabin with me cross-country, sans carrier. This requires a document from a mental health professional entailing the need for an emotional support animal. It was only later that I learned the code for my disorder was a new one; my friend the Freudian analyst had to look it up online. Turns out the category that my professional had selected was 'Life Transition Issues'. Ha!

How can I live with myself, gaming the system? Well, in fact, I have ex-post-facto realized that I really *can't* fare that well without my little Mimmo — my wondrous rescue pup, my enigmapoo, my wookiepoo, my darling. A fuzzy-wuzzy, long-leggedy, bark-colored thingy that many poodle people claim is a pure poodle. (Who knows, who cares?) Now you could snort and denounce this as pampered boomer excess, but then I would counter — so the fuck what? I could retort that I am old and would be cranky and a pill without my fuzzy pal. My baby in a fur suit. My little love child. Without him, who knows, I might actually throw a tantrum in the cabin which would require an emergency landing.

Blithely, a few months back, I had sauntered into the chambers of a lovely therapist with the express purpose of securing such a license for this little creature (who in fact I cling to as the only warm body in my vicinity, who in fact gives purpose to my daily life when it ofttimes evades me, who in fact is my sidekick and turns out to be the cutest damn accessory anywhere. All humans (even grown men) are automatically afflicted with sappy smiles when they see this goofy little chap.) Rightfully so, the doc would not issue a letter without knowing what was up with me and suggested that a minimum of three months would be sufficient. I told him I'd think about it and set off, weighing the

relative costs of a few months of therapy against years of dog-sitting costs and the probability of my significant other suffering long-term stress and alienation. (Wait, does that make *me* an Emotional Support Animal?)

I complained to my daughter about all this and, rather than sympathize, she promptly encouraged me to go anyhow, since I appeared to be struggling with things like being terminally single and other things like career confusion. I did have a bit of extra capital due to the death of my mother, so I thought — what the hell. Maybe something actually *was* up with me after all; and, by the end of our first session, I found myself setting up future appointments.

I soon discovered (every other Monday) that there was a lot to discuss, or in my case explain away or turn into a narrative, a schtick, a monologue into which he was hard-pressed to interject a word. Sure, hitting the 'ripe old age' of 66 produces a butt-load of transition-y shit anyhow, but I had a rather large-ish pile of it. (Oh dear, did not mean to push that metaphor so hard (which proctologists advise against). Tee-hee.)

So back to me. Always back to me.
Can't ever get away from you, Doll!
Devil Doll animated by some extravagant errant life force.
I hurl you across the room, and yet you wear that same taunting grin.
Bad Raggedy.

Anyhow, this state of affairs was really no revelation since I've been plagued all my life by identity questions and have consulted with a few therapeutic specialists along the way. (What is my purpose? What should I make my profession? Who is my perfect mate? Where do I belong? Why do I exist? Why, oh why, is there something rather than nothing?)

Well that last one is just the underlying question on top of which ride *all* my identity questions. Picture a Quixotian nag being ridden and whipped by a spectral character who is in fact being ridden and

whipped by a nasty-looking monkey, itself ridden and whipped by a Heironymus Bosch-ian homunculus (which is probably me). So yes, it did make some sense that I wound up, once again, in the office of a therapist.

Mind you, I'm not truly diagnosable, have no outstanding neuroses or conditions other than this relentless malaise of the self. And mind you again, I'm actually really happy most every day. (Which could then give me the diagnosis of massive self-delusion?) It's just that I seem to have invented and re-invented myself so many times that I'm losing track...

Perhaps all I need is a secretary? One who would kindly place upon my desk each morning a small schedule indicating what I needed to do in order to make progress in establishing myself as *something in particular* and possibly accomplish *something useful*. Ahh, that is a clue, right? Useful.... Useful... Useful. You see, although I have at least constructed a reputation as an artist, and across so many media it's not funny, can I claim any of it is *useful*?

Enter that hoary creature shame, who sometimes shadows me like a mangy, hungry cur. Though I believe in rescuing dogs, this one I seek to tear limb from limb, or at least euthanize. It is only a mean, diabolical spirit who has taken on the form of a dog, knowing I'm a soft touch. But this question of utility leads me to yet another putative source of my shame, which is that I've squandered my natural talents, that I have nothing to show for my years of labor. While others in my circle have accomplished much, I am an outlier, a free radical. And I have hidden from myself. No, more accurately, I've run from myself... So maybe it is in fact a *pack* of curs hounding me.

Ah yes, and another hound has joined my pack. I have recently gotten into the ancient Greek philosophers known as the Stoics, and have thus lured a new canine into the crew dogging me: my growling doubt that I have in any way approximated the concept of Virtue, as posited by those very demanding Greeks. (More on them in my chapter

Being Zetetic:). For Socrates, the headliner philosopher of the era, there are four cardinal virtues: Wisdom, Courage, Justice, and Temperance. As to Wisdom, which is considered the most essential and the *source* virtue, I might have an infinitesimal claim as I have spent much of my life contemplating the nature of existence and the role of humans within it and at least, after all these decades, do have definite opinions, a few effective strategies, and am always happy to advise souls more lost than I. (But this claim may just be the shabby old inference of wisdom deriving from age.)

As for Justice, in my youth I fancied myself a bit of a crusader for the environment and then produced a great number of paintings whose theme was Nature Imperiled. Now, however, all I do is toss money at environmental causes and obsessively recycle and post ardent missives on Facebook. Basically bupkis. I phone-banked for Obama, have made phone calls to senators, lay down in the streets of Boston in an anti-Iraq-war march (which had absolutely no effect), as well as joined the ranks in the first Women's March in L.A., but can I claim to be truly militating for Justice?

Well perhaps on the topic of Courage, I can point to a few instances of acting courageous, at least in the eyes of others — one of which was starting a magazine at the age of 62, ignoring all common sense. And if that's courage and not foolishness and naivety, I'm down for the definition. At least I have the courage of my convictions, and the particular one that led me into publishing was my belief that the concept of aging in this country was simply obsolete, I mean completely whacked. (But was that just defensiveness masquerading as activism?)

Oh, and Temperance? Read my chapter on Drinking. I'm no drunk, but I do like to get merry. In fact, given my approach to a nightly glass of wine, which is relatively bourgeois, I probably *could* claim temperance.

My shrink, who I found adorable, told me that shame is the most toxic of emotions. Like a bottle of tar, he says, that we keep on a shelf near our mirror and day after day slather on more until we've become

so stiffly lacquered we can hardly move. The tip-off for him is my frequent use of the word 'should'. If he catches me saying something like "I should just finish my novel…" he casts a questioning look and shakes his head. "Should? Try the word 'could.' There is no shame in the word could." I get it. 'Could' gives me agency; 'should' locks me into a closet of shame… I could also say, "I want to." Or recognize that I might actually 'need' to.

One thing I know is that if I'd been more mindful of my bottom line during the course of my life, I might actually enjoy more economic freedom and feel I had the latitude to be more active as a civilian. As I have wound up an entrepreneur, I daily wrestle financial anxiety, which then keeps me working weekends on my latest endeavor — perforce self-involved, alas.

In the end I realize I must find redemption — and identity — in the recognition that, after all, I am an artist. Artists get forgiven many sins if they suffer enough for them. And possibly my life itself is my artistic message; my struggle to understand my essence, one focus of my research. Though it might appear to be navel-gazing, navels, once you gaze deeply enough, conceal inter-related worlds. And just maybe my self-analysis will have some relevance for a few other players along the way.

(Wait, I have an idea — a GPS app for the self!)

FREEDOM — IT'S A SKILL (OR IS IT AN ARTFORM?)

To be more precise, the act of *freeing oneself* is a skill. One can learn it. Does it take the now-proverbial 10,000 hours of practice? Maybe. But if you work at it every day (which can also mean *play* with it), it shouldn't be that intimidating. Really it's just mindfulness with a direction. (Consciousness with an intention of experiencing freedom, as the Phenomenologists might say.)

Basically, I'm talking freedom from oppressive aspects of the self — at any given moment it might be any one of Freud's trio: the ego, the superego or the id. But those are somewhat abstract and now slightly antiquated terms. Neuroscientists would rather talk about the nonconscious functioning of the brain (advanced cognitive processing that occurs automatically and without awareness) which is often what makes our decisions in the dark.

I believe the biggest release we all look for, beyond bubble dreams of weightless floating down a rainbow river, is freedom from negativity and fear. Those nonconscious responses are often appropriate; analyzing threats to one's safety is a primary and automatic brain activity. But, being survival oriented, our mammalian brain has developed an inherent negativity bias and interprets many phenomena as dangerous when they are not, an automatic move which, more often than not, curtails expansion and growth.

So then, on the question of shifting negativity to positivity (which is more a freedom *to*), *is* there a switch inside of us by which we can flip modes, from unhappy to happy? Of course 'happy' is a loaded word, and actually not that precise; how about content, at peace, creatively engaged or sensing the good, rightness and fullness of all things? Sure, life isn't always hunky-dory. People hurt each other, cities crumble, idiots ascend to office. But take a few steps to the side

and see the scene from a different angle. Open a door and let in a little more light and you'll catch a glimpse of sun falling on a cheek, or maybe a blossom falling from a tree. Maybe you'll smile and someone will smile back. You'll feel a little surge of elation and a flood of gratitude for such simple things.

※

But worry not, I shall not trip into hippie metaphysics here. Of course you can't be a sunbeam ad infinitum; we are, after all, flesh and bone and subject to gravity's tireless pull. But we're also 90% water. Which means we are constantly in flux and, as water is, liquid, tidal. And, as water does, perhaps we can also *reflect*. How curious that a word which implies a mirroring of light, should become the one chosen to describe what we do when we contemplate life itself. Are we mirroring it? Are we polishing our mirror so we can reflect accurately?

Gratitude is the 21st century move of choice when it comes to achieving a state of positivity. It's like the little bit of sugar Mary Poppins added, to help the medicine go down. Some say it can be as simple as putting a smile on your face, which then bounces back to your brain as actual pleasure. Neuroscientists have developed online exercises to help you shift thoughts from negative to positive. Others say that listening to one's brain chatter and labeling one's feelings can help one gain perspective and achieve greater positivity. However you get there, whatever trips your trigger — my belief is that we do have a choice, so why walk around like a big old cloud when you could be a ray of light?

The question becomes — are you a victim of your circumstances or an agent of your own destiny? If the former, by whom have you been designated as such, other than by the absurd echoes of dismal memories of significant others who really knew nothing about either themselves or you? Are you really willing to cede them control over your life?

No. So let's agree that we can be agents of our own destiny. Which

then entails *practicing agenthood* and undertaking to create our happy place ourselves (check my essay on what the Greeks called this thing referred to as happiness — the much cooler concept of Eudaemonia.) Then check out Jean-Paul Sartre (the leading proponent of Existentialism) whose stance on freedom is that humans, regardless of circumstances, and often because of them, are inherently free.

By the way, it turns out that one of the rewards of exercising said freedom and choosing to focus on the positive aspects of your life, of choosing to be grateful, actually increases the brain's production of serotonin (the amino acid considered to be a natural mood stabilizer) in the anterior cingulate cortex. The ACC is the part of our brains that connects the limbic system (specifically the amygdala — the source of emotionally charged memories and persistent negative thoughts) with the 'cognitive/executive' prefrontal cortex (which does the heavy-duty analysis and judgment we mostly consider our human intelligence).

Reminding yourself to be grateful has an extra perk — it boosts neuron density in your lateral prefrontal cortex, an area of the cortex which coordinates our two forms of attention: that which is stimulus-driven or autonomous, and that which is selective and goal-directed (essential for coherent behavior and awareness). This increased density then impacts emotional intelligence as the neurons become more efficient; it subsequently takes less effort to be grateful, and you will then find yourself more often in a lighter, happier mood.

Can we see this as flexing a muscle, the happiness muscle?

I don't know about you, but I find myself to be an idiosyncratic assemblage of virtues and drives with a name by which I am known and a duty to create the job description of my life. Up to me to fill this sack of skin with meaning, totally up to me. And I want that meaning to be about happiness, whatever that means, or about flourishing, or about overcoming self-doubt and lightening myself, adding light to my body. We live in a vast cosmos, why need we be so chained to earthly gravity? I'm sure future visitors from other solar systems will

marvel at how literal we were. The universe is fucking vast! Put some jet-packs on those silly heavy souls.

Here is a delightful quote from Salvador Dali about this:

"Every morning upon awakening, I experience a supreme pleasure: that of being Salvador Dalí, and I ask myself, wonderstruck, what prodigious thing will he do today, this Salvador Dalí?"

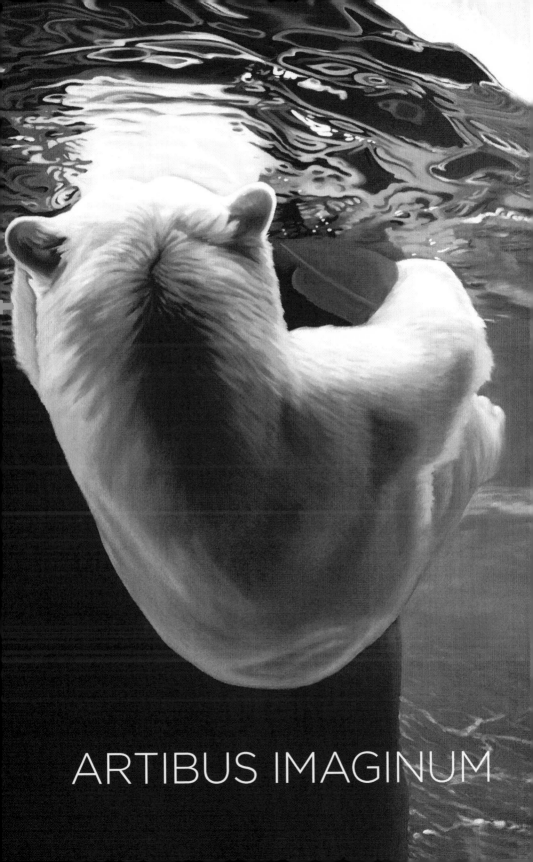

ARTIBUS IMAGINUM

ART IS A BITCH,
ART IS LOVE

I hold a beast, an angel, and a madman within me, and my enquiry is as to their working, and my problem is their subjugation and victory, downthrow and upheaval, and my effort is their self expression. — Dylan Thomas

There is no art without pain and sacrifice. It took me a long time to accept this fact. Whether you're waiting for the muse or fighting the impenetrable density of your own skull or dueling with the demons of self-doubt, art involves struggle. Well, maybe not if you're Leroi Neiman or you're watercoloring peonies; well actually, peonies can be beasts too.

Often I see myself as Lewis Carroll's Alice, in a game of croquet equipped not with a mallet but a squirming flamingo — the perfect image of my daily sense of futility at ever grasping my elusive daemon or manifesting my ideas. A day with only a page written; another crumpled worthless sketch; a poem that seems awesome at midnight but next morning makes a small noise like a croquet ball smacked into a wicket. (It's the damn flamingo's fault.)

Yes, your thoughts have been better expressed by geniuses. But get on with it, churl! Ingrate! You have taken up the banner of Art, and now you must strain every muscle to keep it aloft. Must prove yourself worthy. Trudge on through the muck of your own mediocrity because who knows? You might find yourself reaching some promontory and suddenly seeing the world below illuminated by an uncanny light and at that moment be struck by an epiphany* about mortality! (Like, "Yes, I am going to die! So I god damned well better live NOW.") Or about our relative insignificance because, "We look like fleas from this height."

But just because Art requires pain doesn't mean it has to *be about* pain. Hell no, I want my art to be about joy. Complicated joy. Deep joy.

I want it to set the hairs on your skin to standing, each one a filament of light, resonating at a surreal frequency. I want my work to make a dent in that carapace we all wear, in order to create a tiny reverberation that sets in motion other tiny reverberations that could shake some new ideas out of the ether. That may take a few lifetimes to achieve, but I'm not giving up. You see, even though I'm uncertain about reincarnation, if it turns out we have roundtrip tickets, I do plan on coming back.

<div align="center">�֎</div>

We artists are guard dogs. Throw us a bone. We patrol the peripheries of life, of culture, of being, of soul. We sniff out the truth, then we dig, we unearth. We are your appointed seekers of subliminal syllogisms, of symbolic symbioses, of supernal signs. Our jaws may only grasp such slippery substances for a heartbeat, however, if anyone can hear that beat, it may set up a rhythm somewhere in their soul. Maybe they'll feel like dancing.

<div align="center">✖</div>

Every day it is a struggle, to jockey between the highs and lows. To administer enough caffeine throughout the day. To not overdose. To submit to the doldrums when unavoidable. To rouse oneself from them through sheer force of will. And then of course to swerve before the oncoming SUV full of today's ton of fresh media crap bashes into you and buries you in it.

You have no boss but yourself. You pull out the whip. You brave through doubt. You stride through puddles of melancholy, splashing their dirty water onto your bare legs. You cringe and move on… muttering to yourself about motivation and the corruptibility of the human body, the frailty of the human mind.

And then the distractions. They materialize out of thin air, only the air is actually thick with their needy little sounds, their whining. Like locusts, they come at you buzzing, circling, strafing… You begin a chant, a chant of purpose, even if you forgot the words and can't

remember precisely what that purpose was.

This is the world of the writer, of the artist, of the composer. You might not choose it if you knew. If you could imagine doing otherwise.

In sleep, the transcendent soul luxuriates on a plain of gold.
Love emanates, courses in waves.
You are the Virgin and the Misfit.
And you know this: the source of power is through the imagination.
To access it, to transform with it, to create from it?
Requires self-trust.
And the Self that must be trusted?
The one that triumphs at dawn,
That pulses before identity, before form.

<div align="center">❋</div>

Here's the thing: if you are going to be an artist, you are, de-facto, an entrepreneur. And the harsh reality is that if you don't put shit out there, nobody will *give* a shit. Or rather more delicately — if you don't produce content, you'll slip off the face of the Earth and be forgotten. So your job is to produce content, which means there comes a point where you sort of have to drop your quest for absolutes, higher or deeper levels of meaning or truer truths, and just put it out there. Risk embarrassment; it's part of the cost of authenticity.

You sort of have to straddle the line between these two camps — the so-called 'true' and the commercially viable — or better yet, negotiate a novel treaty. Because what people ostensibly want — pretty faces and bold suppositions when they're young; pretty pictures and suppositories when they're old — is not the whole story. Yes, they want Doritos but they also want gurus. Yes they want gilded crappers but they also want the music of the spheres. They want to forget for a minute that they haven't a clue, that you haven't either and BUY into the hope that you do. They need you, baby. They need you to feel the pain and from it write, paint,

shoot movies and sing for them so they can understand their own.

Now here's a question I ask myself: (after an entire life spent trying to express something, or specific things, or actually whatever was obsessing me, at any given moment) why have I published hardly any of it, from paintings to poems to a novel to screenplays? This baffles me and others. (My therapist thinks I just don't give it the time and the belief.) I could go with that "It's all about the process" line, but it is and it isn't. There is something tragic in the work of an artist never being seen. Absurd really. And I am neither tragic nor absurd.

I've explored the explanation elsewhere that I had fallen into a psychic quagmire catalyzed by my parents' unwillingness to support me in my education. (Leaving me with that basic 'egoic damage' that scholars of feminism consider one of the historic costs of growing up as a disempowered female.) Another explanation — which I actually like better since it releases my progenitors from a penance they cannot enact from the grave — is that, as I've mentioned before, I am constitutionally a Hyphenate. I always felt I'd been born too early and especially now, since that term did not exist when I was growing up. Hyphenate, and even poly-hyphenate, is a catchy meme that gets tossed at readers in magazines like ArtForum and Vogue when covering young Turks of the art world whose work sprawls beyond the old limits. So be it. Having now declared myself a Hyphenate, I will go take a nap. With the idea I will awaken feeling like a new man.

But then Duchamp had it all figured out years ago. In his 1966 interview with the artist, when Duchamp was eighty, Pierre Cabanne pointed out that he was "the first in art history to have rejected the idea of painting…" And Marcel (I just have to call him that since I've lived with his genius my whole adult life and consider him an honorary father) replied:

"I find that it's a very good solution for a period like ours, when one cannot continue to do oil painting, which, after four or 500 years of

existence, has no reason to go on eternally. Consequently if you can find other methods for self-expression, you have to profit from them. It's what happens in all the arts. In music, the new electronic instruments are a sign of the public's changing attitude toward Art… Art is taking more the form of a sign if you wish; it's no longer reduced to a decorative role. This is the feeling that has directed me all my life."

In my current mode of artistic shapeshifting, I am truly relieved to be validated by one of art history's greatest minds.

<p style="text-align:center">❊</p>

But, dear Marcel, I don't agree with you about the invalidation of painting, because we will always crave the visceral, material proof of an artist's vision, of their dedication, of their craft. And besides, capturing anything on canvas is a thoroughly lovely pursuit. If one is doing it right, it *really feels good.* Slapping on the paint, the heavy wet dollop of color; sliding it on with a charcoal-hued, Mongoose hair fan brush that, when laden with a daub of manganese muddled with pale cadmium yellow, looks preternatural during the transit from palette to canvas. In the act of mixing paint, of blending colors, an artist remakes the world, the artist approximates the power of a god.

Now if you can actually create something of merit, that good feeling grows, fattens, develops tits even — magnanimous mammaries of pleasure and pride. I painted my first Polar Bear in 1990, from a faded black and white photo I discovered in New York Public Library's remarkable Photo Collection. I was compelled by what appeared to be the bear's slow, charming dance underwater, but I soon realized that these massive creatures were (not oxymoronically) the new canaries in the coal mine. Before long I made a trek to the Central Park Zoo to photograph their two bears swimming. Thus began my love affair with *Ursus Maritimus.*

Soon I began a series of them, all underwater. I had a political purpose in focusing on them but was also driven to explore the innate lyricism of

these magnificent beasts in their element — water — and by so doing demonstrate the tragedy of their conceivable doom.

It became an act of devotion, seeking out their essence and ultimately their joy, one I share as a lifelong swimmer. I was never a 'wildlife painter' in the traditional sense. I have always seen these works more as abstractions, as distillations of the transcendent beauty at the heart of nature.

The Latin name of their species, Ursus Maritimus, is a grand name evoking their amphibious nature and their tremendous stature. But, even as you read this, they are dying of starvation. Less ice, no access to the depths of water where the seals swim unawares. Their lot, whether in a zoo or in the shrinking Arctic, is not one we would wish upon ourselves. We must face up to the fact that man, who 'has dominion over the Earth and all its creatures' has been a slum lord.

Gus and Ida, the bears who became my buddies and star models, lived in the Central Park Zoo, where they entranced countless tourists and locals with their underwater antics. Alas, neither are with us any longer. After Ida passed away, Gus wound up with what was diagnosed as severe anxiety, evidenced by his ceaseless (and woefully constricted) laps and the accumulation of probably a million flip turns. I was actually incensed when I read an article about his death in the New York Times, which implied he was 'neurotic'. How could he not be, given his circumscribed world, grueling daily routine, the stupefying reality of his life, and the endless procession of voyeurs pressed to the glass walls of his 'enclosure'.

My hope, in presenting these bears at ease and at play in their element, was to charm our species into realizing the value of these top-of-the-line predators to life on Earth, whether as symbols of the glory of nature, or as integral to the impossibly intricate chain of life. I only wish I'd tried harder to get these images out into the world. Maybe now is the time.

* **Epiphany** - from late Greek *epiphaneia* "manifestation, striking appearance" (in New Testament, "advent or manifestation of Christ"). Name of a festival celebrating the manifestation of Christ to the gentiles. Of divine beings other than Christ, first recorded 1660's; general literary sense of "any manifestation or revelation" appeared 1840, first in De Quincey.

Thank you Mr. De Quincey for liberating the term epiphany from the specificity of a particular myth and giving it a life of its own as a private awakening flash, or a sudden vision of the vast wonder of the universe, or possibly just the wonder of the vastness of a moment.

THE ARTIST THINKS
ONLY OF MONEY

"Only the businessman can afford to think about art; the artist thinks only of money." — Oscar Wilde.

When I stumbled across this quote by Wilde, it hit me bang in the kisser. Yes, Oscar!

During my somewhat decadent early thirties, having been 'discovered' by a posse of rich and dissolute young men, I became an interloper in the world of money and managed to get a view of the other side of Wilde's equation. This only served to increase my sense of balancing on a very pointed dichotomy between Art and money (which apparent duality has been seriously eroded over the past few decades by new variables in the mechanics of mass culture). Now successful artists become celebrated arrivistes in the ranks of the moneyed classes. The whole concept of 'selling out', so pungent back in the day, so critical a marker of real vs. commercial work, has seemingly collapsed upon itself and lost its musky fragrance.

Yet for many artists there continues to be a *dialogue* or rather (to cop a gallery flack's word) an *interrogation* between 'pure' artistic freedom and that other state, of being *marketable*. This interplay involves responsiveness to the tastes of the marketplace and, for those who can't admit to that, an ironic stance toward that very marketplace, which ironically is now a taste in the marketplace. It's not really a question of high vs. low. Because while there is a seriously elitist thread that runs through some of the most expensive (often conceptual or simply massive or expensively produced) work being bought by collectors, some of the most well-paid artists these days ransack the malls for inspiration. Of course any artist whose sense of the market is so keenly developed as to open the gates of Candyland deserves kudos.

But really, when it boils down to it, becoming an artist is a risky bet. Even the ever-popular king of commercial art production, Jeff Koons, can suffer the slings and arrows. His offer to gift the city of Paris a 38-foot-tall sculpture of a (white, male) hand holding a bunch of balloon (his signature) tulips, meant to be a plea for unity and compassion in the wake of the Paris Bataclan bombing, was considered by Paris's cultural heavyweights to be opportunistic and self-aggrandizing, especially as it carried an installation cost of nearly four million dollars.

But back to the money thing. The nearly obsolete cold hard cash thing. Money is not the root of all evil. Money is a symbol. Money is energy. And like it or not money is a proof of value, however arbitrarily assigned.

Everybody wants it, whether they acknowledge it or not. Of course some people "will do anything for money" and others go out of their way to avoid it, finding it as terrifying as others do dirt or snakes. Truly it can be a vexing element of civilization, especially if you don't have it.

TIME IS NOT MONEY. TIME IS FREEDOM. YOU SELL YOUR FREEDOM TO MAKE MONEY, SUPPOSEDLY TO GET FREEDOM. THAT'S HOW CAPITALISM WORKS. SOUND LIKE A TAUTOLOGY?

But then this statement rests upon a concept of freedom that is extremely subjective. If you don't have a lot of ideas about what to do with your freedom, you'll probably be less bothered by exchanging it for money. If you do, however, have ideas, that exchange can become onerous (this being the proto-typical artist's quandary).

Money is both the expression of and the antithesis of freedom. With money you gain the freedom to express yourself, with experiences, with possessions, with power. But to earn that money, you sacrifice freedom. This was always a bargain I found impossible to strike. I have foregone the security I might have had numerous times, in order to pursue my

idiosyncratic journey. There have been countless wakeful nights trying to quell anxiety about my financial future, yet still I've trudged onward. I have even spurned the obvious easy routes of marriage to a guy with big bucks. That's been on the table a few times and, again, the freedom factor loomed weightier on the scales of my blind judgment.

<p style="text-align:center">�ꙫ</p>

But then, money has always been a bit of a mystery to me. I seem to make it when I need it but run through it quickly when I have it. I only recently learned that there is a meme called the Money Thermostat — an internal, inherited measurement of what money is worth and what it means to you. I grew up in a traditional, somewhat privileged, mid-century household where money was never discussed with children. Even though both my parents had experienced financial hardship at some point in their young adulthood, my father was a charming man who found success fairly easily. Money, at the point I entered the picture, hardly registered as a concept and I naturally drifted into a financially clueless adolescent backwater. We got allowances, not much, and had to do simple chores for them. Incessant bickering brought financial consequences, requiring the deposit of a nickel in a big jar, as did errors of word usage (that one apparently just for me) for saying 'like' and 'really,' which apparently I, like, really said a lot. Or for saying 'you know' which, you know, I did say a lot.

Suffice it to say that gaining adulthood (if it is a gain) without a firm grasp of the meaning of money left me in a state of arrested development. But the issue ran deeper. Emerging into my late teens during the Hippie Takeover, when anything one's parents did was suddenly suspect, the possibility that I could easily morph into another country club WASP was a loathsome one. Money corrupted and besides, hippies didn't need it (except maybe for drugs and carpets for their yurts). Unable to withstand the juggernaut of capitalism, that mentality folded its hand fairly quickly and suddenly my generation launched itself into

the moneyed Eighties. There were European cars to be bought, adventures to have, and oh yeah, still drugs to buy.

There is a boogeyman shadowing me when it comes to money. Guilt. Guilt that I came from an upper middle-class background and (although I have tried) never put it to good use. Guilt that I've tossed so many opportunities away. Guilt that I'm so fucking old and still haven't got it together.

※

It's not like I was so privileged that I didn't work. In high school, I worked part time as a salesgirl in a ski shop (while reading the Existentialists on the side). My senior year, when the family moved to New York, I wound up at the Brearley School for girls, with the distinction that I was probably the only non-virgin at the entire school. I got a reprieve that year from working, since the school was quite demanding. Instead I spent hours in the library at the Museum of Modern Art studying Dada, and started making Super 8 films; my senior thesis was not a paper but a Dada-like film based on a Dylan Thomas poem. The original doubters and rebels, the Dadaists clearly primed my mind for my ensuing artistic exploits. Of course I also imbibed the Surrealists, because they clearly saw beneath the fuzzy surface of things. And all of them pilloried the rich and the bourgeois.

While in art school I got work as a waitress, as a clerk in an art store, then went on to do the odd artsy freelance job. Of course art school back then was a playpen for miscreants whose only outlet was art. Notice I did not say a 'career in art' because nobody, I mean nobody, discussed how the hell we poor sots were actually supposed to make a living except as waiters. So I just toddled along, waited tables and fed on my fantasies, and on my deep dissatisfaction with the world at large — the spooks and stooges in D.C. and the robber barons whose corporatized greed had set us on a course of planetary ruination. One of my favorite artworks produced during my schooldays portrayed J.

Edgar Hoover kissing his bulldog. And then there were the classic soft porn nudes which I posed beneath formations of stealth bombers — my jibe at the military-industrial complex. Obviously this perspective on the uses and meaning of capital was splattered with my distrust and hostility. (Now, it seems, the update on that unholy formation is the *military-industrial-media complex.*)

Once out of school, I felt driven to make my thoughts more specific. My focus shifted to the strangeness of ego and consciousness and the failures of civilization. Reading Baudelaire, Rimbaud, Jarry, and Sartre led my impressionable mind down the gloomy path of Weltschmerz (German meaning 'world-pain' or the anxiety caused by the ills of the world). I began composing darkly pop lyrics, manifestos, and apocalyptic essays condemning the state of the world. Stuff like this:

I'm a Renaissance cripple. At night I lope through the Elysian fields, by day I smoke camels, loiter on street corners seemingly agape. Eyes rolling with apoplectic desire, I tussle with Leviathan fantasies, try to wrestle them into alignment with the stalactites of cement...

My dreams like hot poodles pull me through streets crawling with pedants, pederasts, yes men, and psychopaths. Glitter falls from my exhalations onto economic indicators looking most foul. Dogs lick my hands. Naked and wet on the edge, babe in the city so alone. The world is an orphanage.

You get the picture. This while working in Manhattan as an assistant to a producer of high-end commercials at Wells, Rich, Green, a major ad firm founded by the wunderkind Mary Wells. My boss was a bit of an anomaly, a feisty, zaftig Jewish gal who wore slinky polyester wrap dresses, thigh-high boots, and smoked Virginia Slims. She was actually quite liberal with me, had me taping voice-overs and dealing with talent. The account I worked on was Sure Deodorant. (Talk about cognitive dissonance.) And the lab results we produced turned me off

anti-perspirant for the rest of my life. *See how a guy in a steam bath sweats everywhere but where the Sure has been applied!* Nature defeated becomes nature defiant. I'm sure the miracle of anti-perspirant is actually carcinogenic.

As luck would have it, a new Head of Production was hired. He brought in all the assistants one by one and started handing out raises, but when I petitioned for a raise as well, I was coldly rebuffed. Moving forward, he stated, he wanted only film school grads on his staff (an irony, given the events told in my essay, Loser). It didn't count that I was studying film editing at the School of Visual Arts, and screenwriting at NYU.

Barely internalizing my loathing for admen, I went on to interview at other agencies, this time as an assistant art director; after all, I had earned a Baccalaureat in Artibus Imaginum (love that name and have always striven to uphold it). But I soon discovered the creative component was a minimal fraction of the job and dry technical matters the larger part. I could have gone that route nonetheless, advanced to become an art director one day, but I found the environment of advertising still bore the heavy taint of the materialism us sixties kids had been trying to banish from our souls. Addicted as I was to the aesthetics of the Romantics and the Dadaists, the work seemed a perversion of my artistic principles, or a sell-out, to use that antiquated term. Now of course, as I've pointed out, there is almost no relevant distinction between fine and commercial art because it's all up for sale.

<p style="text-align:center">✳</p>

Anyhow, I had bigger fish on the line, I thought, a TV series I had developed on the life of Nellie Bly, the world's first female investigative reporter. I even got a big meeting with a honcho at NBC, but when he said he had a better idea — to do a series of one-hour documentaries on five important women — I felt I'd run into a stack of cinder blocks. He had totally missed the appeal and import of telling Bly's whole story

dramatically, had somehow felt that it was a good enough move to give an hour to the five women history had already deigned to recognize. Smelled to my overly sensitive nose like yet another sell-out, and I never was good at compromise. Of course these days I would have jumped into a kiddie pool from two stories up to have that gig.

I wound up getting another job, this time in PR. (Never could decide if I was a painter or a writer, but there I was — an unidentified fledgling hyphenate falling between the cracks in a stratified society.) The PR firm was run by one of the all-time great queens of the era, a guy named Harvey. I interviewed with him at his spacious uptown apartment where the walls that weren't full-length mirrors were papered in white and silver chevron stripes. He appeared at the door in a vast, purple Halston caftan concealing a generous physique and, after a few cursory questions in a fabulous drawl and much cocking of his head back and forth, seemed to find me a workable addition to his crew.

At first, the job was actually a hoot. It was just me and another young woman and a client list of seven fairly big restaurants. Mostly we wrote press releases which were faxed to gossip hounds like Richard Johnson at the New York Post, whose Page 6 column could bring the high low or the low high, and Liz Smith, who by then had become a serious power broker in Manhattan society. Our job was to pen, in the sassiest possibly way, details on who had been seen in what restaurant, or what novelties the chefs had concocted. This was the leading edge of the era of celebrity chefs and we had a star: Charles Palmer, of the River Cafe. We considered it a coup when we actually got him on TV. We were also required to hang out at Studio 54, for the occasional party, or to scout stories. Actually, I was never quite sure why and at first I got my kicks, including high up in the dark upper rows of the theatre. But ultimately I wasn't a scenester; the late nights out, the entire schmooze and party scene, just became a loudly soundtracked bore.

Then Japanese actor Toshiro Mifune came to town. Renowned for his work with Kurosawa, Mifune was one of my major cinematic heart

throbs, so I proposed to Harvey that the sushi restaurant we handled make a party for him. Harvey told me merely to report to the gossip hounds that he had already appeared there. This was too much for my sweet little principled soul and I quit. (It never occurred to me that I could have made a solid career in public relations.) It probably didn't help my attitude that I was reading William James at the time.

The moral flabbiness born of the exclusive worship of the bitch-goddess SUCCESS. That — with the squalid cash interpretation put on the word 'success' — is our national disease. — William James

I then eked by, in a tiny 5th story walk up studio in Little Italy, on the sale of an old ring left to me by my paternal grandmother. I set to work researching another heroine, one whose story, like Bly's, had also been obscured by male historians — Victoria Woodhull. Daughter of an itinerant midwestern preacher, who early on showed talent for channeling the divine, the beautiful young Woodhull wound her way to New York in the 1860's where she acted as a 'magnetic healer' to Cornelius Vanderbilt, who ultimately set her up with her own Stock Brokerage firm, from which she produced a weekly financial newspaper.

Woodhull went on to become a leading suffragette, a charismatic heavyweight in the Spiritualist movement, a firebrand in support of Free Love, and a tireless promoter of the end of double standards for women. She was nominated for President and her running mate was to be Frederick Douglass. Their candidacy was stalled abruptly when she included a story in her weekly newspaper about the adultery of celebrated local minister Henry Ward Beecher, who had previously made vilifying comments about her free love stance. A sensational trial ensued and gripped the imagination of the entire country, some even say turning many a religious individual into a cynic. Victoria ran again in 1892, this time with the support of Elizabeth Cady Stanton, but the timing was wrong and in the end she was found a tad too flamboy-

ant. When Vanderbilt died, his son gave her significant funds to leave the country. She headed for England, married a prominent financier and lived out her days peaceably.

I was convinced Woodhull's story was a winning project. Then one day I sat next to a kindly older man on a train who turned out to be an historian. He became intrigued by my synopsis and offered to give me seed money to start writing. When I finally handed in my treatment, he rather huffily told me he had discovered (through what channels I know not, since this was pre-Google et al) that a film project was already being funded, starring Faye Dunaway. I was crushed. But at the time, with two strikes against me in the film business and nary a mentor in sight, I summoned my Fuck Him, Fuck 'Em All mojo. I was hardly heartened when I realized a few years later that this script never saw the arc lights.

But maybe I should exhume old Victoria, that iconoclastic, trail-blazing feminist. The time could be very right for her second coming…

OR I COULD JUST
CALL MYSELF A LOSER

And I have, in moments of self-loathing. From my current vantage point, with the media having drummed the "there is no such thing as failure" meme into us all, I am well aware that the winning/losing dichotomy is counter-productive, but then I *did* grow up competing with two boys. Anyhow, I will here pull back to investigate what seems to have been a pivotal factor in the development of my psyche.

An unsolved question has hung in my mind for some years: why have I not achieved the kind of 'success' I always believed I could? Even my friends, all successes in their own rights, wonder this. (Success determined here by some sort of recognition and some sort of bankroll.) So I ask myself — what the hell has stood in my way? Was I simply a deluded neo-romantic, like the benighted Ugo Foscolo, whose early 19th-century book of sonnets, Wrinkled Is My Brow, Sunken and Intent My Eyes (a fabulous title if ever I heard one), contained the following gem:

> "*Alone most days and sad, ever pensive:*
> *Hot-tempered, alert, restless, and tenacious:*
> *Rich in vices and in virtues both, I praise*
> *Reason, yet I follow my heart:*
> *Death alone will grant me fame and peace.*"

What *was* in my way? Fear of failure, fear of success, not feeling I deserved it, or just plain overthinking? There's another theory, put forth by a shrink I saw once: that I was retaliating against my parents because they refused to pay tuition, even though they could have, for my getting a graduate degree in film. Yeah, I liked that one because I could offload the story onto them.

In fact, it was not once but twice they refused. The second time around, I had applied to a program in the Graduate Science department at the University of Pennsylvania. In this case I was still going to be filmmaking; having created two historical projects and been inspired by the BBC's The Ascent of Man, I decided that I wanted to make educational documentaries. When I learned that Adrian Malone, the British producer who co-produced it with Jacob Bronowski, was at Penn as a guest professor in the science department, I hopped a train down to Philly just to meet him. I think he admired my gumption; he told me if I got accepted, he'd take me on as his own protégé.

I actually did get accepted, which blew my mind. But my parents balked again. Really? I mean if this was their overall approach to teaching offspring how to make their own way in the world, fine, but they had paid for my brothers to go to law school and to business school... so why not me?

No good answer. I remember stalking out of the kitchen reeling and seething (yes, one can do that at the same time). It seemed patently obvious they didn't believe in me. (Or was it my gender? Or was it that old bugbear of maternal competition?) At that time, getting a scholarship when one's parents had enough capital like mine did, was not in the cards. I was shocked, I was angry, and I should have fought harder. Sure I could have run off and made art films like I had in high school, but who would ever see them? And I wanted validation from an institution. The odds of making it without that were miniscule. So, belligerent child that I was, I decided I would prove them wrong. And from there, if that therapist was right, I was setting off on a self-destructive journey; how better to get back at them than destroy my own future? Apparently this is not an uncommon, if utterly unproductive, unconscious ploy.

But I don't actually buy the theory. Because I was, after all, operating under the mid-century, midwestern mentality that women really couldn't get away with careers like film producing. I, and perhaps many other young women, swallowed that concept whole and then created a

fantasy self that actually *could* do anything. But as I ran up against the inevitable obstacles, the distance between reality and fantasy grew, so that my ideal self became an Ubermensch and my actual self became a truculent* fraulein. (Pardon my Nietzsche here and the use of the German male, but this is the only way to describe the self in question and, by the way, my wonderful ex-Grandmother-in-Law Lily always used crack me up by telling me to "Be a mensch".)

<div align="center">✖</div>

Growing up in the 50's, women were inherently less free, less rewarded, less 'allowed' and that translated, for many of us, into less worthy. I figure I was poorly inoculated against this virus meme and it has often laid me low. And even though I have proved myself worthy many times, I notice a certain pattern of nearly arriving, of coming in for a landing at a state of relative success then banking left and up, back into the clouds. It's as though, when it appears success is within my grasp, I automatically check it off my list either because I'm terrified of making that landing, of winding up on earth, or because I need to keep proving I can do more. And so, rather than build on what I've done, I fly off to conquer another field… This is my Tigger complex at work and it is *this* that I must conquer.

I embrace my Existentialist self, the one that recognizes it is a form of 'bad faith' to blame my history for my present. And I relate all this not as any sort of excuse, but as a cautionary tale. This particular gender-based mind-set is finally, for the most part, being laid to rest. At the least I can rise, as a parent, above the faulty decisions made by my own parents when I was growing up, and forgive them for the lack of awareness prevalent in the era. And hopefully I will make less onerous mistakes. On the positive side, my experience taught me to question every pre-conception I might have had about my own child's potential. I sought at every turn to encourage her to pursue her heartfelt goals, and have been rewarded by a happy and accomplished young wom-

an. I have also acquired a certain humility about my own expectations and aspirations; after all, evolution spans generations. Maybe my own trajectory is really just part of a larger climb toward greater awareness and liberation.

<p align="center">�֎</p>

To be a success, a failure, a winner, a loser… who makes these distinctions? Football, sure. Stock Market, maybe. Employee of the month? Of course. But what's with the labels, girl? Are you a brand? Do you have a double R branded on your butt? *(And how shiny are the awards one gets along the way? And who shines them, anyhow? And on what shelf will they wind up when one is dead and gone?)*

Yet, I'm still at it, even now… still looking for that benediction. Angling, I guess, for the recognition I never got from my dear old progenitors. My daughter, who did a college thesis on attachment theory (which categorizes an infant's attachment to its mother), informs me that I fall under the category of anxious-ambivalent. My friend, a Freudian psychoanalyst, believes my attachment to be 'secure'. I'd say I'm a mixologist and drink from both wells.

But it is interesting to note that for the most part the Freudians have stopped doing psychoanalysis, meaning the 5-days-a-week sessions prone on a sofa. Who has time? In addition, there's a whole range of approaches to therapy that don't dwell in the past. Mercifully, at a certain point, after jerking off under the asphyxiation of one's youth, one reads a bit about the Stoics and all sorts of things fall into place, including one's parents. Liberation involves liberation from one's past. And calling oneself a loser is just another losing game. In the end, our personal freedom is a project each of us must undertake on our own.

* **Truculent** - a word that has almost as many adjectives defining it as there are dictionaries. Here are some: ferocious, savage, belligerent, pugnacious, scathingly harsh, aggressively self-assertive. "If you

are quick to argue, always looking for a fight, and hard to please, you are truculent." 1540's, from Latin *truculentus* 'fierce, savage', from trux 'fierce, wild, savage'.

Truculence rules in Game of Thrones. Hard to judge who best fits the term — but I would guess Arya Stark, who had every reason to be wildly fierce, having lost most of her family and come to realize that no-one was to be trusted. Truculence in her case is a key to her survival and should serve her well in the 8th season.

CHAMPION OF THE DOWNTOWN 'UNDERGROUND'

It was 1980, and there was something serendipitous in my becoming the newly-appointed director of the Beard's Fund, a foundation dedicated to experimentation in the arts in New York City. The Fund had been established a few years earlier by the extraordinary Sandra Payson. Sandra, daughter of Joan Payson Whitney, had inherited a hefty bank account and for some reason needed a "beard" to conceal her actual identity as philanthropist.

During a random meeting with her son-in-law (who probably cast me as a petite bohème in need of a patron) he mentioned that she was looking for someone to head her foundation. The next thing I knew, I was walking into her Sutton Place apartment, a lush, colorful place filled with a drop-jaw, top-flight collection of art by major Impressionists, all bathed in the refracted light from the East River. For some reason, I shared a dream with her which she was shocked to find paralleled a dream of her own the night before. Instant symbiosis. Absolutely surreal.

The Fund had a distinguished board consisting of luminaries in music and theater. Our music advisor was none other than John Hammond, the record producer who launched or furthered the careers of artists like Dylan, Seeger, Springsteen, Benny Goodman, Billie Holliday, Aretha Franklin, and Leonard Cohen. A bit daunting for a naive sprout like me.

My position entailed fielding applications and hunting down potential stars. I soon found myself in unfinished lofts in Wall Street listening to atonal, post-Cage-ian work by relatively underground composers, or at ad-hoc spaces in tenements watching artists smear themselves with chocolate. I spent a lot of nights at the Kitchen, a legendary venue in

the west teens where young choreographers, composers, performance artists, and storytellers were featured to usually ecstatic, hip audiences. I heard Spaulding Gray, Eric Bogosian, and Julius Eastman there amongst others.

During the first of four yearly grant selections, I had acquitted myself, despite my own background as a recent art-school graduate, with enough executive flourish to make the grade. I was thrilled to find that all but one of my favored artists won grants. John Zorn, an audacious young composer who I knew had serious talent, was unfortunately nixed when Hammond chose instead to grant a very much older composer, who in my mind was not in the least bit experimental by contemporary standards. They were friends it turned out and it seems older composers can have it a bit rough, so I relented.

<div align="center">❈</div>

At any rate, it was in the middle of my second scouting period that a request from a group known as Colab came through asking for an immediate response. A very clever consortium of artists, many now established, Colab came together as a non-profit with grand plans of collaboration and cultural disruption. Their application was for a vast exhibition installed in a Times Square (pre-Disneyfication) massage parlor. This sounded fabulous to me, so I headed over to see what these guys were up to. It was a total scene. Artists Gone Wild. Someone, in a later decade, could have made a reality show out of it.

It was the sculptor John Ahearn who led me through the site. Artists were still mounting things and, with only a few days before the show was meant to go on, the plea was a desperate one — they needed cash asap or the show couldn't open. I looked around and felt the hair rise on my neck; there was some seriously challenging work here. Jean Michel Basquiat, Tom Otterness, Jenny Holzer, Kiki Smith… Other artists I had never encountered before. Much of the work was raw, radical, sexually explicit, often nihilistic. Although some of the work was

truly powerful, a lot of it appeared done with no concern about quality or make. But I guessed that a purely aesthetic appraisal was not the point; I quickly concluded that this show had to go on.

Startled, inspired, and exhilarated by the scandalous nature of it all, I headed back to my loft office to see what I could maneuver. The prospect was challenging due to the fact that the Beard's Fund operated on quarterly panel meetings and long written assessments. This emergency appeal would have to break the mold. In addition, pitching on behalf of this highly provocative exhibition, I would be staking my newly-formed reputation on a wild-assed collective of Lower Manhattan/Bronx cultural renegades. This act could easily chuck my fledgling career into the Times Square dumpster. All the more reason to proceed, I told myself; I am an artist first, and the reason I gravitated to this Fund was to help enable my peers.

I called Sandra, the benefactress, and explained the importance of the show, likening it to the Salon des Refusés, the famous 1863 Paris exhibition organized by artists who at that point couldn't get picked up by a gallery yet are now household names. I urged her to offer up the highest grant, which in the early 80's was the not-insignificant sum of five thousand dollars. She thought this way too lavish for such an enterprise. I countered that this show would make art history and, since the aegis of the Fund was to foster experimentation in the arts, we had to be a part of it. She finally assented to the first-ever 'emergency' grant of 4,000 bucks. I was chuffed.

A few days later, a visit for Sandra was arranged. I had arrived earlier and delivered the check. Although I ran around downtown in a black pleather jacket and pointy black boots, I dressed in my one grown-up looking navy suit and white peter pan collared blouse. I gritted my teeth as her limo pulled up. Sandra entered the first floor and I could sense her stiffening... She was a statuesque woman, almost a Valkyrie. Her hair was cut in a Lauren Hutton pageboy, but always looked a bit windblown. She often wore capes and knee socks or dressed in odd

combinations of plaids. Truly an iconoclast herself, she was nonetheless of an era and a milieu in which raunch and vulgarity were rare. She was an heir to the Whitney fortune and part of an esteemed philanthropic family. The walls of her apartment on Sutton Place were hung with Renoirs and Monets. Bringing her to this den of iniquity — what the hell was I thinking?

She lifted her nose ever so slightly in the air as John and I escorted her through the space. As I recall, it was still in a disheveled state, and of course works were hung with thumbtacks and tape. She quickly picked up the pace and soon we were following in her wake. But before we climbed the staircase to the airless top floor, John took the lead, chattering I am sure about how avant-garde it all was. I myself hadn't even seen the attic installation, but as we entered I gulped. Sandra's head brushed the array of paper fans hung from the ceiling, each one printed with an identical black and white photograph. My eyes turned as hers did, to focus on the image — a graphic depiction of a fist doing something astounding to a man's rear end. My jaw dropped as I watched, in what felt like the slow motion one supposedly experiences just before one's death, as Sandra turned and vanished downstairs. I looked at John, smiled faintly and charged downstairs.

She strode into the street, climbed into her limo and slammed the door before I could reach her. Just before the car pulled away, the window slid down.

"I'll talk to you tomorrow," she said darkly, and the silver-blue limo sped off into the chaos of Times Square.

In a state of shock, I walked back into the massage parlor to find John and a handful of artists standing around with slightly guilty looks on their faces. I laughed.

"Well that about brings my career in philanthropy to a screeching halt."

With which John guffawed and yelled "That's it guys, we got the dough. You can pull all the stuff off the walls now."

It was all too perfect. Whatever happened next, it was a great moment.

✼

Sandra called the next day and, bracing myself for dismissal, I listened as instead she told me she realized this show was the state of things in the art world, and she wanted to support it. I was fairly in awe of this grand dame at that point. She was a great and adventurous character; I wish she were still with us. As it turned out, the show made the covers of both Art Forum and Art in America; there have even been retrospectives of the show in recent years. So I was vindicated, and it gave me a little extra street cred in the downtown art scene. And John Ahearn, whose career has subsequently been firmly established, rewarded my efforts by doing a live cast of me in his Bronx Studio. I think I was his first white model. The bust still hangs on my living room wall. More to the point, it made me feel like kind of an honorary citizen of Colab — a true distinction.

ART IS LIFE IS... MATERNITY???

It is 1981 and, in part because of the access The Beard's Fund gave me, I was adrenalized by the renegade energy awash in lower Manhattan. Inspired by the hunger strike of Bobby Sands, an IRA leader and political prisoner unjustly treated in prison, I pulled together a huge gathering of downtown artists for a quasi-political salon in support of general rebellion.

I had already started writing a multi-media stage work about Sid Vicious (his pseudonym) a few weeks after his death — "John Simon Ritchie in America". Before a casket, and beneath a big screen playing black-and-white video fragments, John/Sid channels his dead girlfriend Nancy; remains silent while a chorus of young boys, The Alienated Youth League, chant dirges about life in general; and blurts out angry punk one-liners while trying but failing to shred his bass. While it reflected my sense that his death was a culturally triggered tragedy, the play was actually funny as well, and I wound up in London handing it to Michael White, producer of Rocky Horror Picture Show. He played interested and fêted me a bit, but really only had his eyes on the zipper of my shiny little capris.

This was about the breadth of my social connections and, unlike today, where a social identity gets built through countless avenues online, there were few routes short of becoming an actress or a rocker. But it was a comically glorious era, and I fairly flew through it (wondering half the time what the hell was going on). I wrote, I inhaled, I danced my ass off, consorted with artists, slept with the uptown and the downtown boys, including Mick Jagger, until this was discovered by his not-insignificant other, Jerry Hall. (I have a nearly completed roman à clef in the wings, Epistemology of a Party Girl, a novelized rollercoaster ride through those heady times.) Ah, I guess those were 'the good old days', all spun with a soundtrack of Punk and New Wave. The disgruntled get bored, however, and resistance inevitably wanes. One can only wear so much black. And Disco soon ascended to the throne, fueled by the drugged masses. Obviously, what the world needed next was silver lame and oblivion.

At this point, still director of the Beard's Fund, I had a shot at becoming a 'somebody' in the art world. Positioned as the brave soul who was part of the 'downtown' movement that birthed the next big thing in the art world, I was invited to speak to a crowd of culturati, and met a guy from Chase Manhattan's art investing department who later became head of MOCA, in Los Angeles. I could have easily parlayed my way into an advisory position or some other comfortable gig. But I couldn't handle doling money out to artists when what I wanted was to pursue my art as well, so I left the Fund. I had decided to write a novel and, more or less penniless, to do so I would have to live over my parents' garage, smack dab on a main country road in Connecticut. An almost impossible space in which to write…

Eidolon, named for the Greek concept of the daemon, or spirit double, was a novel mixing elements of my own story with a fantasy about finding Atlantis. However, just around then my life took on a semblance of fantasy itself; through the Beard's Fund I had encountered a crew of entitled rich kids who found me amusing and pulled me into their world of Dom Perignon and cocaine. I wound up living with one of them, a jolly rich boy fairly devoted to me, in a funky historic house an hour north of the city, where at least I could write and didn't have to feed myself. I set up my old electric Olivetti in the empty living room and set about finding the beating heart of Eidolon, but more often than not found myself staring into the blackened 19th-century fireplace or out the windows at a scrawny pack of leafless trees. I wrote sometimes savage, sometimes melancholy lyrics. Often I fled the oppressive quiet to meet the party boy in the city. Naturally this cozy though mongrel set-up couldn't withstand the light of day for long.

Back in Manhattan again, my next gig was at a one-woman PR firm in the Brill building (Broadway home of the SNL offices and all sorts of agents and showbiz types). Our clients were some serious uptown and downtown art galleries and a few punk rockers. I wrote tons of letters — one did that then, wrote individualized letters which were actually

mailed. But I couldn't quite see where it was all leading. It only made me more antsy to forge my own path as an artist, or rather as a hyphenate (although no one knew the term back then), because by this point I had a play, a novel in the works, and a few demos of me singing my art rock lyrics set to the electronic music of a charismatic, temperamental German I wound up living with for a few months in Upstate New York. (Terrestrial Alien was my best tune.) I actually managed to get a record deal with an up-and-coming label who loved what I was doing but found the German morbid, which in fact he was. They asked me to find another musician to work with.

Back then the very label of bi-polar was not in current parlance. All I knew was that Axel was prone to shifting moods. Sudden bursts of sunlight would just as suddenly fade to black. One day he was sweet, the next angsty and manic, and the next gloomy and saturnine. Finally, we parted ways and, shortly after, so bedeviled by his affliction, he took his life. In the end it seemed pre-destined, brought up as he was in the ruins of Berlin, in a schizoid household under the aegis of an ex-Gestapo officer. Yet his act was shocking and saddening.

Eventually, through friends, I met another composer with whom I finished a set of demos. Then one day I realized I was in love. There was a wedding and it was shortly thereafter that we gave birth to a darling child. Money issues were conveniently laid to rest for a while as he also had a successful career as a shipping broker. My husband was fairly old guard when it came to parenthood, urging me to stay out of the work force and tend to our child. It irked me at first but soon I realized it would give me time to paint. Thus began my Polar Bear series, which led to a commission from Absolut Vodka for a big environmental campaign involving the Arctic. Not easy squeezing in serious painting time or, come to think of it, any semblance of intellectual coherence, with a toddler wandering underfoot. But it was then that I learned what pure love is, then that I learned what it meant to put someone above myself. I wouldn't trade her for the most glamorous career in the world.

MEDITATIONS ON THE ORIGINS OF THE POM-POM

Coming late to motherhood was a sign of the times; this was the mid-eighties and all us blooming post-war females were coming into our own, supposedly. I knew almost nobody, in downtown Manhattan, who was producing offspring. I mean, this was the nabe of the famous Mudd Club where I had only recently partied. *Offspring*, that is how I thought of it, in those cold biological terms… at least when I wasn't feeling haunted by the humid magenta void of my own uterus and wondering how much longer I could avoid coming to terms with it.

The turning point was a simple moment in time, a moment really quite pure; I picked up my new nephew for the first time and looked into his perfect, Gerber baby, saucer eyes and fell right into them. I found myself emitting sounds I'd never heard before, cooing, gurgling, liltingly inflected babble. My body suddenly announced itself very much alive; fermenting hormones began bouncing around like pinballs.

A few weeks later, one of those pinballs hit its target; apparently, I didn't hear the bell it tripped. That would have been the night I 'forgot' my diaphragm. A month after that I hadn't gotten my period and my little breasts were suddenly getting big. What the? Wait… No… Really? Had that one encounter with a flesh-and-blood baby utterly undone my lack of interest in motherhood? Like I say, it's that simple, how it happens.

My pregnancy was basically care-free. Despite all the kale and liver I forced myself to eat in order to fuel the making of little Remy (I was quite sure it would be a boy, because I would have NO idea what to do with a girl, having not been a very good one as a child myself), I never got morning sickness, never upchucked, not even once. I had

every intention of returning to work as a PR flack for clients in the art and music world. Nobody sat around just being moms back then. My husband, who had spent a few years in Bali studying music, managed to orchestrate the plans for a young Balinese girl to be our nanny.

Well, all my fragile constructs soon came tumbling down. Firstly, the dear little soul that emerged was female. Uh-oh, I thought, I know nothing about how to be a girl much less how to raise one. Then the Balinese nanny realized she didn't really want to leave paradise. And soon I, dazzled by the sheer magnitude of giving birth and coming face-to-face with my own progeny, found myself reluctant to go back to my 'career', which had never felt like my destiny anyhow. I certainly had not counted on falling so deeply in love with this little puling creature, nor on coming to the conclusion that no third party (whose interest in this budding life could not be guaranteed) would be the one to witness her taking her first step or uttering her first word. Besides, the salary I would earn would just barely offset the expense of childcare, so suddenly I was breaking new ground in Manhattan as a stay-at-home Mom, or at least it felt that way to me.

※

Delphine's coming was like a monsoon. For months I lived a sub-aqueous existence — a daft drunk floating on a sea of tepid milk. I moved like an acolyte in some mysterious primal cult, opiated by the exhalations of new life. This was a moment of conversion and I, as a new initiate, willingly dropped my silk cloak to pursue the path of re-nunciation and true liberation.

Suddenly, all the contours of identity I had managed to map had shifted. The topography had gone phantasmagoric. Where there had been ranges of mountains, there were now soft lush valleys, where there had been high windswept plateaus, there were vast misty marshes, where there had been wild deserts, there were little green parks with prams in them. It was all new terrain; they were not on my map. Yet there was an unsettling ancient feel to these places that drew me into them.

But it wasn't all peaches and pudding. A few months in, this new regime started to seem like tyranny. Staring down at my little putti-faced ruler knowing I would change her diapers six times that day, was like crashing from a psychedelic. At the prodding of increasingly vivid memories of more dramatic experiences, my irascible ego began to reawaken... And so I inhabited a state of cognitive dissonance. At once rejecting the value of my creative pursuits, tethering them to the mundane, and yet feeling them loudly champing at their bits. And all the while falling, every day, more deeply in love.

But now there she is, burbling at me.
Number one. For the foreseeable future.
My teddy girl. On top of her little head, soft and fuzzy,
a diamond of flesh pulses with the beat of her heart.
She has hiccups.
There is a soft rumble of small running feet from upstairs.
A white pigeon swerves before the window.

Her hands are translucent. My heart!
Caught in a vertiginous updraft.

I am lost to the world I knew, would not be recognized there now.
Even I have trouble identifying the figure before me in the mirror.
It is somewhat solid but so very soft. Hair never in place.
A dogeared shadow of my earlier self, unable to maintain a constant
form, swirls about me in desperate ambiguity.
I do not know where to put it.
My brain seems occupied by a preternatural force, inscrutable, ineluctable.

Things have gone topsy-turvy. What before loomed ominous and big*
now seems absurd. And what, in the global sense,
had seemed insignificant, has blossomed.
A pom-pom on her booty. Little pomme, little apple of fluff...

The urge to ornament, create around her a tiny altar.

"The little cloud is a flaming golden fox. And the crimson one is a streak of desire."
She is watching me look out the window.
The red sun shines from the omniscient black of her eyes, ignites her ears.
I am face-to-face with a miracle.
She opens her mouth in a silent laugh.

So like all new mothers, I soldiered on. And, after all, was not really a stay-at-home Mom. It was tough relegating all that formerly creative time to the miniaturized world of a baby, but as she grew and gathered steam, and learned how to express herself, we became fast friends. I pursued my career as a painter and took my adorable girl child everywhere with me. Museums, hikes, expeditions, dinners out. Having grown up without much guidance or expressions of love from my own mother, I felt it deeply important to give everything I could to my own daughter. Poor child was subjected to long philosophical rambles as I drove her to school and pontificated on the nature of life.

And, although I'm not taking credit, if there is one thing I am proud of in this world, it is helping to bring up a magnificently original and brave young woman. I am consistently surprised by her wisdom, her sophistication, her humor and her logic, and terrifically impressed by her deep humanitarianism. Being a part of who she is may be the truest accomplishment I will experience during my lifetime, and it is a humbling thought, recognizing how psycho-social evolution spans generations. Maybe the one thing I have shown her, even if at times by negative example, is that fear is, if not exactly an enemy, a stout opponent. But that it is one we can defeat.

I took the flickering glimmer of light cradled in my mother's paint-stained hands and ran with it, ran so hard the wind fanned its flames. And now my daughter takes that small torch and illuminates a brave path of her own. She will out-distance me, but for now we are running

side by side, sharing the light and grinning with delight. I believe she's watching me as avidly as I'm watching her... and somehow I think my mother is watching us both.

* **Topsy-turvy** - Earlier topside-turvey, probably for top so turvy; where turvy probably means overturned. In an inverted posture; with the top or head downward; upside down; as, to turn a carriage topsy-turvy. 1520's Probably from *top* "highest point" + obsolete *terve* "turn upside down, topple over," from Old English *tearflian* "to roll over, overturn".

Good grief man! You're a sailor and have capsized your dinghy in high seas more times that I can remember, yet yonder blond has you topsy-turvy and terrified in love.

THE ARTIST THINKS ONLY OF MONEY PART II

Life in downtown Manhattan, lived in a Tribeca loft overlooking a small park and what were then still dairy warehouses, was an ideal place to be a New York mother. The air was clean and it still felt like a frontier. I had plenty of space in which to paint (though never enough time) and a small community of artists to consort with. But when my daughter approached the age of six, I realized I wanted her to have a free-ranging childhood like I had, running wild through nature, through leaves and grass, dirt and bugs, sweet air and dark nights.

We moved to a hilly suburb north of the city. Though our old farmhouse was perched along a main road, it was embraced by woods; there were deer and coyotes and lilacs and peonies. There was also a carriage barn across the driveway, begging to be turned into a painting studio. Unused for years, it was raw and dusty, but we sheet-rocked it and added two enormous skylights. Bathed in a perfect northern light, I painted and I painted big.

My bears were getting raves from friends, but I began to feel I might forever wind up a painter of my giant pals, and considered a mere 'naturalist'. Besides, I had lots of other ideas, so I took off on a new tangent, still environmentally motivated, of painting taxidermied animals in bizarre contexts like pinball parlors or looming over quasi-religious scenes. I called the style Synthetic Realism. These were good times for my work and lovely times with my child. But my marriage, despite an auspicious beginning renovating the old house together, was becoming increasingly difficult, possibly skewed by two miscarriages, certainly strained by my husband's unresolved conflicts with his own parents.

As the growing power of computers, and the newly-minted program Photoshop, gave wing to my ability to create more complicated, hybridized compositions, my artistic ambitions began to morph. As

well, the long lonely hours in the studio made me yearn for civilization again. I wound up back in the city to study software and soon wound up less interested in big canvases than digital collages destined for light boxes.

<p style="text-align:center">❈</p>

Concurrently I was teaching my daughter to read. Trying to make the odd orthography of the English language appear reasonable to a young brain led me on a search for the origins of our most excellent Mother tongue. Before long my desk was littered with books on everything from English history to American slang. I was suddenly seized with the desire to *play* with it all, and soon my word game project, Pandelexium, began to materialize. Over the course of the next five years, I repurposed old games (everything but crosswords), created new ones (like the Neologizone — a contest to see who could come up with the month's best neologism), made over 50 photo collages to be converted into interactive game pages, and studied everything relevant to CD-ROM development. Finally, I previewed it for investors, or rather the two or three I could drum up, but nobody could figure out how to monetize it, least of all me.

This dream now stalled in its tracks, I decided to start working again. I took a course in advertising at the School of Visual Arts; actually got an A from my prof, who lauded both my imagery and text. Seemed like a good start, but it was with classic bad timing that I started to take interviews; the ad business was cratering as the Great Recession washed across America. My husband underwent some major career shifts and money angst resurfaced, as did his growing dissatisfaction with commuter life. Things got all tangled up. Arguments and resentments mounted and I found myself submerged in an uncharacteristic despair. By now my daughter was a sophomore at a local boarding school, but well aware of the crisis. To me, divorce seemed the only way to alleviate the family's suffering. Whether it was my ineptitude with

money or my attempt to retain my sanity, I took a quick settlement, trading future financial security for a release from onerous legal labors.

Since I never intended for this book to be a detailed memoir and have no interest in discussing divorce, I will say no more other than it was the most painful period of my life. Remarkably, my ex-husband and I have maintained a friendship. And, over the years, I have been working with my generous daughter to heal the wounds it caused her.

Post-divorce, I did wind up with a few years of 'maintenance', enough to reconnect with my original ambition — to make films. I was already writing a screenplay so, after a few years, I took a leap of faith and headed to the only place to do that at the time — Los Angeles. Off I went, with high hopes and with a man who happened to be in the business and who became my partner. Once there, I tried my hand at almost every position in the industry from casting, to script supervising, to shooting behind-the-scenes videos, and to a consultancy in script analysis and development.

Dreaming, all the while, of becoming a director, I wrote two screen-plays; the first, Lucy Does Weather, was a fantasy rom-com about an Olympian Goddess of Weather who, frustrated by humans mucking up the climate, decides to come to Earth to sort things out. Lucy crashes a hot air balloon in the Mediterranean and gets rescued by Dimitri, a Greek guy who falls for her and later follows her to the US, where she masquerades as a hot-shot meteorologist with an apparently uncanny knack for precisely predicting weather. Lucy gets co-opted by a faux environmental group run by a wicked oil baroness, then kidnapped by thugs of a Chinese agribusiness kingpin, and finally winds up back in Greece starting a wind turbine business with Dimitri, who has taken over his father's shipyard... Alas, I couldn't get an agent. Too high-bud-get for a newbie, I was told. At a certain point, with Obama in office, I thought the story was no longer relevant because we were entering a new age of accountability, especially regarding the environment. Now, however, with the planet being venally defiled by the arch-villains cur-rently in power, the script seems prophetic.

The second screenplay was a 'genre' piece (meaning horror) which I opted to do since my partner had a gig shooting ultra-low budget horror and I figured, with his connections, maybe I could wangle a deal as well if I wrote a seamy enough script. Vermillion was my J-horror (Japanese styled, meaning sort of ghostly ghastly) story that takes place in the art world of downtown LA. I'm going to novelize that one, so I won't reveal any more. To get such productions off the ground, one has to off someone in the first ten minutes, and then continue to slaughter along the way. Luckily before I descended to those depths, the script attracted a German producer with a supposed fund behind her. Under her close scrutiny, Vermillion went through numerous rewrites to make it more art-house. In true Hollywood fashion, the fund collapsed, but she turned up some Beverly Hills millionaire who wanted to finance it, *if* we cast his daughter, yet another bland bimbo, as star. I refused. My German gave up on the film business and moved back to New York. I soon came to the conclusion that if my partner couldn't get any serious projects off the ground, how was I going to? This time I couldn't even get an agent to respond.

These years taught me a lot about the business, but the hardest lesson was that without money behind you, or the status of a twenty-something with a solid network built in film school, the odds against success were staggering. There may be more competitive fields, but the film business ranks at the top of my list. Deciding to break out of the endless and often fruitless waiting game of Hollywood, I made another rational move and swerved into publishing.

<p style="text-align:center">�֎</p>

I didn't wake up one day and say, "I want to be an online publisher," but it was almost that sudden. The day I received my first copy of AARP's monthly newsletter, which arrives with no warning when you hit the age of 50 (and how the hell do they get *that* mailing list?), I noticed a sense of ire rise from my gut. I leafed through the poorly de-

signed magazine, caught glimpses of the sickeningly enthusiastic, fairly condescending banter. The basic message was, "Pop your pills in your old alligator bag, strap a Med-alert pendant around your neck, hop onto your scooter and head straight downhill." I thought, "Screw this. This is not for my generation."

After a couple years of receiving and immediately tossing the magazine, I became so revolted that I muttered, "Someone could do better than this. *I* could do better." That was the day Realize Magazine was born.

I spent weeks designing the look, then more weeks redesigning it (liabilities of being a perfectionist and an adept at Photoshop). I sought out old friends who could write and created dozens of images to lead their stories. I worked with a coder and created playlists through streaming sites and then did video interviews as well. But while I was at work on this, my partner, who I had adored, seemed to be drifting into serious debt and a barely masked depression about it. Despite my excitement about Realize, he hardly looked at my work in progress. His lack of interest, and what appeared to be a highly uncertain financial future with him, began taking its toll on me. I was ten years older than he was and found myself feeling grave doubts about my dreams materializing in the coming decades.

It was right around then that my father passed away. A father's death, whether overtly or otherwise, unsettles one's very foundation, perhaps more so for a daughter. Slowly it dawned on me that I now was sailing singlehanded; there was no longer any safety net. I came to the difficult conclusion that my relationship was not supporting me and that I needed to be free to explore my own trajectory.

Lucky for me, my father left me a small sum of money. While others, more sensible, would have preserved it as a nest egg, I saw it as a means of publishing Realize for a couple of years. (It was a leash just long enough for me to get myself wrapped around a tree.) Despite the magazine's enthusiastic audience, the job description of solo Publisher proved to be way too unwieldy. I decided to spring for a lovely and

brainy assistant for a few months, but when she took off for a role as a serious journalist, the list of tasks fell to me. I performed all editorial functions from finding and editing writers who would work for free, to creating illustrations for their work, social media marketing, and on top of that trying, as a complete neophyte, to solicit sponsors or advertisers. It was simply more than I, or my dwindling finances, could handle. I then decided, given the huge rush of content to video, that my best move was to enter the world of video content production. I made a valiant attempt to establish the Realize Channel and launched a Kickstarter campaign with a very complex three-minute video and daily social media clips from supporters. But when my mother passed away halfway through the campaign, I lost my mojo. Couldn't sustain the rah-rah sensibility.

Now, hitting that age range when boomers find it very tough to get employed, I have no clear sense of how I'll stay afloat into my seventies. I have a few ideas, probably typically pie-eyed — to wit: *writing a book?* Who makes money on that these days? And, once I've written it and formatted it for self-publishing, then begins the really hard work of marketing it. A serious full-time job and I ain't even getting paid.

But I've always lived on the edge, and I guess on some level I choose to do so because it keeps life exciting. The great unknown. What further adventure will arise in the endlessly absurd game I play with money?

WRITING AS SKIPPING STONES AND OTHER METAPHORS

(Caveat — these stones fly far afield...)

What is this thing, writing? This extraordinary, downright bizarre ability that humans have developed? That we found a way to take the numina flitting through our brains or rising up from our guts or demanding release from our hearts, and make it visible; that we found a way to code sounds... even before that we found a way to utter sounds that had value, that had meaning, that above all connected us to each other — this is mind-blowing!

But what of the struggle one engages in in order to actually produce the words, to actually congeal one's thinking? And why give a damn to record these individually produced, induced thoughts? Are they anything other than fleeting perceptions, wills-o-the-wisp, unbidden ephemera? One will never know unless one spits them out.

So at least one valid reason to write is to clarify thought. Useful, that one, if not to others, to oneself. But then the world is filled with the hopeful expressions of writers who wish to convince us that their thoughts are actually true, or might supplant our own weak cognitive meanderings. Of course they hope to make a buck, but most likely they also simply want to hear themselves think. And this at least is an honest goal. That is mine, in fact. I swear to the Almighty (which in my case is the Universe itself, as if it's listening) that I hardly know what I think until I start to write. My thoughts unfold as I write. They're like hopeful little seedlings in my brain which, if deprived of the photons of my concentration as I write, would never grow. It's fascinating, miraculous really, to see your mind at work. You don't know even 90% of what's 'in there' until you start writing.

And that's when writing is like skipping stones. You send them out over the low waves only to see them take an immediate dive below, but you keep trying and then one lovely stone suddenly sprouts wings and just to amuse you chooses to skip on the water, one, two, three... seven whole skips. And that's your reward. A written thought sailing forth on its own course...

Sometimes, however, writing is more like lepidoptery*. Poking about in the wilds with a little net held high, ever seeking an elusive butterfly. (And who, in his spare time, hunted for butterflies? None other than the great wordsmith Vladimir Nabokov!) Then again, sometimes, writing is more like fishing. You can sit there for hours, with your hook in the water, scratching your head or your balls or your twat, wondering what the hell you're doing and why you ever decided to be a writer because it's damned hard and sometimes the fish are definitely everywhere but where you are.

But then, and often it happens while you're doing something très mundane, some thought will get spanghewed* right through the paper backdrop of your life, proceed to seize you by the wattle and throttle you with its message. And then you sit down and the words are there and you say, *Ah, this is why I write.*

All well and good. But some days I just don't want to write. They say that writers have to write even when they don't want to and right now I don't want to. However, the fact that I've said I'm a writer means **I had better write.** I mean, can you really call yourself a writer if you only write when the moment calls to you? If you suddenly get very antsy or sleepy when it's time to write, when you fidget and fuss and repot ferns?

But my fern is 10 years old! A vast, florid lovely creature that has survived many periods of drought due to lazy fernsitters and it was just about fed up with its miniscule pot and sending wild hairy vines all around it searching for sustenance, which sometimes it got from fish meal when I could bear to smell it, but is now doing beautifully thank you very much due to my repotting, and anyhow what has greater value in life? Those moments of connection with dirt and living green

or struggling to produce words for an unknown audience?

Notice I said, *I had better write*, not **I should write**. My shrink tells me not to say 'I should' anything. Because 'should' casts a lengthy shadow of shame. (Oh, but what an excellent driver for a writer is shame; you can languish, sputter and spout in a penumbra* of self-loathing and brow-beating!) But I'm done with 'should'. Hardly say it anymore. And even though I've touched on self-doubt, and rattled off numerous self-incriminations, I've finally gotten the message that self-love is where it's at.

<p style="text-align:center">❊</p>

Anyhow, if I tell people I'm writing a book, and I indeed want to write a book, I damn well better write. (But is that really different than saying *'I should write'*?) I guess there's a reason I'm not a shrink, or a professor; any reality beyond my own skewed perspective is so bloody slippery. Oh, and what else is bloody slippery? A newborn! Which is really how I see myself as a writer.

So here I have to honor my metaphors and make a completely non-sequitorial pitch in here about having a child. (Oh well, there are way too many reasons, but re-grooming your sense of reality and your preposterous sense of self are two of them, not to mention putting new energy into the system, energy you can help direct and oh, the inexpressible joy!) How else can one guess at the experience of a newborn; how else begin to comprehend how you yourself developed?

I don't mean the moment-to-moment reality of an infant, but that reality which lies within their genome, ready to spring forth with abandon. This quote from Jean Paul Sartre, pre-genomics, seems quaint in this regard:

"There is no human nature… Man first of all exists, encounters himself, surges up in the world and defines himself afterwards. If man, as the Existentialist sees him, is not definable, it is because to begin with he is nothing. He will not be anything until later, and then he will be what he makes himself."

While my teenage identity was greatly fortified by reading Sartre, who gave me a stout sense of agency, this is a loaded statement at which current neuroscience would raise an eyebrow, since it is now commonly believed that free will is a bit of a snark. This would even raise a brow of Sartre's contemporary Carl Jung, who persuasively argued that we come loaded with all sorts of unconscious artifacts somehow secreted into our mystical core that play out in our development. And, Jean Paul, how could you forget the overwhelming nature of 'civilization'? But I give the genius his due, since his whole oeuvre is dedicated to extolling and capitalizing on the freedom we possess despite, and often because of, the difficult situations we inhabit.

Anyhow, can I even guess the reality yet hidden in my own genome, which if I unpacked would spring forth like a mother-fucker? But again, isn't that why I'm writing?

And should a writer... *Oops!* Let me rephrase that: *is it a good idea* for a writer to edit her initial paragraphs before continuing a diatribe such as this? (Or is this a disquisition?) I am capable of infinite divagations here, which is why my dear friend Billie told me I must check out Cyril Connolly's book, Unquiet Grave. Her reason being that it may relate to the scattershot way I'm writing this book. She tells me I'm like confetti?

Billie tells me to buy a used version so I can mark up the margins. But that's almost the price of the new book, not to mention days and days of waiting for the snail bearing it to arrive. So I ordered a new one. The Amazon page says, "This enduring classic is *'a book which, no matter how many readers it will ever have, will never have enough."* Ernest Hemingway."

Well, we all know Hemingway is 'the man' don't we? Or do we? (All I know is that, according to friends of mine, his writing study in Key West looks just like my living room. And when their son, who sometimes writes in my living room, saw their picture of it on Instagram, he thought it *was* my living room.)

"All right, stop right there Honey," snarls my super-ego, "does any of this hopscotching constitute 'writing'?" Long pause for reflection... indeed, am I just spinning like a western inflected Dervish, more to catch the drift of my own thoughts than to interest or amuse or enlighten anyone else? But isn't this my mission? To spell out (spew out?) the daily stream of consciousness (blather?) so that others might actually realize:

1) *They're* not so mad, or
2) They should read Cyril Connolly because of what Ernest said, or
3) They ought to write their own damn book! or
4) LIFE IS SHORT!

I actually think that writing is NEVER ONE THING. Sometimes what the act of writing demands is to be pondered and fondled and tickled and allowed to ferment, and sometimes it needs to climb out of the crib, wailing like a brat.

Oh, I'd better add Brat to the list of names I call myself.

* **Lepidoptery** - the pursuit/and or collection of butterflies. Lepidoptera: an order of insects comprising the butterflies, moths, and skippers. The name means "scale wing," and lepidopteran wings are covered with microscopic scales, which are iridescent, brightly colored and usually visible as the "fuzz" along the edges of the wing.

I know this word because an avid lepidopterist stepped into my life and netted me — one of my all-time favorite writers, Vladimir Nabokov.

* **Penumbra** - 1) The shadow cast by the earth or moon over an area experiencing a partial eclipse. Coined in 1604 by Johannes Kepler from Latin *pæne* "almost" + *umbra* "shadow" 2) The partially shaded outer region of the shadow cast by an opaque object.

The penumbra of his profile overlaid upon her rosy cheek lent her face a melancholy, lavender cast.

* **Spanghew** - British dialect: to throw violently into the air; especially: to throw (a frog) into the air from the end of a stick. (Shucks, sorry about the image this might conjure up, folks.)

As far as I can see, our current leader just took the nation, shook it up like a can of Coke and spanghewed it into the stratosphere.

ART THAT PEOPLE LOVE

As a hyphenate, I allow myself a great deal of wiggle room between media. Even though I'm not producing art for Art's sake at the moment (whatever that means anymore), I think about it all the time. I look at it all the time. And I have to say — there is so much art out in the world these days, it's bloody overwhelming.

It doesn't help that there is really no longer a 'there' there (ala Duchamp). Because Art has mutated as quickly as culture itself, and ever since the cultural relativists took over, or the deconstructionists or whatever they call themselves, things ain't been the same and Art just happens to be one of the biggest of those things and it barely looks like it once did. Because now, anyone can call themselves an artist. And if they have a big enough social media presence, or some heavy-hitter friends in the art world, or just happen to really, really believe in what they're making, they will be accepted as such.

Many will complain that it's all gone downhill and, for sure, there is a lot of half-assed art sliding down the hill along with the mud as the deluge continues. But that's too easy a statement — one designed to get you off the hook when it comes to understanding and evaluating contemporary work.

I have, countless times, walked into a gallery only to spin on my heel and exit. Because the work was like contemplating a void, only less instructive. Strings leading from a fuzzy black and white xerox on one wall to a fuzzy color print on a neighboring wall or dust piled in a corner or photos of dust bunnies under a bed or photos, blurry, of young people with tats lying on sweat stained beds. (I could go on, but...)

Sure, these artists are trying to say something, but it usually feels like they're appropriating an earlier artist who was quoting an earlier artist whose main theme was art's inability to say anything in the first place. Or it looks like they thought they could capture a pessimistic trend by documenting and sensationalizing the dissolution of society.

Or they're sometimes just plain lazy, expecting the viewer to do all the work by connecting the dots only to find that the result is a prone stick figure — a simplistic, nihilistic concept that leads nowhere.

But the problematic thing is that sometimes what looks to be vapid and attenuated, may actually contain a germ of life. The LA County Museum of Art staged a big show of the work of French artist Pierre Huyghe (pronounced breathily as Hweeg). As first you walked into the cavernous gallery space (gotta love LA for all the space it has to give art) an usher asked your name, then loudly announced your arrival. Ha! Great start, but once in, you would look around and feel like perhaps they were taking the show down. I saw one woman enter, look around, snort, and abruptly leave. But had I known, I would have pulled her back, because Huyghe, who is now in his 50's, is an original. And as you delve more deeply into the chambers of his mind, a really interesting story begins to emerge.

Yes there are pieces that seem gimmicky or knee-jerk, but amongst them are some stunning works and it is the *totality* that works a special magic on the viewer by splintering her thought processes, throwing them into the air, then occasionally reconstructing them along new lines. This is what contemporary art, at its best, will do.

Take Michael Heiser's monster installation in a wide swath of sand in the back 40 at LACMA. It's called *Levitated Mass*. I made a video about it, entitled Art Rock (actually a subset of 80's New Wave). Anyhow, Heiser found the biggest damn boulder (80 tons) he could find at a quarry miles away from Los Angeles and, with a hefty budget, got a hauling company to drag this outrageous behemoth to Fairfax and 6th where it was cantilevered over a deep cement trench so that visitors could walk underneath it and admire this singular object. Not of his making, mind you, but of Earth's. Yes, it was chiseled and pried forth, but this was not so much an act of artistry, since it preceded Heiser's selection of it. Yet Heiser's *act* is his presentation of the rock. Of course the rock's mere weight, and the countless dollars LACMA spent to in-

stall it, factor in as well. This could be seen as hubris, or a metaphor about hubris. Strangely, in these days, we find ourselves knocked out by the sheer financial genius of some of these artists (think Damien Hirst, who studded a skull with diamonds and has since created sculptures costing thousands merely to produce). Other artists marvel at and deeply envy the charisma these A listers must possess to surround themselves with such a wealthy fan base to help finance them.

Perhaps the loftiest goal is to create artwork that people love so much they want to be photographed inside of it. Chris Burden's big installation of antique street lights at LACMA is actually a living sculpture; it is always alive with people wandering between the rows and posing for photo ops. It is a testament to the possibilities of art touching people, engaging them, interacting with them. Then there is Anish Kapoor's huge chrome Bean in Chicago, near the Art Institute, where there are always small clutches of tourists stroking the surface, laughing at their reflections, and striking poses for innumerable photographs. Artworks like this leaven our earthbound psyches with the yeast of vision and play, lift us out of ourselves into a higher realm.

IF I WERE
WOLFGANG TILLMANS

Wolfgang Tillmans is a photographer, I would hazard to say basically a stylist, but an increasingly political one (and of course these things are not mutually exclusive). Wolfgang sort of gets away, gloriously, with murder in the art world, not like Trump thinks he could on Fifth Avenue, but close. I don't know how he does it. Must be in the attitude — or that he is given credit for seeing something yet unseen, yet unknown, the not yet real. And possibly because his subjects (they're young, often gay, and they're hot) are quite indifferent; they lure us in and convince us they *are* the real.

I saw his retrospective in London in 2017, and it was genius — not any one piece, just the whole presentation. The show was a prime example of the blasted-out landscape of contemporary art, perfectly housed in the brutalist warehouse of the Tate Modern. Mixed in among his photos were vitrines with abstruse essays from scholarly magazines. I don't know how many people really focused on them, but their function appeared to be to give gravitas to an otherwise diffuse collection of images. In effect it's like an act two in a slightly dystopian drama and something you witness over time. There is no exact punctuation: people locate what intrigues them and even if nothing says *Art* to them, they experience something — titillation, boredom, an expanded awareness of otherness, maybe even a sense of superiority over the artist.

So if I were Tillmans, what sort of venue would I choose? I think some sort of contrapuntal space like the Old Tate, or MOMA or LACMA, my local joint.

There would be some, like, real Art here and there. (Tillmans also shoots office spaces (mostly his own) and cars, then prints them on aluminum, which looks super cool, even if the images themselves are ultra-mundane.) I think I'd prefer images from space. Space always

reads *Important*. Especially now, since we all may need to be going there soon if any more environmental shit hits the fan. *(Maybe get Tesla as a sponsor?)*

I'd take a page from Tillman's playbook and scatter about (actually toss in the air) pamphlets from obscure academic groups. They will remind viewers that they aren't as smart as they think, or maybe what I mean is educated. Screeds and such. The stuff can actually be illuminating, but the sheer volume of verbiage will repel the casual viewer. *(In my exhibition, there will be a quiz at some point and those who answer correctly get to do Simon Says with a B-list celebrity in a hallway. Those who don't are sent to an interrogation room.)*

There will also be a great deal of live action. Actors will swing around on a Jungle Gym, reading from the above obscure academic texts (actually these will be sung, almost liturgically), and from works by Montaigne, Heraclitus and Eddy.

Italian neuroscientist (and hottie), Giulio Tononi will be receiving guests, in a line, after they've gotten a glass of champagne. Each guest will be allowed one question of him. Both this and Tononi's answer will be filmed, then looped into the outdoor bar area (if at LACMA) or across the different floors of the Tate. Occasionally dancers will come up to Tononi, badger him about his work or attempt to touch or kiss him.

Participants will have been instructed to come with something, a costume, disguise, or mask to establish an alternative identity. Of course, there will be AR goggles available but there will be a dance competition in order to get one. In fact, dancers will be running through the galleries, shrieking, laughing, and uttering quotes from philosophers. As well, random dancing will intermittently be required by all participants, with occasional interruptions à la the children's game of Statues. I'm thinking there should be paintball.

The music upon entering the galleries will be Hanna's Theme from the Chemical Brothers' soundtrack to Hanna. This will establish a sense of wide openness cut by a slightly dark edge. (The lyric contains numerous repetitions of the phrase "begin again".) Other soundtracks will set a specific tone for each gallery; some ambient music, soundtracks like The Martian, some boys choir, some Congolese and Cameroonian artists (one has to cut the irony with some genuine beats).

The overall effect, unlike that of Tillman's big retrospective, will be of a daft romper room for quasi-intellectual play.

(Since my current faves are constantly updating, you can find the most current playlist for my Pseudo-Tillmans event on my website: www.ellaryeddy.com)

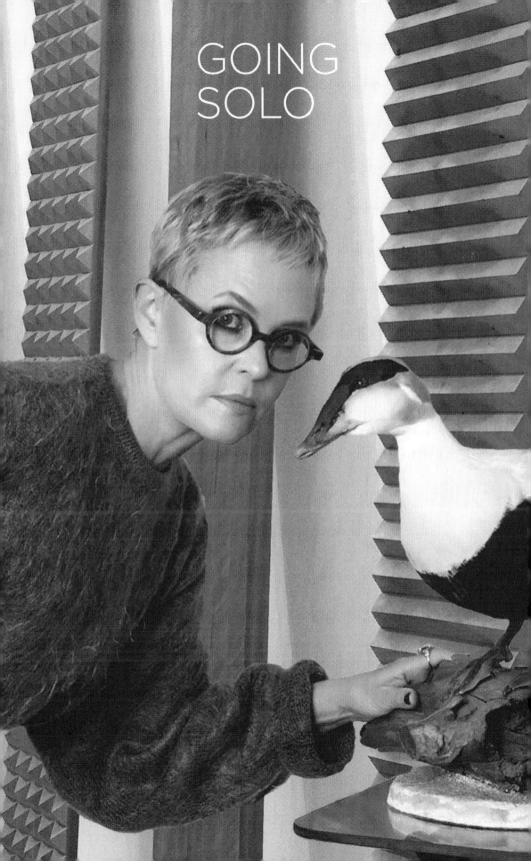

SOLO POST 50 or 60 OR WHENEVER

Despite my disinclination to write advice or approximate a self-help scenario, I found myself thinking I could possibly make a buck as a magazine writer. I made a connection to a woman high up in the Hearst Corporation who, after our interview, called me an influencer and urged me to write a piece which she could show an editor or two. So I wrote this piece, a puffy sort, hoping to meet one of their many audiences. The recommendation that came back was it would be Woman's Day. Sort of a slap in the kisser to one as pseudo-intellectual as I, and at least seriously antithetical to most of what I've written to date. Anyhow, the piece comes across as a bit of a manifesto, and therefore take note: I believe that those who write manifestos are often hoping to exhort themselves to meet their own declarations...

Drop whatever obsession with partner-hood you might harbor. Cease drooling over your fantasies of the lives of the married. Release all your preconceptions of what it means to be single, including your own 'singlism' (the stigmatization of being single) because really, when it comes down to it, being single can be immensely liberating.

Of course, who I am to tell you this? I am sort of recently single, and singularly so. But then each individual comes to the state of single-hood by idiosyncratic routes, so my experience of living on my own couldn't possibly resemble yours, unless... unless there is a high plateau we *all* can reach, regardless of background, a place which we will eventually realize is not just perfectly fine, but maybe even wildly fine. Is that an oxymoron? No it is not, because that place happens to be your *very own self.*

Let's go back to liberating. I'm writing this wearing a pink wig (prepping for Halloween) and massive baby diapers I bought at a local H'ween Pop-up. And, since I am single, I am presently unattached to the psychic well-being of a partner who might currently be pouting in

the kitchen, unwilling to dress up for a night of hi-jinx, or simmering in the bedroom due to a dearth of recent sexual activity, or in the den obstinately watching an episode of Mr. Robot. And, joy oh joy, guess what — it's Not My Problem!

Yes, I know you can imagine the scenarios… He/she may have scowled at the price of the truffle you bought even if you're making the pasta. He/she may have wanted to stay home last weekend instead of tripping out to the desert to go rock scrambling and so is now him/herself brooding over the HUGE inequities in the relationship. He/she may be upset you won't engage in interminable discussions about the State of the Union, or even the state of your union. And on and on. And yet, isn't that what those of us, who last in them, find worthwhile about marriage/partnerships — that we can engage in these petty power struggles and then prove how enlightened we are, as we have learned how to forbear, in the name of compromise, compassion, and maturity? Hmmm, not a selling point for this consumer. But maybe I just had bad luck in the matrimony game.

Of course, I'm not here to dis married life. And it just so happens there is a big flip-side to single-hood — which is that you have nobody to blame if you have a pathetic Saturday night. Nobody to blame if there's nothing in the fridge. Nobody to hold your hand when you're deep in a self-deconstructing funk. But, ah — self-reliance! It is a beautiful thing.

Being a girl of the Fifties, I was automatically implanted with a slow release device leaking some sort of hormone that amped up my desire to be married. But now, having been seriously partnered up from my thirties onward (a marriage and a second long relationship), I have a keen sense of the differences between partnership and the state of being single. I cannot speak to raising a child as a single mother (my daughter did grow up in the setting of a marriage), but I can speak to some recent years spent on my own. While they did take a period of adjustment, these years have now become the most exhilarating and productive time

of my life. Not only is there life after 50, there are vast horizons to trek for the brave individual striking out on her/his own.

Sure, there might be a few hurdles along the way — navigating the dating game, dealing with all the 'honey-do' chores that are typically assigned to spouses, and then of course learning how to orient yourself within the apparent vacuum of extra free time. But this is part of the thrill, and part of a learning experience that is all yours. For me, the wide swaths of unfettered time, time not claimed by nor dedicated to another, was not so challenging; as an artist I know a lot about alone time. However, any active mind will quickly deduce how to occupy itself and begin to flourish within the freely flowing air of single-hood.

But wait, you may say — *Dating*? Why are you *dating* if single life is so perfect? Because, I retort, you never know; you might actually find someone more fun than yourself, maybe even a new friend in the bargain. At the very least you rack up new experiences and can later recount them when you regale your friends with your comic chronicles of dating.

But I am begging a question here — the question of intimacy. Beyond child-rearing, this need is one of the primal factors driving us to pair up. And I feel it. I walk through the park and see a young woman throw her arms around her lover and kiss him madly and wish like hell I could do that and could feel someone's warm flesh melt into me... But is a partnership/marriage guaranteed to deliver intimacy? Ahem. Intimacy is no sure thing in a traditional, or for that matter a modern, marriage. How much great sex or even just pleasant sex is happening in marriage? Stats are way inconclusive. (Am I talking myself out of something?)

Now some people love the single life precisely because they can spend so much time with their favorite person: themselves. And then, some of us are just not built for partnerships. Some of us are, but provisionally; I would include myself in that latter category. Which means my solo life is groovy, but I remain open to the idea of a partnership.

Notice I say the *idea of*. The thing is, I have quirky habits, a very strong aesthetic sense, the personality profile of a cruise director and a pre-existing love affair with my wookie-poo (that's a poodle crossed with a wookie). Potential partners might find my antics exhausting. Funnily enough, even if I found someone to fit into this jigsaw puzzle of my self, if they were too amenable I might get bored. Like I say, it's all so tricky.

One of the great boons of becoming single again is rediscovering the deep pleasures of friendship. There is current research pointing out how much greater is the circle of emotional strength of the single person vs. the married one. Within marriage there is typically a drift toward insularity; the focus narrows as spouses often wean from old friendships and turn to each other for the bulk of their emotional needs. So when studies are done examining loneliness, guess what? "People living alone are less likely to be lonely!" Why? Because friendship is the major factor impacting one's sense of loneliness, and singletons are just more motivated to maintain their ties with friends, family and neighbors. They learn to develop networks and keep them fluid and alive, creating for themselves a wider, more stable community.

As for all the books promulgating the theory that married people are happier? Highly skewed research, writes PHD Bella dePaulo, who studies the studies that such authors employ (and who invented the term singlism). Her findings: single people, especially those that have always been single, are at least as happy as those who've stayed married, and way happier than those who've divorced. (I might beg to differ on this score, as one of those who are divorced and is as happy as the lot of them.) Yes, there is a noticeable blip upward around the period of a wedding, but once the nuptial high subsides, studies show that happiness levels return to those that preceded the union.

Given all of this, I approach my single life with a grand sense of humor. And I stab it with the Stoic Fork — a swell little precept developed by the ancient Greek philosophers known as the Stoics, who divined this core principle: there are things that one can control and things one

cannot. Yes, this was later converted into the popular Serenity Prayer and for good reason; the Stoics were into creating Tranquility. Since life is full of events that are out of our control, either before and definitely after they've happened, we're best off focusing on what we *can* control — which is our *response* to events. So rather than waste my precious time fretting about some other life I could have, I choose to love my life as it presents itself right here and right now.

So if you're single and feeling simper-ish — try a little attitude adjustment and re-contextualize. Sure, like almost anything of value in this world, independence takes work. So put in a little effort, then wake up in the morning and say hello to your delightful old self and learn to savor the sweetness of going solo.

ROCKETING THROUGH LA

What am I doing, rocketing down Washington Blvd at 10 pm? Just exiting a birthday party (for a man today turning 101) to which I was invited by a Berliner I just met at an art opening because I complimented his fedora. (Well, hell, it was really fine taupe felt and had a leather thong band cinched with a safety pin.)

Golly. I guess I'm having fun. I guess I'm doing what single women do when they open themselves to whatever life might present at any given moment, when they realize they have to hurl themselves into the mix, despite being fairly aware that the whole thing is rutting (notice I found another word for fucking?) random.

The rain (is it really rain?) is falling in LA, even on Washington Blvd, that hell-forsaken wanna-be four lane highway transecting a commercially induced void. The 'boulevard' is slick with it, bursting with the green and red of it like Christmas only it's such a Jewish town or is it a Buddhist town? But then it *is* also Christian-ish with the huge Hispanic population, the Korean, and Russian, and, well, not so many of the unlapsed Anglo Catholics and Protestants. Regardless, it's a factory town built in the desert where people come and fabulate wildly, and fairly godlessly, in the hopes of netting the public's imagination for 14 bucks a pop.

And the Angelenos are dreaming tonight, more weirdly than ever; angling to satisfy an American hunger that has been distended and warped by the sicko charades of a national cast of self-appointed players — the military-industrial-media complex. But there is internecine warfare amongst the colluding teams. Who knows, maybe the media will win. And why not? Why not just make our political parties Fox vs. The New York Times? Change up the bloody players, man. (Then why don't we just go interview people on the street with the following question: "If you could choose any position in government, what would it be?" Then give them the job and televise what happens next; turn it into a

reality tv show. Oh wait, we just did that in 2016.)

But it's raining! And I feel how much I've missed it. The washing away of our sins. The sheer intoxication of water being gulped by every living thing. It's a mass satiation event. We will not go extinct! We will not go extinct IF we stand up on our rear legs and holler.

Rain, Oh Rain. Now home, I look out the window and see that strange, lonely old boy walking up to the house across the street that he inherited when his parents both died two years ago. Ever since I've lived here he has sported the same ratty little pony tail and dressed in faded black, a has-been Punk who had a job as a sound engineer somewhere, at least that's what his dear old Dad said. It was Jerry who I met first. He was adorable, always in his ancient, patterned ski sweaters, and he gave me blooms from his meager front garden. Jerry, the successful 88 year-old studio violinist with his incapacitated wife lying in bed… It was Jerry who told me about his disappointing son Robin. We had some nice chats about the other neighbors, concurring as to who was odd and who was not, but then he died. Poor pimpled Robin, to whom I wanted to extend my sympathies after their deaths, revealed memory banks jammed with Bad Dad stories, and Bad Mum too, but he did get a prime piece of LA real estate.

Now he's at the entrance, still not great at opening the triple-locked front door; he had always lived over the garage. He's stooped as hell, probably younger than me but doesn't look it. I wonder, did Robin ever inspire desire in anyone? I think about desire, about how it is heightened by obstacles, yet feeds on the hope of surmounting them. But some obstacles defeat desire, perhaps aging is one of them — sliding downhill in a rusty old hulk with the brakes shot. Ah, such are the thoughts that arise in the solitude of a dark rainy night in LA. Now melancholy, I wonder if that is true, wonder if I myself will ever experience desire again. "Shit." I shake myself and head to my desk to write.

I'M A BAD GIRL

A guy friend asked me if I had included something about heartbreak in this book. I hadn't thought about it, actually. Partly because this was not originally meant to be a memoir, but also I guess because, and I'm sorry to say this, the obvious heartbreak in my world has come from me. I'm the heartbreaker. I'm a bad, bad girl. Maybe not as criminal as Fiona Apple (bless her genius, confessional heart) but bad enough.

Or at least that's how it looks from the outside. However, allow me my defense. Because I need to deconstruct this thing. So the word 'heartbreak', to my friend, meant *romantic loss;* he was assuming this was a book for chicks, who in his world like to read about such stuff more than guys, even though guys get hit just as hard. And this is how the noun is most often applied — to a heart trampled by a lover's rejection. Which is different than *heartbreaking* — which relates to more devastating affairs, like sudden death, or the crushing of someone's aspirations, or even a nation's response to a grand loss of stature.

Then also, using the words separately, 'broke my heart' can refer to moments when the look on a child's face, realizing his father has left for good, spelled it all out. I also wonder if Hillary Clinton felt her heart break the night she lost the election. I know I would have. And then we have the recent story of Debbie Reynolds dying of a broken heart when her daughter Carrie Fisher died. Whatever else one thought about Debbie, this fact is incontrovertible proof of love. I know the same would happen to me if anything happened to my own daughter.

But back to the foremost sense of heartbreak, which is when that big juicy Valentine's Day heart, pumping in the clouds, is accompanied by a noisy ripping sound as it's rent in half by a bolt of lightning. That precise moment has never happened to me. Yes, there were the moments when I realized that a fledgling relationship would never emerge from my foggy hopes for it. But those moments mostly just evinced a sigh, in part because this was obviously its destiny from the start, and

because I hadn't bothered to focus sharply enough on that fact to pull back from something which had developed as much from good sex, laziness, and the convenience of always having a date, than from any sense of a soul merge.

So I am guilty of causing heartbreak. Which makes me a Bad Girl. But my defense is that the attendant awareness that I caused anyone pain, while not exactly heartbreak, is soul-ache. The times I chose to end a relationship caused me months of angst and grief. It is not only the heartbroken that suffer, believe me. The sense of loss of a deep relationship, no matter how flawed, is as real for the 'breaker' as for the 'broken'. And the moment when the words of finality are uttered wreaks just as much sadness. So maybe in fact it is a heartbreaking moment. You desperately want to spare your lover the pain, but you realize, when it comes down to it — it's Them or Me. Pretty basic emotion, yielding a decision you may doubt for the rest of your life.

What becomes evident is that there is an apparent dichotomy of the 'agent' and the 'victim'. Let's consider the victim position: if one's lover radiates malaise and unhappiness, and a sort of psychic barrier to intimacy, is that a desirable state of affairs? One can hang on in the hopes it will change, which is indeed another sort of victim position. Hoping is a state of mind, but to me not an active principle. So instead, one might struggle to analyze what's gone wrong, and attempt to change the situation, which has the benefit of giving one agent-hood. But when it becomes clear that nothing one can do will alter the course of things, you will actually suffer heartbreak, but you will also finally find a sense of relief. Release from the struggle. Acceptance that something had reached its final chapter. Liberation. And ideally a desire to move on, to regain your autonomy.

But despite this sense of 'agency' there may be a lasting effect for the 'heartbroken' member of the duo. Although they say that all is fair in love and war, I don't actually believe that. Because if you weren't the one to 'pull the plug,' you might wind up feeling like the other party

somehow cheated, somehow robbed you of the chance to make that fatal blow yourself. And, you can then console yourself with having tried harder than the other, for being more valiant in love. That is if you actually had been and were not just hanging in out of complacency… Oh, the complexity is infinite.

The real difference in the moment of heartbreak is that the heart-breaker has arrived at their conclusion a while earlier, maybe even years earlier, and has been suffering with a sense of impending doom all along. Obviously this doesn't apply to those whose hearts are impermeable, those sadly damaged souls who dismiss relationships for all the wrong reasons and are constitutionally incapable of a reciprocal relationship… that's a different situation from those I found myself in. Because in both my breaks-ups, I fought like hell to avert their demise. Couples therapy didn't work. Attempts to buoy sinking egos didn't either. There are lim-its to our abilities to manufacture the strength to sustain love.

"Love never dies a natural death. It dies because we don't know how to replenish its source. It dies of blindness and errors and betrayals. It dies of illness and wounds; it dies of weariness, of witherings, of tarnishings."
— Anais Nin

But then again, maybe I'm just one of those people who was not designed for lasting love. Maybe I'm too shallow, too egotistical, too uncompromising, too inept at choosing partners; or maybe I'm just a love junkie, craving the adrenaline, the oxytocin flaring in the blood of new lovers. Maybe I'm too juvenile to understand that romantic love is but a moment in time, like the striking of a match whose higher pur-pose is to light a candle and illuminate a larger field in which a lover is only a reflection of the true object, which is love itself.

Yet I do hope there is hope for me (a fitting tautology). However, as I said before, I consider hope a sort of solipsistic and passive state of being, at least when it comes to love. Hope seems like a cat looking

out a window — hoping the bird will come to the sill. And even if that happens, if you, the cat, haven't gotten out of the house, you'll never grasp it anyhow. But I guess if the cat didn't hope (which most likely includes her being let out into the garden) she would wind up lying around on the couch watching the tube for kicks instead, which must be the reason we all have hope — to keep us off the couch.

CONFESSIONS?

*Love — it's a pang, it's a potshot, it's a pathogen hidden in our genes —
one we cannot fight. It's a pain in the ass, a parallel universe, a pantheistic
paean to our urge to procreate, to prosper, and to pre-empt death. And
who should monitor our passions but putti, puttane, and poltergeists.*

So, the title promised confessions. Where is the juice, you wonder?
Who gives a damn about all this other verbiage if there is no trace of
passion indulged, spent, lost, no trace of sanity forfeited for it? Given
that I've got that novel about my early thirties in Manhattan, I thought
I could excuse myself and leave all the romantic intrigue aside, in favor
of my intellectual life, my 'argument'. But then I realized I've left out
a surgeon's view of the beating heart of the matter — my apparent ad-
diction to passion.

Gravity is killing me. I am too here.
I want
The hurt of your leaving lips.
Existence running through me let me devour you.
I am weird for you, I implode.
I...collapsar, black, holy.

Now, on the other side,
Gravity neutered,
Acid blue is shooting
Straight from my core.

And I confess this first: I'm actually a fairly private person when
it comes to emotions. Basic WASP reserve? Something to do with my
astrological chart? Not that I believe the stars reflect our true natures,
but there are some puzzling accuracies. Only one of which is that my

moon (ruler of one's innermost self) is in Cancer, a sign given to deep emotions and the tendency to hide them, and whose iconic form is the crab — a scuttling creature, shelled but always seeking shadow. Perhaps I don't reveal the history of my heart, because it perplexes me and brings me sadness. All that 'falling', and all that falling straight through.

Isn't it strange that the verb we choose is fall when we talk about love? Maybe that's what we really look for, the feeling of falling, of surrendering to gravity, of releasing our grip. The object is then the pretext, the figment we use to rationalize our Desire for Oblivion, our flight from Self...

Yes, I've known many men and fallen for many men. From the handsome cowboy who put me on his horse at the county fair when I was 4, to William, the wild boy who deflowered me at 16 and who I married in defiance of my father who, of course, was my first love. There were men after my divorce at 21, nearly a decade of them... dalliances mostly, with wicked young men and charming grown men. There were men who were too serious, too frivolous, too heavy, too lightweight, too stolid, too amorphous, too controlling, too hands off. Like Goldilocks, I kept trying the different beds. And here I am now, in Baby Bear's bed, my own...

So yes, there is an involuntary ellipsis of those crushes, those affairs, those interludes. And yet they haunt me, their wraiths slipping through my thoughts, staining them a bruised violet, loitering in the tender lacunae in my psyche.

※

When I finally decided to include some fragments about my life in love and lust, five men came to mind. But then others came winging out of the mist. (This was in the afterglow of the 'sexual revolution' after all.) There was a poet, a journalist, a sly lapsed catholic with a big taste for drugs, an heir, and an investment banker (both of whom wanted to

marry me), a writer, a conceptual artist, and for a while, until I decided I would not enter into groupie territory, Mick Jagger. Some of these will not make it into my novel, so herein I exhume them from my past.

<center>❈</center>

I knew William was trouble; that's what I loved about him. I was sixteen and he a year older. He had a mop of wavy ash-blond hair, a square jaw, a smile that curled like the Cheshire cat's and he drove fast in his shiny British Racing Green Mustang. He threw open the crypt of Dostoevsky and Sartre, the marvelous void of Existentialism, and pulled me into it. For months he argued, in long missives, for me to yield my virginity to him. To him, it was the proof of love, the full expression of it. And as I still possess those letters, epistles of unsullied lust and yearning, I know that I summoned every defense I could. I even quoted the pathetic nostrums of advice columnists. "How much greater the pleasure will be if one waits for marriage." Etc. Etc. I thank William that they didn't work. For from the very first time we made love, and it was truly making love, I knew sexual bliss. I opened like a blossom in a time-lapse film, and the weight of the honeybee that landed on my petals, even as he took my pollen, bestowed meaning upon the very pinkness at the center of me.

Of course there was the added intensity of having to dissimulate, concealing from my parents my newly de-virginated status.

The pleasure that comes of exercising a power that questions, monitors, watches, spies, searches out, palpates, brings to light and on the other hand the pleasure that kindles at having to evade this power, flee from it, fool it, or travesty it. Capture and seduction, confrontation and mutual reinforcement — these attractions, these evasions, these circular enticements, have traced around bodies not boundaries not to be crossed but perpetual spirals of power and pleasure. — Michel Foucault

It was an ongoing evasion that wound up being exposed one day in New York, when a clueless executive walked in on us making love in an apartment owned by the company my Dad worked for. The upside of the discovery was that I was sent off to get birth control pills. The downside was that my parents watched me like a hawk nonetheless. They too could see that William was trouble.

※

There was young Henry, the innocent, I dated for a year. 21 to my 31, he was tender, thoughtful, tall and willowy yet with baby fat still clinging to his rosy cheeks. He introduced me to the downtown music scene, the Mud Club, Max's Kansas City, CBGB's. I fell in love with Johnny Rotten and Sid Vicious; they were exuberant, foul and alive. I wandered around in old corduroy jodhpurs, a Nietzsche sweatshirt, and a vintage pillbox hat made of deep violet feathers. We hung out in his tiny lower East Side apartment, with the neighbors yelling down the hall, and played records, loud. He took me to meet his mother. Clearly he was slumming in New York as he came from upscale Pittsburgh. Warhol's roots in another echelon of Pburg may have led to his job at Andy's fabulous magazine, Interview. He also took me to a cousin's working ranch in Montana where we rode horses and ate a lot of beef and I recorded streams running through the property and brought home a horse skull with a bullet through its forehead. I also saw my first (and not my last) fireballs as we rode one evening down into a valley and three enormous, lime green fireballs cruised over our heads, following the contours of the valley down and then up over the next hill. Not one fireball but three. It was magical. I will always thank Henry for those days, although, alas, he won't answer any of my comments on his Instagram feed.

That is probably because he felt betrayed, when Jagger came onto the scene. What was so odd and compelling about the arrival of this interloper was that I'd had a premonitory dream about it a few weeks

earlier. In the dream, Henry and I were making love in a beautiful bedroom when in walked Jagger, who simply stood by the door watching us. Suffice it to say, when I met him a few weeks later, I was shocked, then slowly realized what the dream was about.

<div align="center">✖</div>

Then there was Jonathan, who I literally ran into one day diving into the subway station in Soho. I was late for work at a tiny uptown PR firm, my hair was wet (I never bothered to dry it) and I was probably dressed in my faded mauve mechanic's jumpsuit and the white Danish boots I had blown a weeks' salary on. He immediately invited me to dinner.

Jonathan merged and acquired, companies that is, for Banker's Trust. He had a burgeoning art collection in his Soho loft — artists like Rauschenberg, early American works, and a lot of very impressive African masks. I believe he saw his collection more as investment, or some sort of prestige branding. But he was ardent toward me, found me very amusing, and I love to amuse. He also let me stay in his loft when he travelled, a lovely respite from the maid's room, painted urine yellow, which I rented in an old mansion on upper Fifth Avenue.

After a few months, he took me to the Plaza for dinner one night and asked me to marry him. I was actually shocked. I enjoyed his adulation but he was probably 10 years older than me and seemed from another generation altogether, in fact seemed downright ancient. The fact that he was wealthy was in no way an inducement; money meant little to me then. Also, he knew nothing about contemporary music, which was a serious issue. Really he was just too proper and I guess his looks were too far afield of the handsome boys I usually went with. He had an interesting face, but it was badly pockmarked and almost always bore a grave expression, at least until I made him laugh. Ultimately our sexual proclivities didn't quite mesh. But we remained friends and he even took me to Vienna and London, with no sexual demands made whatsoever (my pre-requisite to joining him).

✖

Then along came Arkady, a Croatian physicist who took my breath away. Eyes like vast pools of molten chocolate, a long lanky body seemingly made of rubber, a goofy resonant laugh, and a tongue eager as a puppy's. Working in Princeton at the Niels Bohr Institute for Advanced Study, Arkady was a specialist in Chaos Theory, and he wrote magnificent, surreal letters to me. I reminded him, he said, of the little boy in Bergman's Wild Strawberries, and that little boy, who curled himself around the shoulders of Viktor Sjostrom, reminded him of a little lizard. So my nickname became Lizard and his became Arkady, a link for me to Arcadia. Many saurian puns abounded as he cooed to me with his lilting Croatian accent. We came so close to — what, I don't know, really becoming a couple, marrying? I don't remember now. But there was a drawback — his insistence on an open relationship. Gamely, I did try to share him once, under a big duvet with his sometime lover, a dark and demanding dancer. But it left me feeling emotionally adrift and, though I tried to muster the courage to forfeit ego, sadly I let him go. Besides, there was another contender in the ring. The man I would finally marry… but that's another chapter of another book.

✖

Lovers became excuses for exuding poetry. There was one particular man, a man who was still a boy, a boy with raven black hair, honey-colored eyes, blue-white skin and a slack jaw that begged to be nuzzled. A man who moved like a girl, slow of motion, curvilinear in gesture, a girl willing to be taken. Jules quivered when I touched him, and melted into me. He didn't mention his girlfriend until it was too late. Although I finally decided his interest in drugs was not purely recreational, I do remember one lovely Easter when we took psilocybin and I painted lavender and mint green warrior stripes on our faces before we set off for a picnic in Central Park.

"Radiating with an inner warmth"
I yelled for all to know.
Please unzip quick this uniform
Because my hands are sealed against my ears. I must learn to hear
with my guts.
In a half nelson that lasted the entire night,
Genitals became mouths and tongues
And osmosis occurred rampantly.
His eyes grew enormous and jumped off his face onto mine.

But these affairs were long ago, and this is just a slice of a time when the goal was the high, the rush, the exaltation, when I was nowhere near ready for true partnership, and still didn't believe in my own mortality.

I look at my parents' life together, and that of my two brothers, both married for years, and wonder how I evolved so differently. Again, that channeling of a mother who chafed at her domesticity, who must have yearned at times to be free? Or was it just a matter of Nature (ever unfurling in her endless process of diversification) performing a spontaneous mutation with me, creating me as a 'sport', an organism that differs substantially from the basic stock or species? Sometimes it actually feels that way.

I muse, though rarely, about what might have happened if I'd stayed with any of them, especially if I'd stayed beyond the seventeen years I spent with the father of my daughter, or the eleven I stayed with the man who came after. What life might I have led in those parallel universes? Would I be happier now, still mated? I believe I would not have been, although of course I would have been a very different person and would have found some sort of happiness. But the path I have chosen has led me to a richer, stouter, wider, wilder sense of self than I could even have imagined back then.

This is the monstrosity in love, lady — that the will is infinite and the execution confined: that the desire is boundless and the act a slave to limit.
— Shakespeare, Troilus and Cressida

But this monstrosity does not affect art. Because in art, the execution is not dependent on a lover, or rarely. In art, one channels desire into an act of the imagination, an act of creation. The energy to produce art is boundless, and it is that which breaks the chains of the slave.

ELEPHANTS AND BAGGAGE

The Elephant in the Room, when you go on a date somewhere north-ward of your fifties, is a big ol' fella pulling a shitload of baggage. That elephant was still in the jungle when you were younger. And you were in a loincloth and bustier swinging on a vine hollering for love.

You look at that sunny face on OK Cupid and say, "Hey Cupid, man, let's shoot an arrow at this one." Cut to the date: their stories of exes and their contingent resentments, the debt and damage left in the wake of divorce; stories of children grown and not grown, maybe successful, maybe screwed up by your divorce; complaints about ancient parents, ghosts of flattened dreams, and the goddamned age factor with its stunning diversity of maladies. Slowly the image, after a date or two, pixelates; the happy face dissolves and the show's over.

One guy's OK Cupid profile linked to his Facebook page which featured a picture of his ex-wife with the caption, "Still in love with you." Another's featured images of him with women on either side, but their eyes had been scratched out. As if to say what? That they were no longer in the picture? But there they were, just eyeless. And I'm sure they didn't see that coming.

Another bloke I met for drinks had been dumped by his celebrity yogini wife (when she fell for a big-time celebrity yogi) yet the guy still lived in the same small town where she lived and where she was still a minor celebrity. Maybe it was a pissing match, or maybe he truly didn't care. I didn't want to stick around to find out.

Then there's the guy who warns me that he brings his young daughter everywhere. He's 73 and she's 12. I'm cool with that; our first date was at the Brewery Art Walk in downtown L.A. But his second date idea was him coming over to give me a massage and 'munch my minge'. Okay, I admit to being currently offline in the sexual arena, and for way

too long, but that's a tad, like, *forward,* no? And I also confess to having to look up that word, since I sort of assumed he meant that but had to do a vulgarity check anyhow. Hey, you're my lover of a few months, and you're lolling around in bed in silk pajamas then suddenly turn to me and say, "Maybe your minge could use a tickle?" I'm down with that. I ain't no prude. So ciao, grandpa.

Then there's a corral full of guys who've never been hitched. There are always reasonable explanations, like — she wasn't ready, then by the time she was, he wasn't, or the long-distance romances that went on a little too long. But there's always doubt about these sorts — like what is it about him that led him to skip off the normal path? But then, what is normal anyhow? And really, this cannot be a deal-breaker these days, since the deals are not arriving hot and heavy.

Of course it's all a case of relative desperation or the relativity of standards. And there is a big scale on one side of which is a bag full of (no, not elephant-in-the-room-shit) the sweet joys of single life and on the other, a bag full of... is it 'joys' or is it simply 'plusses' of the partnered life? Dear Heavens, am I auto-selecting as a 'spinster'? Ah, that word... maybe I'll re-coin that term to be One Who Spins Her Own Fate, with all the modern-day connotations of the word. (The spin doctor is in, and she's in a good mood.)

Moments like this, I must resort to prose-poetry or graphic poetry or, fuck it, something less matter-of-fact than everyday prose.

Suddenly I'm immersed in a pool of men.
They've emerged,
nearly in unison,
a la Esther Williams.
Wannabe players
who missed their moment,
like me...
All trying to find another.

Each one presents himself, a daft bouquet.
A bit half-assed, drooping, due to low expectations.
And we're all trudging about, into and out of these ersatz
assignations, with the cleaving feeling that it's hopeless.
Or at least I do.
Maybe those guys — maybe they live in a blissful state of denial.

Anyhow — how will I even know the One?
Will he bear stigmata?
Simply pump out the right pheromones?
Or will it take months of testing?
And who has time to commit to that?

How can one trust one's senses, so errant to date?
How do I know when one little factor —
simply a smoky baritone,
or the sudden bemused gaze he gives me —
could be one of those hooks my shrink talks of?
That make you drop your defenses,
drop your panties and
forget about those other TEN qualities he doesn't possess,
those needs you've declaimed, that you've whittled down
from a massive list of wants. Those little hooks that, were you
in your right mind, and not bursting with oxytocin, would set
your little hound barking?

How will I know The One?
But really,
why would I assume there *is* a One?

(Because One is your Teddy bear.
One is your Pussy.

One is your Mother.
Or your Daddy.
One is possibly your Self.
No actually not.
Your Self is a Multitude!

One is what you think you can create,
If only you can find that other One,
And, like, do a soul merge with them.

Ha!!!
Didn't you do that already? And then what happened?

IT'S A MYSTERY

Not to oversell my value here, but it really is a mystery to me why I'm alone after almost five years of being single. I mean, I totally dig my life, but it seems very weird that there's nobody out there for me, nobody that would get me, want me and inspire me to want back. Nobody that would seize my attention, surprise me, and obviate my search. Well, hell, two giant black holes collided a billion years ago and sent so many wild and different gravitational waves into the universe, I guess that could be a reason.

Not that I'm giving up. It's just in LA nobody seems to see me as I see myself — a ready to rock-and-roll play-pal. I mean, I certainly dress the part. But that's a downside of life here — you can basically rule out randomly meeting some cool cat on the street. Yes, I could move to a hipper hood, but those are predominated by millennials and young marrieds. (And oh yes, New York hovers over me like a beckoning apparition…) But even if one does encounter guys on the street, one can't just stop them and say, "I don't suppose you're single, are you?" I told my daughter I was thinking of doing this and she said "Mom, just do it!" But the few times I've tried (outside cafés or in museums), the guy plays along, loves the flirting, then casually mentions the inevitable "we" as in "we live in Chicago"…

So here I am with a radically active imagination, numerous talents, and an idiosyncratic wardrobe (curated through the decades), none of which, except when I travel or go to a gallery opening or visit friends, I have anywhere to exhibit.

Maybe I need to look at women a bit more earnestly. Or differently. Because really, the most happening folks in my age range seem to be female. And hey, maybe that woman over there would make a great partner? I remember meeting a few women along the way that elicited a more than platonic interest in me, but what's a longtime straight girl to do? I wouldn't know how to come on to a woman without feeling like a

predator. I mean, you can flirt with a guy... get sort of girly and playful. But with a woman? No clue how that's done because an admittedly obsolete question comes to mind: *do I want a girl or want to be a girl?* And what if it's both? I am clearly clueless.

And also quite lazy. I have to drag myself over to my OK Cupid account and once there quickly became exasperated. Just now I have threaded through 300 questions on Elite Singles, not to mention burned through $132 for a six-month ride. And here we go again; the first guys I see are non-starters. One says he's thankful for 'salvation', another's photo is him sitting inside a tiny cabin cruiser with his Mac open. Yet another posts a blurry photo of himself, then a bunch more of his shrimpy little dog and some sunsets. Mostly guys just send 'smiles', which hold as much weight as a passing glance. Or when I see a guy with even an ounce of potential and write him a full two sentences to open dialog, I never hear back. Do they believe themselves too cool for me? Is it that I posted my *real* age and, because they're so cool, they only cruise younger chicks? Fuck 'em. But then, maybe I come off as too self-confident, too cool for school myself? I don't think so; at the behest of my shrink, I groomed my profile thoughtfully. Well, there is one photo where I do look like a smarty pants…

But damn! That's me. And if they're not down with that, like I said, Fuck 'em! Yes, this all seems truly hypocritical given my bumptious stance about being single but, once again, allow me a little cognitive dissonance. Like I keep asserting, I'm groovy running solo, but I *am* a creature with great reservoirs of affection, hardly tapped except by friends and my wonderful child. I have so much more to spare. So if you're out there ~ Hello Darling, whatever gender you may be… I'm here, with the energy of an adolescent, a mind like an infinite toy chest, and I'm ready to play.

EROS AT 60

Well, I know one thing for sure. There's no reason to give up one's single status (if one has worked hard to make it one's own) for shacking up with just anyone. This attitude, however, can leave you with certain animal needs unmet. Woefully unmet.

Sure, those resolutely wanton* post-hippies will tell you to just take a roll in the frikkin' hay. But they don't get it. Time is so damned precious at this stage of the game, why would I waste it by taking what could potentially be a late night wrong turn down an empty midwestern farm road (like in half the teen horror flicks you've ever seen)? First of all, I don't want to mingle body parts, much less linger in bed with someone who doesn't totally fascinate me. And secondly, a meeting of the groins soon becomes a psychic contract — and who keeps it, who breaks it? All that can become as tedious to negotiate as a legal document. Maybe I'm presumptuous in claiming that I'm actually more concerned about hurting someone than being hurt.

But there's something else: the very concept of desire, hot-blooded, irrational desire, seems at this age to have become a sort of a chimera, a hangover from the good old days, a memory now sadly warping. Egad, that sounds goddamned harsh. And look, I really, really want to believe that it's not true. But there is nothing, to date, that seems to refute that sentence for me. Maybe it was always a fantasy, that lurid movie poster moment of fire-breathing intoxication, maybe it was just the *idea* of it that ever made it happen, made it real in the first place? Or maybe not. The road to sexual delight is a circuitous, hazardous one, that I do know. It took me years to arrive at my personal Shangri-La, and for chrissakes I actually managed to hang out there for a decade until some shadow, some phantasmal reality seeped into the palace. I think it was actually the chill rush of time passing, and a glimpse of the future where life in bed would not suffice for the deeper needs of the self. The bliss of the Shiny Magical Present suddenly looked weirdly sepia-toned, as if

Deep Throat was being watched on an antique projector by the shade of Anaîs Nin.

But I must remind myself (especially at this age) that in sex, the real Mistress of Ceremonies is The Mind. All else is just mechanics, just stagecraft: sweat... scent... a body arching underneath you... pillowy lips tracing the contours of your body... firm muscles rippling under your hands... soft skin rising to meet your touch, yielding all to you... Damn, I digress! And damn it, of course beautiful bodies are key players in the script of desire, but this here is a low-budget production, so we cast the best actors available. We soften the focus, dim the lights, amp up the Barry White. *Wait, can't we get Jeremy Irons?*

Yes, where *is* my aging Lothario? Where is that well-travelled miscreant who is my perfect match? Match.com hasn't turned him up, nor has OKCupid or JDate. Of course I know I'm a brat and way too snooty. The evolutionary point of such selectivity, if it ever had one, has far passed its due date, and yet old habits die hard. A wonderful man once said to me, in a cab in Kuala Lumpur, that for me there would be no man who could rise to the stature of my own dear Daddy. Perhaps true, but I'm trying. All I need is a fast thinker, goddamnit, fast and playful and if he *could* think fast enough I'm sure he could fast-talk my pants off.

Yes, she said wearily, the fact that vibrators come in so many shapes, colors and speeds, is a cause for celebration and gratitude. But after too much down time from the real thing, there comes a point where even quality time with one's dildo becomes an entry on a to-do list, a nod to one's general health rather than a craving for release. Of course release can come in higher, more achievable forms. Buddhists promote this notion, as do Stoics. And I can totally grok that. I would, however, liked to have arrived there by choice, not dragged there by the short hairs.

But life is a work in progress, I remind myself. So breathe out. Breathe in. Take a toke. Stroke your dog. Eat a few bonbons and rediscover the bliss of simply living. So if Mr. Right never comes around the

corner, you've always got that. And really, the bottom line is that just plain being alive is goddamned sexy. Guess I better get out that dildo after all.

 * **Wanton** - 1) (of a cruel or violent action) deliberate and unprovoked. 2) one who is ill-behaved, especially (but not originally) a lascivious, lewd person, c.1400, 3) being without check or limitation, from *wan-towen* c.1300, "resistant to control; willful," from Middle English prefix *wan-* "wanting, lacking" + *togen*, pp. of *teon* "to train, discipline;" The basic notion perhaps is "ill-bred, poorly brought up."

 As Flies to wanton Boyes are we to th' Gods, They kill us for their sport.
— Shakespeare, King Lear

 Her cheeks burned as she recalled how forward she had been, how wanton. But then she grinned, thinking, "Why should I be contrite? I wouldn't be if I were a man!"

AMBIVALENT ADVICE

for People with Long-Term Significant Others

Myself, already noted as a risky personage for partnerships, has this to say to those who have them and are questioning them: don't leave them, at least not yet. Despite my self-imposed embargo on advice and my plaudits to the single life, I exhort you to consider:

1) The alternative. (And this requires much internal and external analysis.)
2) How grand it is to have someone who *knows* you, who ideally by now *accepts* you, or at the very least who has ostensibly *tried* to understand you... who may, yes, *annoy* the hell out of you BUT who has redeeming qualities.
(If none of the above applies, feel free to ignore the rest of this.)

> He doesn't dance? Go party with friends who do.
> She doesn't read? Join a book club.
> He's clingy? She's remote? Return the behavior and see what happens.

What, you may ask, about the undeniable lure of titillation from external sources? Okay. There is that. So participate in it together. Go to a sex club, for chrissakes. Watch porn together. Or write porn together. Or make porn together — which will be good for a laugh. Just get dirty, or at least try it.

What I'm trying to convey is that it's all in your hands, kiddo. The decisions you may be weighing could be based on fantasies, misconceptions, and ancient resentments. Air them all. See if any are real. Sure, you will find that some *are* real.

Intransigent narcissists who insist on playing you for their Mothers (who happen to have borderline personality disorder) do exist. Mates who don't even try do exist. Men who hit do exist. Women who only marry for money do exist. So do women who will always compare you

to their perfect Daddy. Mismatches never fully acknowledged due to the emergence of offspring do exist. Illusions, grandiose expectations, and vast gulfs between life philosophies do exist. Some of these issues *are* deal breakers. And of course, partners do get tangled in extra-marital affairs. But even the missteps those present can lead to renewed passion. It's at least worth giving it a try.

> But I wouldn't know.
> Because I'm not one of the ones who stayed.
> Hey, maybe you're a risk taker like me.
> So head out on your 'vision quest'. See what you're made of.
> You may be surprised to find that the stuff you're made of ain't all that substantial.
> Yeah, despite ancillary benefits, such moves are major risks.

And if you're looking to find another match, this time (possibly! really!) made in heaven, remember the sea may still have a few fish, but they're now mostly jellyfish and they're not actually edible. You will wind up online wading through floods of them, and in their wake swirls the emotional detritus of their former relationships, chunks of their non-biodegradable neuroses and traumas, destined to float forth like discarded beach toys or used condoms. And perhaps you too are amongst the flotsam, the jetsam, the damaged.

But I hardly think so. Because maybe you find you *were* built for solitude. And thus you must rejoice. And saunter off, dear Childe, to a realm of your own devising. For that is both your penalty and your victory, your purgatory and your transcendence.

Like I said, ambivalent advice.

A GUY NAMED THOMAS

I met Thomas a few years ago. Very public setting. Clear attraction. We emailed each other, we called, finally we had dinner. We kissed, he left town. He flew me to a city that will remain unnamed. We kissed, we fucked. He flew me to a city in Malaysia. We fucked. He flew me to London, to Rome, to Amsterdam. We sometimes fucked. But mostly we chatted endlessly and ate terribly well.

Then one day he came to Los Angeles, apparently to live. This prospect was daunting; did I want to have a full-time boyfriend? I was unsure, yet excited. We had a few nice meals out, non-stop conversation, just like always. But after each, though I was clearly expectant, all I got was a tiny bird peck on the lips.

Then we took a day trip, before which I resolved to get to the bottom of the mysterious lack of physical engagement. Abruptly, on the road, I asked "So what's going on with us?"

His reply was casual, "We just have to start over again." Ah, I thought, I guess he's right. (I hadn't actually seen him, despite numerous Skype calls, for over a year. He was living mostly abroad or, when in the States, was entangled in business in another state 24/7.)

I came back from the day trip feeling happy, on the one hand, that there appeared to be no obstacles to our relationship, but still feeling a hovering sense of doubt. Yes, it had been a thoroughly gray day and it had been raining now for some days, which is, for an Angeleno, ever-so-slightly discomfiting. We're not used to gray, day-in and day-out. Gray makes us blue.

But I realized it was much more than that, as I tried to decipher the slow-motion turbulence occurring somewhere near my heart. On the one hand, his remark seemed to produce a sense of possibility, but on the other it seemed to imply *duration* (consider that word, and the fact that in French dur means hard), a period devoted to 'getting to know each other again'. I wish I had said, "But we don't really. We know each other fairly well by now."

But I didn't, because I realized the man is deliberate about everything, the way he applies himself to his work, the way he eats, even the way he makes love. I don't move slowly. Never have, and by this stage in the game, never will. I don't wait. I forge ahead, I surge forward, I leap — usually without looking below.

But really… why does everything have to take so long? On my dying day, I know I'll be asking the opposite question — "Why did it have to go so fast?" But not now, because now everything takes too long and I never have enough time. No time to wait, to take it easy. Life is a stream moving swiftly. I stand sturdily in that stream now, but one day I will weaken and be washed away, downstream. Not that any of this will matter then. I will be generously absorbed into the sea and merged with all the other creatures who have ever lived and I will be consoled.

But today? The wet gray has seeped into my psyche, staining it blue, a dank umbery blue. And all the yellow fire blazing in me is dampened and now rises as a green smoke which burns my eyes 'til tears splash out, all over my oh-so-solitary self.

When I was younger, I would have waxed petulant. Would have pouted and stalked off. Nobody asks me to wait, I would have said. But now that I see how few men come close to surprising me, to delighting me, I realize I must linger, must pause, must be patient, must endure a bit of penumbra, hopefully to rediscover the light…

In the warm sea of experience we blob around like plankton, we love, absorb or hate, avoid each other or are avoided or are absorbed, devoured and devouring. Yet we are no more free than the cells in a plant or microbes in a drop of water but are all held firmly in tension by the pull of the future and the tug of the past. — Cyril Connolly

THOMAS PART II:
THE UNAVAILABLE

Still nothing more than silly end-of-the-night kisses from Thomas. Here's what I really want to say to him but am too reluctant to bring up because I don't want to look like a needy chick:

1) I want to know what your feelings are about me. At least I think I do.

2) I am a fundamentally joyful person, but somehow, since you've arrived, my expectations/hopes are seeming absurd and that absurdity is now interfering with my joy.

3) I'm trying to figure out your hesitancy about a next step — like romance, or just plain sex? Here are my postulates:
 A) You would rather be with a 19-year-old like your old friend Ray is. (Even though you're way too smart for that.)
 B) You're terrified because you actually do dig me.
 C) You think I'm too high maintenance.
 D) You say you want to be able to move with the seasons and you see me as someone who is 'too rooted' (which is probably as bogus an excuse as any).
 E) You really *are* a super-nerd who really *doesn't* need anyone… but then you did say that you "want to *fall in love.*"
 F) The fact that you actually said that to me would seem to indicate that I am not that someone, since you didn't look at me while you said it. But you do know you can't just make that stuff happen, right?
 (Why am I making excuses for you? Trying to interpret your semaphoric replies to my rare queries.)

4) I'm in a fish or cut bait sort of mood. I really want a lover, want to feel real love again. But I'm not catching that drift with you and my hook is sliding downstream.

5) I hate repressing my need to discuss this. It's totally not me to censor my emotions.

6) Okay. That's enough, right? Oh wait, one more thing… I'm this close to giving up on you. I don't have all the time in the world and anyhow, if we can't get any closer or more intimate, how the hell would I even know if it's really you I want? Like I say, I'm this close… Actually, now I'm there. Fuck Off, Thomas.

So I read this to my shrink, because I thought it was funny, but because it was accurate too. He warned me against actually communicating any of the above and then he asked me why I would put answers into Thomas's mouth. Damn… but that's why I pay him.

I suck at romance. I suppose I could consider the possibility that Thomas is really just as lame at this game as I am and that now, our being in our sixties, we're worse at it than ever before. Do we both come into this circle, this bizarre pentangle chalked off by paranoid romanticists, like innocent novitiates? Are we more aware of what we don't want, than what we do? Have we been so burned that we're desensitized to all the places licked by flames? (And really those places number only two, more-or-less. Heart and groin. Oh right — and mind.)

But when it all boils down to it, the biggest burn I feel is the one where I die alone. Is that where fear and love conjoin in an untenable embrace? Is this all coming from my twitchy amygdala, core of my lizard brain? Surges of the survival mechanism? Yes, of course. How tiresome that damn reptile brain can be…

SOMETHING ABOUT ME AND MEN

A man is seldom ashamed of feeling that he cannot love a woman so well when he sees a certain greatness in her: nature having intended greatness for men. — T.S. Eliot

Certain men in my life, while cohabiting with me, chose to ignore the fact that I was in an ongoing and really, really excitable state of total efflorescence. Yes, they loved to fuck me, loved to eat my cooking, loved to tell me I was beautiful, and one of them even laughed at my jokes, but when it came to allowing me the pleasure of hearing their genuine appreciation of the work I did, the projects I had undertaken? Or even inquiring about what drove me, what I envisioned? Not in their toolkit. Unearthly quiet reigned. I got used to it. Stopped noticing it. Learned to fill it with my own self-aggrandizing babble.

On some level, both my major intimate relationships were hobbled by this issue and, as one would, I always attributed it to an ancient aspect of the male ego or to the default complaint of narcissism. I could also easily charge off on a diatribe about how the source of this reluctance to recognize the awesome in the female is the male fear of it. I would then soften the accusation, since millennia of civilization have reinforced for young men the notion that to be male is to want, need, and aspire to be great. And how can you be truly great if you're not greater than all the other creatures on Earth, especially those pesky, often searingly intelligent females of your species?

However, I recently had a discussion with my shrink, who took me on a tangent from this argument with his remarks that, even now, I seem to have a habit of zeroing in on men who are 'unavailable' in an emotional sense and that, when I got involved with guys like this, I was (in my words) replaying the same low-level trauma that I experienced

through my youth from a father who, while kindly and generous, never really paid much attention to me, much less understood me. And, while I was at it, was reprising a similar role in a similar minor tragedy with my mother. In short, I chose men who seemed likely to withhold recognition, just like Daddy, just like Mommy, because I'm hell bent to make them *yield* it like Daddy wouldn't or Mommy just plain couldn't. This is not a novel concept; I had often applied it to others but never made the connection in my own life.

One of the signature acts of my nineteenth year was to marry William, my crazy-assed, heartthrob lover, who was just a year older than me. This radical move was ostensibly undertaken in order to prove fealty to my ardent sweetheart, but in fact it was really an act of defiance toward my father, who assumed he could shock me out of living with the lad when I joined him at art school in Chicago. Dad bluntly stated that if I loved him so much, I should just marry him. At which I stuck out my jaw and said, "Then I will."

So Dad was happy enough to risk this gamble and marry me off to a boy who had 1) tried to commit suicide (albeit largely for effect), 2) treated grown-ups like Neanderthals, and 3) prided himself on being a known miscreant. Well that's a bit of an overstatement; William was a gorgeous, half-Jewish, half-Catholic atheist (looking like a serious contender for the role of a Nietzschean wunderkind if not an Ubermensch) who himself was happy enough to keep me dangling in the sticky web of his own identity crisis while deftly ignoring my writhing in the gossamer silk of my own.

Daddy, Daddy, look at me! Mommy, see what I made?

What I made that time was a massive mistake: the union lasted all of two unhappy years and poor William eventually expired at the age of 51 due to drug-related health issues; obviously he had suffered more than I. As for the ensuing major players in my life, they deserve

anonymity because, after all, it was I who selected them out of a cast of hopefuls, ostensibly in order to re-stage my Electra complex. They were handsome, intelligent and it seemed like a good idea at the time.

So how, at this advanced age, do I manage to foil this tendency in myself and actually find lasting love? Got me. If I haven't managed this in the forty-some years I've been in the game, how would I pull it off now? As one latently gynophobic (male) gynecologist once told me — *the only way not to get pregnant is to abstain*. But lust always rules and, being a diehard romantic, I lust for love.

My dear philosopher/shrink also tells me that one falls in love three times in life and that only the third one is the real one. Of course the first, if you're a woman, is your Daddy. Which, as I've blown through more than three loves already, kind of leaves me in the outfield staring at the trajectory of a winning home run hit as it flies into the hands of a teen so hopped up on hormones that he leaps five feet into the air to catch it.

Strangely, it was Thomas who told me he doubted that it would be possible for any man to replace my father. I don't recall talking about Dad much to him, so this struck me as a stab in the dark. But it sort of hit home. I idealized my father because he was handsome and athletic, charming and funny, dressed with casual finesse, took wonderful photographs, and gave us all what he thought we needed. Maybe nobody can replace my father; maybe nobody ever should. And maybe Thomas's remark was a wake-up call from someone altogether different.

The final twist on this tale is Thomas responding to an email I sent a month later while I was out of the country. I said, "I don't understand. There used to be a 'there' there, but now it has simply vanished." His reply was that, over the last year, he felt that it was I who dropped the ball. That I never responded to his requests that I visit. My response back was, "When did you ever extend a proper invite, like with dates, or…?" But at that point the dialogue just dwindled into the ether, with a closing thought from me that we start the starting-over process over

again, bearing in mind that no balls were intentionally dropped.

And yet, back in LA again, and despite the same great chatter we always produce, it seems that the emotional vacuum persists between us. My new missive to Thomas would commence thusly:

I do believe I'm going to stop trying to charm you, even engage you. God damnit, like I said — stop trying to charm you... in short, bother with you. You may call tomorrow morning or maybe you won't, but either way, I do believe that I don't believe that I give a shit.

It is tragic really, the amount of time and thought I blew on you. Or is it really comedic? But why bother to label? Those opposites flux so rapidly from one to the other. Maybe all along it was the pursuit of the unavailable and the fantasy of any sort of logical future when we're two radically different sorts. Yeah, looks like it's time for ol' Tigger to bounce, stripes all wiggling, just because they can...

DANIEL, THE EXCEPTION THAT PROVED THE RULE

There was an exception to the status quo of the past few years (the putative Rule of Choosing the Unavailable). Well there were a few other exceptions, actually, but not exceptional libidinally like this one. I will have to leave out the details to protect the innocent (myself) but suffice it to say I saw the man in a video (or rather I thought I saw him) as dreamy, not only for his languorous way, his perfect sweep of salt and pepper hair, his lovely square jaw, but also the topic of his discussion, one close to my heart. He was a PHD on the subject and in this video was working it well.

In fact, I had a professional interest in meeting the man, which legitimized my machinations to do so and, after nearly a year, we met. At one point in a long conversation, a videotaped interview, I actually reached out and playfully chucked him under the chin. A totally unconscious gesture that made us both giggle. Egad. Where did that come from, girl?

At any rate, it took another 24 hours before Daniel and I wound up at dinner, buzzing with lust, then in bed. That fast, that hot. Moonlight flooded his room and oxytocin, the hormone of bonding, flooded our veins. I had to tear myself away at the end of the evening. (Don't like sleeping with strangers, actually have a hard time sharing a bed for sleeping purposes with anyone these days, and don't like the morning after awkwardness.) Plans were made and off I went.

A weekend in LA transpired, lovey-dovey as hell, a swell mash-up of rising late, eating late, wandering like fools through town, down a beach and back again. Drifting but warm, close... Then another visit to LA planned, including my joining him at a wedding a few weeks later, but this second trip suddenly and oddly became so truncated, it wound up only a lunch date.

Stunned but curious, I went through with it and after lunch agreed to take a swim with him at the hotel pool, where I swam and he watched… I guess I qualify as an exhibitionist if, despite the circumstances, I found this mildly titillating. I emerged wet and sat in his lap, asked him what was going on, whereupon he said words etched in my mind as absurdly pop-psych. "Is it okay if we remain connected, but not enmeshed?" Enmeshed — a word I'd heard him use before, signaling a distasteful, dysfunctional version of love. "What makes you think that's what I want?" "Well, I'm just so focused on my business… I can't do a serious thing here."

Right, so we'll just have a quick fuck and off you go to the wedding you had originally invited me to. "Sure." I said. "Sure thing, but actually I've really got to get going…"

The story of that weekend wasn't quite over however. A friend of his had invited me to a party Daniel had mentioned he was attending as well. Since I had another friend going I decided WTF. How would he respond after all this? I dressed red-carpet-ish, in a sleeveless dress of hot yellow, black, and white cotton yarn knitted into a sheath and walked into the party where I spotted him in a chair chatting up a small circle of young people. (He had a very compelling narrative about scientific self-actualization.) It was a small living room; there was no way one wouldn't notice entrants, especially with the host greeting them, especially dressed like I was. But the dear fellow didn't raise his eyes. It was only after nearly an hour that he left his acolytes and joined the small group I was chatting with. "Oh, hello Daniel…" I gave him an indifferent, minuscule smile and continued chatting with the others, leaving the party a few minutes later.

Mission accomplished. Man confirmed as blackguard*. A week later my shrink talked me down from the toxic shock of it all by putting together some earlier data I'd shared with him about Daniel. Apparently this eminent scientist, with his brainy theories about rising above our unconscious drives and attaining transcendental status, had a case of

arrested development, locked in a sort of teenage Don Juan complex. The method was to seduce and then deflect, and if possible repeat, to keep getting that same rush of seduction, with the same woman. But not this one. Not this one... So, yet another pie-eyed vision of endless sweet sex crashes against the rocks of reality. Another fantasy partnership filed away under Nope. Excuse me while I lick my wounds then practice my rebel yell.

* **Blackguard** - scullion, kitchen knave. Perhaps once an actual military or guard unit; more likely originally a mock-military reference to scullions of noble households, of black-liveried personal guards, and of shoeblacks. By 1736, sense had emerged of "one of the criminal class." Hence the adjectival use (1784), "of low or worthless character."

His mother was a fishmonger, his father was a whore, and young Jack became a blackguard, picking pockets and nicking scented hankies from the ladies just for fun.

MY IDEAL PARTNER,
AN EXERCISE DEVISED
BY MY SHRINK

There are five categories to consider here, as you'll read below. Mind you this is the Ultimate Wish List, which will shortly and mercilessly be whittled down to a hardcore bottom line. Jeez, do I have to? Yes, if I want to get clear about what I really, really need. And by the way, don't try this at home. This is only one half of the process, the other half best handled by a capable therapist who can catch you on your innumerable tricks, feints and self-deceits.

Physical
Ah, the Physical, think I… given my experience to date, this is going to be a stumbling block. The handsome guys are usually psychically vacant or taken or into men or irredeemably narcissistic. But here goes. Here is the fantasy:

You know how to move. You like to move. You revel in your body.
You will dance with me, and nearly as crazily as I do.
Your eyes will fix me in their sight, contemplate me, make me a bit nervous.
Even if you don't swim, you will start to swim, so you can be subaqueous with me.

Tallish, athletic but not obsessively fit.
A bit of flesh. A bit of heft, but muscle tone. Energetic.
Strong legs. Boyish. Animal.
Your skin radiates health.

You have a good laugh, a ready smile, a good jaw line and
voluptuous lips.
A sense of style, but an easygoing one.
You enjoy wine, like to eat well, maybe even cook.
Your voice resonates, sets reverberations rippling in my chest.

Intellectual
Your ideas startle me. You have lots of them.
Your way with words surprises me. And mine surprises you.
We amuse each other effortlessly.
We provoke each other to examine our beliefs.
We tease each other a lot.
You're edgy, curious, like to debate, but don't have to win.
You have opinions but remain open to alternatives.
Politically more or less liberal, socially very liberal.
Libertarian could even work, if of the anarchic sort and not the
tea party sort.
You know how to handle money.
Tech savvy.
You might know more than I about the mechanics of the world, but
less than I about the world of art.
You could be a lawyer, a financial guy, a doctor, an architect, an
academic, an artist but not a broke-ass one.
You're already into or on the verge of your next project.
You love to travel and you do it with panache — a little high,
a little low.
You're an adventurer.
You have some sort of artistic outlet like music or writing…
You love music, including new music, and your musical tastes are
eclectic. (This actually feels fairly important.)
Likewise art and movies — well-versed in both classics and modern.

Emotional

You will be wild, but will make me feel safe.

You will know how to cry, will know how to say I love you.

Because you are deep and marvelous, your irksome moments will be mere peccadilloes.

You are ballsy. Funny. Goofy even. Maybe a little sarcastic, ironic.

Flexible. Unruffled by obstacles. May even like a fight.

Open. Openhearted. Free. An optimist but a realist.

Flexible and you ride over bumps with equanimity.

You love people. And animals. And the outdoors.

You're engaged.

We will discuss resentments and dissolve them before they ossify.

And you have resolved issues around past relationships; harbor no resentments of note.

You love/loved your parents or at least one of them. Same with siblings.

You have a child and a good relationship with them.

Spiritual

Atheist or agnostic or Buddhist or Reform Jew.

Could be raised as a Christian but not practicing.

American transcendentalist like me.

You believe in the human spirit.

Sexual

You're hot for it but not driven by it.

Like to grab me and slap a kiss on me.

You take your time and you're generous. Playful. Inventive.

Able to access your anima, but overall masculine.

A really, really good kisser.

�֎

So I read the entire thing to my dear shrink while noticing his grin getting larger as I did. He then told me to go home and look at each attribute and consider whether it was essential. Only the qualities I couldn't live without should make it to my second list.

IDEAL MATE, ITERATION #2:
CAN I AT LEAST GET THIS MUCH?

You:
Are athletic but not obsessively fit
energetic
have a good laugh
love wine as much as me.

You:
Have startling ideas and are surprised by mine
are curious
socially liberal
tech savvy
an adventurer.
love music
know how to handle money
have no financial worries.

You:
Will make me feel safe
know how to say I love you
will really understand me and love me.

You:
Are ballsy
funny

flexible
openhearted
engaged
love the outdoors.

You:
Are agnostic or atheist
an optimist
believe in the human spirit.

You:
Love sex but aren't driven by it
Are playful in bed
and a really good kisser.

I don't even get started reading this and my shrink, my guide, says "Really? So what if the guy doesn't like wine? Or he only drinks scotch? Or he doesn't like alcohol altogether?" "Well…" I say, "I guess I could live with that. I guess what I really meant was having things we shared an enthusiasm for." *And if that turned out to be swimming instead and he was fine with my nightly glass of wine, or sometimes two, which would sometimes lead to me dancing around the house to Japanese Pop? Guess I could live with that…* He sends me back to the drawing board.

ITERATION #3, THE BOTTOM LINE

You:
Are physically vital (healthy, energetic)

socially liberal
free of financial worries
an adventurer

You:
Will make me feel safe
will really understand me and love me
share with me a love of ideas or a love of adventure or a love of art
or music

You:
Are fun
funny
flexible
openhearted
engaged

Agnostic or atheist
an optimist

You:
Like sex
and are a really good kisser

This time the first thing he nabbed me on was 'will make me feel safe'. He thought making someone else the guardian of my safety was giving over a lot of responsibility and ultimately power as well, and asked what I really meant. I thought again and said, "I guess I want someone to be engaged in my well-being, someone who will look out for me. He offered, "someone who is trustworthy, respectful, someone who honors you?" Yeah.

Then, since I had a question mark by the agnostic/atheist entry, I thought to elaborate on that. Well, I said, he could be a Buddhist. He remarked that Buddhism was less a religion than a philosophy. Check that. He asked if I would include someone who was into paganism, which is what many people these days are claiming... like being into

Wicca, or Druidry or Nature worship or… I wrinkled my nose. "Okay, I sometimes call myself an American Transcendentalist, like Thoreau or Emerson…" (Major sidebar here: In fact, Emerson and Thoreau considered themselves pantheists. Although a diverse group, pantheists basically believe the universe itself, and the unity of all life, to be the real deal behind what some call God; more succinctly — there is no personal God or anthropomorphized being behind everything. Being itself was the all-encompassing, self-sufficient, eternal reality. This concept has a long history amongst philosophers, starting with the Pre-Socratics, the Stoics, Spinoza, Hegel, Nietzsche, Jung, and William James. The group also includes scientists, poets, and other leaders such as Einstein, Rumi, Lao Tzu, and Elizabeth Cady Stanton.)

Back to my Ideal Partner discussion — we then hit upon the entry of 'an optimist', whereupon I mentioned my ex's generally pessimistic world view, condensed thusly: "If you have no expectations, your expectations will always be met." Surprisingly he concurred. "Expectations are the gateway to despair." All righty then. But what about the general excitement and huge expectations of your typical newlyweds? "Nothing wrong with hope, because that's more open-ended. But expectations, unmet, breed disappointment and resentment." He went on to explain that the either/or of pessimism/optimism is too artificial a dichotomy, that realism is a better choice all around. Duly chastised, I changed that entry back to 'realist' (which I'd actually used in the first rundown) and added 'open-minded'.

"And the one most important quality is what?" he asked.

"Oh yeah, *available…*"

MY FINAL LIST

You:
Are physically vital, socially liberal, free of financial worries and an adventurer!

You:
Are trustworthy, respectful, and will honor me, will really understand
me, love me
and share with me a love of ideas or of adventure, art, or music…

You:
Are fun, funny, flexible, openhearted, and engaged.
Are agnostic or atheist, a realist.

You:
Like sex and are a really good kisser.

You. Are. Available!

Though I have let go of those bi-monthly sessions, if this list were
all I walked away with (oh, and my Emotional Support License for
Mimmo!), I would consider every dollar well spent. Hardcore, work-
able guidelines aren't so easy to come by these days.

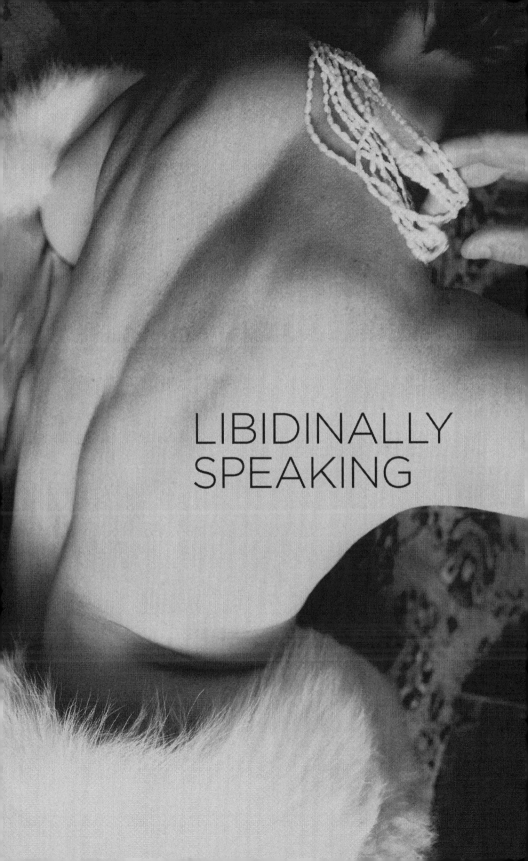

LIBIDINALLY
SPEAKING

I WANT MY WORDS TO...

If I could find you, my phantom other...
I would draw you to my waters.
Dunk you in them.
Then swish my words around you, like little goldfish,
nibbling at your ear,
glittering around you.
Dazzling you.

You would hardly see me,
a subaqueous blur of blue
coming at you like a torpedo, slow mo.
You wouldn't know
what hit you,
what warm current.
My words
swirling sweetly, suavely, swimmingly,
would swive you, Daddy,
make you Dizzy like Gillespie.

You'd feel you'd been wilded
by the chant of a siren.
Drenched
in the salt tang of a sprite.
Slicked
by a silkie.
Milked
by mellifluous merfolk,
then left panting on a distant shore.
Senses rising up against
your ego's slapdash hegemony.

And it would take all your strength
not to hurl yourself back into my pearl bright sea.
Waves swelling with wicked innuendo,
sparkling with libidinous language,
leading you finally to cry in response —
I Submit.

WHAT MAKES AN OLDER WOMAN SEXY?

I fell asleep the other night wondering this, having contemplated the subtle erosion of the various bodily bits which supposedly evoke sexual urges.

But before I launch into my exegesis, I must make a minor (and defensive) detour and query the same about older men. What do we find sexy about Jeremy Irons or Clint Eastwood? Isn't it their self-assurance? Their ease? Why is it considered that they look great when their hair turns silver and lines define their face, yet this doesn't apply to women? I know, this is a huge topic, and a bit of an old saw, and frankly I'm really bored by it, as any self-respecting woman of our generation would be and yet, the imbalance does persist. (Oh yes, I forgot — and how could I, given contemporary media — we are sex objects.) I know... Betty Friedan and Gloria Steinem fought hard on our behalf, yet that did little for the Australopithecus brain of our male counterparts. Hello Ladies, we need to, as they say, represent.

Of course, traditionally, women of a certain age went and did strange things to their hair: dyed it too dark, or tinged it violet, or permed it, or waved it, or essentially made it look seriously goofy. I mean really, do the same to a man and he'll look ridiculous too. Then of course, older dames insisted on wearing too much jewelry and makeup and floral print silks or absurd matching outfits a la Queen Mum. So really, we've been doing it to ourselves for years.

Anyhow, let's get down to the nitty gritty. What is it that makes an older woman sexy? First of all, it's how a woman inhabits her body. No matter the size or shape — is it her temple? Does she treasure it? Is she proud of it? Does she own it? If a woman owns her body, she's damn sexy. Every shape has its attendant curves and delights; a woman who knows how to display them just plain rocks. And let's not forget the

structural elements, the bones, many of which, as the flesh shifts, gain more presence, more sculptural gravitas. Consider shoulders, consider hips, consider the back...

Then of course there is the way a woman moves her body, not simply in bed, but everywhere she goes. It's like a signature, maybe funny and abrupt, maybe languorous and full of grace. It's something every woman might contemplate — how much is conveyed by the way she moves. And by the sound of her voice. A cultivated female voice is something which only grows more alluring with age. Don't forget how much sex occurs in the dark. A resonant voice, a voice modulated for allure, a 'come hither' voice, can unbutton any psyche. A woman who has control over the tone, the inflection and the colors, can float you on the oscillations, on the waves of her voice. Yes... cougars purrrrrrr.

But a voice is rudderless without a mind. And what is the sexiest part of anyone? The mind — for that is what creates the context, spins the tale. Knowing when to stroke, when to resist, when to yield, when to quicken, when to slow... when to submit, when to dominate, when to make a sudden volte-face... And, let's banish any doubt — an older mind, or shall we say a sophisticated mind, filled with experience and stories and years of observation, can knock a younger one out of the ring.

And then there are the eyes. The power that emanates can cause spontaneous combustion. And of course, the mouth. It can hunt with agility at any age, and again, years of experience make it a formidable adversary to any prey that it targets.

Ah, and then there is her hair. I was just about to descend into my down dog at yoga this morning when a friend, well into her 60's, strode by, her honey blonde hair radiating outward like that of a Botticelli nymph gone Electric Ladyland... and this woman looks hot on a yoga mat; she slides into her poses like a serpent, then holds them like a Tantric Rodin. Truly, an inspiration to get on your mat. But maybe you've clipped your locks short, like Judi Dench short. Since I sport that look, I happen to find it kind of hot as well. First of all, it's a truly liberating style

(absolutely no maintenance) but it also projects a sort of boyish quality — which can lead to some obstreperous behavior in the bedroom.

Of course the historic 'refuge' of the older woman is her style. Unquestionably some of the most wonderfully dressed females on the planet are over 50. The reason is that they understand what works for them, what flatters them, and who they are... so their style is unique, often above and beyond trends. And that is just plain sexy. Self-awareness is sexy.

Then of course, there is her language. Wordplay is wildly sexy. Having a sporty, funky, yet educated vocabulary is a huge libidinal asset.

*Let me lick the shadows off your brow and then here, on your luscious lips, leave *lambent traces of sunset.*

And then there is my favorite element — the laugh (which is of course linked to the voice.) The way a woman laughs, how easily and how often, how hard she laughs, how lilting her laugh... does she giggle, chuckle, chortle, guffaw? Does she snort? To laugh is to open. As an English proverb states: *A maid that laughs is a maid half taken.* Or as the dour St. John Chrysostom, an early Church Father, darkly opines: *Laughter does not seem to be a sin but it leads to sin.*

And so, let us laugh, darlings, because the paramount quality that makes a woman sexy is her outlook on life. And if she laughs without measure, most likely she derives great joy from life, has the ability to transcend pain and grief and still find pleasure in the mere fact of her existence. And is this not the most appealing element of any human — their ability to feel and express joy? To me, this is our single-most captivating virtue and one which, in my mind at least, is infinitely sexy.

* **Lambent** - 1. Flickering lightly over or on a surface: lambent moonlight. 2. Effortlessly light or brilliant: lambent wit. 3. Softly radiating; luminous. 1640s, from figurative use of Latin *lambere* "to lick," from Proto-Indo-European root *lab-, indicative of smacking lips or licking (cf. Gk. *laptein* "to sip, lick,")

ON HAVING A
YOUNGER MAN

So I know without a doubt that I am sexy, in part simply because I like sex. And I have no doubt that this predisposition and self-confidence, given the proper venue and a partner of equal mind-set and more-or-less equal age bracket, will lead to satisfaction. But what of the younger man who might present himself? Perhaps a decade younger, because they say that I look young for my age (though I am not fooled, as I am my harshest critic).

Then how to confront the sense of diminishment that one experiences when naked, as one's body seems increasingly intent to announce itself as 'aged'. A slow-motion shudder of disbelief and despair. Shhh, honey. Remember you awoke this morning choosing not to bemoan but to posit cheer. (And why isn't there a word for that act, an antonym to bemoan, which might be to 'becheer', which would mean to focus attention on all the elements in your life that deserve a joyful noise.)

Dutifully then, I try to re-contextualize my skin. Its motley-ness. Its laxity. And I decide to consider it an elegant, thin-ply sort of neoprene, so soft and subtle as to merely drape over the muscles… a sporty sort of velvet, shall we say? Because why are wrinkles and folds any less beautiful in skin than in velvet or silk?

So before the mirror I stand, imagining myself before a decade-younger lover and wondering why my body should be seen as any less beautiful than his. Alas, not for long. I recognize that sloth 'hope' has attempted to seduce me, because I now see I am caught in the age-old trap that Shakespeare saw centuries ago. (Hamlet, sad sack that he was, still could find one sadder: "Frailty thy name is woman".) I refer to the trap the female has been taught how to set for herself, of succumbing to object-hood, of having to be perfect.

Must I concede the fight, wearily concluding that desire is all about

the flesh, that desire *resides* in the flesh? One doesn't desire bones, and even muscles are of relative importance. It is the blooded rubberiness of flesh, it being the most fully alive substance we'll ever touch. The flesh exudes fragrance, yields sensation; it is that which transmits the electric, non-verbal, rosy-hued urges of passion.

And yet it is ironic that the attempt to capture desire, to corner it, arrest it, leads one into the shadows, that realm that reminds us of death. And there, mercifully, one is reminded that when enfolded into penumbral depths, one's sight becomes less dominant, being overtaken by one's hearing, the sense that causes us to yield to the legendary, fatal call of the siren, which summons perhaps the truest expression of longing and desire - the urge to relinquish one's self in the arms of the other. Now an awareness springs to life in my mind - that desire is immanent, and surpasses the senses, being finally a longing of the soul itself.

DILDO

Sometimes the *idea* of sex is better than sex. Which is a damn good reason to own a dildo.

Evidence of solitary female pleasure dates back millennia. The oldest know dildo, discovered in a cave in Germany, has been traced to the Upper Paleolithic period. So we've been fooling around with these 'false tools', as Saul Bellow mysteriously once called them, forever. False tools in the sense they were not *real* tools, Saul, like the kind you use for your own 'work'?

Naturally the actual etymology of the word dildo is unknown, but there are several theories about its origin. Perhaps it refers to the phallus-shaped peg used to lock oars into the sides of a dinghy. A less-likely theory, to my mind, is that it is a 'corruption' of the Italian *diletto*, "delight." An even less likely one is that it derived from its similarity to a *dill* pickle, clearly a dumb guy joke.

The classical Greeks called the object an *olisboi*, pl. *olisbos.* And tracking whether this had any relation to the ladies of Lesbos took me down a merry garden path where I plucked several wonderful new terms to describe lesbianism. *Tribadism,* which derives from the Greek *tribas* or *rub,* came to mean "a woman who practices unnatural vice with herself or with other women." Makes one wonder if the Greeks also considered male masturbation to be either a vice or unnatural. Why do I doubt it?

In the days of Ben Jonson (early 1700's), whose dictionary was the first published compendium of English words, the most common name for a lesbian was *tribade.* Jonson also used a term from a Latin root — *fricatrice* — which also meant rubbing. And the English even coined the term *rubster,* which name cracks me up. By the 20th century, however, the terms *sapphist, lesbian,* and *invert* ascended in popularity. Pity the poor girl who was an introverted invert.

The Oxford English Dictionary clocks the first appearance of *dildo* (in English) as 1593, when a playwright named Thomas Nashe wrote

"The Merrie Ballad of Nash, his Dildo" — a woeful, lengthy plaint against a male lover's stalwart competitor. Remarkable the number of metaphors Gilbert Nashe invented to vent his chagrin about his uncooperative member, as his impatient lover takes her leave, apparently with a dildo. I've whittled down his 330-line poem here (the italics are his lover's remarks):

Adieu, unconstant love, to thy disport;
Adieu, false mirth, and melodies too short;
Adieu, faint-hearted instrument of lust,
That falsely hath betrayed our equal trust.

.

My little dildoe shall supply your kind,
A youth that is as light as leaves in wind:
He bendeth not, nor foldeth any deal,
But stands as stiff as he were made of steel;

"And plays at peacock twixt my legs right blithe
And doth my tickling assuage with many a sigh
And when I will, he doth refresh me well,
And never makes my tender belly swell."

Poor Priapus, thy kingdom needs must fall,
Except thou thrust this weakling to the wall;
Behold how he usurps in bed and bower,
And undermines thy kingdom every hour:

.

He waits on courtly nymphs that are full coy,
And bids them scorn the blind alluring boy;
(Curse Eunuch dildo, senseless counterfeit,
Who sooth may fill, but never can beget...)

Truly poignant. But back to the objects at hand… and the activity at hand. I've always believed that the mind was the sexiest part of the body. In which case, liberating it unto its libertine ways, unleashing its lusty narratives, can be achieved in countless ways. But liberated women can be terrifying to some men, who fear both our ascendance and our lack of need for their own, less reliable flesh-and-blood members. The Southern Baptist preacher Dan Ireland has been an outspoken critic of such devices and has fought to ban them on religious and ethical grounds. Ireland has stated, "There are moral ways and immoral ways to use a firearm… There is no moral way to use one of these devices." According to Ireland, "Sometimes you have to protect the public against themselves… These devices should be outlawed because they are conducive to promiscuity, because they promote loose morals and because they entice improper and potentially deadly behaviors." (Because guns don't?)

If Daumier were a woman and alive today, what charming mockery she would make of Mr. Ireland, waving his raggedy little flag of patriarchy over what is most likely his own wavering little member. But we women take the high road and, banners and dildos in hand, sally forth all flushed and ecstatic.

ODE TO A SPECIFIC FEMALE PLEASURE ENHANCEMENT DEVICE

(by Georgie SPOTtiswode)

For some reason, despite navigating the sex-hopped sixties, my genteel WASP upbringing still retains a slight stranglehold on my ability to publicly speak about, OMG, dildos. I remember the first time I ever laid startled eyes on one — in the hands of my young, studly 17-year-old lover who had found, in his maiden auntie's room at his family home on Lake Michigan, a curious item — ivory plastic, slightly bananoid in shape, and suddenly humming. He proceeded to brandish it giddily all over my innocent little body.

From that teenage peak, my sex life, with a couple of interesting detours, verged on the vanilla — until encountering a fellow who appeared to be my knight in shining boxers. A decade of awesomeness followed, including a small arsenal of sex shop accoutrements. Ye olde white leather, fur-lined handcuffs (which I preferred to buckle on *him*), a few diminutive soft-core whips we were mostly too pre-occupied to use, a dildo for him and a few for me. Having given up on the slightly grotesque, exact simulacra style, I eventually gravitated toward a darling device called the Dolly Dolphin. Shaped somewhat like a dolphin just about to dive (and having thoughtfully retracted its fins) the Disney-esque Dolly, a heavenly shade of periwinkle, naturally bore a nascent grin. Now *that's* what I call Adult Swim. After a few good years of submarine service, Dolly died a quiet death. She returned to me in a dream and hinted that it was time to move on.

My standards now set rather high in the design department, I consulted a boutique called Toys in Babeland in Soho, New York. Its name now trimmed to Babeland, this is a sex shop disguised as an art gallery; it is that tastefully curated. Babeland's clerks were all sexually liberated

connoisseurs and the objects all state-of-the-art. Lelo came off as the most artistically and technically impressive manufacturer in their collection. With a price to match. Wistfully, I demurred. But when a holiday sale appeared in my email, I jumped on it. Now the proud new owner of one of Lelo's Monas (I moan at the pun), I can report serious customer satisfaction, as of the third trial run.

Opening the long black box, whose shiny recessed lettering evoked sensuality from the start, I gazed at Mona, colored a gorgeous popsicle purple, half buried in her cutout black cardboard silhouette. Really something that belongs in MOMA's design wing. I pulled her out, felt her perfect heft, and smooth matte finish, slid a finger along the gleaming white handle and turned her on, admiring the illuminated buttons. She came to life in my hand, gently humming and begging for me to take her for a ride. On our first spin, the word *Ferrari* sprang to my lips. The same mad power waiting for your command, same responsive handling and, for a novice, the unpredictable wild surges one gets with a sports car.

Or maybe, I thought, as I kept pressing her buttons hardly knowing which did what, she's more like a Bronco. You could get bucked right off this baby. Okay, so maybe the best idea is to first hold li'l Mona before you, aimed as you might in action, and *then* fiddle with the buttons. Pretty simple really — one to accelerate, one to decelerate, one to shift rhythms ahead, one back. Control is in your hands, darlin'.

Indeed the Mona is packed with enough options, enough permutations in speed, power, pulsation and rhythm, to keep you pretty busy for years, I figure. And by that time, Google will have a voice-activated dildo. Hopefully one that understands my twisted sense of humor. Wait, maybe I could manufacture it? I quickly do a search for "Google Dildo" and find they haven't gotten there yet (get your priorities straight Google; who cares about a damned robotic car?) but there are in fact a few apps that will vibrate your goddamned phone for you, turning it into an ersatz sex toy (redefining the term 'phone' once again

and presumably adding a new twist on the phrase 'phone it in'). I guess this could be useful in a pinch, like if you were caught in a tree while a flood surged below?

Recently my daughter asked if I wanted to join her at a day-long event called Cycles and Sex. Created by some clever millennial women, the day featured panels focusing on menstruation, childbirth, and sex. Although ultimately my daughter already knew everything that was discussed (she has two Masters degrees, one in the field of sexual and reproductive health), I found it enlightening, at least on the topic of sex and different paths to pleasure. Naturally there was a merchandise area presenting all sorts of things from menses-trapping undies, cannabinoid lubes, and various devices. But the most astounding product being touted was a dildo that connects, via bluetooth, to an app on your phone and records the wave patterns created by your orgasm, thereby supposedly showing you what really turns you on. It's an elegant device and concept, but I wondered why one needs an app when your body does a damn good job informing you on its own. At any rate, perusing their website later, I found a description of the three basic 'orgasm patterns' — the Ocean, the Avalanche, and the Volcano... I'm still trying to sort out exactly which is my orgasmatype, if I may coin a term. But then why would I care? I can name mine whatever the hell I feel like!

Recently a truly 'disruptive' dildo got fully funded on Kickstarter; Mod could supposedly be 'controlled with your brain' or programmed to follow patterns (like old disco tunes?) and respond to environmental cues like heartbeats. But, along with five other start-ups, Mod's manufacturer was stopped dead in its tracks by a 'patent troll' who is suing the companies due to his purportedly previous patent. Market freedom in the cyberdildonics field is a valuable and highly contested entity. So hold on to your vintage devices, ladies, and remember: it's *almost* all in your head!

HOW TO SAY NO
TO MEANINGLESS SEX

What the fuck. It's been how long since you got jiggy with anyone? And how un-wonderful is that?

Look, if you've got a body that wants it, you've got to deal with that. Don't put it on hold, baby, deal with it. The longer you ignore the impulses of yore, the deeper they recede into it. (Note that the following advice leads one in two opposing directions, and both can be legitimized.)

It is with a sense of amazement that I can enumerate more than a few men that I have resisted, or possibly dabbled in and then resisted. Nobody said it was easy, being single. No more than anyone said it was easy being married. Just way, way different.

So picture a police station line-up with, say, six perps, any of whom would have gotten up inside of this. Meaning me. And for each I have a reason their mission did not pay off. In short, my question was always, and fairly early on, "Where is this leading?"

There have been men with soft lips and lithe bodies who hadn't a penny to their names. And men for whom that list included heavy drinking. There were handsome guys that were cool in bed but hadn't an original thought in their heads. Most recently I was petitioned by a long-time happily married dude. We'd known each other as children but had lost touch for years. Now friends again, I found him to be a sympathetic listener, and a great storyteller. I was simply happy to hang with him and I assumed he felt the same way. Sure we occasionally texted funny sexual puns, but I figured that was a harmless form of flirting since there had been no further intimations. Then one evening (we used to go to the movies when his wife was out of town) he made his pitch. And I have to say I was half inclined, but it left me troubled too, not only due to his marital status.

How do I clarify this particular scenario? In response to the big question: I know it leads nowhere. But a second question arises, a peevish one, somehow referencing ancient gender grievances from a childhood with more entitled brothers, which is: Who is profiting? If he and I both profited equally, awesome. But this question raises still another one: Why would I even have to ask this about an old friend? Surely we were both profiting equally as far as the moment went. But afterward? Wasn't this dude, who was absolutely married, the Ultimate Unavailable (for which I am told I have a penchant)?

What he would get was an above-average titillation. Me? I would probably get a reasonable quota of jiggies, but then? What would happen when I suddenly got into the mood - could I text him at the drop of a hat and arrange a booty call? Inherently not in the cards. I guess I could choose to make myself unavailable too — that would even the score, thought I. But what sort of juvenile warp had I entered at this point?

I gave the proposal a long weekend of thought and found myself juggling a trio or more of different objects, of awkwardly different dimensions, but all too weighty to juggle decorously. Did I want it? How much did I want it? What does it mean to want it? Can I do without it? Why do without it? Why am I so hung up (it's only sex)?

Finally, exhausted by the mental inquiry, I realized that my darling nonconscious brain had already made its conclusions and my conscious brain concurred: "Does not compute." In short, regarding not only all the deliberations but all the unintended consequences — quel bore. Guess the sixties mentality had an expiration date. Plus, I've got my projects to attend to. And I've got a dildo.

JOY IS A VERB.
IT'S SOMETHING
YOU DO.

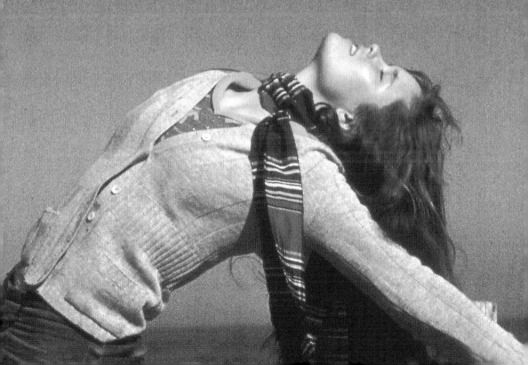

SWIFT ELATION

How can I capture that bizarre and swift elation? As I turned onto
Tenth street walking toward
Sixth, that updraft?

I round the corner, look up and the dense purple sky suddenly,
in a silent bang, becomes a firmament.
Maple leaves shift coyly before the street lamps
and sting me with a green hypnotic.

That zephyr lifts me and everything else -
the skewed shadow of an old bicycle,
the plastic lid to a coffee cup,
a young man in a bow tie stopping to fix his shoe
before the curlicues of a wrought iron trellis,
four green garbage pails piled against one another,
posed as if behind a veil,
a fragment of a conversation "… but she thinks she can do it!"

Humanity gleams in these signs.
Poignant, palpable, there.
Each adds its tone to a long beautiful chord resonating in the column
of air running up and through me.

Perhaps it had been building since I left that cafe where I had been
telling a man that New York was simply ugly. As if, while I walked
uptown, the city had been swelling with the anticipation of its easy
refutation. Perhaps my reading Rilke, in that cafe, had sensitized me,
had peeled back that layer of deadened flesh which sheathes us as
we walk the earth.

Jubilation always lies in wait, just below the surface.

JOYSTRUCK

The best piety is to enjoy — when you can. You are doing the most then to save the earth's character as an agreeable planet. And enjoyment radiates.
— George Eliot

All I really want in this life is to maximize my joy. I simply want joy to be co-extensive with my self, through the entire span of my life. Gee, is that asking too much? Uh-huh, yeah, but only of myself! It's asking that each and every day I find a way to inhabit a state of being that at the minimum can *entertain* the idea of joy. Ideally joy itself, but that would be a whopping order: "I'll have a Whopper... I mean, one of those Infinite Joy Burgers, please."

Except there isn't a fast food joint for that and you can't actually *buy* one of those Happy Meals. Nope. Your AmEx card won't get it for you. Yo Mama can't make it for you. Some app can't deliver it for you. You want it? *You* make it.

You're not feeling it? The well of joy ain't bubbling forth? Okay, you need to work on that then. Because it is in *your* hands and nobody else's. The potential for joy, in fact, *is* a question of choice, at least for most of us. Consider Marcus Aurelius, the great Athenian Emperor who spent much of life in campaigns to preserve his Empire — a lonely hard life on the battlefield but one in which he took time to scrupulously record his thoughts. Naturally his *Meditations* revolve around the imminence of death, but as well around the immanence of joy:

Look within. Within is the fountain of good, and it will bubble up if you simply dig.

When you consider the multitude of lives lived in the millennia that has passed before you, you see how miniscule are our human woes. Take heart. Laugh at how hilariously tiny you are and how enormous your plans are! Shouldn't it be liberating how quickly our presence will dissipate after our death? Few are those who live down in history, and of

those many are remembered for misdeeds. Those that stumbled across some great discovery or performed some act of heroism? I assume the acclaim is quite meaningless to them now.

I do think there are a few basic categories of joy:

1) The one that hits you upside the head. A kind of everyday, Gee Whiz joy that zaps you awake, gifts you with a total lightness of being, and has you suddenly singing about bluebirds sitting on your shoulder. It's a Giddiness out of the Blue. It's a prismatic flash from the edge of a lover's glass, it's a poem sent by your daughter, it's a bubbling up like a fountain of champagne rising from your belly straight to your heart and blasting it wide open. This is a squealing sort of joy, a contagious sort of joy and you can catch it from others. And you will if you keep your own heart open.

2) There is the very active, physical version of joy that comes through movement — yoga, swimming, hiking, skiing (any flow-state sport), sex, playing with children, dancing! It has everything to do with breathing, with dissolving the boundaries between body and mind.

3) Then there is the joy that dawns on you, or rather in you. Often emanating from moments of contemplation, or from imbibing the natural world, it is an act of attention, of a consciously evolving recognition.

I am reminded of a dream I once had in which I looked down at my hands and discovered an orb of phosphorescent protoplasm nesting in my palms, all warm and luminescent and alive. All immanence. (A term employed mostly by monotheists, but the general idea of immanence refers to an indwelling of spirit, the *divine* becoming manifest in the material world.)

In essence, joy unifies spirit, mind, and senses into an exultant state that transcends self. To see again the pure and breathtaking beauty of existence. *Being there.* This is something we can all access if we choose to.

Dwell on the beauty of life. Watch the stars, and see yourself running with them. — Marcus Aurelius

There are so many routes to joy, it's wild. Take a walk in the woods. Rescue a dog. Go sit in a tea parlor and discuss ephemera with the guy sitting next to you. Go to a concert. Spend an afternoon at a museum. Dawdle! Cook a meal for friends. Take a long bath. Play frisbee. Put on some trance music and dance. Plant tomatoes and basil. Watch them grow. Eat them. Play chess with an old codger. Take photos of your neighborhood and realize how much beauty resides in almost every corner of the planet. Consider your luck that you live where you do and not in a war zone. Read some Byron and realize that the universe is a marvelous symphony.

The angels were all singing out of tune,
And hoarse with having little else to do,
Excepting to wind up the sun and moon,
Or curb a runaway young star or two.
— Lord Byron

Clear your channels. Then bask in the life force. Let it enter you. Allow it to ignite you. Radiate baby, radiate.

THE DEEPEST, MOST ABIDING JOY

(To my daughter...)

Every time I drop you off at the airport, my heart draws into a clenched fist, attempting to stanch the flow of blood and love and the sorrowful anticipation of absence. We've done this so many times. After a deeply wonderful week (the easy yin-yang of us, the eruptions of hilarity, the sweet moments of silence), the long dumb drive to LAX is like a prickly form of purgatory. You, returning often to big looming life questions, questions upon which I've offered a vantage point. (A mother's 'take it or leave it' vantage point — advice always to be taken with food. And, remarkably, often you've taken it.)

And I, returning to a bevy of questions as well. Questions for which you too have offered advice, sage beyond your years; for at times we reverse our roles. Some questions I've rumbled through in this book, but others, I have held closer to the vest, like — why are we still an entire continent apart? Yes, it was my decision. (It was your eighteenth year and you seemed so *launched* in your first year of college. And then there was the hands-off style of my own parents, which left me on my own recognizance once I arrived at Sarah Lawrence.) It *was* my decision, although it was seconded by my therapist, to break free from my convoluted past and follow my dream of moviemaking. But it was never my intent to be gone so long, nor ever my intent to jeopardize my bond with my girl. Which, woefully, I think I did, but which, with love and articulation, we've rebuilt.

Now, after some years, it seems that time and proximity are relative and of relative value. And yet... long swathes of time apart where we could be hanging on the beach or making a new pasta sauce or grabbing a beer in a dingy, hip Brooklyn bar? I keep telling myself this must change. And it will.

But for now, in the land of nearly interminable sunshine, I settle into a state of timelessness, where the pangs of absence slowly become a part of everyday life, where they get softened by my obsessions with various projects. But then you visit and I realize I am like a little barrel cactus, suddenly, after a rainy spring, bursting forth with bright red flowers. When I fly back East to visit you, I can slip into my old life, but I'm an outsider, a pretender — happily riffing off the intensity of the city, but wondering if I could really come back; if I've gone too soft, too left coast, to withstand the inclement weather and smaller apartments, the headier competition and the seething proliferation of symbols, signifiers, and signs that lure the innocent, like tourists to the storefront ladies of Amsterdam. And anyhow, you don't know where you'll be in a year...

This last visit here, I wondered if you'd wondered why I didn't write more extensively about you in this book, and finally asked if you were upset by that omission. You admitted to being a bit bewildered. Naturally so, since I've told you so often that you are the most important person in my life.

You surmised the reason to be that this was a book about me, a portrait of the artist and her struggle for independence, and that somehow maybe the motherhood piece jeopardized that picture, threw off the composition. Oh, no. No, no, Darling. No.

It's that I wanted to keep it all private, wanted to keep *us* private. Because I *am* private about my deepest self. Because I want to protect you. Because I don't want to attempt to catch all that love. Don't want to net it, trap it, pin it. Because how can I? And why would I want to proclaim this to the world when so many who wanted children don't have them?

But perhaps more to the point is the fear of representation, as Sunni Muslims have of representing the human form, especially the face of God. Which makes sense, really. Beyond considerations of blasphemy, if God had a face, it would indeed be impossible to represent. Likewise

any rendering of this deep, living thing, this uncanny symbiosis that can emerge between mother and daughter. I don't believe there is a formulary for the natural magic of this maternal bond. Its roots are visible; it is at once logical and biological, yet it is evanescent, spiritual. It eludes precise taxonomy and every cliché Hallmark has thrown at it.

I have been granted the temporary guardianship of a beautiful individual — you — for whom, by some miracle, I was the conduit into this world, whose body and soul are part me, but new and improved, having grown into a vastly larger, expanding being, so alive and so happening, so already in the future. A future you yourself have built, out of trial and error, out of passion and struggle. Having emerged from a youthful doubt of self to a radiant belief in self — a progression not easily achieved — you have become a deeply empathic, visionary, and just human being. I will consider myself enormously privileged to continue to behold your blossoming.

This is the transformation all parents desire for their children, and many parents are denied. So when one is given the gift of participating in this experience, one finds oneself in a state of awe. And out of respect, does not speak openly of it...

But now I will, and I do it as a testament for you.

※

TO MY TRUEST LOVE, MY ONE AND ONLY BABY GIRL

From the moment you appeared everything changed. I went from a whirling dervish bohemian, hell bent on proving herself to the world, to a grown up. Or at least the inklings of one.

Every morning I would run my finger from your forehead down to the tip of your nose, tracing its sweet and perfect lilt. Your eyes would gaze at me — vast blue irises like aqueous planets orbiting my soul. Question marks really. Who will you be to me? Will you know me?

Will you make the world readable for me? Will you keep me from harm?

And thence began the eclipse of my own monstrous, needy ego. I tried to tear myself away, thinking I could do everything — continue to work, establish that I was more than 'just another mother'. But how could I let anyone interfere with the amazing dialogue that had just begun? How could I bear to let another be the one to hear your first words or see your first step? Oh, I was hooked.

Yeah, you turned my brain to plush, Baby Girl, as I filled your crib with goofy critters made of the same. But every day was a new world, seen through your eyes. You were the explorer, and I the savage you met at the shore. I showed you the world I knew, naming every plant and star. I spoke to you of the arcane beliefs held by a few of my lonely tribe of artists, misfits, and philosophers.

I tried like hell to learn your daemon, so as not to alter its sacred course. I delighted as it awoke and led you to sing like an angel and dance like a little Isadora. And although I might have lost patience with your occasional stubborn refusal to move at the wild-assed pace of my own mind, I studied you like a holy book, to learn the meaning of your idiosyncratic ways. And learned that every human being grasps the world differently. You led me to study and discover more about the two hemispheres of the brain, which then led me deeper into the reality of the right. You helped me confront the turbulence of my soul and focus its power, yoking it more effectively with my left.

I suffered helplessness as you budded into a woman seemingly over-night, as on your chest appeared a miraculous set of breasts that dwarfed my own by several magnitudes, as you struggled with the primitive ways of adolescent cliques, struggled to merge your own sensitive and artistic soul with the hierarchy of the popular. Suffered again when in college you fell for the most conventional boy on the planet. But I never questioned you, knowing that it was part of your trajectory. And I rejoiced when you realized that you were in no way a conventional girl. That you had found a way to take that deep vulnerability and link it to your fiercely independent daemon.

I celebrated as you made choice after choice, all from your heart. And found a path quite different than mine, one full of love and dedication to others. I marveled at your growth into a startling and gorgeous young woman, who stood her ground against some powerful, wrong-headed elders. And I found it was easy to stand with you as your heart butted up against some aging mores of society and found love with a woman, a woman as brilliant and original as you. I felt such admiration as you moved on to experience yourself as fully independent, and took off for a year's study in Global Health in London; as you traveled as widely as you could from there, often alone, just like you had when you'd struck out at 18 for a six-week experience in India, studying the loss of old birthing methodologies in tiny rural clinics. And I am impressed again, as you wind up back on the streets of Brooklyn, working for a non-profit enabling the rights of women.

In short, I am the proudest mother in the world. And though you no longer need me to protect you, I will, to my dying day, continue to stand sentinel for my truest love, my one and only Baby Girl.

SOUNDTRACKS

As Editor of Realize, I often got asked why I didn't publish on paper. Forget about the financial aspect; the bottom line for me was that I wanted to post my playlists. I heard so many fifty- and sixty-somethings complain that they didn't know what to listen to anymore, short of what their kids would, if not too bored, recommend. So many of them wound up with the same stuff on rotation: Dylan, Stones, Springsteen, Nora Jones... Maybe they'd branched into the Chili Peppers, maybe a bit of Tom Petty. Not to say there isn't a huge cohort of us who have a wide scope. And I'm not dissing anyone who doesn't. It takes time to experiment. But that's where I hoped to come in with my playlists.

I originally housed them on realizemagazine.com in a widget from a streaming service called rdio (pronounced 'ardio'). rdio was an off-shoot of Skype that, unlike Spotify, kindly gave affiliates a monetary nod for new signups. When rdio got bought by Pandora, I loped over to Apple Music because, despite some current issues with them, I am hardcore Apple, and they too, unlike Spotify, duked affiliates. You can find some of my playlists there — my 3-hour American Thanksgiving playlist and my playlist of covers of Goodbye Porkpie Hat. Labor of love really because both playlists had to be painfully exhumed and reconstructed from weird data files provided by the disappearing rdio. But at least ten others have vanished into the haze of corporate mergers.

Why do I care so much about music? Number one reason is that *I love to dance*. If I'm not too wrapped up in work, I try to take a break in the evenings and groove out around the house. Number two reason — I am exalted, fired up, mellowed out, tweaked up, retuned, rejiggered, and totally rewired by music. A little of Mozart's Cosi Fan Tutti, amped up loud while cleaning the house. A little Thelonius Monk during a dinner party. A little Rihanna and Janelle Monáe for late night house dancing, or some Grimes or Empire of the Sun. Some Jon Hassell (one of the greatest, most transcendental horn players alive) on a long hike,

or maybe Arvo Pärt. Radiohead for a sullen rainy afternoon. And then, when I'm writing, I have a day's worth of soundtracks from the likes of Alberto Iglesias, Howard Shore, and Ennio Morricone. Oh, and the soundtrack to Peter Pan, by James Newton Howard, is brilliant for a yoga session.

I care deeply about music in every form and I have ever since my somewhat musically deprived childhood. Dad had a few old jazz records he'd play for cocktail parties. Eventually he updated to Stan Getz, and would spin a little Tijuana Brass when he and Mom kicked off their Margarita phase (which actually never ended, and by the way my Dad made a righteous Margarita). Beyond that, they possessed some Bob Newhart comedy records, the obligatory Christmas compilations, and one, just one, classical record — Tchaikovsky's Russian Dances. I'd put on my fur Cossack hat and gyre around the living room when otherwise bored, but that wore thin when I hit 13 — about the same time I gravitated out of the little white cotton socks I wore with my patent leather flats.

In fact my only source of classical music was in elementary school, where we were treated to twice yearly performances by the small symphony orchestra of one Dr. Zipper. (Hmmm, I now wonder — was he sire to the Squirrel Nut Zippers? Certainly his brand of classical music would make you want to swerve to Swing as an antidote.) Anyhow, I kid you not, Dr. Zipper conducted just like his name — very zipped up. He sported a teeny John Waters mustache, perky bow tie, quasi-zoot suits, and a tightly zipped little smile. Every time he lifted his baton his whole body would follow 'til he was up on his toes. Needless to say, we'd all snicker as he bobbed up and down on his tiny conductor's box. And I doubt any of that potentially transcendental music penetrated our smart-assed little heads.

My only other conduit for tunes was a sweet little pink plastic box with an antenna — my first transistor radio. WLS radio, out of Chicago, brought a bit of the big wide world home to me. Taught me how

to dance and taught me about the pain and longing of romance. (Jeez, did I really want to grow up?) If there was one song that sank into my young psyche, it was probably The Miracles' You Really Got a Hold on Me, which gave me my first taste of something deeper and wilder than I could ever find in the emotionally arid terrain of the suburbs. But I soaked it all in — from Chubby Checker to the Drifters to The Four Seasons and Leslie Gore (although I decided she was really dumb for crying at her own party).

It was on WLS where I first heard the Fab Four, circa 1963. I actually wound up at Shea Stadium, just barely a teen, for their first US concert in 1964, guest of an older cousin. We were rather high up in the stands, which wouldn't have been such an issue but for the wall of sound emitted by the phalanx of caterwauling girls that separated me from the Liverpudlians. I was incensed and repulsed by their behavior — quite irritable to be associated with them by gender. But I was an instant fan and to this day, when cruising through my library of their songs, believe that almost everything they wrote and performed was some kind of channeling of the divine.

Oh, I almost forgot the sweet Baby Grand upon which, at 7, I began lessons that continued until I was 14. My mother had inherited it from her mother and it had been mostly unplayed for years. I actually loved playing that piano (which my mother eventually painted a soft gleaming black) but my teacher, for most of the years I played, had a very mundane sense of what a young girl should play, and thus I was saddled with tunes from South Pacific and such. I did learn how to play a decent Sentimental Journey and finally begged for a copy of Alley Cat when I was 12. But by that point my mother had come up with a method to keep me practicing — offering me a dollar for every tune I played flawlessly. Alas, this psychology had the reverse effect and I soon balked at the coercion. Besides, I was now 14 and had just discovered boys. Needless to say, back then, developing aspirations (and I probably would have) of becoming a pop musician were less logical than of

becoming an astronaut. (In fact, I later did make an attempt at creating a career as an art rocker, even got signed by an indie label, but that's another story...)

At any rate, what my parents did provide us with in the way of real musical education (which more than anything else, probably cued my ears to music's real potential) was the occasional visit to an old Navy pal of my Dad's who played a great trombone. Good old Fred — Irish stock with a beet red face to match and a devilish sense of humor — would get a few other blokes together in his living room and blow. It was alarming what he did with his horn. It was entrancing. I had no context for it whatsoever, but it didn't really matter that it was some white dude's version of New Orleans jazz, it felt real. Suffice it to say that when, at the end of my junior year in high school, we moved to Manhattan and I found myself in the village, I soon discovered what jazz really was.

See, I could live my life so beautifully if I could just *score* the whole thing. Which is why I love soundtracks. When I paint, when I write, sometimes just walking the dog... I want to find a mood, sink into an emotional reality, displace my small self and travel through the vast deeps of Big Self. Great composers can do that for you, can underscore your narrative.

Take for instance the soundtrack for Tinker, Tailor, Soldier, Spy, written by one of my favorite modern composers, Alberto Iglesias. The first tune in it is entitled 'Smiley' — the name of Le Carré's anti-hero, the retired MI6 agent played with tragic finesse by Gary Oldman. Just listening to that track lures me into a world of espionage, betrayal and evil, and it surrounds a more mundane hour with an air of mystery, lending my own small world a sense of urgency and import. And what I find is that I rise to the occasion, sometimes write from a more expanded world view and with a greater sense of drama.

I figure that's why everyone runs around these days with headphones, at least young people do... because they're creating the soundtrack to their own lives. I'm totally down with that.

And of course now, with the internet, all the music in the world is laid out for us — a living, global, aural landscape. Every color, tone, and shape a different facet of man's infinite capabilities to express through rhythm and melody, through instrument and voice. Music is the true proof of man's grace. But not all of us have access to it. If had millions of dollars, I would put it toward making sure all the children of the world have access to all the music in the world.

And what I'll do when I finally get my bucket list in gear, is learn how to D.J. I really want to create dance parties for 'adults' and this, for me, would mean layering in moments to break free, moments to slow down, and periods of trance atmospheric stuff for just breathing and letting all that energy course through every corpuscle. Ah, sweet music, the universal, fluxing plasma that connects each one of us to the divine.

WHAT SYNCHRONICITY CAN DO FOR YOU

There are days when worlds seem to be in collision and you're caught in the crashing debris of alien starships or Russian cyberhacks. But I'm not talking about that vast space overhead or just beyond, I'm talking about that vast space within.

After dreamlike drifting through the fascinating void, where everything is possible and you're in the flow... suddenly, hulking elements of one's psyche seem to loom at the curvature of space/time and threaten your demolition.

It is one of those days, when I begin to feel like Atlas (but without the ripped abs) holding up this big old planet (but it's just my little old existence) and suddenly the immense weight of the effort, and the possible absurdity of it all, is pressing down on my beleaguered shoulders... How can I continue to hold this damn thing up all alone?

And then I notice that I'm actually not standing on terra firma (of course, because I'm holding it up) but have both feet planted in thin air. My psycho-geographical quandary then springs to mind. Having lived all over the States, forever in migration, I began wondering where in fact I really belong, and where I could afford to live. And now two of the main considerations in anyone's life (the hurtling space hulks I earlier referred to) are threatening to collide, with me and my big old planet in between. (And I'm feeling like poor Bernie Mac, in that movie Bad Santa, crushed on the grill of his truck when the bad elf's girlfriend plows into him in her Caddy.)

I have to start some seriously deep breathing and remind myself: *It's all about the focus of your attention.* Where you put it is where you'll dwell. So, my left brain reminds my right, "Consider how damned lucky you are to be alive." (This is a condensed version of my thinking.) "And bloody well sod off with all this blubbering. You're not dead,

you're not decrepit, you're fucking full of beans so ignite that fart and float onward, girl!"

So that afternoon, when I haul my sorry ass into a yoga class at a sort of hippie studio I rarely frequent, imagine my surprise when the lovely +50 yogini at the head of the class begins to speak, although I don't remember her exact words, about the eternal flux between ease and difficulty, between harmony and discord... and how this is simply life, that it is at the core of what it means to be alive, and how yoga is the way to ride those fluctuations and accept them all. This on a day when I am clearly in the old 'trough of despond' that the Romantics wrote about. *Now that is synchronicity.*

When my parents bought an old house that had once been the studio of a famous American Impressionist painter, we found a few treasures left behind. One of them was a hand-carved plaque that they mounted over their bedroom door. It said, in gilded script, "The Tide Turns at Low Ebb as Well as High." Yes, even those Romantics knew that. You don't have to be Hindu or Buddhist to know that. You just have to be alert to remember it. Every day.

So it's another day, and I continue, in however wobbly a fashion, to keep this old globe in the air. Thinking now: Well, I may be up in the upper reaches of the atmosphere, but now I'm on this surfboard see, riding the waves of change... and actually that's kind of groovy. And, if I forget how to stay on that board, I can count on synchronicity to remind me.

JUST BEING ALIVE

And the rose
Like a nymph
To the bath addressed,
Which unveiled the depth of her glowing breast,
Till, fold after fold,
to the fainting air
The soul of her beauty
and love lay bare.
— Percy Bysshe Shelley

I don't have a lot to my name. No house. No swell car. No clear future. But what I do have is my old landlady's rose garden. Now that she is gone, and the three young dudes renting downstairs apparently don't see color, it is I who wind up with her roses.

Tema was unique. By the time I met her, she was 82, had the profile of Edith Sitwell, stood nearly six feet tall, and had a mouth full of dentures barely restraining her often imperious and acid appraisals of all and sundry. But she came to trust me, and over the years her story of struggle and tragedy unraveled. Hidden for two years in the cramped basement of some compassionate Poles during the Nazi invasion, Tema wound up marrying another Jew who had been interned in China during the same time. He was long gone by the time I rented the upstairs unit of her duplex, but her fighting spirit was stoutly intact. She gave short shrift to her caretaker and to her son. But the bizarre shooting death of one of her grandsons took a huge toll on her, leaving her own son with the care of his daughter-in-law, who was pregnant with twins, and her two existing children. The hurt he exuded on his weekly visits was profound. There is always someone who can put whatever pain you think you're experiencing into clear relief.

But back to her roses, which are all that is now left of her here.

Tema instructed someone to arrange her roses in a grid pattern, like pieces on a chess board. (I kept expecting Tema to morph into the Red Queen and have off with her gardener's heads.) There were 16 bushes in all and, together, they almost made a formal rose garden, but not quite. I used to ignore them; they depressed me — so skeletal, so pocked and gangly. They stood forlornly, like old clowns. But one day after she died, I looked at the motley crew and realized, hell, they only need some love.

Of course a heavy spring rainfall had sent months of sweetness down the tubes, down to their rosy little toes wiggling in the earth. So I found myself lured into their thorny, fleshy, crimson-and-coral world and discovered that roses are actually sort of submissive... I mean like sexually. Because the more I take the shears to them, lopping off errant branches, the more they sprout in glee, the more willingly they yield their luxuries. Perhaps what this really means is they dig me, to use a gardening metaphor. They dig my attention, so they return it in kind. Wow. If that's all it takes, we could actually have heaven on earth.

So I have roses. I have a roof over my head, food to eat, and friends along for the ride. I've got a body that can course through a mile of water, a fully functioning and reasonable mind (and a capacity to amuse myself with it), a beautiful, brave daughter, a darling dog, and a classic 20's Spanish duplex, for which I pay way under-market rent. How can I not choose to be ecstatic?

Because really, just being alive...
what could possibly be more luxurious than being alive?
Being *more* alive?
Not possible.
Being alive in paradise?
Doesn't exist.
This Is It, Lambchop.

Being alive means *being*, from second to second, and *feeling* all the while. Cogitating? Possibly. Perceiving? Probably. Engaging? Hopefully. But perforce it means *breathing* in and out — that reality, that activity you consistently forget, that actuality that makes you alive and that *is* you, Honey Child, living.

There is a German word for existence, *dasein,* which is so basic a word that it literally means 'being there'. Philosopher Martin Heidegger probed the word quite deeply and remolded it to mean the ideal state of being an engaged human individual, an almost sacred state which derives its strength not from simply being but from the work of being an attentive and authentic self in the world. This is work, mates, but it is our work as humans.

※

I find myself walking through an all-day heavy rainfall, find myself the only person on the street, with the only dog, and I begin to feel I'm in a transformative reality, acutely aware of the being-ness of all things, the there-ness, the aliveness, and suddenly I want to make some sort of statement, to recognize the moment, but what the hell am I supposed to say? Ideally I would have a name for that experience. (Yes, how very Western of me, but hear me out.) Okay — *awe* is a start, but it implies a sense of majesty, which would be an overstatement of my feeling. And why do I find myself struggling with residual Judeo-Christian impulses — the urge to name one force, to deify? (Which is how we got Monotheism — that need to think there is One Creator, traditionally an anthropomorphic urge, and one which hasn't worked out so well, sociologically speaking, what with everyone claiming their One God is *The* One God.)

So where does that leave me? Whether the force is Electromagnetism or Light or Sound or Thought or simply The Force... even the scientist in us wants to call it out! Maybe we could name it Cosmo,

except Cosmo Topper was the boring old bank President in the 1937 Hollywood classic, Topper, so maybe not, but then maybe that's perfect. It kind of domesticates the concept nicely. Or how about Fido!? Maybe that's as good a name as any other. Fido the Faithful. Creative Force of the Universe. 'Here Fido! Come!'

So where is the word for this feeling I get of *World Love*? I've been searching online and can't find it. I've found world-pain and world-weariness (German, of course — *weltschmerz*; even the word sounds painful). But I want something jubilant, transcendent, bigger than everything, heart bursting. Perhaps the query is rather: what is the word for *Life Love*. Surely the Greeks have a word for it: *agape* is little too tied to older religions, but the root *philia* could be adapted. Since life in Greek is *zoë*, oh, of course: *zoëphilia*. I'm a zoëphiliac!

Oh hell, who cares? I want to liberate myself from it all so that I can simply walk down a rainy evening street inhaling the green scent of life, free of thought, free of questions. And then maybe I can just start singing.

PAROUSIA

There is a Greek term I love: *parousia*. Its original meaning is *arrival…* or the advent of some special personage. New Testament writers used the term in regard to the Second Coming. Philosopher Martin Heidegger recast the word to invoke a sense of one's *arriving in the moment*, becoming present, inhabiting a state of pure being.

August:

A new breed of dog days
wagging you by the tail so hard
that suddenly you are furless.

Having played the dog and named it Love,
having eaten all the hidden bones,
having eaten from the tins they bought you,
you fall into a dream and awaken as a beautiful woman,
alone by a lake on a small stretch of sand,
prone, beneath a chute of coursing sunlight, immobile.
And around you, all Being is still.

Leaves sodden with summer,
the water's surface taut,
a plane of living granite, an ancient green descending into black.
Your skin, oiled, sucks leaves of gold from the air.
Your skin, that sheath once slashed by every thought,
is now a veil, transparent,
transposing every fold and curve of your desire.
Beyond translation.
Parousia.

REDONE BY ZEN

There have been several times in my life when I've experienced a suspended sensation of being out of body, or rather being truly *in* mind and body at the same time. One of them concerns the art of meditation. Forget what I might have quipped about that ancient practice, it is still something I aspire to learn more seriously.

There is a place we can go, when we allow our minds to go silent, a place full of delight and joy. I have glimpsed it before, mostly walking in nature. But in this case, residing for four days in the foothills of the Sierras, it comes to me in spades. Because here, beneath cobalt blue skies and between bosomy hills draped in dry yellow grasses and peppered fragrantly with pines and manzanitas, is where my Zen retreat is taking place.

I soon learn this state of joy can happen anywhere, even facing a blank white wall. For there is an essential joy residing in our natures as well as in nature herself. That joy is waiting patiently beneath and within every move we make, every sight we behold, every breath we take and every word we speak. It is ours at any moment we choose and, if I understand Zen correctly, it is our surest path to a sense of fulfillment.

Even though Buddha lived centuries ago, he arrived at a realization whose truth exists in a form as actual and as primal now as it did then. And that is, basically, that it's all inside of us; everything we need is inside of us. All we need to do is remain present to it, to remain aware. To remain conscious of the essence of being alive, which is in fact joy.

In the past, I had experimented with various stripes of meditation, often quipping that I was the Tigger of meditation practice. A taste of Tibetan, a dash of Hindu, a slice of Tantric... even swam in a soup of aurally-enhanced brain wave syncing. And yet nothing stuck, nothing came across as what Tiggers really like. I came to the conclusion that I was simply way too Western (and juvenile) to get it.

Then I heard a Zen monk named Cheri Huber speak for an afternoon, and some new sense of the possible flooded my body. I felt a sudden urgency to learn more of what she seemed to understand and express effortlessly. I felt she possessed some secret about life. I signed up for a silent retreat. The idea that I would not have to utter a word seemed incredibly attractive.

<div align="center">✿</div>

Upon arriving, I climb a small hill, walk under an enormous pine, through a variety of tiny cultivated maples, cross a tiny wooden bridge spanning several small ponds filled with reeds and lotus blossoms. My first glimpse of the main Monastery reveals two long, low, Mission-style buildings separated by a breezeway looking West, over the hills. The roofs are made of Spanish clay tile and, I later learn, the walls are of pressed earth. There are rows of mullioned casement windows framed with dark burnished wood. I take a very deep breath, inhale the fragrance of sunbaked life and feel an instinctive urge to bow.

We will be bowing a great deal from here on in... pressing our palms together just above our hearts as we lower our heads in deference. Gassho, it's called. It means my heart and your heart are one. We bow when we pass each other, we bow to the Meditation hall upon entry, we bow to our cushions, we bow again to the room... After a while, it seems odd not to bow to almost everything.

So the silence element... in fact it is not total. We are treated to numerous talks by the gifted Huber, and in turn are allowed to ask her questions. We also engage in a variety of fascinating and revelatory exercises — mostly visualizations and processes of self-inquiry — the results of which we then share with another partner or sometimes the entire group. These exercises can be at times cathartic. Yet throughout, we never respond to our fellow retreatants and always keep what is called 'custody of the eyes' — our eyes downcast slightly to allow each of us to experience ourselves beyond the gaze of 'the

other', beyond the need to return to our socialized personae.

Now I have never consciously been in the market for a teacher, but listening for four days to Huber's wisdom leaves me with the feeling that if I were, she would be the one. Skip the fact that her physical self is adorable — a diminutive, sprightly woman with a silver-haired pixie cut and an easy grin — what creates her real charm is her steady grasp on all the things that really matter. This must be the result of 30 years of Zen practice. I see her almost as a gardener; she's done the hard work, plowed the fields of the human psyche and is on an intimate basis with the dirt from which we spring. Which means she knows the weeds — how and where they grow, and how to free ourselves from their tendency to steal life from our intended crop — our true selves. Of this wondrous species, it is very clear that she has a stellar awareness. And it appears to be a mission of hers, one she cherishes, to help us discover that awareness for ourselves.

Cheri is a bodhisattva. While ordinary people dwell in their tiny, private universes, motivated by somewhat narrow desires, a bodhisattva, though undeniably an ordinary human being, lives by vow. *A bodhisattva believes that all of life, including the fate of humanity itself, lives within us. The caveat is that anyone who directs their attention, their life, to practicing the way of life of a Buddha is a bodhisattva.*

<div align="center">�</div>

Of course, then we get down to the nitty-gritty of sitting... Hmmm. It takes me more than a minute or two to get my body aligned, which entails bravely repressing infernal urges to fidget. Am I the only hyper-kinetic child here? When finally I win that battle, I am now faced with a larger campaign — to align my mind with the experience of pure existence, with the conscious awareness which is the living grail of Zen. This, I am quickly made aware, could take me a lifetime. We are meant to count, up to 10, at the bottom of each exhale. If, however, somewhere along the way thoughts have intruded, we must return back to 1.

After a few sessions where I never get anywhere near 10, I asked Cheri, "So what happens if I don't make it to 10, or even to 2? Do I just keep counting 1 at the bottom of each exhale?" She smiles. "That's right!" "And if I were to do that for the rest of my life... I guess that would be okay?" "That's right!"

There is a word that recurs frequently in the short recitation we read before each morning sitting session, and it is 'suffering'. Now I am used to thinking of suffering as something acute — a serious, damaging condition — one belonging to the disadvantaged of the third world or to the mentally ill. But in Zen, it becomes clear that we are all suffering on some level, until we become truly aware. And one of the lines from the recitation is: "We are here to use everything in our experience to see how we cause ourselves to suffer, so we can drop that and end suffering." *When I suffer, then, it is only because I choose to experience life as suffering.* Why would I do that to myself? I can imagine a few reasons, such as suffering becoming part of one's identity — but I think: it shall not be part of mine.

The happy news in Zen is that conscious awareness is a practice that just *begins* on the cushion. This is an immensely empowering practice. The whole point is that life itself is the vast workshop in which we learn to be present. In between Cheri's talks, our exercises, and the sitting, many of us take long walks through the wooded hillside acreage of the Monastery. During these, while maintaining that heightened sense of awareness we are beginning slowly to understand, we find ourselves noticing the utterly profound grace of Nature. Things that might have gone unnoticed suddenly spring forth like messengers from the deep; I spot a dandelion, poised to release its silken seed parachutes; its head describes a perfect geodesic sphere built by each translucent filament connecting to another at a precise angle — a heart-stopping instant of bio-geometric perfection. Next to it, a hot yellow dandelion blossom widens; nestled into it are two different species of insect sharing, without issue, the rapture of golden life within.

So much knowledge seems to bubble up during these four days, I feel like a bottle of shaken Champagne. And I notice a more pronounced experience of what Cheri calls the 'dropping in' of insights; it happens so easily when we are unguarded and open. We are continually urged to examine the ongoing dialogue between our 'conditioned minds' and our authentic selves. Actually, rather often we discover it is instead an incessant monologue on the part of our hyper-active egos, which is what impedes our access to true insight and causes our suffering. But we are encouraged to cut ourselves slack; Cheri points out that our egos are survival systems, the manner in which we manage to squeak through childhood without being sent to our rooms for the duration. Alas, those systems perdure as we mature, and soon we are being guided solely by (and beleaguered by) these defensive strategies and not by our own true natures.

The aim, or work, of Zen is to dissolve the conditioned self and reveal and release the true self, which is in the flow and is eternal and is goodness itself. By the fourth day, my psyche finds itself stretching out on a couch the size of the universe. My inner child is having a blast. Gazing at the towering, magisterial pine that stands at the entrance to the Monastery, and listing slightly to the right just as it does, I swear I have learned to understand tree. And I'm sure it sounds absurd, but I think, or rather I sense, that I can even talk tree. It's a different time-frame altogether. Curiously enough, I later learn that in Greece, just before Plato's ascendance, people sat around giant Oaks and somehow received wisdom. It's no wonder that people like to quote Heraclitus, who predated Plato and Socrates, when it comes to understanding the nature of time...

I hesitate to cajole into words what is in fact a visceral, sensory, deeply integrative experience. Coming to it with 'Beginner's Mind', this experience of the conscious, compassionate awareness that is our authentic nature, is world changing. I recommend interested readers read my interview with Cheri on my magazine realizemagazine.com.

None of this can really be understood rationally, or through language. And this is why retreats are so essential.

What I learned at the Monastery is that it is, in fact, never too late to arrive at oneself or, shall I say, never too late to experience the merging of the 'small I' with the 'big I', to drop into that sweet zone where the true self cohabits with that larger presence, which is Life, the amazing force which flows between and connects all beings one to another. Never too late to really know what we seem to be here to know, the radiant beauty of pure being.

HOW
TO
PLAY

*EPISTEMOLOGY OF A PARTY GIRL

(A glimpse at the general idea of my upcoming novel…)

Back in the day, I went to parties and I went to clubs, and I swear I was studying the nature and the very possibility of knowledge! In fact, the occasional hilarity I was somehow inspired to kick into gear opened up whole new paths of being and understanding within my psyche.

*Epistemology is the study of the nature of knowledge, justification, and the rationality of belief. (From Greek, epistēmē, meaning 'knowledge', and logos, meaning 'logical discourse')

Crack it up to being born in small-town America, then growing up in a suburb, surrounded by archetypal members of the repressed-and-drinking class. *Or* being born in 1950 and coming of age in 1) some of the most vexing years for heady young females and 2) some of the best years ever in terms of hell-raising fun. *Or* having a mother who psychically channeled her bohemian fury into my DNA. *Or* just being *born* a Party Girl.

Keep in mind that being a Party Girl and being an amateur Philosopher are NOT mutually exclusive.

Also keep in mind that being a Party Girl has way more ramifications than merely cutting up at parties. In its purest form, it is the urge to make life a party, a party that you throw — on some level or other, instilling a sense of joy, of play into everyday life.

For in the mind of a true Party Girl, she is the party.

But of course an *avant-garde* party girl also indulges in an ongoing *critique of* the party, of the *meaning of* the party. In fact she must make serious inquiries into why others do not share her approach to life as a

potential party. She may even wonder if the world, as many epigrams assert, is indeed divided into those who do and those who do not... or two 'parties' (as in political parties, who typically have wildly different appraisals of what a party should be like).

Party (n.) from 12c. Old French *partie* "side, part; portion, share; separation, division", literally "that which is divided," from the French: *partir* "to divide". *Sense of "gathering for social pleasure" is first found in 1716, in the general sense of persons gathered together (originally for some specific purpose, such as dinner party, hunting party).* Party (v.) "have a good time," 1922. Phrase "The party is over" is from 1937; Party Pooper is from 1951, American English.

In the best sense, parties are about play, specifically role-playing. We can dress according to a part we want to play. We can engage others in a jesting manner if we wish, because a tad of recklessness is part of the game at parties. Flirtations, jokes, jibes, pranks, dancing, bellowing with laughter. All wonderful for the soul. We really need to party way more often than we do. Really.

ART IS PLAY, LIFE IS PLAY

I believe I became an artist so I could keep playing. Because that is at the heart of what art is about. Playing with materials, concepts, and possibilities.

Give me a tube of blue.
What blue do you have in mind?
Is it Pthalo (I love to say it, knowing it starts with P), Ultramarine (not just marine but Ultra!),
or is it Cerulean, Manganese, or Cobalt?
Ah, give them all to me!
Then give me Hansa yellow and Viridian so I can make my own Proprietary Blue — Oh, and maybe a touch of Van Dyke brown to tone it down and because I love the work of the painter it is named for.
Now, get the hell out of here and let me play!

It is said that in Play, the player must accept the rules of the game.
But is Play always confined to the structure of a game?
If we assume so, then what are the rules in art? My first response is None!
But then I think, maybe this:
To create something that actually *says* something, that possibly *means* something.
Not in language, but in form, color, symbol.
Otherwise what are you doing?
Art is not an autonomous function. (Well, a few guys got away with it — Pollack for one, but I'm sure he would rebut this accusation.)

I'm not saying you can't finger paint, but that's another sort of play. It's child's play or therapeutic play. An activity undertaken to liberate. So that's play in the service of health. But is it art? Not in

the contemporary value system of art. Which in my mind involves the pursuit of meaning. Which may include beauty or it may not. In contemporary art criticism and for hordes of young artists, beauty is a non-starter as an aesthetic value.

So how do you play and hunt for or create meaning at the same time? You play with ideas, with memes, with existing tropes or cultural artifacts. So what are the rules for this then?

A Boston College psychology professor named Peter Gray has analyzed the various theories of play and created a few essential elements. One of which is that Play is *guided by **mental rules:***

*"Play is freely chosen activity, but it is not freeform activity. Play always has structure, and that structure derives from **rules in the player's mind**.... A basic rule of constructive play, for example, is that you must work with the chosen medium in a manner aimed at producing or depicting some specific object or design. You don't just pile up blocks randomly; you arrange them deliberately in accordance with your mental image of what you are trying to make."*— *Peter Gray, Free to Learn*

Okay, that works for me as a validation of art as play. If you're an abstract artist, maybe what you're trying to make is an expression of a particular feeling, or an expression of the impact of color and form. You are challenged, by your mental rules, to actually materialize this feeling or impact. Within these guidelines, anything is possible, and this feeling can produce an experience of exhilaration or that flow state recognized by Mihaly Csikszentmihalyi.

But, as any player knows, in play there is struggle as well. To play at the top of your game, whether or not you win, is what it really comes down to. And this gets back to playing with yourself, against yourself. Which in my case gets back to the positive side of the Tigger meme.

As an avid 'creative' I have often felt impelled to continue to transform my artistic practice and have therefore traversed many genres.

Given how wildly art has morphed over the past century, how widely different activities can now be classified as art, it is perhaps not unusual that I would do so, nor that my most current iteration would involve using my persona, to some degree, as artist's material. Like Anish Kapoor *plays* with pigment, or Kiki Smith clay and the human form, I have begun to *play* with my lived and my *live* experience, my own inhabited being, as the elemental media.

As you may already have read, I keep asking myself, 'What if I were Wolfgang Tillmans?' A German artist — as are many of my faves (perhaps because they're so conflicted), from Joseph Beuys to Sigmar Polke to Gerhard Richter — Tillmans takes candid shots, clips intellectual diatribe, prints automobile and office photos on aluminum, and puts it all together with serious panache and what appears to be an "I don't give a fuck what you think" attitude (obscuring the fact that "I'm an artist so I do, very much care, and please pay attention"), and more or less asserting that "by my mere combining of all these cultural artifacts I present you with a statement about the zeitgeist." This has become a new norm in Contemporary Art and is wildly liberating, yet is also laden with the risk of the entire accumulation falling flat conceptually. If I were half my age, I might join this movement fixated on cultural assemblage, but at this stage of my life, less is more, so I return to my game of solitaire.

※

Part of my 'argument' is that this lifelong effort to discover (and accept) who one is, then live accordingly and give that self full expression, is the mightiest struggle of our lives. And it can lead us through countless changes if we are open to it. I think about my own mother, who was a painter. She saw art as the way out of the deal memo most women of her time, unaware of their rights, reluctantly signed. But later in life she discovered she was more of a curator, and lo and behold an entrepreneur, founding a remarkable gallery of American Crafts in

Manhattan. Then I consider my Dad, who held so many different positions in business, from marketing for Parker Pen and Canon camera, to founding a ready-mix cocktail product line, to becoming a magazine publisher, all the while working that bon vivant thing he had in spades. It was all so cinematic, such a performance.

My Dad was a chameleon, and I guess I am too. They are creatures admirably built to reflect their habitat at any given moment and, since my habitat is LA, a very media-centric town and probably the world's biggest stage, it feels weirdly natural that I'd want to play in this new game — of self-appointed media personae (however bush league). Yet when the thought popped up in my psyche recently, late at night mind you, that, "Maybe now I could come out of the closet as a performer," I found it a tad peculiar, since I'm fairly hermetic much of the time. But as a child, I did get shoved into a metaphorical closet as both a hopeless ham or an overly loud singer. So I guess I can attribute this thought to a feeling that, as I age, I have less to lose. That I can then stake out new ground for myself just thinking, "I'm not an age, I'm a type." Because, hello — *we're all types!* No matter our age. Those types may stretch, distort, reconstitute as we move through life, but at the core, there's something going on which insists on being known. I guess that is what a *daemon* is. Our daemons drive us to all sorts of extremes. And for me, it just turns out to be Play.

TO PLAY OR NOT TO PLAY, THAT IS THE QUESTION

I say Play! Because we can! On this tiny orb flying in oblong orbit in the middle of the Absolute Vast, Play is beauty at its most primal, most ecstatic, most marvelous.

Play is our animal self at its purest. It is a great gift, for it confers Freedom. The freedom to invent, to imagine, to adopt different roles, wear masks, to cavort and to soar.

So I shall ask you not "How do you do?"

but "How do you *Play?*"

Or "How shall *we Play?*"

And at what game? A new game that no one has played before? Yes, let's play!

Actually, my fantasy is to establish myself as the Minister of Play, or High Priestess of it or Play Czarina. When appointed, I will build vast halls dedicated only to play. But, since they already exist for children, these will be for adults, so many of whom have surrendered their capacity to play by believing the only way to attend to the duties of adulthood is by remaining serious at all times.

These halls will host other activities as well; keep in mind the origins of the word play:

From the Old English plegan, plegian *"move rapidly, occupy or busy oneself, exercise; frolic; make sport of, mock; perform music," also from Middle Dutch* pleyen *"to rejoice, be glad, to leap for joy, dance"*

So in these halls, all sorts of ecstatic happenings will take place. Perhaps I'll call them Out of the Box Halls or Jolly Joints or... or perhaps I will start a sort of Geisha school. I'll call it a Player Academy. (Really, we must take back the word 'player' from the Hugh Hefner breed

because, alas, that sort of player only wants to win, or play with (mostly) women's private parts and hence their emotions.) But back to Geishas, the aim here will not be to produce refined concubines, but create a class of players and funsters...a class of amusers, a class of cognoscenti in the world of play. They will be of every gender. But of course there is a self-selection process already happening here, when you consider the role playing already happening amongst many tribes.

My Play Academicians are not to be considered jesters, who were just witty performers standing before a court of the besotted ruling class. No, these will be gamesters, highly interactive sorts who will get you off your butts and make YOU play. In this sense they are leaders, but any player can take that position if they like.

Let me sink into something absurd and obliterate the excesses of normality.

All creativity emerges from play — the free movement of the intellect and spirit. Language, courtship, sex, dance, music, art, theatre. Improvisation in any sphere. As one of the first theorizers on the topic of Play, Johan Huizinga stated: "The first characteristic of play is that it is free. It is in fact Freedom." Play is primordial, is of our essence. 'Work' is something invented by us but play is part of our DNA. Play is the antithesis of death. Why labor your entire life only to wind up a corpse? To play is an urge, an urgent need. Stifle it at your peril.

(As I write this, a gang of neighborhood kids are outdoors banging on bongos and boxes, jumping up and down, blowing bubbles and chasing each other with light sticks...)

There is a word in German that I ran across while reading philosopher Martin Heidegger. (Before I knew he was a Nazi sympathizer, I loved his work and I guess must still recognize his genius despite the warped workings of the rest of his mind.) He uses a word I love: *ursprung*. It means origin, source, roots. And I believe that play is an integral part of our ursprung, in fact part of the ursprung of the Universe,

which is clearly always at play, inventing and reinventing itself.

We can safely assert then, that human civilization has added no essential feature to the general idea of play. Animals play just like men. — Johan Huizinga, Homo Ludens

Well I get what he means, but this *is* a bit controversial, since humans have refined and developed the art of play in so many astounding ways. At any rate, Homo Ludens means Playing Man and Huizinga looks deeply into all human activities and discovers that Play is essential to all of them. Not only to games, but to all our rituals, including religion. In fact he believes that culture *arises* from Play.

You can deny, if you like, nearly all abstractions: justice, beauty, truth, goodness, mind, God. You can deny seriousness, but not play. — Huizinga

Play, a given and a right, in fact an imperative for any child, somehow flies the coop as we become adults. The ability to enter a play state slowly atrophies until we are surprised to find we've become *Old Bores!*

Beyond day-to-day survival, one of my missions, or actually a driving force in the general trajectory of my life (and why I've chosen art as a lifestyle) is to feed my inner child, feed her chocolate and toasted marshmallows and cotton candy. Give her the space to dance and holler, to say really naughty things and run away before getting caught. To play pranks, to play make-believe, to play for real. To fulfill the role of Puer Eternis. To reverence the puckish impulse to Play Above All. I consider this mission to have an ancillary benefit — my sense of self gets a free ride, rides the power of play like a 15-foot curl with no end.

What is true for children's play is also true for adults' sense of play. Research studies have shown that adults who have a great deal of freedom as

to how and when to do their work often experience that work as play, even (in fact, especially) when the work is difficult. In contrast, people who must do just what others tell them to do at work rarely experience their work as play. — Johan Huizinga

This to me is an essential truth. And in my ideal world, everyone would have the latitude (within reason) to work when they felt the urge to do so. To accomplish their work, but on *their* terms and within *their* allotted time. But that's a whole other vector…

Anyhow, there is the play that Huizinga discusses, of game and theater, but what of the play of one individual unto itself? I play with myself. And it's a good thing. (I don't mean like when I was 11 and got caught 'playing with myself' under the covers. A humiliation was attempted and to some degree succeeded. A general undermining of self-confidence… an abrupt awakening that one didn't know the rules, and that the rules were pretty weird. Took a long time to get over that. And a long time on my own.) But playing with oneself: how can you know your fellow human if you don't know yourself? How can you know yourself if you don't play with yourself? Compete against, play-act with, hide from, pretend, role-play…

The verb to play, meaning 'to take part in a game' dates from the early 13th century. Play as opposed to work, since the late 14th century. Related usages such as 'to play along', as in cooperate, is from 1929. To play house, as a children's activity, is from 1958. To play for keeps is from 1861, originally said in games of marbles or other children's games played with tokens. To play with oneself in the sense of masturbate is from 1896; wish I knew who first used it!

The intensity of and absorption in play finds no explanation in biological analysis. Yet in this intensity, this absorption, this power of maddening, lies the very essence, the primordial quality of play. Nature… could just as easily have given her children other useful functions of discharging

superabundant energy... But no, she gave us play, with its tension, its birth, and its fun.

*Now this last named element, the **fun** of playing, resists all analysis... it cannot be reduced to any other mental category. No other modern language known to me has the exact equivalent of the English 'fun'... Nevertheless it is precisely this element that characterizes the essence of play. Here we have to do with an absolutely primary category of life... We may well call play a 'totality'... and it is as a totality that we must try to understand and evaluate it.* — Johan Huizinga, Homo Ludens

MY EIDOLON APPEARS
IN THE NICK OF TIME

Having traveled to the other side of the planet and learned that Western culture is a consensual figment of our imagination, that those in the East have a *totally* different approach to almost *everything*... within the same few months having been to the middle of this vast American continent (Chicago) and puzzled over why Midwesterners all seem so rooted, so happy in place and realized that I am a creature who roams the edges... and, a month later, having been to a highly orchestrated wedding weekend with Texans and Vietnamese and seen the twain meet and wondered about togetherness and love... and finally having found myself the editor of a chimerical beast called Realize Magazine which appeared to be haphazardly tromping off into the wilds of the internet... having realized that the dough I've poured down the throat of this beast is becoming gruel thin... having unsettled my formerly cozy, workable domestic life and found myself treading cold waters... having wondered if I, myself, am the Chimera... in short, having totally blown my mind, I guess I could say I'm in a weird place right now.

I search through notebooks, scribbles, and random recordings for clues to my quandary, or coordinates to guide me through this wilderness, and stumble upon a voice memo from 2011, all about Play. Play, which was always my lodestar (even when in the depths of despair and doubt about the life of the artist). Play, which always defined me, at least Play as the counter-principle to Order, to structure, to normalcy... Where are you now dear Muse? How do I resurrect your limp body, currently draping itself across my lap?

While searching Google on the topic of Play, I stumble across a lecture by Garcia Lorca on Duende: Play and Theory of the Duende. Only Lorca could spin *duende* like that, including the word *play* in his essay. The duel 'played' between the soul and death? The Russian

Roulette mode of play? Duende, the deepest force behind all great art, as a very dark player?

Although darkness lurks within all languages, duende is an evasive, yet all-encompassing word you won't find anywhere else but in Spanish, and although Lorca borrowed the word from Iberian folklore (a duende is a goblin, pixie, or elf, usually mischievous), he poeticizes it, abstracts it. Duende evokes the liquid heat of tar black eyes, the eternal spilling of blood, the deadly, centripetal spin of a flamenca, the apparition of the waiting skull behind every beautiful face. Yet Duende incarnates as a Trickster, often cheating in the mortal game of life. The fact that I am so drawn, in my current anomie and disjunction, by this entity inclines me to believe I have recognized in this term my own Nordic version of it. A chillier, harder version of it. (I do have Bergman-esque genes.)

"With idea, sound, gesture, the duende delights in struggling freely with the creator on the edge of the pit. Angel and Muse flee, with violin and compasses, and the duende wounds; and in trying to heal that wound that never heals, lies the strangeness, the inventiveness of a man's work."
— Federico Garcia Lorca

When Lorca contrasts the Duende to the Muse and the Angel, the latter both appear a bit lightweight by comparison, not to mention fickle. Both indispensable, however, because they represent the *Ideal.* Which hearkens me back to The Eidolon (the title of my first and unfinished novel).

In ancient Greek literature, an *Eidolon* has two meanings: 1) a spirit-image of a living or dead person (which could also possibly be a daemon or a doppelganger); a shade or phantom look-alike of the human form or 2) an ideal. My usage of Eidolon is that of an ideal. Because of the significance I attach to this role (and against standard usage regarding capitals), I will henceforward capitalize the word.

But my Eidolon is a tease… like the duende, a dark player. He/she leads me on in an unending game of hide and seek. I think I've found him/her in the umbelliform penumbra of an ancient, enormous copper beech, then find myself climbing 20 feet up and suddenly looking earthward to find a crowd of concerned people below begging me to come down. I hear my Eidolon laughing.

But now there is this sensation of being the Eidolon myself, being an unsubstantial representation of myself, or as French philosopher Jean Baudrillard would say, a *simulacrum*. Is this merely due to the fact that this morning the Los Angeles sky is a cold and broody gray? Which brings me back to my psycho-geographical conundrum; what brought me here (the film business) is no longer a valid factor for me and yet what place *is* valid for me now? So many of my old friends are back East, living in expensive important cities, where I probably belong. But then I contemplate the cold, slushy winters and long stretches of gloom, and wonder — how can I leave this land of eternal sunshine and remarkably cheap rent and my newer friends?

How have I wound up in this fix, this bind, this strange imaginary cube whose walls are closing in on me? What is the damn word to describe this feeling? Is it finding myself at the center of a maze, and realizing I have wound up in this same spot several times already? Quagmire isn't the right word — too fatal. Yet I am feeling both rootless and bound at the same time — like a dead astronaut floating through time and space…. Yes, I have hurled myself into the universe with flaming thrusters, launched myself into a solitary orbit, and run out of oxygen.

This all gets back to — Who am I? Why am I? What do I have to offer the world? Somedays I just have no clue. But then I hang on through this doldrum for a bit and bang! Suddenly step into a luminous shard of ecstasy, a bolt of sunshine rushes through my body and I *Taste. Life. Again.* Lap it up. I lap it up.

(Or was that my Eidolon, not as an ideal, but as my daemon, my spirit guide, my purest self, a self of light, who has appeared to

revive me by allowing me to walk into her glistening form and merge with her?)

I have learned of late that I'm not the only person to like the malleability of the word Eidolon. In the Odyssey, Homer presented Helen of Troy's Eidolon as an independent entity that gives Helen life after death. Walt Whitman wrote a short poem in 1876 called *Eidolons* in which Eidolons are phantoms or ideational forms.

"The stars, the terrible perturbations of
the suns,
Swelling, collapsing, ending,
serving their longer, shorter use,
Fill'd with Eidolons only.

Exalt, rapt, ecstatic,
The visible but their womb of birth,
Of orbic tendencies to shape, and shape, and shape,
The mighty Earth-Eidolon.

The noiseless myriads!
The infinite oceans where the rivers empty!
The separate, countless free identities, like eyesight;
The true realities, Eidolons."

Wow. Clearly Whitman was seeing through the visible to another deeper, more conceptual realm, one filled with primordial forces reminiscent of Plato's concept of Forms, which precede matter and which are therefore the most primal reality.

I recently discovered the poet Hilda Doolittle who, in 1961, the year of her death, published a long poem called Helen in Egypt, in which Helen's Eidolon appears. I must read more about H.D., as she is known; it is said she was a highly influential and experimental mod-

ernist poet, as well as a "flamboyant narcissist, rambler, friend maker", and ardent seeker of the nature of self. A woman after my own heart.

But down to a less vaunted realm, witness this array of sci-fi books and games including Eidolons of all manifestations. None of these existed when I named my novel, or at least were unknown to me, in the pre-Google Eighties. While cruising the internet looking for Eidolons, I found an exhaustive list on Wikipedia, and was startled to discover that an author whose trilogy, The Mechanical, I had just finished (leading me to decide he was one of my all-time favorite authors) had written an earlier series, which featured Eidolons as primal agents of human destiny.

Wikipedia is mistaken in describing the nature of Eidolons in Ian Tregillis' Milkweed Trilogy *as other-worldly entities responsible for magic.* In fact, Tregillis presents them as inchoate but intelligent forces largely hostile to humanity, who appear to perceive us as a stain on the universe.

"The Eidolons don't have the same relationship to the universe that we do. In some sense, they are the universe—intelligent manifestations of it.... It's tempting to say that reality warps around the presence of an Eidolon, but that's not quite right. If anything, they're more real than we are. So rather, reality follows them. Orbits them. Things become more real than you might otherwise be used to. It can be unsettling." — Ian Tregillis

So you can see the concept of the Eidolon has traveled wide. Below I have excerpted from Wikipedia's long list of games and books featuring Eidolons. It all may seem ridiculous to you but I find it fascinating; it portrays these imaginary beings as having endured long and morphed extensively. Recently it seems more often than not that artists have chosen the path of Tregillis, casting these forces as malevolent. Yet Eidolons remain steadfastly open to interpretation and to the aims of the creator. Why not create sage Eidolons? I leave you to contemplate the possible existence of your own Eidolon and to what purpose you will put it.

A selection of Books (and yes, mostly fantasy fiction):

• In The White Ship, by H. P. Lovecraft, the city of Thalarion in the Dreamlands is ruled by an Eidolon named Lathi.

• In Clockwork Angel, by Cassandra Clare, the protagonist is a 16-year-old girl whose father was an Eidolon, a shape-shifting demon. Tessa, though not a demon, learns she too is an Eidolon. (Very weird that in editing this I suddenly see the transformation from daemon to demon. Must have noticed this long ago but obliterated the pejoration. Hmmm.)

• In the Wildstorm Comic, Stormwatch, by Warren Ellis, the Eidolon is a superpowered villian who travels the world telling people he's seen "the other side" and that there is no God. In reality he is actually just a disembodied ghost pining for oblivion.

Games

• The Eidolon, a 1985 computer game by Lucasfilm Games.

• In the Warhammer 40,000 universe, Lord Commander Eidolon is the First Captain of the Emperor's Children Astartes Legion.

• In Magic: the Gathering, on the plane of Theros, an Eidolon is a spirit created when the soul of a dead person separates from its body.

• Many Final Fantasy games, specifically Final Fantasy IX, Final Fantasy XIII, and Final Fantasy Type-0, allow players to summon magical entities called Eidolons to assist in battles.

• In Dungeons & Dragons, 4th Edition, an Eidolon is a golem-like animated statue brought to life by a shard of divine energy. (I like this one.)

• In Eclipse Phase, an Eidolon is a specialized computer program that acts as digital body for digitalized minds, allowing infomorph characters to specialize. (Infomorph is cyberspace term for a hypothetical, virtual information entity that possesses emergent qualities such as an ego or personality. Coined by Charles Platt, in his 1991 novel The Silicon Man, it refers to a discreet consciousness, uploaded into a computer,

which has the information processing capabilities of a human brain and is run on a mind-emulation software platform, in effect a cyberbrain.)

• Eidolon, a first-person survival game set in an aesthetically alluring and minimal post-apocalyptic Washington state. I'm not a gamer but I'm pissed I don't have the right graphics card to play this on my Mac.

And, last but not least, Eidolons have made their way into the music world.

• Eidolon is a heavy metal band, as well as the name of an album by black metal band, Dark Fortress.

Like I say — time to redeem the Eidolons and shift them from forces of malevolence to forces of benevolence and enlightenment!

DRINKING FOR CLARITY

It is no surprise to me that the imagination should bring fevers and death to those that give it free play and encourage it. — Michel de Montaigne

Drinking. It's in my damn Anglo-Saxon blood, aw'right? Coursing through my DNA is a river of fermented fluid. Bred on this neurotoxin, I twitch at the thought of its absence. I am told, however, that my condition is not alcoholism, but a mild form of habituation: a glass or two of wine every evening with dinner is just a sort of civilized addiction, which now is considered to actually promote longevity — perhaps because people will continually look forward to their nightly glass of wine?

I know I'm not truly addicted; I don't get the fantods (the fidgets), yet can I stop? I never drink on movie nights, or lecture nights (clearly all I need is diversion, engagement, activity). But really stop? I've tried, feebly, a few times and every time I get to 10 PM I tell myself, well, clearly I don't need it; I forestalled this long, so obviously I *can* stop, and therefore I'll have a glass of wine.

Call me sybarite, call me lush, call me tippler, call me hedonist and you would be correct. But guilt-trip me about it? Don't bother, I can do it to myself. Although I finally gave up on that; one can only fight so many battles against one's inmost drives... And I take heart in the fact that my various muses have all plied the same luscious vein. Lautreamont, Rimbaud, Baudelaire, Dylan Thomas — there are too many to enumerate. For artists, the protocol has been the same for centuries. "Disorder the senses" and find the secret source of the self, which is the not so-secret-source of civilization.

The artist makes himself a seer, by long, prodigious and rational disordering of the senses. Every form of love, or suffering or madness: he searches himself, he consumes all the poisons in him and keeps only their quintessence. This is an unspeakable torture during which he becomes the great

patient, the great criminal, the great accursed, and the great learned one among men. For he drives at the unknown. — Arthur Rimbaud

I memorized this quote, under the killing flourescent glare of Boston's Lechmere line, returning home from my classes at the Museum of Fine Arts. Surrounded by the blue collars of Somerville, I had repeated these lines like an incantation. I thought, I will stalk the unknown. It is my duty as an artist.

Of course the 19th-century types only had absinthe, hashish, cocaine, and opium whereas we have many more substances to abuse, to throttle the self into yielding universal truths. (In fact there is something absolutely alluring about absinthe, the Green Fairy, the real stuff made from Artemisia Absinthium, which you can only buy online at rather exorbitant prices. Absinthe's most vital ingredient is Thujone, a terpene, and is arguably considered the prime mover of the shifts of consciousness for which the drink is prized. Hello — a multiplicity of terpenes intertwine within the phantasmagoric soul of weed as well.)

Yes, the Poor Ol' Self. Forever locked in its little keep, kept in the dark about the real world beyond, gazing at Plato's shadows on the wall as the days roll by one after the other. If the key to release from this prison is a few drops of alcohol, if the flight path to higher realms is a few puffs of weed, if the secret code to unlock the truth is the occasional hallucinogen, then so be it! (Well, I wax a bit hyperbolic, since I haven't touched the latter for decades, but what was once revealed to me remains etched in my psyche.)

But am I playing fast and loose (love that phrase)? I claim that we must dive into the self to find truth, and yet that we must escape the self to become free (back to the toroidal nature of it all). In fact I consider the self to be a phantasmal creation equipped with the tiny, nearly useless wings of the Ego, itself clutched by the fearsome claws of the Super-Ego and saddled with the throbbing genitals of the Id. So while we would escape it, the only way to tame it is to know it. Like Socrates said.

For me, a glass of wine, beyond enhancing any food, softens the clangor of the chittering super-ego. Yes, meditation can do the same, it just takes longer. And I am always looking for the secret shortcut that transects the field and breaches the walls, that path where the shadows of unknown creatures flit alongside as you run, the path where you hear your own panting like a rhythmic baseline beneath the melody of nightingales...

Frankly, trying to maintain myself in pristine condition until my 90's has dubious value, as my various powers will probably diminish by then anyhow. My physician friends don't like it when I comment that the liver is an over-rated organ, or that you might as well ride the Wild Mouse while you can still hang on to the bars and still have synapses on tap. My Mother's baby sister (who by the time I knew her as my auntie was a pixie-like, margarita-loving smart ass) once said "I might get run over by a bus tomorrow, so what the hell?" As it turns out, she died quite peacefully at 85. I salute you, dear Miggs, with this glass of Pinot Gris.

HOW TO PARTY LIKE AN ARTIST

First of all, what the hell does it mean, to party like an artist? Eating and drinking with your artist pals around a big wooden table and shooting the shit about art? Maybe moaning about how fucking hard it is to make it in the art world as it's presently constituted? (Then about how it always was fucking hard?) Vaunting the value of the sacrifices made, validating one's peers in a comradely fashion, while secretly wondering what Damien Hirst was doing that evening? Sweetly pissing on the works of other lesser artists, which would mean almost all of them not present? Dreaming gloomily about the days of Peggy Guggenheim in Venice, when all the greats were in attendance, while knowing those parties will never be reprised? Yes, indeed, La Vie Bohème of the 19th century is long gone, as is fifties Montmartre, and even eighties New York.

Well, even though I've said I have no interest in writing a How-To book, maybe *this* is a how-to book: HOW TO PARTY LIKE AN ARTIST! I can see the marketing blurbs now:

What to wear
What to serve as drinks and tidbits
Who to invite
What to say!
What to play?

Anyhow, here are a few notes toward a book I'll never write.

If it's your party:
What to wear: Men's pajamas and a smoking jacket, or a seventies polyester caftan, preferably in an abstract print.

What to serve: As drinks, some made-up confection. Your skills as a

mixologist go a long way in proving that you are creative at *everything*. I will post my favorite summer drink on my website. I call it Pond Scum because there's so much mint in it. As for tidbits — Pigs in blankets, Persian cucumbers dipped in black lava salt, batter-fried crickets?

Who to invite: Only invite any A-listers you know if you're *sure* they're not snooty and will add to the merriment. Who needs stars that look bored and leave early? Do not invite the pretentious. Do not invite the intemperate.

What to say: Sadly, political talk seems to have overtaken the role of gossip, but don't like go all downer on the party vibe. Read a book of philosophy or an artist's memoir beforehand so you can make awesome references and come across as an intellectual. And heck, it's your party so "cry if you want to". Well, actually don't.

Who to spin? Easy, go to my blog and find my current playlists. I'd start with some Charles Mingus, move on to some LCD Soundsystem, throw 'em for a loop with some country western, then circle back around to Little Dragon and Bjørk!

As for play? I highly recommend Fictonary — all you need is a big ol' dictionary, some paper and pencils.

Re: Other people's parties:

What to wear: If it's upscale, go mod, minimal, color-blocky… or wear some sort of uniform. Pale makeup and blue eyeshadow. Shoes are critical. Ideally something you've blown your monthly budget on. Converses are acceptable but only if the rest of the getup is wildly unique. Actually, Converses have become boring. Do not wear anything covered with splotches of paint.

What to say: Follow your host's lead. But if they appear to be under-fueled in the content department, go back to the guidelines for your own party. Ideally say nothing unless it's supremely memorable.

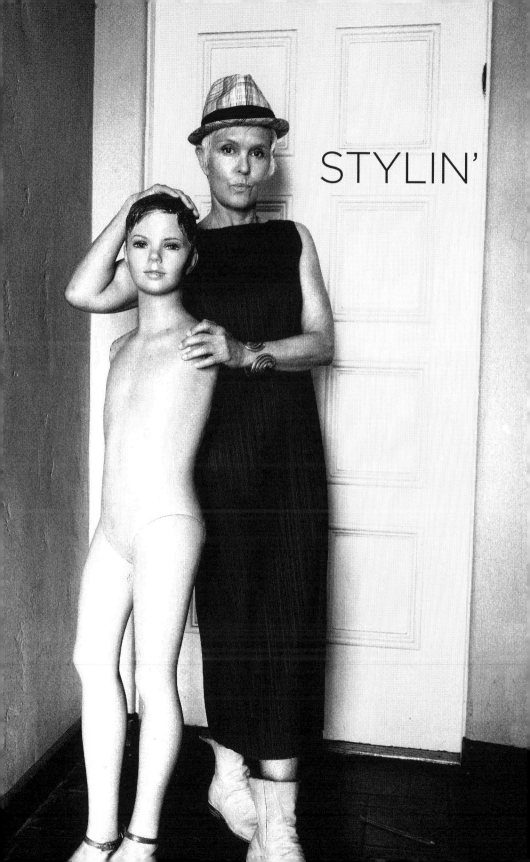

STYLIN'

STUFF WE WEAR

I saw my stuff hanging on a hook in my brother's perfect, Swedish Modern bathroom (to be precise, a red American Apparel hoodie and a pair of gray, magnified-heather-pattern knit sweatpants from the Gap) and I thought — I must write about *Clothes*. Not style *per se.* But the mere fact that we have to clothe ourselves, and how clothing has become a dominant element of world culture. Possibly even *the* dominant one.

We wrap ourselves. We wrap ourselves in sheetrock and plywood. Or in marble and glass. We wrap ourselves in sculpted steel attached to wheels. And we wrap ourselves in garments. We can hide out in our abodes, but we can't hide out on the street. Some of us may want to and may think we do, but no matter how you dress, and whether you like it or not, you're presenting a particular self to the world in the way you dress.

There are infinite stories to be told in the way we dress. And I wholeheartedly believe that clothing influences people. To dress with thought, or panache, or whatever you want to call style… if you can pair that with good ideas and the ability to express them, well, you shall be ready to take the cake. If you can find the party that is.

"All dressed up and nowhere to go." Such an ardently melancholic line. Especially as I, for one, now live it. I *used* to dress and go Somewhere. And, as a young artist, I dressed on a dime. For months, when I went out to clubs, I wore a hunter-green nylon suit that looked super Grace Jones — wide shoulders, no buttons, harem pants, if you can believe it. Hell, it was the eighties. Wore it with a pair of coral red heels, very forties (high-sided and deep V-cut, modified-cone heeled) which I wore with white ankle socks. Sometimes I skipped the socks. I could see how it might be sexier.

What if everyone dressed in a way that would make dancing at the drop of a hat feel totally natural? I mean — dress so you could really cut some moves. No stockings, no ties, nothing that confines movement.

We could all dress like the Kryptonian Council in the first Superman series! Well, maybe not that drapey. Or just do like I do most days, which is to dress in a onesie.

I don't shop at Gucci or Prada (although I absolutely adore Miu Miu) because they're all outta my price range. But who needs them, really? For instance, both Zara and TopShop have really fun designers working with them. And both companies have been doing some cool stuff with neoprene in the last few years. From the latter I got an awesome sky blue, black window pane checked gathered circle skirt that could have come out of Tim Burton's Alice in Wonderland (if it were set during the 50's). And from the former, a long jacket in pale smoky pink neoprene suede with the black interior showing in its cut seams. Sharp. Affordable. I'm all about that. Why blow good cash on fashion unless it's a piece that will define you for a decade or two? And who the hell are you gonna be then?

Me, I'm not all that static, can hardly predict my mood or incarnation for the next day, so investment dressing doesn't really work with me. Oh, except that I keep almost everything that wasn't a mistake in the first place. Which means that at my advanced age, I can rifle through a closet spanning a few decades. (That Tidy book? I'm not cracking it until you put a gun to my head! I'm a maximalist, honey.)

But back to money. Some of the coolest styles always emerge from people who haven't a cent and are cherry-picking thrift stores and stealing from their parents' closets. Because ultimately… it's about the cut, the color, the pattern and how you mix it all up. Doesn't take a fortune to do that.

Some people think they don't have the body for fashion. Bah. I went to a local event at LACMA the other night and there was a very hefty chick in a long, flowing, red and navy striped dress. She was curvy as hell and looked superb. If you crave style, then love your curves and work with them. Or lose them. Like I keep saying. It's in your hands. The whole damn thing is in your hands.

So look down at those hands. See life squirming in them? It's begging to be played with. And if you don't — it will leap out and run off.

As for me? I guess the way I use fashion is as a form of announcement. Here I am. What will you make of me? What will I make of you? Who holds the cards? What can I do with you or even to you that I couldn't if I were dressed less imaginatively? Life is a seduction, not a boxing match. Light my cigarette and I'll study you as you do. Well I don't actually smoke, but I want that level of interaction. More of it. But Give it to Get it I always say.

Anyway. Step out of your comfort zone, people. I don't want to be the only Krazy Kat on the street. Play with your style. Free yourself and you'll free others!

CULTURE DRIFT
AND FASHION

How does one define culture at this point? One does not, one really cannot, because in the next micro-second it has moved on. That is the only thing one can say about it at this juncture — it's ephemeral, a fast flux, a blur. On second thought, maybe it's also a beast — a huge, hungry, gangly beast. A beast on a spree, a beast broken free of whatever tethers once restrained it, a beast with enormous appetites eating up all the innocents it encounters on its rampage.

The most dramatic visible element of culture right now, drastically inflected with the celebrity consciousness swamping the world, is Fashion. It absorbs the attention span of anyone looking at entertainment media, at social networks like Instagram and Pinterest, or even just walking down a city street. Because really, everywhere you look, it's almost the first thing your eye asks your brain — what are they wearing? Of course 'fashion' and 'style' are two distinct entities. The former being what is 'of the moment' commercially, what's walking down the runway, and the latter being the imprimatur of how one presents oneself to the world, how one visually configures oneself. External vs. Internal?

Of course there is an endless loop between the two. Fashion steals its cues from the street, from the style of whoever is clever and bold, and the street robs them back by finding a cheaper and cheekier way to approximate the immediately evanescing memes of fashion.

Where the two collide most spectacularly is in the music business. Just load up any music streaming site to see what the glitterati are wearing. It's always over the top. Now that we're beyond Madonna, it's characters like Lady Gaga setting the pace, bless her meaty soul, and Katy Perry following suit, bless her candy ass, and now, if you want to be a star, you better dress like nobody else, which gets harder and harder to do. Rihanna, in my opinion a real powerhouse of personal style, turned

up at last year's Met Gala in a Comme des Garçons get up that looked like an American quilt colliding with Godzilla in the middle of a flower show. Nonetheless, brave women all, even if at times a bit desperate. But I thank them — for making whatever daft ensemble I jump into in the AM seem totally plausible.

But are the fashion brands themselves getting a bit desperate as well? I mean, how many more iterations can the fashion world produce? How many more ways to clothe a human? And, by the same token, how much more is there to say in words? How many more ways to state the ineffable in Art, which is continually battling its own obsolescence, its own cannibalizing of former memes? What taboos are left to demolish? What new ground to break in the field of manufacturing meaning? And where will the endless quest for the *New* leave us, except panting, on the field of the been-there-done-that?

But back to fashion, which presently is overexerting itself to capture something *New*. If you glance at the quarterly issues of hipper-than-thou fashion mags like 'Fucking Young' or 'The Gentlewoman', you'll find models barely out of pubescence bedecked in truly outlandish outfits. I'm just riffing here, but I could see a willowy Asian person (of unknown gender) swathed in peach colored fake fur, atop asymmetric blue and black plaid harem pants, yellow and black patent leather saddle shoes with six-inch platform heels and a plastic sunshield atop a shaved head. Maybe there'd be a Pomeranian as accessory.

But this trend is trickling down even to the more classic magazines. Recently I opened a Vanity Fair and two adverts leapt out at me. A tiger, ready to do who knows what, is poised in the middle of a bakery, in the middle of a Gucci ad. Gucci is using tigers as accessories, tigers in bakeries! Probably shot in Rome or Paris, where you can still get away with stuff like that. But what the hell are we telling ourselves? We can have it all? Buy Gucci and take home a tiger with your brioche, baby.

Then there was a Kate Spade ad. Photographed in the middle of an empty cobble-stone street in downtown Manhattan, a Japanese model

in a pink wig is smiling sweetly at, and apparently really starting to bond with, a camel, a real live camel. (Well, this is after all perfectly logical as she is wearing a skirt printed with tiny camels, which obviously necessitates the real thing. Just wondering if the camel had nightmares post-shoot? Or maybe it simply made the smart move and segued into a new life as a celebrity dromedary.)

From the perspective of an average, say, Middle American human, all of these get-ups and antics might appear a bit hysterical. And although I agree (because in fact I was at one point a Middle American, at least 'til the age of 16 when the family got the hell out of Dodge), I actually dig fashion hijinks, because that's how I like to dress.

Alas, I am just a small-time culturati and truly, it doesn't pay to be a small-time culturati. Ideally you start very young accumulating social media cred so you can amass some brand capital behind you. The more your social worth, and ultimately the more your net worth, the more the fashion houses throw their rags at you. Eyeballs on bodies, *ad infinitum.* (There is an artist installation at Burning Man which is in effect a kaleidoscope into which you put your head and see yourself reflected for-fucking-ever. Is *this* culture now?)

The fabulous thing about culture is that in fact no one person can define it. It's in the eyes and ears of the beholder. (Is that decentralized and global enough?) And the more you evade the norm, the hotter you are. Kenzo, that fab brand of the 80's, is now being run by the duo behind the equally fab Opening Ceremony, who claim that they don't labor over marketing, they just follow their gut, or their Muse (the former being more reliable). So far, their biomes seem to be up to snuff.

Back again to Vanity Fair's ads. Once again there are men, or rather adult boys, in Calvins. But unlike a few decades ago, when their butts would have mimicked ripe peaches, these fellows are now starkly pre-pubescent and unremarkable, and their Calvins look like super-geek undies or skinny Depends. Anomie rules. But then it has ever since the Punk Era; models are at their most alluring, ostensibly, when their look projects supreme boredom with it all. And maybe that is the correct response.

WE ALL BELONG
TO A STYLE CULT

Doesn't matter if you're standing in line at Supreme, or shopping the Real Real's online consignment sales, or mad for Rachel Comey, Opening Ceremony, or Celine… Doesn't matter if your jeans are skinny, boyfriend, pre-torn or you only wear pencil skirts. Or if you wear Docs or Choos or clogs. Doesn't matter if you say you don't give a damn about style and pull on whatever t-shirt happens to be on top in your drawer or the pile on your floor and your jeans may be way out of date… because no matter what, you are a member of one Style Cult or another. As in a cult, your approach to fashion is a defacto creed of sorts, a belief system by which you, in part, define yourself and present yourself to the world, bedecked in the raiments and signifiers of your chosen cult.

My particular cult is fairly arcane, and for that I often get street props. Perhaps it's a mash-up of boho cowpoke with Japanese aesthete, of avant-trekkie clown muddled with a splash of gangsta. Or whatever. But I know it's a cult, even if I don't know who the leader is. Hell, maybe it's me… and maybe secretly that's what I strive for.

Golly, I denied the fact for so long, I almost believed I didn't really care about style. But there comes a time in one's life when you just can't hide from yourself anymore. How often could I find myself mentally sifting through which jacket to wear with which jeans and which boots to wear with which skirt before realizing that I was casually obsessed? Of course it was part of my DNA, as my mother was fashion fixated and dressed me, as a teen, in twee, heathered wool skirt-and-sweater ensembles by a company called Villager — on the preppy side, but with an impressive choice of tweeds and cable knits, all in exquisite shades. Add the Peter Pan collars, circle pins, and penny loafers and you join a sisterhood of haute-suburban clones.

But I soon rebelled and by my twenties was dressing in thrift store finds: 40's dresses with poodle patterns, or rows of rick rack, or big buttoned shirt dresses with vast skirts. Really never gave fashion much of a thought back then, because it didn't matter what I wore; I was young and more-or-less darling like one is in one's twenties. My favorite dress of all time, which cost me $8, was in fact a VFW uniform — a khaki, military shirt dress made of a stout rayon twill, with a tailored waist and a pocket over the breast embroidered with VFW in crimson. It fit like a charm and in my mind seemed appropriate for any occasion. But then that was the late seventies, and retro ruled. In the winter I wore a huge bourbon-colored swing coat with a big rounded collar and fat cuffs. The rest of the time it was bell bottoms or boy's jeans and kid's t-shirts. I especially loved tourist t-shirts like the one that featured a leaping deer, beneath which, in red script, was the word Wisconsin, or the one I picked up from a street vendor in Rio, emblazoned with an adorable, pugnacious little cartoon demon. I also wore little boys' button-down shirts from the fifties — I most remember one corduroy shirt, red with a tie print and a deep V placket of black corduroy down the front. Ah, to be an art student back in the days when nobody taught you anything about commerce. We graduated, heads filled with projects and concepts and nary a clue about how to make a living.

Bouncing around Manhattan pushing thirty, I was still living on a shoestring (even lived once in the maid's room in a huge old mansion, rented out to other miscreants like myself). Mostly wore the stuff I'd found in Cambridge, although my mother took pity on me once and dragged me through Henri Bendel, where I found an amazing pair of hot teal blue, wide wale corduroy overalls and a French warship-gray raincoat, made of material like they use for foul weather on boats. I wore that coat even in the winter. The man who would become my husband was so scandalized that I had no proper winter coat that he marched me into Norma Kamali where I chose a hardly more useful garment. It was like an old school, 1920's opera coat. Dark gray velour

on the outside and deep black plush on the inside with a voluminous collar. I don't think it even had buttons. Never did dress sensibly.

Along the way I met a fashion designer named Robert Molnar, who has now gotten the acclaim he was due in menswear. We were introduced by a wonderful painter named Milo Reice, who asked Robert to make me a dress. Milo had a crush on me, I guess, and gave me an extraordinary painting featuring myself as a princess in reverie, with a lion laying his head across my lap. I got along famously with Robert and together we designed a very fanciful dress I wore everywhere. A beautiful smoky green blue (which I call Gainsborough blue), it was made of silk file and had a boat neck, puffed sleeves narrowing at the wrist to a row of tiny buttons, a plunging back, with more little buttons, two big ruffles around the skirt, and a wide sash with huge bow at the hips. Sort of like something a young girl would wear in a Singer Sargent painting. I partied well in that dress, and often wore it with a pale pink hat with a vast brim, which I turned up in front. Add in my pale white stockings and the same coral red, high-sided, angled stack heels I always wore for dress-up. I did make an impression. Alice in Wonderland at Studio 54…

When I finally married, my husband's mother, a complete fashion victim obsessed with propriety in all things, occasionally handed me a check intended to spruce me up sartorially. She had at one point been quite svelte and well-financed enough to stuff a stunning closet. But as she'd doubled in size, I suppose she got vicarious pleasure out of dressing others and her donations did round out my own wardrobe. Since I was on my way to being the mother of her grandchild, she had a certain amount invested in me, so to speak. Not that she ever really cared for me, since I barely shaved my legs and insisted on wearing ankle socks with everything. (Puer Eternis, Perpetual Youth Syndrome.) She and her mother traveled to Italy yearly to a spa for her mother's health and they always returned with designer bags and mohair sweaters. Birthday presents were large checks with the intended goal of wardrobe improvement.

She never knew that sometimes I invested in stocks instead and actually made a tiny wad of cash. But I did buy a Prada bag once, and some outtasight Prada shoes, very space age: quilted silver Mary Janes, with a sporty white border around the top and a wide gray-and-white striped elastic band over the arch. Never seen anything like them before or since. I will be donating them to the Met Costume Collection when I die.

At any rate, the Eighties is hardly worth describing since it was probably the single-most embarrassing decade of fashion ever. I did not escape the burden of shoulder pads stuffed into jackets that looked like they'd come from the set of Flash Gordon. The harem pants and pleated peg legs were tolerable, but just. I believe I've finally given all of it away. When my then-husband moved into the fashion business, working for various Italian firms and finally Gianni Versace, I wound up capitalizing on sample sales. I was just the right size and wound up with everything from double-ply cashmere men's cardigans, to Versace pant suits with those dreadful, huge gorgon head buttons, to lots of Lorenzini men's-style button down shirts and some truly divine Cantarelli wool suits which, alas, I have nowhere to wear in Los Angeles. This is only one of the reasons I may have to move back to New York.

But divorce took its toll on my finances, as I was more interested in my liberty than financial ease. Fool that I was, since it can be tough to enjoy one without the other. And fifteen years down the road from that, with finances waxing and waning, I find myself cribbing from and remixing various components of my style history. Thanks to some now very sensible global clothiers, I've been able to combine $40 jeans with old blazers and bang up whole new looks. And the older I get, the more inventive and daring.

Although I dress to kill when going out, dress like a vixen when in hunting mode, and love to play the kitten, at bottom I am more-or-less an androgyne. Some of that's determined by my body type, which has always been boyish — small breasted, narrow hipped and lean. Yet

when I think of it, this gender fluidity, if I can claim that, is both personal and political for me. It has been one way to exhibit my deeply anti-authoritarian streak. Nobody is going to tell me how to dress or behave.

Most of the time, however, I dress to amuse. Myself first, then any other imaginative souls I find out in the world. My daily garb switches from amongst a couple of styles. One is a lesbian cliché — baggy jeans with suspenders, fedoras, porkpies, and oxfords or Blundstones with crazy socks. I scored a mechanic's denim jumpsuit (on radical sale in Boston at a store called Denim and Supply which is a covert name for Ralph Lauren, which if I'd known might never have ventured into but, well I got it at 70% off, because I guess Bostonians are more uptight than Angelenos). Or there's my gym slacker look — blazing yellow sweatpants with white racer stripes, worn with a red hoodie. In the summer I get a bit more girly, pattern-y, and shift-y on some days and on others, I sport a pair of vintage denim overalls I picked up at the Rose Bowl Flea for $15. One day I noticed the stamped buttons said Bill Blass; he was a very high-end designer, so this must have been the seventies when they were all trying to be hip. I would totally have worn them the first time around, except they would have been 10x the price even then!

But really, onesies are my garb of choice. And when I wear one, I find that everyone, from my physical therapist (a guy) to my trendy 12-year-old neighbor and his mother, want to know where I got them. (I scored a trio of them on radical sale from a Norwegian company called OnePiece.) Really they're the comfiest things around, except when you have to pee, but I've got the workaround on that if you're curious. Weekend gallery openings are open season for fashion and I'll wear any odd combination of things in my closet. It is, after all, the purview of the artist to dress according to whim. And I am nothing if not whimsical. I'm totally comfortable with sartorial self-expression and, as I get older, even more so. This is the tremendous boon in the

aging process. You care less and less about who thinks what about you.

Here is my fantasy get up for my first shoot in Vogue (we all need dreams, right?) — an oversized pair of hot pink, wide legged cropped track pants with orange and purple stripes down the side (they're on my instagram if you're curious); topped with a pointy collared, button-down shirt patterned in big, hot pink roses; purple furry mules (even if they'll be so last-season by the time you read this). No makeup except hot pink lipstick. I can hear the sneers: "How old did she say she was?" And I'll holler back. "I forget!"

BOUDOIR DECOR

As a medium girl (not a little girl nor a big girl), I hated Pink. I resented the damn color because it was the color of sissyness, of dolls, of being sashed and pleated and embroidered and not playing outside. Pink was pusillanimous. But then Punk hit Manhattan, in the seventies, and the color Pink, with a loud banging, ascended to a ballsy throne, whereby pink finally seduced me.

I bought a bubblegum-pink leather jacket on King's Road in London. No buttons and a shawl collar. I was going to scrawl ANARCHY on the back but thought better of it. I even wrote a tune about pink called, what else: I LIKE PINK. ("Vomit in the sink, take another drink, cuz I like pink, I'm in the Pink, in the Pink/I drive a pink caddy, got a pink sugar daddy...")

Now, eons hence, my feelings about pink have changed shades. A pale pink I would call Pink Peppermint Gelato is my new thing. And a sassy pink-patrolling-peach, which I would call Spanky Pink, can make me faint. But then I'm an artist; I swoon over color on a regular basis. I dream about it too and just now, because it's late and I'm losing track of rationality, I'm conjuring up what an awesome boudoir would look like, what colors would spill it over into the realm of fantasy; what a lady such as me (although I ain't no lady) might require in her innermost sanctum. Of course it depends on what she might do in there, but for argument's sake, let's assume anything — from burrowing down with a book, fondling her doggie, lolling about in a state of hypnogogia, or getting wildly and consensually ravished.

So. I shall start with what my delicate skin will encounter most, and that had better be high thread count, Egyptian-cotton sheets, ideally in a softly ruddy pink, like the color of Cherubim Cheeks on old French ceilings. These would just barely peek above a duvet (in a color evoking Eggnog liberally stained with Pomegranate) whose folds would reflect the supernal shade of Robin's Egg Blue satin with which the canopy had been draped.

At the windows, exorbitantly bunched silk curtains in a hot Antique Coral, pulled back with enormous braided tassels in sienna and cerulean and gold. Walls — a pale Aegean Turquoise blue. Wide-planked bleached wood floors with small silk orientals in golds, siennas, and manganese blue. A huge, faux, polar bear rug. A small 17th-century French, white ceramic fireplace. No chest of drawers, since that would be in the dressing room, of course. Stacks of books on an Empire bedside table with gilded, winged female caryatids and lion paw feet. More books and objects jammed into brass étageres and, for setting off the entire room with a golden hue, a few Empire candelabra (these with putti caryatids).

Now as for the art on the walls. Well, I've awakened to the same painting every day for the past decade and it still seems the most appropriate image for me to continue to consider upon arising. (Well, I did paint it after all.) This is a large oil painting, six feet tall, and in it a nearly human-sized Peter Rabbit is being chased by flames as he runs through a pale green wood, concentrating raptly on the planet Earth he holds above his head. This serves as a reminder for me, every day, that when I plan my day I keep in mind the precarious state of life on this swell planet.

I already have the best image for over my bed, a portrait of one of my guardian spirits — the bust of a Lassie look-alike, floating on a background of what else but Pink Peppermint Gelato. I wouldn't mind another canvas, and I may just have to paint that as well. In a church in Siena years ago I captured a photo of an exquisite stained glass window featuring a young child (yes, it was probably Jesus, but any child will do for me) that, due to the sunset streaming through was transformed into a gleaming, golden, magical creature. I imagine rendering the child with his/her hand resting upon a miniature horse and both embedded in a grove of gold leaf. Perhaps there would be tiny bluebirds overhead, and other animals poking their heads in…

Hmmmm. Well now it's time to hit the hay and my actual sheets,

which happen to be a sort of sultry, Mediterranean blue — to sleep, perchance to dream I sleep, in my ideal boudoir. Oh, but at least I have the perfect dream companion at my feet, my sweet little enigmapoo.

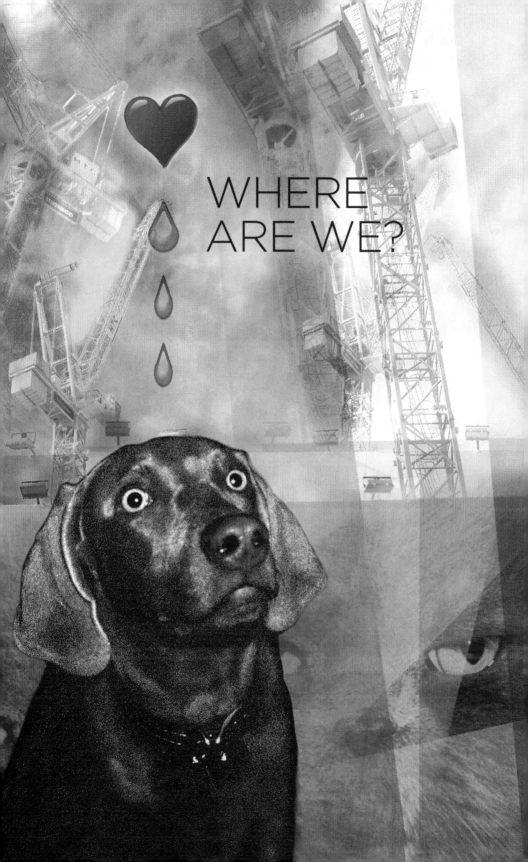

HOME, ARE WE THERE YET?

A rambling meditation on the meaning of Home

I recently spent five weeks away from home, visiting four different cities. One day in New York, around week four, I noticed I was not really *missing* my home, nor my current home town. I marveled at this; possibly it was due to a vacation mind-set or staying in the home of good friends and being with my daughter. But it did give me pause to wonder where in the world do I really *belong?*

This was not in fact a new process: having often uprooted myself, this question is always hovering in the psychic space above me. "Where do you call home?" This old saying probably had more depth in earlier times, but now it's a provisional thing — where I call home. What sprang to mind, in that moment in New York, was the phrase 'On Not Leaving L.A.', as if it were a concept that implied its opposite.

In fact I suffer from a form of bi-coastal psychosis or bi-location — the East Coast is where I spent my young adult and parenting years, where my oldest friends and my daughter live. Yet I've lived on the West Coast — wound up here for creative reasons — for a decade and now a small circle of newbie buds are starting to ground me here. And although in some sense I am actually a New Yorker, I wonder if at this point I could manage to sustain my now very So-Cal, sunny nature when battered about by New York's 'New Weather', the throngs of fellow humans, and needing to seek refuge, due to higher rents, in much smaller living quarters. In Los Angeles, there's simply more space — more room to stretch, to meander, and of course to 'space out.' As a relatively high-mach type, I would find it hard to sacrifice that perma-grin, La La Land weather, that weather which is not weather, the endless summer that seduces one to the sort of surreal, fantastical thinking that fuels Hollywood. And in some ways, L.A. is a sweet hometown. Easy living and all the culture you can stand if you just get off your ass. So why the doubt, the uncertainty? Do I simply have a

restless, nomadic soul, one that would probably never find peace in any one locale?

From that moment on, I find myself ruminating about what Home actually means. Home… Home Sweet Home. Home away from Home. Homesick. Hometown. Homegrown. Homeward Bound. "You Can't Go Home Again." "Home is where the heart is." "This little piggie goes wee-wee-wee all the way Home." And then there are 'my homies' — the ones that pull me East.

The word home has multiple vectors, but I'll take the Old English word *ham* — "dwelling, house, estate, village" — as a starting point, because the duality of the term was at the core of my perambulations. Home as residence. Home as locale.

Home is as much metaphor as reality. As much a construct of time as of place. As much about memory, imagination and possibility as about the stuff of beds and TVs, photos of Junior in jersey #44, and Grandmother's crystal. For some, home is a holding cell, for others a haven. And for all it is a reflecting pool, but one many of us rarely gaze into as such.

I search Amazon for books about the nature of Home and find nothing that would appear to answer my inquiry into its nature but this one — an older book called, House as a Mirror of Self: the Deeper Meaning of Home. In it, Clare Cooper Marcus, an architecture professor at UC Berkeley, explores "how personal crises, the need for privacy, couples' power struggles, divorce and career changes affect one's feelings about, and design of, one's living environment."

Her case studies of people's emotional ties to their homes offer widely divergent perspectives on what makes a house a home. As did Carl Jung, Marcus maintains that one's home is a symbolic mirror of one's inner self. Having interviewed over 60 people in their domestic settings, she found that "many had excessively bonded to a residence or its contents as a substitute for close relationships with people; at the opposite extreme were those unable to settle down in one place because

having a permanent abode was fraught with unresolved emotional issues from childhood."

It's a provocative work that also includes exercises to stimulate thought about the nature of one's relationship to one's abode. These include making drawings and entering dialogues where one both speaks to and takes on the voice of one's house. Curious, I made a drawing of my home (one can be free in its depiction and I chose to use a symbol to represent it — a six-sided, orange, star-like amoeba thing, reaching out like a living, pulsing being surrounded by the sun, myself in water, people and dogs, hawks and my winged self in a cloud). I came to realize that, despite my quandary about my locale, which to me is an issue as deep as the home itself, I had in fact made a pretty swell dwelling anyhow.

But was it a particular structure that Odysseus pined for, that he strove so fervently to navigate back to? Or was it his wife and son and the harsh Ionian landscape, the glint and scent of its rock. Proust knew, with his madeleine, that power of scent. And any homesick human, when returning home knows that feeling too, the one you get from the level of wet in the air, the way light bounces off color and the smell of the earth, of home turf. Locked deeply in my psyche is the smell of moist mid-western soil, the living green light of deciduous trees in summer and the brilliant blue reflecting off of snow or pinned behind hot red leaves.

The life of an artist can make buying a home an unwise decision. Hence I rent, and gasp to think how much I've spent to date; but then again, when I leave, I just turn the key. I've also evaded years of ridiculous interest and liberated my capital to *realize* the dream of my magazine.

My home is the upper floor of a 1930's Spanish-style duplex. The kitchen cabinets are original (charming but rumpled) as is all the bathroom tiling. The borders of the shower doors are rusting a bit and the thermostat is paleolithic and dull-witted, but over the years I have convinced my landlord to repaint and replace all the appliances. He did

recently balk however at ripping up the ancient nylon wall-to-wall carpeting I've hidden for years under orientals. This old carpet was really beginning to 'harsh my mellow' and when I mentioned this to my good friend Billie— an older British actress possessed of an impressive mind and dramatic vocabulary — she urged me to make a 'commitment to place'. She pointed out that this is a common error made by renters who postpone such things and years later, still in the same lodgings, regret it. Billie convinced me exposing the wood floors would refresh my soul, so I determined to foot the bill myself, reasoning that it all balances out with my relatively reasonable rent. I have always had wood floors in my homes and now I will again gain access to the cool feel of wood beneath my bare feet and, having staked my claim, this place will become more like home.

But this renovation stuff requires serious effort, even if one isn't doing the work oneself, and I now see that there's a wild child part of me that resists taking responsibility for the mundanities of a household. I am living solo at present and so have the decided benefit of being able to treat my home like a treehouse if I feel like it. And I usually do. But of course dust will pile up even in a treehouse. And the more objects you have, the more stuff you have to dust. This is when I want to flee. House as sanctuary/house as dead weight.

When I asked Billie about her feelings on the topic of home, she immediately stated that her home *owns* her… and referred to "home as husband". She lives in a wonderful rambling Greek-influenced house, with as much outdoor space as indoor (part jungle, part English garden, part Toscana *al fresco*), but she is tied to this place and its endless upkeep. She often expresses a longing to leave the house and this town and head back to Europe. Yet she is too deeply attached to the ideal refuge she's created.

Of course there's that other issue when contemplating a shift of home — moving, an enormous enterprise. Along with death and divorce, one of the bogeymen of life. But beyond the physical feat of

moving is the deeper, psychic one. Finding oneself pulled between these two elemental forces — the comfortable known (mother?) and the tantalizing unknown of life without her.

Billie also remarks that in her milieu, visiting her circle of friends, she always feels at home. "They all possess a great array of books, Kilim rugs, a sort of crafty chaos, a certain kind of lazy invitation to have great conversations by nice big fires, food, booze… and of course gardens."

Gardens, the great or small Outdoors (there is always this duality, inside the doors, outside the doors) are another major component of what makes a home, at least for many. Ah, to have the land, leisure, and capital to garden. But then again, even if I did, I might find myself a tad too lazy. Lay it out, yes, but dig holes? Don't know. Take a power saw to prune the saplings? Well, that's kinda sexy… and yet I have obviously not made the production of a garden a priority guiding my life. (Well I did try, in my suburban period when bringing up my daughter, but was defeated by deer and moles.)

For some, home is a major pre-occupation, a huge investment of time, energy and money. I've done that, put in a lot of work to create a home for my darling kid. But for now, I have my treehouse filled with paintings and taxidermy, and spend more money on travel and the experiential side of life. Yet I realize that creating that inviting atmosphere Billie invokes is something that I too would like — a place to entertain, to rouse conversation, to foment minor revolutions over a good meal. With my newly revealed wood floors, maybe I'll do it. Or maybe I'll get too busy. Or maybe I still won't have the perfect circle of dinner companions and anyhow, I work in my dining room.

But as it turns out, those sleek new floors do indeed groove me into a higher level of Feng Shui, another pre-eminent factor in the nature of home. Billie remarked that when visiting others she sometimes finds she cannot sleep in their guest rooms — the energy is off. "Homes possess energies." And they're either positive or negative or maybe just ambivalent. "Everything is a little story, every little object…" she says.

Home as narrative; we embed ourselves in our histories. And all those objects/stories hold energy — that either sustains us or detains us.

Home is also very much about acceptance — of what cannot be changed, or of what is sufficient. Having a certain amount of detachment about one's abode? Seems like a positive thing. And of course home is about control — do you have it? Is it yours to manipulate as you please, do you have to collaborate with others? Is it a symbol of stasis or strength or strife? Is your home fluid, always in flux or frozen in time? Does it truly express yourself? Do you share it with others or is it an altar to your solitude?

Of course women and men of this era have different senses of the meaning of home. Traditionally men, but equally modern women, may be indifferent to the state of the home front, and only seek respite there from a frenetic work life. Some men embrace the elements of building, renovating or maintaining a home, yet others are completely uninterested or downright reluctant. Some women find creative outlet in transforming a house and then some, rearing a family, may find home a padded cell.

For women have sat indoors for all these millions of years, so that by this time the very walls are permeated by their creative force, which has, indeed, so overcharged the capacity of bricks and mortar that it must needs harness itself to pens and brushes and business and politics. — All hail Virginia Woolf.

For either gender, home can be a gathering place or sadly sometimes more of a showplace, and one that lacks heart. Herein lies a rub between many cohabiting couples. Histories collide. Meanings collide. Aesthetics clash. Clare Marcus has much to say about couples navigating the choppy waters of sharing domestic space. The last two elements in the etymology below are intriguing, especially when you think of who is usually the ruler of a household.

Domestic (adj.) early 15c., from Middle French *domestique* (14c.) and directly from Latin *domesticus* "belonging to the household," from *domus* "house," from PIE *dom-o- "house," from root *dem- "house, household" (cognates: Sanskrit *damah* "house;" Avestan *demana-* "house;" Greek *domos* "house," *despotes* "master, lord;" Latin *dominus* "master of a household")

This question of home can have huge ramifications for those approaching their later years… the empty nesters. How long do you hold onto the family home and when, if ever, do you downsize? For many, especially those who find relationships shifting and domiciles breaking up, this can present an acute dilemma… or a fertile opportunity. I submit it is the latter. And there seems to be a growing awareness amongst the over 50 and 60 crowd that letting go is a very liberating, very appropriate act. I'm not there yet, but I can see it on the horizon. A moment when just arriving on my yoga mat, as one brilliant yogi says, I know I am home. How apt it is that home and Om share the same resonant sound.

On a very deep level, home is about privacy, about having a domain all your own. We all need our hideouts. It is one of the most primal of urges; we see it in children who always find a way to create their own private empire, whether under a porch, in a tree, or in an attic. The need to isolate oneself and find oneself surrounded, as in the womb, with only that which nurtures and protects us. This is where we breathe. And even in these temporary abodes we choose a handful of objects that extend our identity beyond the edges of our flesh, and which state to ourselves who we are.

Ultimately you cannot think of home, of an American home, without thinking of all those who, out of their own volition or not, manage to carry with them, in their soul, in their gut, a sense of home that requires no home town and little more than four walls. "Papa was a rolling stone, wherever he laid his hat was his home." A good friend says, "Home is where I feel safe." She was referring to a point when she

and her young son were living in one room, in a new town, with little but a few suitcases.

Dwelling is the word that seems apt here. I love the idea that it is a verb. Here I am dwelling, here I dwell. It's a curious, almost contradictory etymology as you can see below...

Dwell (v.) Old English *dwellan* "to mislead, deceive," originally "to make a fool of, lead astray," from Proto-Germanic *dwelan "to go or lead astray" (cognates: Old Norse *dvöl* "delay," *dvali* "sleep;" Middle Dutch *dwellen* "to stun, make giddy, perplex;" Old High German *twellen* "to hinder, delay;" Danish *dvale* "trance, stupor," *dvaelbær* "narcotic berry")

Despite the historical divagations of meaning, our current notion of dwelling now chiefly resides in the sense of lingering... which then, *sotto voce*, implies sleeping. Ah... Home as the place we lay our head. To sleep perchance to dream. Is that not really what a home ideally offers? A place to rest in tranquility, to reunite the fragmented elements of minds that have been jostled by the day, to have the space and the safety to let our souls wander freely beyond the four walls, to explore and to create the worlds we will awaken the next day to create.

L.A. <> NEW YORK

Hugging opposite coasts of the enormous land mass currently defined as the United States, New York City and Los Angeles are basically antipodes — geologically, meteorologically, architecturally and culturally.

In New York, meaning here mostly Manhattan and increasingly sections of Brooklyn, much of life is lived amongst big cubes and rectangles of granite and brick, towers of glass and steel. Life is vertical. One ascends and descends at a pace determined by machines and mass transit. One is always cognizant of the Other, as there are millions of them, yet one learns that each is unique. One is always face to face with the disparities in fortune.

Traversing the city, a New Yorker participates in a choreography of flow, on busy streets darting and weaving nimble as a trout among reeds. One curses the tourist standing like a lump in the crucial zone of a corner. One is in constant surveillance mode — eyes clocking, through infinite saccades, the passing faces, seeking significance.

New York light ricochets, in myriad shards, off acres of glass, at midday casts a blue tint to life below. It flickers off stately piles in granite from Quincy, Vinalhaven and Deer Isle, slides across shafts of Indiana Limestone and Tuckahoe Marble, and filters down onto red brick and Portland brownstone. But the ubiquitous tone is concrete, which coats the town like a layer of frosting.

As moths camouflage themselves for their habitat, New Yorkers garb themselves in gray, blue or black. The daring blaze forth in hot blue, red, sometimes even yellow. The occasional swath of green or row of trees, or Central Park or the High Line, remind one that this is Earth. And of course the humans, coursing in streams, testify too.

High up, windows of buildings only feet away both reveal and reflect a multitude of lives, possibilities, questions. By night, the city is a Caravaggio, a liquid screen of chiaroscuro, black black, hot yellows, icy LED blue. Faces gain a mask-like quality. Street theatre.

In places, the boroughs still feel like villages, yet many of their inhabitants tunnel into Manhattan or downtown Brooklyn to work. And no matter the height of the buildings, New York in all its boroughs is relatively regimented, block after block after block in grids marching ever outward in a strictly metered rhythm. Manhattan's mighty rivers, the Hudson and the East, rush downstream with an intensity mimicked by its denizens. To live or work in Manhattan, or really in any of its boroughs, is to be acutely aware of time, even obsessed with it.

New Yorkers are assaulted by serious weather; whipped in winter by slicing winds and rain, sometimes forced to navigate drifts of snow hardened into canyons. In summer, they are steamed like Chinese buns, as the streets burn and millions of air conditioners pour hot breath into the air, making the days feel thick as tar. But New Yorkers experience the seasons like epiphanies. Spring is a sacred happening. Autumn a time of reflection, preparation, and bracing for the unknown.

All these elements converge in the construction of the character of a New Yorker. New Yorkers endure. New Yorkers collect, collaborate, seek unity. At the same time, they hone their identities. To define oneself is an imperative felt by all New Yorkers.

Los Angeles, by contrast, is horizontal, almost suburban. A hardcore Legoland through which one moves at a pace determined by the flux of apparently autonomous vehicles. There can be a luxuriousness about LA, a process, as one drives, of unpacking the city, of unfolding a map, slowly, patiently, persistently. And those times when the traffic ebbs, one feels a sudden freedom, moving through this vast terrain like a free radical. Like Pac-man, a cognoscente can transect neighborhoods through an endless number of detours and zig-zags, but what is called 'rush hour' on the main drags is in fact hour upon hour of a slow bleed. Unlike in New York, where mass transit means exposure to a multitude of bodies, nationalities, in LA one is exposed only to bodies enmeshed in bubbles of steel. Here one is isolated, left to one's own reveries, while the road slowly grinds by.

But the light of LA is a friendlier, more amenable blue. More sunshine, more color. Sometimes blisteringly bright. Blue walls, pink walls, peach walls and yellow. Towards sunset the light drenches everything, especially exposed flesh, with the melon-y hues of Maxfield Parrish. Film slang dubs it 'golden hour.' This is, after all, the Golden State.

The nickname La La Land is not only about the fantasy of Hollywood, but about the timelessness of the place. There is no history but the one Angelenos invented themselves. The trippy context of time here is correlated to the weatherlessness. Here you can wander about trilling "lalala" because seasons will never interrupt. Years slide by with few markers. In the spring there are evenings when one is caressed into sweet oblivion, as ocean zephyrs* surf a super-long curl all the way inland cooling and softening the edges of the town. Yes, we have June Gloom, but it doesn't exactly lead to Heathcliffian moroseness, just offers enough gray to fuel the writers of melodrama.

Of course the summers can be devilish, suffocating, but one can leap into the ocean or retreat to cool interiors… One is only ever uncomfortable for short spurts. But the town, after days of desiccation, does get dusted, gets bleached, a boneyard of dead flora. Then one remembers this is a desert. The town is a mirage willed into place.

Winter may bring a tad more rain, a few days of quasi chill, but this has only a mildly waking effect on Angelenos, merely reminding them they are on Earth. In the beach towns, staring at the great Pacific, one might mistake it for a vast screen, playing an infinite loop of waves.

Oh, there *is* that other reminder of LA's particular and precarious position on this planet — that ancient terrestrial crack, the San Andreas fault. Although I believe few people fixate on it, the fault figures in subliminally, breeding a different sense of time, aka impending doom. Perhaps this is one reason so many big budget dystopian films get produced here. But then some sort of doom lurks around all of us these days.

Nonetheless, Angelenos, unless they're dissatisfied with their agents,

are generally happy-ish, generally bearing a slight smile on their faces. Why not? When in doubt, sit in the sun for an hour and banish darkness.

Like New York, this is a town of immigrants, but unlike New York, LA is a frontier town, a destination of hope or fantasy. Consider all the diverse ethnic groups who have landed and rooted here and flavored the culture: the Hispanics, the Koreans, the Japanese, Chinese. And all the flocks of emigres from Europe, from the East Coast, from up North, looking for new lives. That's why I came.

I've lived in both towns. I love them both and hate them both equally. Life in L.A. is about as paradisiacal as it gets in this country. Why would I ever leave? Because it is too goddamned chill, a town made lazy by smugness. But hell, my tiny world is sort of an urban social miracle: I know all the neighbors on my street and they're all so damn friendly. But it's an arbitrary collection, and to find people that truly resonate on my cultural frequency has been an effort.

Perhaps I just came here too late. See, New York continues to beckon me, like the Green Fairy, with luminous bedroom eyes implying depths of intrigue and heights of intellectual buzz not as readily available here. New York promises action, affront and challenge. And above all, surprise.

So do I forfeit the big 1930's duplex I rent for half what new rentals cost, with its arched doorways, huge fireplace and backyard for my dog? Do I relinquish the endless run of sunny days? Do I squeeze into a space 1/3 as large? Do I find myself feeling forlorn amidst darker realities, thrust into the moodiness produced by long stretches of cold dank weather and the equally dank concept of time that it breeds?

I am torn between two lovers. Los Angeles is the touchy-feely surfer dude and New York the smart-assed cultural historian. One would fuck me on the beach and ask no questions, the other would debate me about the relative value of Wolfgang Tillmans and possibly fuck me against his bookshelves.

Maybe it's time to head to India, and clear my absurd, bifurcated

American mind. At least time to sit down and drop all this angst bred of place and simply meditate. But I don't do that well. I could instead read Kerouac's Satori in Paris, and then dream of Paris… where, if one could afford it, one could pass the days languishing in cafés, or could truly slip into Nothingness or some sort of mildly aggravated mental state prescribed by Lacan or Baudrillard. Sigh. Maybe I'll just stay put and dream. We Angelenos do that quite well.

* **Zephyr** - a mild breeze, possibly a tickling one, a little lithe lick of air. Late Old English *zefferus*, denoting a personification of the west wind, via Latin from Greek *zephyrus*. Zephyrus was the God of the West Wind and of Spring Breezes. One of the four directional *Anemoi (Wind-Gods,) Zephyros was often depicted as a beardless youth scattering flowers from his mantle. Nonetheless, probably related to *zophos* "the west, the dark region, darkness, gloom." Sense of "mild breeze" is c.1600.

Stray strands of her silver hair, rustled by tiny zephyrs, cast glints of light across her merry blue eyes.

STUFF

It's everywhere, Stuff. You can't avoid it.

And you seem to *want* it. Or so you think but then you get it and you think again.

What is this stuff? I bought it. I bought into it. I thought it would make me happy. It's supposed to make me happy. And it doesn't. It's just more fucking stuff.

Except, well, there is *some* stuff that I can't let go of. Stuff found on my various perambulations through the world. Meaningful stuff. Or rather stuff into which I have injected meaning, like:

1) A tiny reproduction of an 18th-century French bust of a little girl, bought for $20 in a small town antique store — probably originally done in bisque but this one, produced in the 50's by the Italian firm Borghese, has a dense taupe overlay so that only traces of red clay are revealed. Absolument mignon, as the French say.

2) A little 19th-century stuffed ram covered in real lamb fur with tiny curls and little inset eyes and paper maché horns, a gift from my oldest friend.

3) My PeeWee Herman talking doll, (well actually I bought it for my daughter).

4) A kid's Kodak Brownie 'Holiday' camera bought in a countryside 'boot sale' in East Anglia, UK. It's a Brownie that's actually chocolate brown!

5) A small black wooden sailboat from Damariscotta, Maine. Pays homage to my childhood in a dinghy.

6) A super long Stick Bug I bought in Lugano, Switzerland and nearly had to forfeit to a US customs officer on my return. (Suspicious entomological specimen.) It's an exquisite work of art, sculpted by Mother Nature.

7) A Native American artifact my mother owned, a remarkable

piece of pottery by Hopi artisan Fannie Nampeyo, a living legend who apparently achieved her beautiful finishes by rubbing her vessels with Vaseline then burnishing with a pair of pantyhose. Genius and adaptation.

8) Various small white objects: polar bears and feline buddhas in crackleware. Munny characters (fat-headed bear-like creatures with no facial characteristics but a small crease where the snout would be) in black and sky blue. A Chinese snake in celadon and a Japanese rabbit figurine in ultra white clay with red whiskers. Painted iron bookends with the old RCA dogs pushing noses against the books, and a miniature porcelain bathtub emblazoned with the logo of The Plaza (circa 1950 as well) which I lured off my ex-grandmother-in-law.

9) My foot-high reproduction of Rodin's The Thinker, bought for a song in a garage sale at a mansion in Connecticut.

10) My foot-high, headless Venus de Milo (with enormous wings) bought for another song in the same garage sale.

All of this is in my study, and it doesn't even include the taxidermy in my living room, and my Victorian birdcage, and and and... Without realizing it, at some point I became a collector. And now, sigh, I am surrounded. Possibly penned?

A WAKE UP CALL

What is the point of our species?

Yes, you can ask that about any species, but we've made a point about saying that there is a *point* to humans. And yet somehow that point seems in question at this point in time. (I am being quite pointed in my accusations here.) The point is, what is the point of the human race? If we're not here to elevate and transcend and transmute, like alchemists, the dross of the base elements into something higher, then what is our point? And are we doing that at this point?

Waking up a few years ago in Los Angeles, I was suddenly stung by the question (for it surely is a question, in fact *the* question of our future on this planet). I was actually *gobsmacked* by the thought of how incredibly *fragile* our entire biosphere, the whole shebang is. (Love that word.)

Like, how we, who are the apex of the Eukaryota*, are far more vulnerable than we know, in fact about as hardy as the fruit hanging from our trees, or the honey bees buzzing around it... or that once were. Now, another dire prognosis for our biosphere is fairly probable, since our Blunderer-in-Chief has pulled us out of the Paris accord. Look, if we're going to validate our claim to having dominion over the planet, it's time for us to look beyond our little nano-worlds and rise to the challenge of securing a healthy living planet for future generations.

Now of course we have more going on for us than the little frogs and bees — mainly human *agency*. But can we say that we've truly laid claim to that asset? Recently, a young man I know, when asked by his mother to recycle something, muttered, "What's the difference — the whole planet's doomed anyhow." Yikes. How the hell have we let things come to this pass? And I'm talking to all you people supposedly at the helm.

But in the aftermath of the 2008 crash, a growing number of historians studying what they call "fossil capitalism" have begun to suggest that the

entire history of swift economic growth, which began somewhat suddenly in
the 18th century, is not the result of innovation or trade or the dynamics of
global capitalism but simply our discovery of fossil fuels and all their raw
power — a onetime injection of new "value" into a system that had previ-
ously been characterized by global subsistence living.

But more than half of the carbon humanity has exhaled into the
atmosphere in its entire history has been emitted in just the past three
decades; since the end of World War II, the figure is 85 percent. Which
means that, in the length of a single generation, global warming has brought
us to the brink of planetary catastrophe, and that the story of the
industrial world's kamikaze mission is also the story of a single lifetime.
— David Wallace-Wells, New York Times

Look, goddamnit, we humans are supposed to be luminaries; we've
made astounding breakthroughs in the realm of technology — na-
no-scale motors, 3-D printers — we've mapped genomes, made robots,
sent men into the cosmos and harvested human organs from pigs! So
why have we not gotten our asses in gear to harness such tectonic cogni-
tive shifts into solving the biggest problem of all — sustainable energy?
WTF is going on here?

This is the era of Globalization, right? But the only thing globalized
on this planet is manufacturing and media. We're all one — not because
we have a unity of higher purpose, but because we all want shit for cheap,
and we've all been herded into the same Pleasant Valley of cheesy celeb-
rity worship and fed the same weedy diet of faux news and ads. There
are too many struggling players, too many conflicting global interests,
too much internecine strife and in fact no true leadership to be found
anywhere except amongst the major CEO's who, addicted to growing
their already sizable bonuses, are being allowed to herd us into extinction.

In fact, I'm a pie-eyed optimist by trade, so these disquisitions are
not 'really me'. But I gotta say it's getting harder and harder to 'be me.'

Which is really what this is all about; I refuse to give up my sunny disposition just because the powers that be choose to piss on my parade.

But now to my point (and this *is* leading somewhere), several critical concepts have been running through my head recently, like a gang of undomesticated dogs. And these concepts are words which are, although on the face of it they may not appear to be, indeed *actionable* verbs. Words that enact deeds.

1) **Adapt**. *And here's a critical question*: If we will ultimately be forced to adapt to a highly reduced, wildly unpredictable, and dangerous natural world, why don't we start to *adapt* now and possibly maintain some planetary integrity? Such adaptations we make now would possibly be less onerous and might even feel refreshing, empowering, in the sense that we had *chosen* to (and here's another juicy verb) —

2) **Sacrifice** certain things… in order to reach a higher plateau of earthly existence. Often the word adapt means to bend to the exigencies of circumstances. But I choose to apply the more pro-active definition. Adapt should be understood as a more muscular act — such as:

3) **Transform**. To transform implies an act of agency, which is what is needed now, as in *transform* our approach to life on earth, to how we interact with the biosphere.

These thoughts give rise to another word of import, one typically heard only in the context of battle:

3) **Surrender**. And the question is: *Have we deeded ourselves rights (planetary) that are not rightfully ours?* And finally, a noun:

4) **Dominion**… that impressive word we invented to give ourselves the apparent grounds to traipse, tread and trample this earth with

abandon. So if we were to surrender those rights, and not under fire, is that not a show of strength instead of weakness? The strength of vision and wisdom and grace?

But my final question is, and I'm putting the political back into the personal here — where it belongs — how do I wriggle out of this lamentable condition I've posited, that of inaction? Some thoughts:

1) I could head for the hills.

2) I could blather on, raise minuscule alarums, and assuage my conscience that I did so, from my Aeron chair.

3) I could form small coteries to blather on, drink cocktails, and raise slightly noisier alarums.

Look, I know there are millions of activist groups across the planet, and I've joined a few. Yet few of them seem to have galvanized the magnitude of change required to turn this mothership around from its ill-advised and ill-fated course. I do have hopes for the governors and mayors, but can they pull us out of this abyss of leadership?

Every day is a new day. Then what shall we make today?
Why even live, if we don't make anew or make better or stronger
or more beautiful?
And yet we're always looking outward, at others, and saying
Make my day,
Make me happy,
Make it happen.

Clearly we need a new paradigm for action. This is a mission fueled by necessity, yes, but by hope and joy as well. We can do this! If we can imagine a cleaner, smarter, more unified world — we can make it happen!

* **Eukaryote** - eu·kar·y·ote [yoo-**kar**-ee-oht, -ee-*uh*t] **noun**

Any organism having as its fundamental structural unit a cell type that contains specialized organelles in the cytoplasm, a membrane-bound nucleus enclosing genetic material organized into chromosomes, and an elaborate system of division by mitosis or meiosis, characteristic of all life forms except bacteria, blue-green algae and other primitive microorganisms.

THERE IS ONLY ONE UNIVERSAL NEW YEAR'S RESOLUTION

There is truly only one resolution to be made, and that is to access and engage all one's strengths and talents to become the highest expression of oneself. Yes, this is your mission, if you choose to accept it. If not, walk away, baby.

Now the rest of you, *relax*; what this implies is a process. It probably means continual self-discovery (and that takes work) and constant check-ins with oneself (but that's called being present and we all want to stay on that path, right?) and for sure it includes lapses along the way. What it doesn't entail is all the scatterbrained, externally driven resolutions we all clutch at desperately and drop inevitably.

Forget about losing weight, stopping drinking, giving up smoking; stopping, losing, giving up ANYTHING. And focus on the real goal, which is to join the entire human race in what could be a universal and global goal, one which could reap multiple rewards in the world at large. Yes, civilization is approaching a nadir, and we're all foundering as we watch the integrity of our marvelous planet decline. Yet each one of us can lend a hand, just by working on ourselves first. The combined effect of all our efforts at approaching our best selves, when mirrored around the world, could have staggering consequences.

Change — does this resolution imply change? Of course. Hell, we change every moment of every day. All we want is to *direct* that change… but this doesn't have to be an arduous affair because it will be incremental, some days it will just boil down to remembering to breathe, remembering to taste the air and realize what a miracle it is that we exist. Really, all we need is for each one of us to get out there and be the divine human we were meant to be. Divinity… we don't need to look outward to find it. We invented the darn concept.

Of course at the core of this heroic venture is the mantra: to thine own self be true. For how much time and energy do we all waste avoiding our true selves? Trying to squeeze our massively wonderful selves into the silly personae that get handed to us by our nearest and dearest. Put a Tomboy in a pinafore? Wrest a falcon from a sweetly warbling wren? Teach a cat to heel? Oh well, my imagery pulls me far afield, but the entire animal kingdom is living proof; they do what they're good at and have swell lives doing it. (Do they succumb to the predations of stronger beasts? Of course. But do they suffer the predations of Super-Egos? Never!)

Look, we all eventually move on from this life, but what I personally am aiming for is knowing, when my final day arrives, that I gave to this mission the efforts of every damn corpuscle in my body and every damn brain cell too. And that I had a damn good time doing it.

So Happy New Year, y'all, whenever that be. And rest easy — there is only one thing you need to say to yourself every morning. "Hello Darling, let's get to it!"

THE LIFE ZETETIC*, FRAGMENTS FROM A FRABJOUS PHILOSOPHER

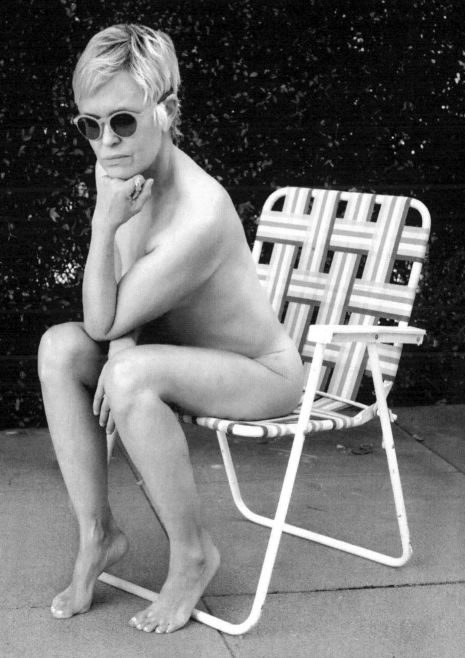

*seeking or inquiring into...

ON BEING ZETETIC

(Zetetic - Greek for inquiring or seeking)

What impels a kid to read philosophy? A bit of contrariness, I think; a bit of smarty-pantsiness maybe; certainly a restlessness in the soul and a cat's nine lives worth of curiosity. I think some kids just come out of the womb asking Why? Why? Why?... I was one of them.

We all know those vague questions that bubble to the surface of our consciousness at random moments, those ideas that streak like neon imps around the corners of our brains, leaving light trails that fade almost instantly... but most of us don't have the time or interest to 'hunt them snarks'. Yet it is a worthy search, one for which the professionals stand by, if only to leave our eyes crossed in puzzlement at their arcane verbiage and to bounce us back to our novels or the latest female detective series, though somehow slightly altered.

Developing a life philosophy is a lifelong project. For me, it's probably been the most important one. Trying to find one's own is, in a non-trivial way, like trying to find the perfect jeans. I'm not talking style here, I'm talking symbiosis — the right fit, the right feel and fading, the right pockets, the exact amount of freedom of movement. Some of us are lucky to find them young, some of us only get those jeans by wearing them, living in them, through a series of trials and adventures.

As a sixteen year old, in the late sixties, I was staring down into the abyss with Jean Paul Sartre and up toward a twilit Olympia with Friedrich Nietzsche, while getting rapturously deflowered and launched like a rocket into fully sexualized adulthood. There must have been some yeasty confluence in those realities... because from that moment on I have been zigzagging doggedly on a path through the past few millennia of Western Philosophy, along with a few of Eastern. This has never been a mere lark, but rather a raptor's pursuit of real wisdom, however

limited my wingspan might be to reach and capture it.

It had to have been easier for us young, post-war Americans to get that primal experience of reflection, a core mode for philosophy, because we had so few distractions. Life was simpler then; we were less globally oriented, less attentionally attenuated, less strung out by confronting each little recorded twitch of a chaotic civilization as it gets wantonly splattered across every surface 24/7. And we were more or less lucky that most of our parents didn't have a clue what we thought or were up to. We had more latitude to think, more alone time, more outdoor time, more time to read, to *play*, to ponder, and really, just to be — all necessary ingredients to catalyze a mind's inclination toward wonder (a noun now more or less trademarked by Disney), so perhaps I should instead say 'a mind's inclination toward *wondering*' (a verb unfettered as of yet by marketing gurus).

Also quite in vogue in the sixties and seventies were two historic Americans — Thoreau and Emerson. They were like lodestars for our generation, offering as they did an alternative to the Cold War, rah-rah nationalistic, and delusional zeitgeist we grew up in, showing us a path back to authentic *being*, often with Nature as guide. I had no clue then that these two Transcendentalists were heavily influenced by my now dear old friends, those Ancient Greeks who called themselves Stoics. Their philosophy has not only long had a sturdy following in America, but has influenced every major philosopher for the past two millennia.

Existentialism had already been on the scene in the fifties, at least for the beat poets and their gang. But in the sixties it became a cultural heavyweight that radicalized the sensibilities of the era, big time. With their slightly glamorous, café dwelling existence, these European intellectuals inspired, in all the young minds that encountered them, a sense of distrust in the version of reality we had been presented, and they cultivated in us the habit of questioning everything.

As a freshman at Sarah Lawrence College, I managed to wangle my way into a junior level philosophy class called The Mind-Body Prob-

lem, taught by a Brit who so looked the part of a modern philosopher: the classic square jaw, heavy black glasses, bad complexion and tobacco stained fingers. I tried to ace out of the final exam by doing a paper on the starkly minimalist Russian painter Kasimir Malevich; my theme was Nothingness, or the Void, or whatever, and I made a poetic case for the fact that I should not be required to write a massive essay because I was instead, more or less, representing the principles of Nothingness. Like I say, smarty-pants. Luckily that paper made it obvious I was not cut out for academe, and thus was spared all its internecine competition and strife. Clearly I would be better off plying my imagination in the field of art. (I left behind at Sarah Lawrence a monstrous abstract plaster sculpture, sort of a Corbusier like thing meant to evoke human striving. I hope the maintenance crew had fun bashing it apart before hauling it off…)

But even in art school, living with a guy whose pals were a bunch of speed-chess playing eggheads from Harvard and MIT, I was still knocking at the door of the philosophers. I wrestled with Hegel and did at least walk away with an appreciation of his focus on the primacy of *dialectic*. The dialectical process was first popularized by Plato, when observing how Socrates, through vigorous dialogue and questioning, attempted to clarify and improve the opposing views of his interlocutors. For Hegel, the term dialectic becomes a bit more abstract; the "opposing sides" are no longer necessarily people but different definitions of concepts, for instance, concepts about consciousness and what it claims to know. In both Plato and Hegel, the dialectical process yields an evolution from views less sophisticated to more sophisticated. For Hegel, the opposition of two different principles, or the argument from *thesis* to *anti-thesis*, ideally yields a synthesis on a higher level — a harmonious unity. I believe Hegel saw dialectic as an essential driver of civilization, although it is not at all clear that any sort of unity is in the cards for our current political climate.

Later on, while trying to finish my first novel and attempting to be very precise about my language (or avoiding the actual task of writing), I found myself lost in a pursuit of the meaning of the words I had chosen. I spent hours buried in an enormous dictionary (Webster's Third International, one of the greats) tracking their origins. Words like *arbitrary* and *authentic, parousia* and *parataxis*. So many of these words were derived from the Greek and then capitalized upon by the German, that I thought maybe I should study the latter, and then wound up reading Heidegger, a German who fascinated me with his focus on the co-dependency of language and existence, on the way we *talk* about being, and on the poor way we actually *practice* being, which is more or less mindlessly. Heidegger led me to Heraclitus, one of the earliest of Greek philosophers and the dude memorialized by that 'Can't step in the same river twice' meme. I was so hot for the Greeks that I even tried a few classes in Greek at a local college, before I realized I was not *that* much of a pedant.

Later, as a young parent with a fledgling mind on my hands, I became fascinated by the human brain, the nature of consciousness, the origins of our sense of self and, as I earlier described, the nature of the English Language. Fast-forward to a few years ago when, as Editor-in-Chief and Chief Bottle Washer at Realize Magazine, I interviewed a professor named Nick Pappas, who taught courses in Nietzsche, Socrates and Plato at The City University of New York. It was a marvelous impromptu conversation and I found myself asking him why more philosophers weren't engaging in public discourse, speaking about pressing public issues. Nick suggested a colleague named Massimo Pigliucci, who was very publicly oriented, whom I arranged to meet, as I was in New York, and whom I have quoted several times in the next essay. Massimo, a professor of Stoicism (and a sincere Stoic), invited me to a conference called Stoicon a week hence. I changed my flight back to LA and spent a very long and compelling day, in the overly lit gym of a lower East side community center, with a

wild and shaggy assemblage of pundits and devotees.

Forget about that stiff upper lip business, which is the Classic Comics version of Stoicism... in fact there is great richness, humanity and everyday logic in their philosophy. The day after the conference, a glorious and sunny autumn one, a small group of the most ardent of us walked through Wall Street and across the Brooklyn Bridge, discussing the tenets of Stoicism the entire way. Pausing over the East River, over-looking a brilliant skyline, I think we all leapt onto some sort of higher energetic level, some less earthbound plane where ideas about how to live a moral life tumbled out of the air into our heads and out of our mouths. Scintillating down to the corpuscles, the day felt like a mutual epiphany. Maybe this is what it was like to experience the world as the Greeks did...

IN WHICH MARCUS AURELIUS PLAYS THE HORN

In fact I first learned of the Stoics in my early days as a would-be novelist, when I had picked up a book by one of their chief proponents, Marcus Aurelius, the celebrated warrior-philosopher-king who ruled the Roman Empire in the second century AD. I think I was probably too young then to fully appreciate it, but Aurelius found his way back into my life years hence when I was facing the serious dilemma of a failing marriage. I had been struggling for some time to make it work; after all I loved the man, the father of my child. But the problems and disagreements, the alienation… it had all led me to lose faith in our future.

One night, exhausted by debating as to whether or not divorce was the only solution, I noticed The Meditations, Aurelius's book, in my shelves. I was listening to Miles Davis as I opened it — The Jack Johnson Sessions, his soundtrack for a film about the first African American heavyweight fighter, whose legendary prowess broke through the tidy boundaries of a racially bifurcated America. Between the dissonance in Miles's playing, his visceral summoning of the fights Johnson fought, and the stark passion of Marcus Aurelius, there was a powerful synchrony. All of these guys knew something about pain.

For weeks afterward, I stayed up late at night reading The Meditations, and discovered that Stoics cut to the chase when it comes to dealing with crises and taking responsibility for one's actions.

Consider the past to be dead. Now live from this point onward according to your highest principles. — Marcus Aurelius

Emperor Aurelius penned his Meditations as often as not while on the battle field. Sober, hard-core thinking that to some appears pessimistic, but which emerges instead from a rigorous method of contem-

plating the cold realities of life and of liberating oneself from them. What better use of philosophy?

<p align="center">✳</p>

Now, as I write this book, I feel the contours of my life philosophy beginning to take shape and, alongside my brief experience with Zen, it has a lot to do with the Greeks, who consistently offer me clarity and perspective as I tromp into the wilds of my later years, a solo explorer.

I think the real draw for us fans of the Greeks is the fact that, in the history of the Western World, they are nittiest and grittiest philosophers of all. The bottom line, one could say. They were probably the first to recognize that the mind is a distinct entity separate from the stream of events: a *happening* place where one could shape a premise about, could develop a take on *reality*, could actually posit *the idea* of reality, and hence *the idea of a world that one could grasp, define, possibly control.* They were there, at ground level, intensely engaged in wonderment — *thaumazein* — and questioning *everything*. And because of this — because they had not twisted their perceptions, as later philosophers do, into abstractions and formulae, nor rendered their thinking in abstruse language, because they looked at the world with the most open of eyes, because their day skies were free of smog and their night skies undiluted by artificial light — their thoughts have the tang of sea, of blood and stone, of pure, living darkness. Palpable, authentic, real.

Intermission:) At this point, anyone not curious about this subject could choose to skip ahead to something a bit more lightweight. Or perhaps proceed to take the measure of their own zetetic impulses and follow me here into a capsule synopsis of the Stoics...

So you might want to ask the Stoics "Who's your Daddy?". Most likely they'd say Socrates, alas now, except in academic circles, mostly

renowned for his stunning suicide by hemlock. This genius left behind no written works, but Plato, his star student, catalogued and extended all his dialogues. I think Socrates (via Plato) captures the beauty of the Greek approach to philosophy:

Wonder is the feeling of a philosopher, and philosophy begins in wonder.

But really, the groundbreaking thing about Socrates was his *method* — the Socratic Method is a time-honored approach to seeking knowledge or truth. The man was a master provocateur, never actually stating his own opinions, but leading others to question their own and, eventually, liberating them from their false beliefs, bringing them around to his position, which was that they, like him, knew nothing. This could have been an ironic stance for Socrates; many consider him to be the man who gave birth to irony, for everyone is pretty sure Socrates actually knew he knew something, at the very least he knew he could question the hell out of the rest of them. But Socrates wasn't just playing; his was a lifelong inquiry into what constitutes a good and moral life. And he *lived* his morals, choosing his own death rather than their forfeiture.

Right… but we're not heroes here, so how does all this Stoic profundity impact our daily lives? Right smack dab in the kisser, actually: in the way we choose to act toward others, how we spend our time and energy, and especially how we handle life's crazy vagaries. Listen to Marcus Aurelius's teacher Epictetus, who was a Stoic luminary:

We suffer not from the events in our lives but from our judgement about them… Some things are in our control and others not. Things in our control are opinion, pursuit, desire, aversion, and, in a word, whatever are our own actions. Things not in our control are body, property, reputation, command, and, in one word, whatever are not our own actions… So make a practice at once of saying to every strong impression: "An impression is all you are, not the source of the impression." Then test and assess it with your criteria, but one primarily:

ask, "Is this something that is, or is not, in my control?" — Epictetus

For example, I can choose to obsess about a past in which I've tossed away numerous opportunities and squandered artistic energy in dead end romances — or not — because, as Epictetus points out, though I cannot control external events, I can control *my reaction* to them. Likewise I can fuss and fidget, natter through the night and lose sleep over a projected future in which I find myself destitute and alone, in which all my gambles have proven absurd and delusional. Or I can cut myself some slack and see that much is actually in my hands, and that which isn't is not worth my time fretting over.

Likewise, when faced with an external or even an internal event, we always have a choice as to how to react to it. We can either allow it to overwhelm us, or cause us to suffer, or we can choose to apply our judgment and reason, and rise above it, or act upon it. Let's say I finally come to the conclusion that I'm actually not all that gifted a writer. I can either trudge about in a funk, that I haven't achieved my dreams, or I can say to myself - "Jeez girl, that wasn't the right dream. Pull another one out of your bag of tricks." There is always something we can offer the world, even if it's selling hot dogs at the ball park; the way you hand them over, the way you take the customer's money, the way you smile. Maybe you can draw a chuckle out of the fan, make some connection... because, why not? Life is short. The way you hand out that dog might mean more in the long run than any amount of words you spilled.

In one of the best books on philosophy ever written, Pierre Hadot, Professor Emeritus in Ancient Philosophy at the College De France, puts it nicely:

The theme of the value of the present instance plays a fundamental role

in all the ancient Greek philosophical schools. It can be summarized in a
formula: In short it is a consciousness of inner freedom. You need only your
self in order immediately to find inner peace by ceasing to worry about the
past and the future. You can be happy right now, or you will never be happy.
— Pierre Hadot, Philosophy as a Way of Life

Happy *Now*, Darlings! Or forever hold your misery....

Hadot speaks of 'all the philosophical schools'; in Ancient Athens, they were myriad. The Stoics biggest rivals were, arguably, the Epicureans. The more I learn about both gangs, the more I debate with myself: am I with the Stoics or the Epicureans? (And why would I have to choose between the two? Oh yeah, gang loyalty.)

Labeled hedonistic by Medieval Christianity, Epicureanism has been wrongfully reduced to a partying philosophy. In fact Epicurus eschewed needless indulgence. One of his essential tenets was, "Want what you have". I'm not bad at that, although I do sometimes like to indulge and do espouse a party philosophy. Still, I think Epicurus would have wanted me on his team, if only as court jester.

Seek simple pleasures, those that satisfy natural and necessary desires,
chief of which are food, drink, clothing, shelter, friendship and love. Not
what we have but what we enjoy, constitutes our abundance. — Epicurus

Epicurus was no lightweight however and he did share with the Stoics a love of Virtue, although both schools sought it in radically different ways. *Virtue?* What *is* that? It's a word, a topic, that the 21st century seems to have waylaid. (Funny I chose that word, since virtue's most recent incarnation, in the late 19th century, was a whittled down and bastardized thing that ladies possessed before they had ever gotten laid.)

But virtue was a very big thing for the Stoics, who took a muscular, full throated approach to it. They sought to be *virtuous* because it was the strongest expression of man's reason, which is our proprietary

turf as humans; virtue exemplified our standing within the hierarchy of nature, our living in accord with the natural logic of the universe. The Stoics believed that while we could never actually reach virtue, our constant striving to do so would make us better humans. A for effort? I'll take that.

Again, although the four Cardinal Virtues mentioned in an earlier essay (wisdom, courage, justice, and temperance) often seem to have vacated the premises in public life, we do have contemporary exemplars - think Ruth Bader Ginsburg, a hero for sure. But here is a sweet incentive for us lesser mortals: *Eudaemonia* — a Greek word that has been shorthanded by English speakers as The Good Life — is in fact a superb term that encompasses happiness, flourishing, and living according to your daemon; and it can be achieved by practicing these four virtues.

Eudaemonia! Damn if the Greeks didn't come up with a killer concept, one which is a star amongst my mental constellations. Eudaemonia is not a 'view from the hammock' sort of Good Life, the sort you may sense as you take another swig of your Dom Perignon. It is instead something that rises up from your soul, that infuses your entire psyche and curls the edges of your lips into a beatific smile.

The Good Life — just considering the notion can bring you closer to it. And this is basically what Philosophy is - considering, rolling over in the mind, pursuing thoughts and theories like a lepidopterist does butterflies. Obviously The Good Life is a huge idea that each of us must address on our own, but the Greek definition creates a sturdy context from which to start.

Back to Epicurus who, more interested in finding the *pleasure* in being virtuous, devised a rather logical workaround, a sort of have your cake and eat it too move when it came to virtue: since one's anxiety over lack of virtue would obstruct pleasure, by positing Eudaemonia as one's chief ambition, one could cover most of the bases, *including* virtue — 1) because virtue grants us the happiness of being good citizens and 2) virtue leads to a better, more secure, hence more pleasurable society.

When it comes down to it, I do imagine I would wind up in the Stoic camp, for if I were confronted with a serious choice as to whether to be virtuous despite some attendant pain, I would accept the suffering. In fact, so probably would Epicurus, since the attendant guilt he might experience if he chose to avoid pain would leave him in a less-than-pleasurable state. Then again, I'm not even sure the Stoics would want me on their team. I'm lousy at self-discipline, fairly vain, and actually *not* always virtuous. I love this quip by A.A. Long, a British Classics Scholar at U.C. Berkeley: *"I'm an inconstant Stoic"*.

�֎

As for dealing with the current state of world politics, do the Epicureans offer the best approach? Seeking to lessen anxiety and evade pain, either physical or mental, they encouraged one to withdraw from politics, which are inherently painful. Sounds like a rational plan, but somehow I think we Americans are *built* as Stoics and, despite our fuzzy definition of it, strive to keep virtue as the bedrock of our actions.

Now more than ever we need to engage in our political destiny, fully aware of this idea of virtue. These are complicated times demanding flexibility and critical thinking in everything we do; what we buy, what we watch, who we emulate, how we exercise our personal powers interpersonally. At this point in man's 'evolution', I believe we mostly all have an intuitive grasp of what it means to lead an ethical life, that we all have an innate moral sense, that we know what's right and wrong, and even know what we need to do, both personally and as a society. But if this is true, the question is — why don't we do it? Have we lost our way?

If you agree with the Stoics, *it's because we don't have a philosophy of life* — one that guides our everyday actions. Well, the Stoics have got our backs, offering us a brilliant distillation of core values for navigating a tricky world and doing so virtuously. There is a wonderful spiritual

exercise developed by Marcus Aurelius; called "View From Above", it entails zooming out from your limited world-view to a cosmic perspective on events and your behavior within them. There is a moral dimension to this, as expressed by a diagram created by the ancient Greek, Hierocles: at the center of a series of concentric circles is your self, from there the scope widens to include your family and friends; your neighborhood, city, country, continent, and finally the planet, and all the beings on it.

A.A. Long considers Stoicism to be: "...*very much a philosophy of interconnectedness... As you try and bring all of the circles closer to the center, you cease to think of anyone as an alien. And don't think your good could be reasonably achieved without the good of other people as well. If you believe we are basically similar, then how is it reasonable for me to do something and it not be allowed for you?"*

Indeed, Stoics thought of their philosophy as a philosophy of love, and they actively cultivated a concern not just for themselves and family and friends, but for humanity at large, and even for Nature itself.
— Massimo Pigliucci, How to Be a Stoic

On a parting note, there is one absolutely HUGE thing both Stoics and Epicureans agreed on — that living *in the present* was pivotal to well-being and moral behavior. Yet another pungent point for this century as so many of us are running from the past and hurling ourselves into a scrambled, imaginary future.

The Stoics taught us to live 'hic et nunc', in the here and now, i.e., paying attention to what we are doing — achieving what some modern psychologists call 'flow' in our actions. But a crucial component of this mindfulness is paying attention to the fact that your choices, even the apparently trivial ones, very likely have an inextricable ethical component to them, and you should be

aware of it and choose according to virtue. — Massimo Pigliucci

All this moralizing aside, reading the Greeks is a lyrical experience. When it comes to exploring the subjective, we most often hand the task to the poets, whose route is meditative and ecstatic. But modern philosophers, although they project objectivity, will often admit that they are just taking a different approach to the subjective, an analytical one; they are the grinders of our lenses so to speak. Philosophers, like poets, bring love to their pursuit, seeking as they do to look through the ephemeral to the eternal, through the particulars of the material world to the universal forms beyond.

Love what is around you. For what else is more suitable for your love? — Marcus Aurelius

FREE WILL? FREE WILLY!

*"If I hadn't spent so much time studying Earthlings," said the
Tralfamadorian, "I wouldn't have any idea what was meant
by 'free will.' I've visited thirty-one inhabited planets in
the universe, and I have studied reports on one hundred more.
Only on Earth is there any talk of free will."*
— Kurt Vonnegut, Slaughterhouse-Five

Well I am an Earthling and, alas, have been inculcated with this notion
of *free will*. And I must say, not intending to be flippant, that attempt-
ing to discuss free will is like opening a can of worms. (I know —
what a sorry metaphor for the freedom of our will. Maybe one of those
worms could actually wiggle out of the can, but it would probably just
as quickly be the first to wind up on a hook or in a beak.)

But seriously, is free will merely a fantasy, a hypothetical Oz pulling
the gears? If we believe it is, that there is no free will, then we can hide
behind the convenience of its non-existence. If instead we believe we
possess free will, we can then trumpet the value of our achievements.
But really, in what way is our will free? And really, what is our will
anyhow? Or rather what is will, since we can't at this point be certain
we have one?

*Philosophers have for centuries debated the nature of 'reality' and
whether the world we experience is real or an illusion. But modern
neuroscience teaches us that, in a way, all our perceptions must be con-
sidered illusions.*
— Leonard Mlodinow, Subliminal

Yes of course we have the *sensation* of willing, of deciding to act
and then acting, but maybe this is just the culmination of a series
of nonconscious actions within our psyches. In fact, current neurosci-

ence tells us that we actually act before we consciously 'decide' to. As I've stated earlier, when analyzing the drivers of human actions, many neuroscientists will give a startling figure of 95% being nonconscious. Clearly that's a huge amount of influence on our behavior. So these covert components can hardly be said to be a function of free will if we are not even conscious of them. Add to this shaky substrata a memory system which is actually quite porous, a bit slipshod, and prone to fabulation. Not to harsh your mellow here, but so far we're building a rather 'faulty tower'.

On the other hand, it's all worked out quite well for the human race thus far. Our brains may have sacrificed total recall, but this editorial process, though unreliable, is how we stay focused in the presence of a daily onslaught of information. It's why, especially these days, we haven't croaked from neuroses, stress, and inordinate paranoia.

When it comes down to it, what we are is a narrative. A narrative built up of approximations, impressions, feelings, and ideas about all of them. As F. Scott Fitzgerald said, "Character is plot... plot is character." And I suppose the cool thing is that *we* are writing the plot. Or rather our unconscious is, while feeding ideas into our conscious brain, which then creates the storyline. The good news is — you're the star of this story! *If* you, whether or not your will is free, write it that way.

Allow me to examine, in real time, this question of the relative freedom of the will:

I decide to invite Thomas over for dinner. I had just been out with him, after not having seen him for months due to our geographical dislocations, and it had been a nice evening, but not as romantic as I had hoped. I really like Thomas and possibly even have designs on him. He is quirky, intellectually stimulating, financially more-or-less stable, and sort of cute. So my desires are fermenting, hence the invitation. But there is a murky brew at work; the most overt ingredients are a longing for romance and sensuality. Let's call those the activating agents. But then factor in 1) my dodgy memory regarding other less appealing elements of his persona and 2) a nonconscious process of denial of the fact

that he probably isn't even right for me, both of which are driven by the essential human motivations, ala Maslow, of a desire for belonging and love, safety and shelter in an uncertain world — all of which Maslow asserts will lead me to greater levels of self-actualization.

Now I don't totally buy Maslow's hierarchical structure, because I'm fairly self-actualized despite a healthy amount of uncertainty about my future safety. Regardless, the question here is free will. Am I free to ignore my longings for safety? Sure, if I had the nature of a mendicant, or the constitution of a Cynic, but I don't. I am a prototypical Western softie and only through great self-abnegation could I arrive at another state, and guess what — I don't want to, which is precisely *because* I am so thoroughly cultivated as a softie, and hardly through any act of free will.

Am I free to ignore my yearning for love and belonging? Is that a rhetorical question?

As I was on my thirtieth lap in my local pool today, I realized that one must separate these two concepts: free and will. Freedom does exist, and we experience it every day if we choose. (Doesn't matter if it's illusory, we can feel it!) In fact we are free to do anything at all, all the time. But that is different than our will actually *being* free when we do anything.

And will exists too; we use it all day long. Doesn't matter that it isn't all ours, that we've more-or-less been handed a biological script, co-written by numerous writers over millennia, because it is us up there on stage, making it all work, experiencing the thrill of the moment, of the tragedy or comedy. Who gives a fuck about free will?

The Stoics did not concern themselves with free will, but with pro-hairesis, which best translates to the modern term "volition," used by psychologists to refer to our indubitable ability to make decisions.
— Massimo Pigliucci, How to Be a Stoic

Exactly, because we exercise what *feels* like our will every day, even if it hardly belongs to us. Scores of progenitors linger in our

bones. Slayers of Mastodons, Eaters of Monkeys and of Men, Ladies abused and abusing and perduring, and all were themselves children at one point and, like them, each one of us has been imprinted with all this genetic code *without our permission*. Not to mention all the molding done by the folks that brought us into the world and with whom we spent our formative years. The Existentialists believed that, even though our freedom is circumscribed by the 'situations' of our own biological and psychological make-up, as well as the real world exigencies into which we are 'thrown', humans *are* free to choose what to make of themselves.

So whether you call it volition, *prohairesis* or will power, or fiddle with the concept the way the Germans do and wind up with *willenskraft* (will power and strength of mind) or *geisteskraft* (bringing in the idea of *geist* or spirit) or *energie* (aligning other tangents like gusto, vigor, momentum and spunk), we humans actually have it in abundance, even if it is not totally directed by us. And it is in that zone of willpower, that we can exercise *agency*. For to presume that no free will means your willpower is irrelevant or meaningless, is a mistake.

It seems to me that the only way to improve our control in this life is to investigate the scope of the dictates controlling our behavior. Unless we methodically and ambitiously pursue the outer limits of our will, we will indeed be directed by all the external forces and extenuating circumstances of our lives. To deal with the monster of accumulated detritus, who stalks us and afflicts our will, we need to acknowledge it, interrogate it, twist its manifold arms and make it yelp, then force it into submission. Which means, as Socrates says, knowing ourselves. By continuing to explore our innermost drives and actions, and striving to further our reach toward virtue, or at least our notion of our best selves, we can extend our control, increase our potential as humans, and maybe even approximate free will.

If, as F. Scott Fitzgerald said, character is plot (and we now know that character is a multiplicity of selves — a medley of determinants from genetics to early life experiences) then, although we cannot say

our will is free, *if* we can alter our character in the least bit, and hence our will, then it may not be free but at least it is *ours*. It is there for us to collaborate with, whether we choose mindfulness practices like meditation, or philosophical ones like Stoicism, wherein our reactions can be cultivated by the assent we allow them or not. Free will may be an illusion, but it is *our* illusion. It may only be a *virtual* Maserati, but we get to drive it.

In the process of editing this, I encountered a long piece on free will in The Atlantic, which basically corroborates my thesis here. But it contrasts a universe in which our will is *free* against one in which our behavior is *totally determined*. What is not included in this dualistic view is fate, luck, chance, randomness. *If* we encounter in our lives *any* random occurrence, and so many are, *and* we are capable of being altered, either to the better or the worse (which the nurture theory would substantiate), then wouldn't it be best for society to lay in our paths only the best experiences, which can then have a beneficial effect on us? Freedom is contingent upon whether or not we can *access* its power. Whether or not we can rise to the occasion. Whether or not we are able, in the first place, to formulate an idea that insists on being made manifest in deed or action. (Which to me is the prime reason for a decent education for every single citizen on this planet.) Ultimately it is not so much an individual choice that determines the world, but a group choice, to create the best possible world in order to create the best possible people. Now that's some serious will power.

10 REASONS WHY
I'M NOT A NIHILIST*

But first, nine reasons why I am seriously tempted to be one:

1) The fate of the Polar Bears! Poster children of the Meltdown.

2) The morbid absurdity of the 2016 election and everything that's followed. Or is it the absurd morbidity?

3) Religious dogma upending rationality, morality, and basic humanity.

4) Greed upending conscience, justice, and balance.

5) Apparently there is no free will.

6) There seems to be a dearth of appealing and available men in LA over the age of 60.

7) We've mostly all become unrepentant consumers.

8) As earthlings, riding through an unknowable cosmos, are we not as vulnerable as fleas riding on the back of a hairless dog?

9) One day I'm gonna die, anyway.

<u>Why I remain a reserved optimist:</u>

1) There's always another day (until there isn't).

2) I'm pretty sure I'm going to wake up tomorrow with my little dog curled up beside me.

3) My friends seem to like me.

4) Although I don't often get to have sex these days, I still want it, which is more than a lot of people my age can say.

5) Secular enlightenment is possible, because every human has a basic nature of goodness.

6) Even though there's no free will, there are millions of restaurants to choose from in Los Angeles.

7) Even if there are no available men in my age group, maybe I'll find that romance is overrated or… I don't know, maybe I'll just forget about it all.

8) Serendipity* happens and when it does, I'm exhilarated.

9) The world is filled with people making truly marvelous music.

10) Maybe it isn't too late for us humans to get it together?

 * **Nihilism** - 1) a complete denial of all established authority and institutions 2) Philosophy - an extreme form of skepticism that systematically rejects all values, belief in existence, the possibility of communication. 1817, "the doctrine of negation" (in reference to religion or morals), from Ger. *Nihilismus,* from Latin *nihil* "nothing at all." (etymonline.com)

 The Encyclopedia of Philosophy (Macmillan, 1967) states as follows: "On the one hand, the term is widely used to denote the doctrine that moral norms or standards cannot be justified by rational argument. On the other hand, it is widely used to denote a mood of despair over the emptiness or triviality of human existence. This double meaning

appears to derive from the fact that the term was often employed in the nineteenth century by the religiously oriented as a club against atheists, atheists being regarded as ipso facto nihilists in both senses."

Famous for his pronouncement "God is dead", Friedrich Nietzsche became the late 19th century poster boy of nihilism. Nietzsche considered nihilism to be the logical consequence of man's failure to co-exist rationally with or enact the values of Christianity.

A nihilist is a man who judges of the world as it is that it ought not to be, and of the world as it ought to be that it does not exist. According to this view, our existence (action, suffering, willing, feeling) has no meaning: the pathos of 'in vain' is the nihilists' pathos...
— Friedrich Nietzsche, The Will to Power

In fact, Nietzsche proposed that there were two sorts of nihilists - the passive sort who succumbs to the nothingness resulting from the decomposition of old values, and the active sort, who sees in the vacuum of any absolute truth an opportunity for the creation of new meaning, to be derived authentically by free-thinking individuals rather than handed down by institutions.

* **Serendipity** - a "happy accident" or "pleasant surprise". Recently voted by a British translation company as one of the ten English words hardest to translate, it was coined in 1754 by Horace Walpole. He formed it from the Persian fairy tale The Three Princes of Serendip, who "were always making discoveries, by accidents and sagacity, of things they were not in quest of ". Serendip, an old name for Ceylon (now Sri Lanka), from Sanskrit simhaladvipa "Dwelling- Place-of-Lions Island".

The fact that she almost took the other way home, that she then decided to stop at the market en route, that she suddenly had a craving for a fruit tart — it all led to her bumping into him at just that moment by the strawberries. It was all so serendipitous or — was it a moment of 'coincidence,' which could be traced instead to 'destiny'? Her romantic mind chose the latter explanation. Either way, it led her to love.

WHAT CAN WE KNOW?

To Know...Okay, I'm really not aspiring to be an egghead, it's just sometimes little things we take so for granted, like the idea of 'knowing', seem to me in dire need of clarification. Consider how many different activities we toss into this general concept of knowing. Here is a short list compiled by David Galin, the U.C. Neuroscientist:

1) to perceive directly, 2) to be capable of, 3) to be fixed in memory, 4) to be acquainted or familiar with, 5) to be able to distinguish. (Note that none of these usages specifies consciousness; they all make sense for instances of nonconscious as well as for conscious knowings.)

Galin considers the definition that best captures the phenomena to be one of the most general; *to know is to be able to distinguish.*

But what do I *know* at this particular moment in time? This could be translated as, what do I perceive directly, and not as what can I distinguish. But once I express a perception, does it not mean I have distinguished it from all other perceptions? Anyhow, here is what I am perceiving:

My desires for the next hours of my evening, which are to watch T.V. instead of write.
Some confusion about my emotions for Thomas.
A strong need to find a lover.
A concern about the oxytocin effect that renders anyone I have decent sex with, or maybe just a hug, to be an object of affection.

But what do I know?
I know that I have a platinum Dennis the Menace haircut;
that I have a dog who manipulates me all day long with his

penetrating, mildly accusatory glare and apparently innocently wagging tail;

that I am at my optimal self, the peak of my powers, after I swim;

that I am a foodie/gourmand/gourmet;

that I am an odd construct of all the above, plus some possibly arbitrarily conflated memories of so-called 'events'.

Oh, and I know (or am acquainted with) a sense of self that wiggles all day between the past, the present and the possible. But am I truly able to distinguish my self from all my sensations arising from memories, events, musings and projections? (Do I *know* myself? I guess I will have to settle for saying that I am familiar with the various permutations of myself...)

Okay, I also know I am staring at a monitor and it is 8:28:28 (which, OMG, is a palindrome!) and I am under 1000 hours away from turning 67. I have just eaten sushi and talked with Thomas about his friend Reynold who is 56, weighs nearly 300 lbs., and wants to marry a 19-year-old whose 40-year-old mother is tatted from fingers to jaw. I know that I wonder about Thomas's thought processes regarding his own future. I know that I don't really know Thomas, that he's more than a tad inscrutable.

So now I'm doing T.O.M on him. Theory of Mind. It's not what you think. It's the way we develop theories about the minds of others. Like — I believe that Thomas is thinking about how I compare to a 19-year-old and also (because I'm really rather interesting in general) that he's finding himself so on the fence that he can't move either to-ward or away from me. (Why am I seeing Humpty Dumpty? Another probably completely nonconscious event, another cognitive quirk.) But of course, these are mere conjectures and hardly something that I *know*.

So anyhow, rather than focusing on what I do know about the man, my entire and useless rumination about him is just me being a member

of a defensive subsection of the female subset of an aging bunch of humans and choosing a plausible (probably outdated) cultural norm to explain my actual feelings. Which are??? Do I *know* them?

Well, I know that I basically do not want to live out the rest of my life alone. Or maybe those are 'just my feelings'? At least I *think* those are my feelings. God only knows. Oh wait, it's like the Zombies sang in 1965 — then it was about a girl, but here it's about God — "You're not there." So if 'he' doesn't know I guess nobody does. OMG that's too dreadful a thought. Okay, Okay. I know already! Here's what I *feel* I know: that I don't really give a fuck! (See, I'm learning to detach. Benefit of growing older and of reading the Stoics.)

But seriously, can we really know what we're feeling, or whence that feeling came? No matter how we scrutinize the vaporous thing, struggle to pinpoint it, often it evades our grasp, melts back into its subliminal realm. I guess the question is, how much do we need to know about our feelings? I know you can get totally whacked hyper-focusing on what you're feeling, so that would be one terminus of the Wild Mouse ride from the nonconscious to the conscious. And then sometimes you just have to fish or cut bait. Sometimes you just have to shelve the effort for a bit, figure things out later, or even never, and probably toddle along at a pleasant enough pace.

And yet, knowing oneself is a primary goal, and the only way to approximate a dominion over those multiple factors influencing one's will. Only with self-knowledge can one act intentionally. Lofty pursuit. And one worth striving for, that much I do know.

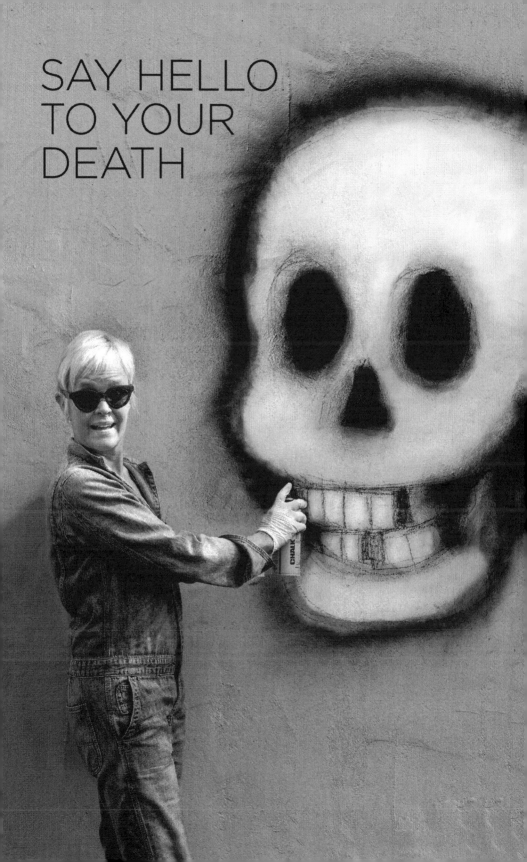

11 GREAT WAYS TO DISTRACT ONESELF FROM IT:

Watch (you have all the devices…)

Shop (anywhere, anytime)

Suck up gobs of internet pap

Pretend to work (you're good at that)

Stick comestibles into snack hole

Think about fucking (you're good at that)

Fuck (you may or may not be good at that)

Think about death (oops, for like a split second)

Fuck

Think about some random bullshit

Die.

DEATH - A FLASHBACK

1981 – Jack Benny, who was 39 for years, is quite dead. There's clearly no salvation in lying. Rochester was probably not that amused by it. But then he's dead too.

My hat rests on my head quite unlike a halo. The sky is not relating to my need for consequentiality. Thus I finally realize a latent capacity for cynicism — perhaps only a stage of self-understanding? No ovations.

Shifting the pink fedora to a cockier angle, I stride across the abyss and wave down to Benny who is serving a light repast of milk-toast to Rochester. I am 31, going on 39. And there are further abysses to cross. (Or is it the same one, and I'd never really crossed it?) I could cross myself, to no avail, and others, to my peril, but that abyss, leering with that Benny grin, was intractable.

Although there were a number of mythical beasts willing to transport me over this abyss, for a fee, the fact that I could put my hand right through their wings was disconcerting. I could bolster my courage with liquid spirits of considerably rare vintage, and then convince myself that it was in my power to make the passage without them, 'wing it' so to speak. But, thus enheartened, I would indulge in hours of carousing, the evening would fly into a blur and I would awaken in a sweat, noticing that the abyss yet yawned at the foot of the bed.

(For three days, I had been using a toilet in a pink-flowered bathroom and a great deal of cocaine. The laundry hamper was made to resemble cut crystal… and I wondered if perhaps it was 'the finest hamper ever made'. On the third night, staring out upon a stormy sea from a veranda once walked by the notorious New York Mayor, Boss Tweed, I had the sudden conviction I would be struck dead, if not that night then another, by a bolt of lightning. Later, less high, it seemed I would probably instead submit to a less heroic death, the usual interminable decomposition. Either way, however, seemed causally connected to my relations with my spirit. And as it seemed there were light years

between my exterior and my interior, I thought perhaps I had grounds for worry.)

We get into the habit of living before acquiring the habit of thinking. In that race which daily hastens us towards death, the body maintains its irreparable lead. — Albert Camus

Now years hence, at the ripe old age of 39, I look forward to Benny serving milk toast to me too.

SHE MOVES ON

Walking along, I bow my head,
the accumulated density of death bearing down.

Walking along, zombie like,
I stare at the pavement as if some answer lies there.
Between the atoms of cement — some deeper truth about
lastingness.
But its mute reply reminds me that we shall never know this
and that the paths we pave, and all the absurd constructions
of man, will long outlive us.

But where does it all go? The innumerable daily moments of
her 92 years.
Her thoughts, her drives… the love and the angst?
All gone now.
Or not, perhaps come to roost in my soul.

I stare at her photo. An icon. I can insert myself into this woman
who, for a moment granted absolute freedom to bring herself into focus
for the camera, stares out with supreme self assertion. Assuming, if only
for an instant, her true role. American Kali.

I can meld with that same woman gazing out her kitchen window,
circa 1960, wondering why she had to be female. Or reside behind
those same eyes suddenly tricked into a moment of joy by her daughter's childish ways, tricked into a moment of recognition that her life
was very, very good.

I tell myself she had many such moments and that is all we can
ask for.

✳

Death.
What a jolly good time to think about life.
So jolly me, Death. Now.
For I'm exhausted unto the grave pondering your ways.
Except for the lucky old, snatched from sleep,
ways you administer with neither rhyme nor reason,
nor beauty, nor poetry, nor comic timing.
Leaving her suspended between heaven and earth for 16 years?

But then there's that bone they toss at you — of meaning.
Is that, Death, what you're on about then?
Kill us and turn us into poets,
architects building meaning out of the ashes.
'The Meaning of Life' or at least something more meaningful
than everything you fucking just took away?
I hold that bone 'for dear Life',
pierce my ear with it so as never to forget.
Look in the mirror and there she is.

But then, at 92, what meaning did she still hold for me —
all crumpled up, unfeathered baby bird,
shell cracked before ever flying.
It's all in the name. Mother.
And now, I myself, careening solo
through the chill updrafts of spring,
know for certain that I am motherless.
As if I wasn't always.

Death brings on great heaving.
Of the soul, the gut, of the tongue.
To be condoled is a dubious salve.

Heaving, Cleaving, Leaving, Bereaving.

Then Weaving. How her life intertwines with ours,
and with all the lives before her,
weaving this long, long twisty path through time.
A path that becomes a helix, a genome.
A big, throbbing, heaving genome.

If we get to the end of it, and unfurl the map,
flatten all its complexity,
then where do we go?

Alzheimer's is an unnatural death. When you have it, you don't have a
moment to even say hello to Death, because the words don't come and
your face recognition sucks…

❋

THE INEVITABLE
TRAJECTORY

Sound of silver talk to me.
Makes you want to feel
like a teenager,
until you remember
the feelings of
a real-live
emotional
teenager.
Then you think again.
— LCD Soundsystem

Death does not concern us, because as long as we exist, death is not here.
And when it does come, we no longer exist. — Epicurus

DEATH!!!

You are a little soul, carrying a corpse around. — Epictetus…

<p style="text-align:center">※</p>

How did I get from 17 to 60? I can only say Time Flies. I've actually seen it. Sometimes on the wings of crows, sometimes on the backs of skeeters, sometimes just as a shadow streaking across my brow.

Look, all I know about Death is that I don't want to be a dead person. First of all, you look fuckin' scary! All your blood disappears into the ether and you wind up a skeleton with yellow skin, a being that NOBODY would recognize as you. Fucked up, right?

I'm not saying I'm scared of death itself. Because it's really the third act shit that gets my skivvies skewed. That loooong decline shit.

That sick unto the grave shit. That 'really gotta go but nobody's show-
ing me the door' shit.

So yeah, crush me with an I-beam and blitz me with lightning or
maybe a javelin. Or leave me to my safari where I go rogue and put
myself in the path of a tiger who leaps, in a long feline swoosh, lunges
at my throat and yanks out my arteries. I will be so shocked, in such
a swoon, that I will not feel pain. And then I will finally be of some
fundamental value to the chain of life.

Hopefully there will be no remains to be processed, save perhaps
my iPhone, which will house all the relevant moments leading up to
my last and which will never yield them up, as the passcode will have
perished with me. Unless I burble it through the gushing blood to the
lovely Hindi man standing over me, wondering what kind of person I
was. And what kind of person was I? Ah — unfinished!

<p style="text-align:center">❈</p>

DEATH!!!
Comin' at ya'.
Grinnin' from a skull.
Stinky as rot.
Just plain zzzzzzzz boring because there's no 'there' there.
And yet! The antipode to life. The dark that defines light.
The fear that goads.

And me,
piling on these half-baked memories
and half-chewed moments —
like dirt on a grave…

but here's the thing.
I don't belong in a grave!
Won't ever be in a grave!

Flames!
are more *my thing*
than dirt.
But only *after* I'm dead, please.

Hello Death.
I hear your heavy breathing.
I see you, your wavering penumbral form.
I know you want to tell me something, but...
I just don't wanna talk to you right now.

Death is a thief, an incorrigible thief. Occasionally Robin Hood, but mostly just a hood. And yet he (notice I don't say she) leaves behind the most important part (Ye old legacy? A lingering, malingering soul? The voluble, valuable memories we've left with others?) ... and in that way is ethical. But wait a sec. I had better get something seriously memorable under way before that javelin strikes, cuz damn, man, I did want to make a *lasting* impression!

The word 'pass' - why do I hate that word? Because of the connotations of just getting a decent grade, or eliminating gasses? Oh, and then there's pass out... Maybe I'd rather say, "Yeah, Mom just passed in."

Okay, call me Pollyanna if you like, but I say all colors change according to the light, likewise all emotional content. So shine the right light in the right places, utter your soliloquy about joy upon the stage, and exit stage left.

The art of living well and the art of dying well are one. — Epicurus

�֎

Middle of the night — as I stumble toward the john, I see a crazed ignominious death, where I slip and bash my head on the tub. And realize this is why men go to war — to die bravely, preferably young, hopefully not ignominiously. But how can one skirt the ignominy of death?

1) Join a revolution or holy war
2) Die in a flash flood saving your neighbor's dog or better, baby.
3) Cut a fart so big it not only asphyxiates you but the whole planet as well and noone will live to tell of your ignominy.

Ignorant are the dead. Ego-driven to their death, are the dead.

Talking about Death seems to have become a thing. Arianna Huffington has staged dinner parties across America to talk about death. The Museum of Modern Art's R&D department just held a two-hour colloquium on death. Come on guys, <u>Death is NOT a Thing</u>!

For my death, I'm planning to just go Poof one day. Like out of the blue, *I atomize!* I'm standing in my favorite ice cream shop licking a cone of lavender honey vanilla and suddenly I giggle and evanesce in a flurry of jimmies and twinkles.

The eccentrics of yore used to drown in foreign waters or die from absinthe or too much lead-based pancake make-up or fall out of a window or swallow a fly. Us newbie eccentrics? We'll do something random like stroll into an Oculus Rift duel and actually get beheaded or get blinded by a drone and walk off a bridge while Instagramming or wind up being an accidental mule for some mutant drug.

Anyhow, why need I try to keep this vehicle called my body functioning? It will corrode at some point so why prolong the suspense? Oh, of course, because Life is Oh So Exciting!

And You Never Know ——
Tomorrow might be your lucky day.
Or have we given up on those?
They do seem as random as anything else.
Like, what powers do we possess to manufacture them,
to materialize lucky days?
Hmmm. I'll have to work on that…

You laugh —-
I am old.
I creak, I crumble, I stumble
Toward my grave.
Yet still I hear,
your steps not far behind.
Ha!

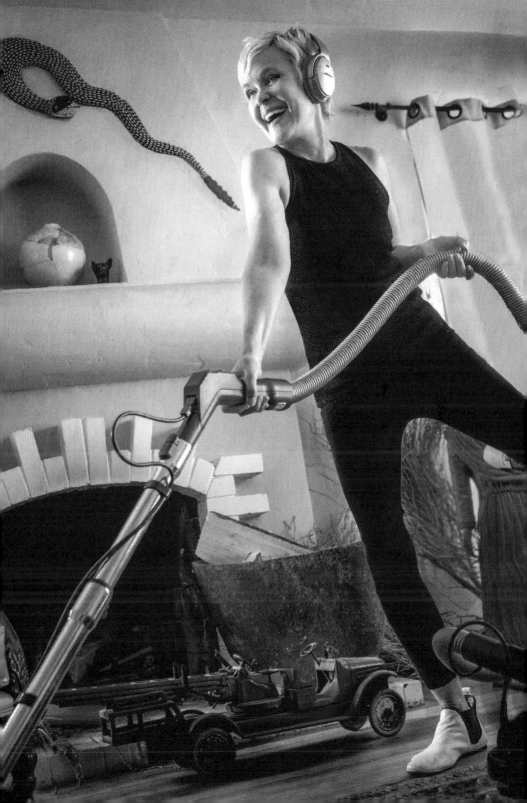

SCHEDULES AND HOW NOT TO STICK TO THEM

My shrink wants me to make schedules. I keep forgetting that he told me that, a few months back. At the time I thought, yeah, I should totally do that. (As if I'd never heard of doing this… and yet, somehow it had always eluded me or rather I never could actually stick to one, except longitudinally. Oh and there I go again, using the word *should!* Perhaps I could rephrase that line… Yes, I might consider doing that. Or, I might actually *need* to do that!)

So I made a schedule. Here's what happened to it:

Write. (Oh but, I do have to take a swim because it's the only really warm day for the next two weeks. 75 degrees is primo outdoor swim weather, and the forecast of 60 and below for the coming weeks just doesn't cut it. Unheated locker room. Stiff afternoon breezes by the time you emerge and a long walk to the showers. Yes, I'm a Wisconsin Girl but it's all relative, so sue me for becoming a weenie Angeleno. It just happened, okay, like it does to everyone who moves here.

Anyhow, to continue… *then* I will write all day. I don't even have to put that on my schedule because the calendar in my head always says WRITE. DON'T FUCK OFF. And yet… really weird things that totally necessitate my dealing with them intrude, like ALL DAY.

Okay, I do have a major dinner to make this evening and damn, I do need peanut oil or some simulacrum to fry the chicken in. Why am I making fried chicken when this is really not my thing? The real answer is Thomas but, beyond that, out of the blue a few days ago, I was suddenly gastronomically impelled to make my own Ranch Dressing. Having sussed out the various approaches on my phone, I went ahead and made a truly killer dressing — I call it Penitentiary Dressing! (Give those girls in Orange is the New Black some herbs and buttermilk. That

will transform the inmates. Good food will radicalize them into being Good Girls!) So naturally, my thoughts turned to fried chicken. Again, I am a Wisconsin girl, which is not so far from the South after all.

So off me and Mimmo (which I happen to like better than "Mimmo and I") go to Trader Joe's to get some oil, where I see that they have Grapeseed Oil! Low smoking, heat tolerant… excellent. But I'm here now, so I stroll around. Kill another 15 minutes, then remember I need something from the local cosmetics shop next door where I know all the girls because I chat them up when I really don't have time to kill but need to kill it anyway because I'm avoiding my desk. They find me amusing. And I love their constant changing of looks. Today I drop in for some SPF lip gloss for outdoor swimming and find Angela whose hair has just been turned a raving purple. It's all over her hands. I remark on how often she changes up her color, and she tells me she is going to a wedding. I'm so used to young women being bridesmaids that I assume she is as well and ask what color her dress is. "White!" "OMG! Congratulations! What color is his hair gonna be?" She laughs.

Lost 15 minutes but gained a nice high from communal camaraderie. Now I'm home and it's already after eleven. Must organize, tidy the joint up a bit. Gawd, this is a major effort. Things have to be moved. Piles of stuff, stacks of magazines like Bon Appetit, Fast Company and Wired, and the occasional J Crew catalogue I dog-ear and never buy from. Silos of dunning letters and begging missives for this and that environmental group (every creature, every wild zone, every element of the universe, has my address and communicates their needs through their human emissaries).

After an hour the place looks artistically 'lived in' if not tidy. But, there remains this problem of five boxes of slides in my living room. Family slides (over 5000 by last count) that I've painstakingly edited over the past six months down from myriad slide carousels.

Finalizing this tedious labor suddenly becomes something hugely, manically important. Which means that I must at that very moment

correspond with the digitizers who will convert the slides to pixels. Long text chats with Jeff, then clarifications by phone with Victor (heavily Hindi inflected voice) then two separate calls with Francis (even sexier Indian accent), which conversation turns into a discussion about the weather in Bangalore — cold in winter and in the summer, as it's hill country, quite "balanced, really". All of which is being conducted while whiling away my writing time.

Actually I have now come within an hour of finishing this fucking archival project off before taking my absolutely necessary swim. Label every slide box, recheck slide counts... There is already a sense of impending release when this project will be done. Not writing, but something close — finalizing a narrative about my past. I pack it all up, label it and stuff it in my office. Now time for my swim then home to... write? No time. Instead I must set about prepping for what turns out to be some goddamned heavenly fried chicken. And I guess I might as well give you the recipe!

Goddamned Heavenly Fried Chicken

A whole chicken, cut in parts, dunked in
A Buttermilk soak (3 cups: add salt, pepper, paprika) and fridged for 8 hours.
Whiz a package of Rosemary Crostini in blender.
Let Chick parts drip on a rack.
Then dredge (in a paper bag) in
About 2-3 cups of Bob's Mill Gluten-Free Baking Flour
Let sit somewhere where batter won't pool.

Mix half of buttermilk bath with an egg and dip all pieces in it.
Then dredge them in pulverized crostini.
Let all pieces rest on rack.

To a 14" Cast Iron pan add:
1 1/2 pints of Grapeseed oil
1 - 2 T's of Duck fat
Heat to 365 or higher then
Fry with room to bubble…
5-6 minutes per side *with* lid
6-9 minutes per side *without*

It has been said that, in producing perfectly fried chicken, color is as important as time. And I say, "Listen to the Chicken."

<div align="center">※</div>

So, dear Shrinky-poo, (no, he's not half poodle) today I fucked over my schedule, but did something Remarkable and Necessary. Dealt with a major life obstruction and made my first truly Awesome Fried Chicken. If I were to die tomorrow, wouldn't I feel better having done this? Is this not the real question? If I were to die tomorrow, what would I have wanted to have done?

But since I expect to live for at least another day, I promise to Write!

Why? Why do I need to write? Because it's there? Because it's my Hail Mary? Because it might actually turn out to be My Thing? Maybe that's closer to the truth and that's bloody scary. What if it is? Do I do what I always do, Tigger Style? Bounce on to… what?? Oh someone, if I do, please call the Heptapods (the awesome, eerie aliens in the movie Arrival). Maybe they will take me away… or maybe they'll tell me to just stick to my effin schedule.

LIFE IS 90% MAINTENANCE, BUT IT'S THE OTHER 10%

Somewhere in my forties, raising a kid at home and trying to keep an art career afloat, I came to the sobering realization that Life is 90% Maintenance. Now this is a percentage that varies of course, depending on the size and density of the flack field one is traversing, but I would peg that amount at rarely under 85%.

In my parenting era I found myself hamstrung between my career goals and the obvious stay-at-home mom stuff like shopping and cooking, tackling school issues and supervising homework, setting up playdates and music lessons and, of course, chauffeuring. On top of that there was attending to the varying states of disrepair of appliances, computers, toilets, and roofs; paying bills, dealing with banks, utilities, insurance, doctors, dogs and vets. Then there's all the personal stuff like keeping the old bod in shape, arranging social events, and navigating tricky in-law stuff. A supreme act of maintenance, that one. Don't forget all the career-related issues, in my case fetching arcane art supplies, trekking to photo labs, and stretching huge canvases.

Just when you feel like you're clearing the clouds, the kid is in a sort of groove, the in-laws pacified, the career stuff manageable, suddenly the parents start to fall apart. And there is a whole new ball of wax to roll up the hill. No matter how much you and your siblings decide to outsource their well-being, our beloved progenitors require and deserve a lot of attention. Maybe they've got serious afflictions, maybe they're miles and miles away... But don't forget, one day we'll be there.

At any rate, one day some years back, I found myself muttering repeatedly "I'm going to go live in a teepee. Yup, I'm going to go live in a teepee."

Back to the root of the plaint: with that 10%, can one find time

to do one's artwork? Tracy Emin, an art-world It Girl, recently and quite controversially said, "You can't be a mother and an artist." This statement rankled mothers world-wide, but we all sort of knew what she meant.

Perhaps this is why so many people, when they hit a certain age, have traditionally opted to 'retire' — hoping that their 10% will fatten to a heftier percentage. At the least, one is obviating all that career stuff — the trips to the dry cleaners, the expense reports, the tedious business dinners, etc. But then what happens is you suddenly feel adrift, disconnected, slightly unsubstantial, slightly… unreal. Yes, it's true — and all of the post-war generation is figuring it out — retirement is not the answer, which is why so many of us are not doing it.

Because bitch and moan or not, all that maintenance stuff? That's life. If you were a ferret or an albatross or a jellyfish, it would be the same deal. And when you think of the fact that our 10% of interesting stuff is way cooler than the alternative (0%, like if you're dead) or even the 10% of a ferret, well, you just gotta say WTF: I'm here, I'm alive, and the world is fucking fabulous.

As a good friend reminds me, it is precisely this struggle and frustration that creates character, that provides the context, the backdrop to the real drama, the real action of our lives upon this stage. It is the apparent humdrumness of life against which those moments of heightened awareness, of sudden bliss, arise with greater brilliance. It is those flashes of enlightenment that come glinting off a raised glass like reflections off some vast luminous moon. On our long trek through the quotidian, it is those drops of transcendence, which rain upon our parched souls, that give us the strength, the urge, to continue.

EXTRAVAGANT DINNERS
FOR ONE

(I am an artist, a thinker, a gardener, a scientist,
and a sensualist too; I am a chef!)

Is it odd that I cook for myself, not just a plate of pasta, but an elaborate one? Not just a piece of fish but a chunk of halibut with leeks, shiitakes, and umeboshi (sour plum) paste, accompanied by green beans and wild rice?

Is it odd that I often make complex omelets for breakfast or multi-faceted salads for lunch? That I cook soups and muffins, ragus and burritos, curries and chili, and the occasional batch of gluten-free banana walnut muffins (that in fact are the most awesome, moist, and redolent muffins in the world)? Hmmm. Maybe a cookbook is forthcoming? Naw, don't worry, could never guarantee the outcome… except for the fried chicken and the muffins.

Nobody else I know who is single cooks like this for themselves. What is it? An attempt to shower myself with edible love? A recreation of my mother's kitchen? She who had stacks of cookbooks and piles of index cards of recipes from friends — many of them underlined and amended, with notations of what dinner party they were served at and who was there. Such a faraway world from the relatively hermetic one I inhabit. Haven't thrown a party for over a year. Have a rotation of four people who might be invited for dinner if I'm up for entertaining and not anxious as hell about the status of some project I'm laboring over or concerned that the level of dust and piles of books, notes, and mail might make them think I'm turning into a lost soul.

OK Cupid, the popular dating site, asks myriad, multiple-choice questions of its potential daters. One such question is, "Can you cook?" One of the four answers is, "Yes, I'm a culinary genius." Next it asks,

"When you are cooking, do you closely follow recipes, or do you oper-ate more on intuition?" I chose, "I let my intuition guide me." Then I spontaneously added, "Cooking is an act of love. Who follows the book on that?"

These kind of artistic flourishes got me nowhere on OK Cupid. Nonetheless, I firmly believe that cooking *is* love. But there is even more to it. For me, since I rarely cook with a recipe, cooking is freeform edible invention that often starts with a reverie of flavors that envelop me in the odd moments late in the day. And of course, ideally, cooking is art you can feed your friends. Cooking is luxury. Cooking is freedom. Cooking is sensual, riveting, and playful. And to my mind, cooking creatively, at least recreationally, is essential to being a fully-engaged human on this cornucopian planet.

Personally, I can't see a head of Romanesco cauliflower in the mar-ket without seizing it. Its pale acid-green color alone makes my mouth water. The fractal pattern (like *totally* hallucinogenic) of its florets, diz-zily spiraling in upon each other, hypnotizes me. This is a vegetable, for chrissakes. Of course I am lucky — the vegetable bins in California markets, especially in the summer and autumn, offer an artist's palette of color.

One day, after picking up a head of that Romanesco, I saw a fetching bunch of purple kale (multi-hued curly leaves spanning crimson to blue) and grabbed that too. For some reason, no matter how I was going to cook them, I knew I had to douse them in a home-made ranch dressing I'd finally perfected the day before. Ultimately that, along with that pre-ternaturally delicious fried chicken I described in Schedules, made a meal so satisfying that dessert would have been overkill. In fact I didn't cook that meal just for myself but for a would-be lover, who, alas, was *not* all that sensual. I mean he dug the chicken… but *I* totally tripped out on that gosh-darned bird in its suit of golden, crispilicious batter.

I spend hours in front of my computer and look forward (most days) to cooking; it brings me real tactile release, sorely needed after a

day in the enervating vapors of the virtual world. Funny, but when I speak to friends about longing to find love again, this is often the act that leads the list of reasons why I experience this longing (as if I need one?): that I want someone to cook for again. Someone upon whom to lavish a love made manifest in the realm of the edible.

Actually, we could all become chefs (in our own homes) if we wanted. Maybe if we did, and all spent more time cooking and feeding each other, this world would be a happier, healthier place.

THE LUXURY OF DUST

Dust is us. It happens around us, because of us, in spite of us.

How many hours get spent wiping it away only for it to return posthaste? I have learned to love dust. Because if I let it be, it lets me be. If I don't obsess about it, it leaves me in peace. I'm not saying that a shiny glass table isn't a thing of beauty, reflecting light back into the world. I'm just saying dust's not a *huge* priority. Or until I have guests arriving or it gets on my socks.

Hiring a cleaning person? I'm too cheap to pay for a real one. Think of all the other things I can do with that dough! Eat out with friends, buy an occasional bottle of over-$12 wine! Besides it's almost as much work to clean your own home as to prep it for a third-party cleaner. All that pre-tidying, the hiding of stuff you don't want broken or just plain seen. The way I see it, if I'm already doing that much, I might as well swipe a cloth across 1/8" dust. I might as well do the damn kitchen floor too.

Yes, I am my own domestic worker. But here's the real charm — if I'm the domestic, I can let the whole blasted thing go until I can't stand it. Don't have to adhere to a pre-set schedule. And I'm using way fewer toxic chemicals and electricity.

Besides, there's something really *cleansing* about taking care of your own dirt. Something sort of wholesome about taking responsibility for it. Getting into the corners and scrubbing away the grease, turning dingy linoleum cheery yellow again. And, when you're done, feeling like you've taken care of business. Besides, if you do all the wood floors too, damn it's a good workout.

Now by the time I hit 75, I might not feel the same way, but for now, well let's just say I'm one of the billions of women that do their own housework, not part of the 1% or whatever the hell it is. And I feel solidarity with all of them.

AIN'T NOTHIN' LIKE A DOG

*Or how to achieve higher states of being
through communing with a canine.*

Running way too fast, tripping on my own laces, way ahead of myself;
some part of me knew I had to access the state of being known as *Dog*.

Then I heard of a local pet shop where they welcomed stray hu-
mans willing to walk one of their ever-shifting army of rescue dogs.
One could even foster a dog for a few nights while it was waiting to be
adopted. I did this. Three times. Rather masochistically, since my land-
lady had already nixed the idea of my owning a dog in her building.
Once with a stunning hound with one blue and one brown eye, one ear
up one ear down, nine months old — a potential Purina poster child
— but lunging at everything and a major pisser. I was out of my league.

Round 2 was with little Buzzy. Spiky fur the color of cherry wood,
and a mug like James Cagney, Buzzy turned out to be a serial adop-
tee… I wasn't told why, but quickly learned he had serious separation
anxiety. When I walked out the door, his howling threatened to alert
my ancient, thankfully mostly deaf landlady, living below, to his
forbidden presence on the premises. Tearfully I returned Buzzy, now a
four-time recidivist.

A week later, visiting a friend in Chicago, I passed a church with
a huge banner emblazoned over the doors, PET BLESSING. I was in
fact being given a ride to the airport at the time, but we pulled over
so I could take a photograph and soon found myself drawn to a table
outside where volunteers were taking names. A cherubic older gal with
yellow curls, who seemed to be channelling Shelley Winter circa 1955,
listened as I told her Buzzy's tale of woe whereupon, with a beatific
smile, she offered to make a prayer for him inside. I wrote his name on
a slip of paper, thanked her sincerely and sped to the airport.

A week after that, I decided to see how Buzzy was doing back at
the shop and learned that not only had he been adopted a day after the

blessing was made, but that he'd been paired up with another rescue pup from the same shop, and was now living on one of the swankiest streets in town. Will this bring me back to the Church? Nope, but it did represent a powerful stroke of synchronicity that booked heavily on the adage about the healing properties of prayer... Little Shelley Winters sent some serious reverberations through the noosphere, I figured.

Despite the first two near misses, I returned, this time merely to *walk*. I knew better than to get involved again. By this time, my landlady had gone to her final resting place, but I was working hard on plans for the next stage of my artistic career. Really didn't see a pet in the picture. Luckily, the first few walks, none of the dogs yanked at my heartstrings. Suddenly however, there was a new guy on the scene. Poodlish, but a funky, dusty brindle, whose color variations were reminiscent of the trunk of a pine tree. A little bit of ochre, warm sienna, raw umber... black tipped ears and paws, and a tiny white blaze on his chest.

I chose him for that walk, although he couldn't have cared less; barely looked up or acknowledged me and kept his nose to the ground as he ran a zig-zag path around a few blocks. Oh well. No bonding moment. No slavering love.

But a few days later I saw him again, and this time he pranced up to me on his very long legs as he went into a full-body wiggle, perhaps realizing I was a potential liberator. At the end of that walk, back at the shop, he circled around me once or twice then dashed off again to nose around the joint. The third time around, he was genuinely glad to see me and hovered close in a proprietary fashion so that I would choose him for the walk. Smart little fucker.

By the time we got back to the shop, I found myself quickly reconsidering plans about my next year. Yeah, I could always find a dog walker when I needed to travel for business. Walking the guy twice a day and unloading small fortunes on fancy food, treats and toys, and vets? Uh, I hastily skipped over that part and signed up to foster him — just for a few days I told myself.

The first night I put a blanket on the floor for him and started to fall asleep when I felt him jump onto my bed. I was too tired to resist and for the next few nights he drew ever closer to me. By the fourth day, I called the shop and asked if I could keep him over the weekend. The answer was an immediate no; there was a long list of potential adopters waiting to meet him! I gulped, brought him back and then, in a heart-beat blurted, "I'll take him."

For a week, I couldn't fix on a name. The shop had named him Edgar, but he'd only been there a week and had come in with no tags and no chip. The story was he'd been found running free in Koreatown… but the fact that he was perfectly house-trained, at 8 months, indicated someone had put in some effort. Either they were foolish and lost him, or unable to keep him, but I didn't care because now he was mine.

He looked like a teddy-bear or an Ewok or a Wookie and I stared at him trying to divine his true name. Finally it came. Mimmo. There is an Italian painter called Mimmo Palladino and it had always seemed a jolly name. And now, since people always think I'm saying his name is Nemo, I pronounce it with an exaggerated long Italian Meeeeemo. He is so goddamned cute that even guys smile as we pass. Big hunky guys. And women and children. They all stop and coo.

In a year of career challenges, social challenges, and emotional trials, this little fellow has brought me joy and release. Whenever I am buzzed, jangled or confused, I lie down on the floor next to him to nuzzle and play. In those moments, my entire world-view shifts to his and nothing has any larger meaning than that precise feeling of sun on our backs, the intermingled scents of his fur and my saffron perfume, and that free-floating awareness of a very charmed universe.

MIMMO THINKS I AM A DOG.

PERHAPS I AM A DOG,

CLUELESS,

FURLESS,

NO OLFACTORY CHOPS.

BUT I'LL DO

IN A PINCH.

I HAVE A DECENT BARK

AND KNOW HOW TO PLAY.

DAWG'S LIFE

Why I Sometimes Wish I Were A Dog

Look, I'm not trying to be merely amusing here, but really, I think being human is highly overrated. At least that is what I told my dog the other night, in my best approximation of a British accent. "Dear chap, being human is *highly* overrated."

But am I just being casually snide, or could this be true?

Back in the day, I wrote an essay for admission to college — the first line was: "Sometimes I wish I were a dog." In essence, it was a lament about the issue of having to perform in order to gain acceptance to an institution of higher learning. Well, I got into a pretty prestigious school either because of or despite that essay. But it is a theme that has haunted me throughout my life.

Yes, yes, we've got autonomy. Lot of good it does us. Compare the life of the average dog, and I think you might well consider that it has a life superior to our own. Free meals, free abode, probably as much sex as either you or me, and probably way more fun. Sure there are the countless strays and the abused, but their numbers are probably no higher than those afflicted of the human species. And let's face it, they have the higher moral ground here — their oft-reduced status is not a result of the depravity of their fellow canines, whereas human society *can* be held accountable for its swarms of misfits, outliers, and disadvantaged.

On the plus side, you may argue that we experience *transcendence*. Exultation in our awareness of the miracle of life. A sense of higher truths. But we cannot categorically say that they do not. Perhaps they *live* transcendence. Sleeping whenever they want, free to fritter their time away chewing on toys and licking their dicks.... contemplating the sublime, in short. While we fall prey to all the ills of consciousness and the nattering need to survive in the confusing world of humans.

Look, dogs do not spend their lives fretting about their ideal mates, about their lack of societal recognition, about the futures of their progeny, about insurance, taxes, mortgages, their aging parents, their dwindling libidos… about their death.

Not at all. Sauntering into the sunset, these charmed beasts, in my opinion, have it all figured out… In fact, you've seen that sly grin on their faces? The one that looks sort of shit-eating? Well that's their smugger-than-thou reflection that THEY are livin' the life, and we, their putative masters, are the subjugated. THEY know that being human is highly overrated, they know that free will is an illusion too… but they're not saying a word.

PINK

is the tongue unfurling from the shaggy black orb that is
my poodle's face.
Ribbon candy pink. Supernal *PINK*
Like, really, really PINK

Not rrrose like the French say
Or chrrrosa like the Germans
But PINK! PINK! PINK!
I think
There is something otherworldly in the word.

PINK
It pops
It bops it splatters
It bursts it blurts
It bloooooms.

Surreal
Superreal
Pink is NOT a color but a creature.
A being
A happening
Pink are our secrets and our hidden parts
our softest and
most luscious parts.

PINK!
Here's what I think:
Take another drink,
Vomit in the sink,
Cuz I like Pink,
I'm in the PINK. In the PINK.
And I intend to stay there.

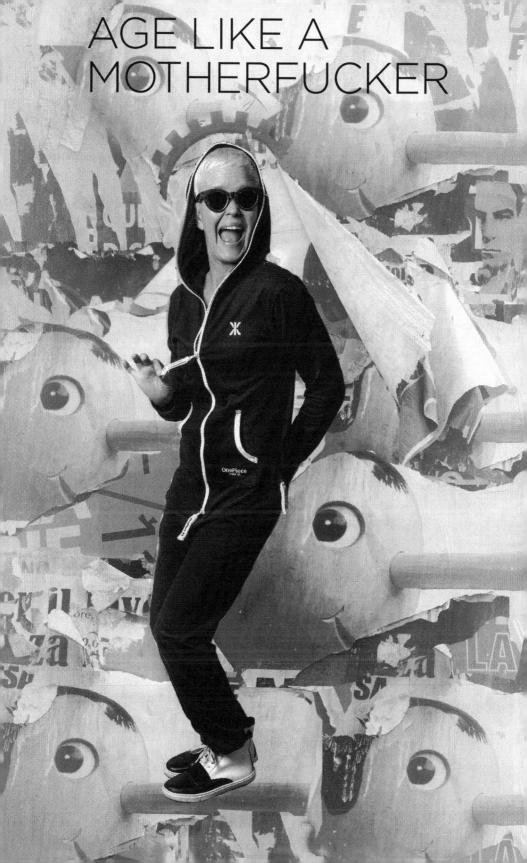

A NOTE ON THIS CHAPTER

Hopefully you are scandalized, but amused as well, by the title of this chapter. And just to clear up any misgivings or confusion, I point out that this chapter, and in a way this whole book, is not so much about aging as it is about creating a worldview that makes aging seem like a non-event. Not literally, of course, but as a meme or as a thing.

Aging, as Americans consider it now, is just a cultural construct, one saddled with myths and misconceptions. In fact, aging is really a *context*, one intimately linked with time, which one rarely notices unless it's moving too slowly or moving too fast. Sure, the slower we get, or the grayer we get — the more 'aged' we become — the more we think about the aging process. And of course we're aging from Day One. But the key to evading gloom about the whole thing, to overriding the stereotypes, it is to keep the mind and the heart in gear, so that a slower body, or a less able body is only a modification of context. With attention, an individual's core dynamic can remain steady. We're like candles, slowly burning our tallow to emit light. The whole point is not the tallow but the light.

Let's say I have 90 years (both my parents did), then that's 90 years I get to fool around on this planet and attempt to make it a better place for future citizens. Major challenge at this point, of course, but challenge brings out the best in us. So what if my faculties are slowly altering? There are as many pluses as minuses in this regard. For instance, the slower you move, the more you are able to see along the way, and to *comprehend* what you see.

Maybe time is a banker (often duplicitous) overseeing our memory banks and, at a certain point in a given life, she starts refusing to lend so promptly, or we simply run through much of our memory cash. Or to switch metaphors, let's say time is a broker, so as our ability to make investments gets reduced, we wind up with a simpler spreadsheet, one where, ideally, the most meaningful assets gain prominence. Maybe the

real trades occur when we move our money from racy, high volatility stocks — our gambles in career, fame, success — and move them to the old reliables, like family, friends, community, and the planet.

At any rate, part of the process is looking back, sorting through, using our age as a lens with which to understand who we were, who we've become, and how to use that in our remaining chapters. And hopefully, even if we're only half-way down that path, we'll all age like motherf***rs!

HOW NOT TO BE OLD

Do understand that I am not saying that being old is to be avoided, nor that you Should Not Be Old, but rather I mean to say that there is a way to *Be* Old and a way *Not To Be* Old. This essay will investigate how to be Old in the Best Possible Way.

Now there would seem to be two different camps when it comes to defining Old. On the one hand there are those who want to celebrate the value and the virtues of age, to *own* aging, to engage with bravery its manifold vicissitudes, to chuck out the urge to remain current, to find delectation in the license of the elderly to be cantankerous, unaccommodating, and obstreperous.

A goodly portion of the English language derives from the eighth-century epic poem Beowulf, which, some scholars contend, places oldness among such virtues as nobility, mercy, esteem, and power. I'm totally down with that, because the old are survivors; they know shit, and they are far less ruffled by the bushwa swirling around us these days. And they have the capacity for greater happiness than most of their juniors. One of the most persuasive proponents of this approach to aging is the Jungian analyst and author James Hillman, whose book, The Force of Character, is a must read for anyone noticing the lengthening shadows of age. Hillman extols the pleasures of settling into an old suit of skin, of taking the slow way 'round. Or, as I see it, simply being who we have, incontrovertibly, become as the years have repeatedly dunked us into the fixative of our own characters.

To be fully old, authentic in our being and available in our presence, with its gravitas and eccentricity, directly affects the public good... This makes oldness a full-time job from which we may not retire. — James Hillman

But there is another camp being staked out by my own, aging, generation. Which is, "Grow old? Like hell." Me? I travel back and forth

between the camps like a messenger, who may well get killed one day because neither camp likes the message I bring.

No one is denying there is a wide terrain between one's youth and one's older self. When you're younger, it's all about individuation — the discovery of self and, of course, absorption with self. Then the focus moves to family and/or career. But then one day, with so much life behind you and a sun slowly slipping toward the horizon, there is a return to the question of self; you experience a huge impulse to recollect the stories, the ideas, the moments, and to reconnect to your tribe. And to not only *grasp* meaning but *express* it, for your own generation and those behind you.

This was for me the incentive to start Realize Magazine, on one level an extremely naive endeavor, on the other a gesture of hope and an affirmation of the ongoing strength of the life force. However, as raising capital is not my strong suit and the magazine awaits a big investor, I am continuing to seek ways to posit a reinvigorated context for the aging process.

※

My approach borrows from a pre-Socratic genius. And here we go then, merrily down the stream, that famous stream of Heraclitus, the one who said, "No man ever steps in the same river twice because it's not the same river and he's not the same man." Yes, that's a tad disorienting, but think about it. Although much of our identity remains stable, day to day, there is a constant flux, a waxing and waning, a coming and going. Every day we are confronted with the decision to either re-affirm our beliefs or modify them. And to the extent we remain vigilant, we discover they often need the latter. This completely relates to the way we decide how we will be old.

Firstly, why would anyone other than ourselves get to decide when we're old? George Burns, who drank a martini a day until he was 90, claimed you're not old until you say you are. I totally agree. In

my opinion, the way to be old is to simply *forget about being old* and just fucking be! Forget about the odd slicing and dicing the world of advertising performs on the life span. It is an outrage! Why do we group 40 - 49 together as if hitting the half-century mark means something other than we define the world in tens?

But really, I don't want to deal with this issue in a style that is too 'on the nose'. The press has been slavering over this topic of aging for the past few years, now that my generation is arriving at the putative gates to the Happy Valley Retirement Village. What I think is that we've all arrived instead at a consensus that the retirement thing has 'gotten old' and, like, we're 'so over it'.

Therefore I will sally forth on the frothy feeling that I am not old *until I say so*. And for me, it truly ain't over until the Fat Lady sings, and I mean really belts one out for me like I would for her.

The secret of genius is to carry the spirit of the child into old age, which means never losing your enthusiasm. — Aldous Huxley

Here is a VERY SILLY little ditty to sing to yourself when you're tempted to say you're old:

Don't get all crusty. All cranky and creaky.
Nor cruddy and crapulous either.
Don't wind up crepuscular
Try to stay muscular
Surge forward, don't totter or teeter.

Codgerdom's just down the road.
But do carve another route.
One you can prance on
Do a square dance on,
While you holler and hoot.

In the presence of fools
Mind your manners
But please, never fold up your banners.
Parade them about when need be.
Which is NOW, if you wanna ask me.

Swing, swim, and swive.
It will keep you alive.
And when in doubt
Break into song.
You never know who just might pipe up
And start to singing along.

Avoid fussbudgetry
and the urge to complain
For this, do read the Stoics.
And before you expire altogether
Try staging a few Heroics.

Animal husbandry I recommend.
Rescue a dog or even a ferret
They necessitate walking
And often yield talking
to neighbors in whom you'll find merit.

To keep the bones sturdy and strong
Run, but not with the herds.
Eat ichthyologically
Work out pedagogically
And fluster your friends with new words.

A prescription for everyday:

A jigger of Laughter
Twice that of Wonder.
Forget the Hereafter
And always remember to play.

Release your damn ego,
The source of trouble and strife,
To all try being a lover —
The key to a beautiful life
Thusly you'll surely discover.

STONERS REDUX

Well, this would be a half-assed chapter on aging if it didn't include some remarks on the latest purported fountain of youth — cannabis! (And yes it comes in liquid form so the metaphor isn't totally skewed, although the fountain might be a tad lugubrious.)

It is an extremely odd and mysterious fact of nature that marijuana compounds mimic molecules (called endogenous cannabinoids) already active in the human brain. In youth, these molecules bounce around in abundance and activate receptors modulating neural activity of all sorts. Alas, this surplus gets depleted over time, which is the reason older brains often experience cognitive decline.

However, recent studies done on those old stoners, lab mice, are yielding thrilling results. Elderly mice brains, when juiced up with cannabinoids, regain the brain functionality of their younger selves! While the brains of young mice get 'wasted' on weed, because their levels of cannabinoid are already at optimum levels, in older mice, the neuronal pathways in the hippocampus (zone of memory and learning) pop back into shape. The news must be spreading, because Scientific American in May of 2017 reported:

A March study showed that in people aged 50 to 64, marijuana use increased nearly 60 percent between 2006 and 2013. And among adults older than 65, the drug's use jumped by 250 percent.

This is comforting news for someone who, finding herself in the occasional southern California hot tub being passed a joint, has only recently discovered the sweet flights of fancy a few tokes can launch. In fact it has become an occasional and vaguely guilty late evening pleasure of mine to inhale a bit and dance around the house or drill deep into my Webster's Third International or spout a bit of doggerel.

But why the guilt? If half the country is drifting about on their

proprietary clouds, whether for pain relief, fun, or 'enlightenment', why shouldn't I? I suppose that's a slippery rationale for doing things, but in this case, I am harming no-one and adding so much to my 'quality time' with myself. There we go again — that I/me apparent dichotomy. I mean, one must ask, especially after a toke, what's with that?

This all may sound like a late model discovery on my part, but it's not like I had never tasted 'herb'. In fact I was surrounded, in my late teens and early twenties, by the haze of second-hand smoke exhaled by all my friends. Back then, however, I found that my already excitable and bustling brain often got pushed to levels of imagination that were more disconcerting than exhilarating. That 'dazed and confused' young mouse brain syndrome. In fact, my brain is still immature enough to reach that point easily even now, but with the advanced delivery modalities now on the market (precise dose pens for whatever state one wants to achieve), I won't.

Anyhow, we can now rack these findings up to another win for the old farts. Did we ever think the day would arrive when an American could walk into a green boutique and walk out with a goofy grin and a small brown bag full of Grape Skunk or Skywalker or Stevie Wonder? (Ah, any product that lends itself to such semantic variants is commendable whether you toke it or not!)

I can already hear future grandchildren smirking at their grammy's silly dance moves or non-sequiturs — "Mimi's stoned again!" But really, as the inevitable decline of our bodies moves apace, as our bodies move down that gravelly road toward extinction, who could deny us the pleasures of escaping into the wondrous netherworlds of the mind, where aging may or may not be 'a thing'. Where there is no body and there is no time and fuck you all!

EXPECTATIONS, GREAT AND OTHERWISE

"Managing Expectations" is a current phrase that really annoys me. We all do it to a greater or lesser degree, to a greater or lesser effect, and often for all the wrong reasons. "If your expectations are zero, your expectations will always be met," as I have earlier quoted, was my ex's favorite expression. For him it was sort of an everyday incantation which I felt was rooted in a deeply pessimistic worldview. It infuriated me back then because it seemed to create a field of negativity and doubt. But now we have the magical thinkers and affirmationists who exclaim, "Believe it and it will happen!" Both views are true and both ridiculous. And then there was my old shrink, who used to counsel that expectations led to despair. But as I search back through the essays in this book, I find that the word 'expectations' appears numerous times. I am a dreamer.

But maybe it's better not to futurize at all, the route chosen by the Buddhists and the Stoics, and simply remain in the present, detached from expectation. Or maybe the right expectation is simply that, "If I put myself out there with my utmost energy and positivity, Something Will Happen, and it might be great." But that's less a specific expectation and more a general inclination toward hopefulness, toward a readiness for whatever life might throw at you.

As I've said, I'm not exactly a Pollyanna, but how the hell would anyone get out of bed if they didn't have the expectation, or rather the hope, that Life Might Just Deliver Today. That this could be your 'lucky' day, that this very day you might turn a major corner and arrive someplace you really knew you belonged? Why would you get out of bed if you believed that today was going to be the same as yesterday? Yes, we all have responsibilities that dictate much of our daily actions BUT it is that component of our ostensibly free will that is the *wild card*. *Our* wild card. Our *Wild Child* Card.

When I was in my twenties, I had huge expectations — amongst them that I would define myself in some unusual and ... definite... way. I actually wanted, based on my own sentimental education, to be *eccentric*. (Riffing on the original sense of the word — as having an orbit not centered around the sun — which to me meant having my own orbit.) Perhaps an absurd driver for a Wisconsin girl, but there you have it. Well, I suppose I actually *have* manifested along the lines of those expectations, but this is more a function of internal reality, of a realization of self, versus the materialization of an external reality.

As for the real world, I guess I also expected I'd have a perfect marriage, an awesome career, a life building toward a sense of accomplishment and ease. Things didn't turn out that way. Lots of reasons why, and many due to faulty expectations. But that's how we learn. And, instead of that homogenized, idealized model, I wound up with an idiosyncratic alternative, which included participating in the maturation of what I am convinced is the most wonderful daughter in the world, and (despite my adverse expectations in this regard) becoming good friends with the man I married and divorced.

No matter how you try to manage your expectations, they are willful creatures and vulnerable to the machinations of reality. Everyone knows the classic Stones quote: "You can't always get what you want." But my therapist had a clever addition to it: "You'll probably get something you never expected." All hail the curvature of the space-time continuum. You can have a swell ride through it *if* you let it unfold naturally.

Anyhow, one day, somewhere post 50, you might even find yourself having a deep epiphany. As if, after a long hike upward, you finally arrive at a crest, overlooking the territory you've traversed. Before you is a vista of the past and the future. You see the dreams that didn't get realized, you see how the obstacles you encountered led to necessary detours and you can see how the path you did tread wound its way toward different and meaningful sorts of marvels. The landscape is truly

vast, and you feel a wash of emotion — humility, acceptance, com-
passion, gratitude and, with a feeling of great lightness but no specific
expectations, the urge to keep on going.

RE-ACCESSING THE SUMMER OF LOVE

As I think about that summer... thoughts about sex naturally rise to the surface. Images of long hair flung in ecstatic arcs, gleeful, salacious grins, undulating guitar riffs, and the conviction that bodies were cosmically designed for infinite lovemaking. But then a counterweight recollection arises — of how clueless we were, really. Free love — what did it mean, ultimately?

Now, some 40, 50 years hence... How do we define sexual love? Where do we position it in the course of our lives? We surely have had more experience than any other previous generation at this point; we must have learned something, right?

I would guess, if we have, that it actually derives from that phrase that circulated even then — "It's about the journey, not the destination" — which through the years has been drummed into our awareness. Yet this is one of the sweet rewards of real adulthood, the awareness that in the long run, it's the tenderness, the playfulness, the imagination and the willingness, that brings the most satisfaction. It's not about the performance, or achieving some pre-ordained goal.

So then — a little appraisal may be in order. Are we all getting our rocks off? Are we now finally really liberated? For a lot of older women, the answer is becoming yes. After years of acquiescing to the antique notion that sex didn't count unless our mates ejaculated, and too often finding that our own orgasms never materialized, apparently women in their fifties, sixties, and seventies are coming to grips with a real sense of the source and the importance of their own pleasure. And, for men too, this is a very good thing. Because slowing up, getting more exploratory, opening up to the myriad stripes of sexual satisfaction, turns out to be great for them as well. The idée fixe of the primacy of Ye Olde Phallus has given way, thus liberating men to be less performance driven, if they so choose.

Look, until anti-aging advances emerge from the experimental stage, our bodies continue to encounter inevitable shifts and, when it comes to genitalia, they're obvious. But that's merely the physical plane. Just as the hard terrain of Earth amounts to only 30% of its surface and the rest is water, the earthly component of sexuality comprises maybe 20% of the situation, and the rest is created by that marvelously fluid entity — the mind. It is in the zone of the imagination that we ultimately make or break our own orgasms. So experiment, baby. Who's watching? (Well, that may not be the right question for some...)

If you find yourself reading this and feeling there's a party somewhere that you weren't invited to — you must remember: good sex doesn't just happen. Eros retired centuries ago and left nobody in charge; we're on our own. But that's the beauty of it — it's up to us. "You can get it if you really want it... But you must try, try and try." (Jimmy Cliff got it, I'm sure.) But if your current status as a sexual citizen is in question, perhaps it's time to wonder why, or rather, perhaps it's not time to wonder, it's time to do something about it.

First — there are some myths that are tumbling, especially when it comes to the likelihood and necessity of full erections. Countless men, from their 60's upward, speak about their ongoing interest in and ability to derive pleasure from sex, even if the old icon of male arousal has faded. It's not about how much blood is pumping up, but how much love and lust is pumping through the veins. However, I'd wager many men never even get to enjoy their post-studly joys since the media is awash with the notion that love can't happen without stiff dicks.

The startling news (which is in fact over four decades old) is that men can orgasm and ejaculate without an erection. According to PHD June Machover Reinisch (for years director of the Kinsey Institute at the University of Indiana and, at this writing, head of future exhibitions at New York's Museum of Sex), there are three distinct stages that appear to occur more-or-less simultaneously in male orgasms, and yet they are not contingent upon one another. The erection is in fact not a

necessary precursor to ejaculation. Whoopee, right?

But we women, less focused on a particular body part, have an inherently deeper awareness of the participation of the entire body in the sex act. We know how our skin responds to stroking almost anywhere on our bodies; we're like kitty cats that way. Our senses have never been confined to one ostentatious six or seven or eight inches of flesh. The number of square inches that comprise our erogenous zone could prove us the luckier sex if, in fact, it weren't also true of male bodies. How lovely that the onus is lifted from that often strutting, often dejected male member. Guys — welcome to your new playground.

And here's another cool fact — up to 70% of women report that their orgasms come not from penetration, but from dutiful attention spent on that cute little nubbin known as the clitoris. And guess what — a lot of women aren't that focused on getting a big O every time either. Really good fondling, really adept tongues…

There is, however, the other side of the equation — the loss of female libido. Again — a much touted 'reality' by the media. But let's deconstruct it a bit. I mean, are you kidding? Sure, if your nether regions are left fallow for too many seasons, they may appear dead, but what richness is concealed in that earth! (References to plowing will not be attempted.) And who the heck decided not to plant? I can bet, if you're in a heterosexual relationship, it wasn't the male participant. Ladies — have you simply checked out?

Of course, there are myriad reasons why we do. One of the most obvious is that we're harboring resentment and taking it out sexually. Ahhh, what a great waste, both of time and potential kicks. If this is the case, I recommend you pick up a little whip and give him/her hell with it. Whether or not they really deserve it (I'm sure they do!) they will probably dig it. And I'd be surprised if you don't as well. Just that little bit of role playing could launch a whole new dramatic career.

At any rate, whatever the cause, when sex becomes a perfunctory act, we disengage. This whole notion that the libido has simply

vanished vexes me to no end. Yes, those libidinous neuronal pathways will get overgrown with disuse. But is it inevitable that we become hapless victims of female drought? I assert not. Naturally, we'll go dry if nobody takes the time to look for our subterranean springs, but they *are* there and flowing silently. In fact it is now commonly reported by older women that although their libido might have gone a bit quiescent, if they are aroused, they find they are still quite happily possessed of the ability to achieve orgasm.

For those women who feel that their libido has staged a permanent vanishing act, I beg you to rent and watch I Am Love, starring Tilda Swinton as the matron of a wealthy Italian family who falls for a much younger man (yes Italian, and yes, a chef). If you can watch their love-making (let alone her eating his cuisine) and not feel a trace of sweat run down your (substitute body parts here), then maybe you're not missing what you don't have and can just relax with that. But if this pains you, then get on down to your local Pleasure Chest, buy a sex toy and take a walk on the wild side.

And really, let's remember that it's not just women that need to learn to demand what is rightfully theirs, it's men as well. We've all been misguided when it comes to sex. And, unless you are committed to a holy order, life without sex is really not life

I DON'T WANT TO END UP
LIKE HAROLD

Harold is 85. Harold doesn't have a combover, he has a real side part. His hair is white and soft. But Harold cannot, for the life of him, stop talking:

1) about his adventures (which for Harold includes anything he's ever done even if it wasn't in the least bit adventurous)
2) about his abilities as a chef, and twice about what he eats for breakfast
3) about, and now going way back, again and again and again, his bloody military days.

Okay, Harold! You were in the army, you met Howard Hughes, the stones in your campy 50's commemorative rings are diamonds... you did xxxxxx and then xxxxx, and every time *anyone* else has a story to tell you just HAVE to tell another one of yours.

I don't want to end up like Harold. Harold has seen everything and been a lot of places. But contrary to his opinion, Harold does not Know It All. Because, Harold, I do! No, just joking, but please, seriously do not let me turn into Harold. Shoot me first.

Oh, they all say that... My mother once said, as she glanced toward a drooling bitty who might once have been a hot chick, or eminent school teacher, or just a bitch, "If I wind up looking like that, please shoot me." But then, when she would totally most have wanted me to shoot her, when she had been waylaid by Alzheimer's for over a decade and would have been horrified to see how she'd wound up, because this had been a very beautiful, intelligent woman... I couldn't. I couldn't because:

1) It would look bad.

2) So bad I would wind up incarcerated. (Don't get me started on honorable deaths.)

3) She might have changed her mind, even if she didn't have one, and

4) My brothers would not have been 'into it', even though one of them never even visited her in the last three years of her life because, well, she didn't have a life. Oh, and

4) Where the hell would I get a gun? The right pills? I mean really, and

5) *How the hell could I do that?* Give me a sign, Mom! Did you mean it? WTF.

What constitutes 'a life'? If we'd have asked her, she would have told you flat out, "This is not a life." But we had to operate under some legal aegis which would incur 'probable doubt'. Of course we doubted that she did have a conscious life, and yet who were we to determine that? Even if this outstanding human had been hijacked, character assassinated, essentially terminated. We were simply her offspring and had no authority. Because 'authority' itself has been undermined by millennia of power-hungry control freaks along the way. Which is for sure an occupational hazard of the work of human genes. Yes, authority has now been ceded to the State. And look who's running that dog and pony show!

Alas, I could go on forever slicing and dicing Alzheimer's and the nature of identity, but really, I shan't, because I'd rather dance. I will shortly put on some music, because Hallelujah, everyone says there's going to be a deluge here in SoCal. Like six inches of rain. A veritable tropical storm by LA standards. A storm to wash away our sins, at least for a while, or at least our dire thoughts.

So I forgive you, Harold, for your sin — the misuse of the cognitive function you do possess in your elder years. Even though it would have

been better spent on my mother. Because you have made me conscious, once again, of that question — about what constitutes a life, and what we do with that life.

So don't shoot me people, just remind me of my own fucking words.

BECOMING INVISIBLE

As Editor of Realize Magazine, I realized I needed to address the widespread issue of older women feeling they've become 'invisible'. As their 'looks fade', older women feel they seem to be fading along with them, right into thin air. I believe I have an antidote.

First of all, I get it. I know that as a younger woman one gets habituated to guys checking you out, sending inquisitive, approving glances your way, if not straight-out cat calls (although the cat seems now to have got the tongue of the guys who used to do that). Then one day you notice that this hasn't happened in a while. And then you start surreptitiously glancing at men to see if it's really true, that you have indeed *gone invisible*.

The issue here is manifold. First — what is it that you're missing out on? Let's look at this phenomenon of not being seen: seen by whom and due to what? Are we not talking specifically about being seen as desirable? Or rather as an object of desire? Get real, ladies. You know who you are and there ain't no shame in it. We're wired that way. Second — take a moment to adjust. Clearly you don't really see yourself as an object. But you do want to be seen, if not as viable or attractive, at least worthy of attention. And that's not a female thing, that's a human thing.

Third — so if you're not feeling it, is this not really a two-way street? What exactly are you projecting? If you want to attract, you need to *radiate*. If you want to have your attractiveness appreciated, then consider wherein it lies. To my mind, what is truly attractive (not just to men, I'm talking even babies and dogs) is energy, humor, and joy. Everybody needs more of all three. Personally, that's what I would want people to be attracted to. So have you in fact simply accepted the aging process as an excuse to drop out? If you were somewhat stylin' in your younger days, have you shuffled instead into muumuus and muted colors? Have you enabled your own vanishing?

For my money there are a number of strategies to re-materialize oneself. First — take stock of the image you're projecting. Do you really want to forfeit an interest in fashion and cede it all to the younger generations? Nobody's saying to borrow your daughter's mini-skirt here, but come on ladies — the world is filled with stunning fashion, even at Target. If you want to be noticed, there are myriad ways to do so, from the cut of your hair to the rake of your boots.

One of my favorite style accoutrements is a fedora. I own at least of eight 'em (not to mention a trilby, a boater, a few pork pies, and a homburg). I gotta say, even if you're dressed in a t-shirt and jeans, that topper does wonders for your street cred. Since fedoras appear to be an item nicked from younger dudes (thank god someone revived them after the largely hatless hippie era), stealing their thunder immediately gets their attention. They wonder — Damn! Who's that dame? "Awesome hat," they'll say. (And keep in mind — the Fedora was first designed for women!)

Then there is all the amazing eyewear out there, just ripe for the picking. I'm not a big fan of zany red glasses on older women, but if that trips your trigger just do it and the rest of us be damned. I mean, really, "That's what it's all about!" Why would you even give a fig about the interest of callow youth? Or of the stereotypical old fart who imagines himself a catch for younger ladies? I'll tell you who will look at you, if you project a confident, happenin' self — other young women. Yeah, that's right... They're dying to see older women staying in the groove, thrilled to see role models since they too are secretly worried about how long their looks will 'last'. So look at this as a way us older chicks can model their future. Get your act together, ladies. Show 'em how it's done.

But then again — why does the gaze of the other have to hold such weight? Why isn't our gaze outward equally as important? Why is being seen any more important than seeing? Seeing with an unfettered intensity that could accompany this so-called invisibility. Which then brings

up the question of who you're checking out. You too will look at hot young chicks, wistfully, guiltily... they're fair game. But how interesting are they after all? They're like embryos in some ways or gorgeous simulacra of the reigning fad. In fact, the truly interesting people out there are the older ones, those who have defined themselves in some unique way and who radiate that sense of accomplished selfhood.

So on top of all that — why don't we do our sisters the favor of really recognizing each other? Why not choose to be more concerned with earning the honest and approving regard of our peers. There are loads of fascinating women out there who deserve our attention so, goddamned it, give it to them and earn it back. In the end, it's up to you to become visible.

LIFTING FACES

I'm not sure how many women over 50 or 60 go through a period of harsh reappraisal of their looks, but I would guess most all of them. And many probably debate whether they want to 'have some work done'. It might take months of looking in the mirror and pulling cheeks up to their former glory; it might take trying a new lipstick, a new hair color, a new wardrobe, to see if it will make them feel attractive again. But they always return to the mirror, poke and prod and wonder.

I was one such female. Maybe it's part of the territory of growing up with a very beautiful mother, who prized her looks and used them to charm everyone from my father, to the grocers, to all the men in her social circle. A mother who herself had two facelifts and never looked anything but gorgeous. But maybe it's the turf of all women who want their faces to match their spirits.

It's a downer to feel like a sprite, to have big plans and tons of energy, and then to look at a face in the mirror that says, "Who are you kidding? You look like old Aunt Lulu with those bulldog jowls." At that point you stop to consider the fact that your face is no longer yours. Sure, it's on your body, but it has nothing to do with the face you've come to identify with, the face you're comfortable in while knocking about in the world and trying to make your way. Nope, it belongs to some old fart!

At that point, the next logical thought is, "Why do I have to I let Father Time play games with my identity? Or Mother Nature be the long-term designer of my face? Why not me? Especially since I can find someone highly skilled with a knife who will rediscover the face I belong in?"

Oh, I know why. Because it's considered vain. Oh, so vain. Because those who haven't taken that path would frown upon you (thereby deepening their marionette lines — but they don't care, because they're not vain). These are the women who are proud to be old and look it.

And that's totally fine, especially for those who, whether comely or not, did not grow up with a sense of self partially *structured* by what was considered a comely appearance, for those sublimely indifferent women that have never believed their looks meant anything. Are there such women? In this culture?

Now I'm a firm believer in keeping one's vanity in check and I do not advocate for endless procedures, treatments, and injections with the intent to fool time. These ministrations rarely deceive anyone anyhow and render the victim oddly puffy, distended, and an obvious repeat offender. One shouldn't deny one's age but simply look the best one can for it.

Current studies reveal that 'handsome' people, male or female, go farther in the world and get paid better too. The term handsome would appear to be very subjective, but then how do these studies get programmed and published? Again, none of this might matter to women who have already achieved the success they feel they deserve. But I guess I'm not one of them. I still have ideas and plans for my next chapter and want to be able to write it like I see it, not be held back by the perceptions generated by a wattle under my chin, or those slightly concave semi-circles under my eyes, or those mildly drooping eyebrows that project that I am a judgmental bore.

Because who I am is really a thirty-year-old. A happy and exuberant one. And I can't help it — I want my face to precede me into the world as just such a person, give or take a few decades. Hell, my real age is probably closer to twelve and yes, I acknowledge that may be a specific type of arrested development rarely available to anyone without some sort of privilege going for them, or an automatic residual effect of being a much-maligned member of the Me Generation. But look, I can take responsibility for countless things, but the circumstances of my birth? Not one of 'em. Could I instead donate more money to my favorite environmental group? Of course, but my bet is that investing my money in this self-oriented way actually gives me greater power to perform more benevolent acts over the next few decades.

And further — I am going to have to get another job quite soon, and we have all heard about the travails of the post-50 folks trying to do that. Screw that. I am arming myself for the fight. Oh, and by the way, it turns out that troops of 40 and 50-something dudes in Silicon Valley, that cult bastion of just barely post-adolescent tech bros, are making the same decision. Okay, maybe that's getting a little weird… and which one is the Me Generation again?

CHINESE ACROBAT

Woke and bounded out of bed this morning like a Chinese Acrobat!
Then quickly discovered I was not.
Some misbegotten twist, some instant of wishful torsion
of muscles I do not own
left me whistling as I landed on the floor.

Jiminy!
Had I dreamt I was a circus tumbler?
Painted red cheeks
and emerald silks?
What imp* had possessed me?
And now,
humbled…
must I never arise again like that?

Oh Enfeeblement, oh Foolishness,
Oh Age!

Henceforth I awaken with a cautionary weight upon my
bounding soul.
I am 60, for chrissakes.
I have to play the part!

But then —
I remember…
This has happened *before*…
I was in my forties.
So it's not *really* about old age!
Just about the ways we, uh, misunderstand our bodies?

I admit, this wouldn't happen at 10 or 20,
but I conclude that I will not give up my obstreperous ways,
until I haphazardly fall
into a grave.

"You are old, Father William," the young man said,
"And your hair has become very white;
And yet you incessantly stand on your head—
Do you think, at your age, it is right?"

"In my youth," Father William replied to his son,
"I feared it might injure the brain;
But now that I'm perfectly sure I have none,
Why, I do it again and again."
— Lewis Carroll

* **Imp** - Old English *impe, impa* "young shoot, graft." Sense of "child, offspring" (late 14c.) came from a transfer of the word from plants to people, with the notion of "newness" preserved. Modern meaning "little devil" (1580s) is from common use in pejorative phrases like imp of Satan.

Come to me my little sprout, my darling dervish, my chocolate slimed imp.

ABOUT THAT TEMPLE, YOUR BODY

Here's the thing about bodies. They need your love. They need your understanding. They need your respect. Just think of what they do day in and day out. Astounding how billions of cells and neurons, hundreds of bones, ligaments, and muscles all come together to deliver you an extraordinary experience on this planet. When we slide into neglect about this miracle we are housed in, we waste it. It's actually a form of abuse. Take care of your body, however, and it will serve you to its utmost.

Sometimes this means realizing the best thing you can do for your body is let it go horizontal for a nap. You've got to listen to your body. Or maybe what your body is begging for is an hour of yoga, a walk, or a run, swim, or pick-up game. Listen to your body and it will lead you to its ultimate performance. Tune it out and it will sooner or later take revenge.

No man has the right to be an amateur in the matter of physical training. It is a shame for a man to grow old without seeing the beauty and strength of which his body is capable. — Socrates

But hey, it's your body, Baby. I'm not here to chide or chastise, exhort, seduce or prod you if you're not already working that thang. Nor do I in any way intend to offer any specific guidelines. That stuff's all over the internet. All I know is that I am a person that feels way better when *I use my body*. When I *play* in my body! As a person who spends a serious amount of time in my head, I know how necessary it is to get out of it. And I am also keenly aware that the more tuned up my body is, the better my mind works. The more flexible my physique, the more agile my psyche.

I grew up being 'physical'. Crack it up to a decade squirming in a

brother sandwich. When I was eight, I even played football with my older brother and quickly saw how you could get mortally wounded, or at least seriously demented. Football seemed so daft, it led me to believe males were as well. "Let 'em play ball," I thought, imperious as Marie Antoinette.

But lucky for me my parents were the active sort. I was privileged to have access to lakes and pools, courts and slopes, and yards to run in. My Dad had learned to sail very young so, at the age of nine, I found myself learning to sail in a dinghy the size of a bathtub, which wobbled like a moonshine drunk as I navigated between monster yachts swaying and straining at their anchors in the gray, extreme chop of Lake Michigan's Belmont Harbor. By 11, I was riding (even bareback) and jumping horses, skiing over foot-high moguls and batting belligerently at tennis balls. Again, I was privileged, but part of this was that we didn't watch much TV, didn't have computers, phones, and game consoles to lure us to linger in our rooms while the sun shined outdoors.

But what I can really crack it up to is growing up in an era when kids got to run amok in the neighborhood, even way past dark, because life was safe. (Well, mostly.) Or when being outdoors was just what kids *wanted* to do; to evade the deadening rules of the indoor world. (Oh, to be in that alluring, darkening, fragrant green now, running through sprinklers, darting into and out of streetlight, hiding in places black with night, places where everything was alive and might even be crawling toward you as you held your breath…)

It took almost nothing to have a blast outdoors, especially if we kept moving. One of my fondest memories was climbing onto the roof of a friend's garage and picking purple gooseberries from the tree hanging over it. She made a devil's brew with it, called herself a witch, and chased us into someone's back yard, into an aging playhouse filled with Daddy Longlegs. Primal Scream, the prequel.

But back to our bodies, now. There are lakes everywhere and pools, hills to hike, roads to bike, beaches to frolic on. There are yoga studios and there are clubs and streets to dance in.

As for yoga. It is essential to my life. I credit the practice of yoga with everything from teaching me how to breathe, to appreciating the finesse and complexity of the human body, to discovering the creativity, strength, and grace my own body possesses. Until you wind up in the class of a well-educated yogi, you will have no idea how many are the muscles interwoven throughout your body, nor how important it is to sharpen your awareness of each one of them in any given pose. Of course, the essential element of yoga is balance. Balance, something we all aspire to, is available to anyone within the practice of yoga. Maybe not every day, mind you, but most days. See, if you're not in a yoga class, surrounded by other yogis trying to be trees, you might forget to try being one yourself. Even if you can't keep it upright on one leg or the other, the pose patiently awaits, reminding you, urging you to find it.

However, the true gift of yoga lies within the very word. Yoga means to yoke — to yoke mind, body, and spirit. No matter what state I'm in when I arrive at my mat, I always leave in a higher one. Because I've integrated the disparate selves, cleared all the channels and opened my body to the life-giving element of prana and the affirming chant of Om. I only wish I could spend a few hours every week just chanting… there is something pure and 'holy', beyond 'religion', in the simple congrega-tion of bodies resounding with song. (Having chosen to use the word holy here and not the word 'sacred', I searched online for the etymology of holy and was amazed to discover that its roots link health, healing, and wholeness. Old English *hælþ* "wholeness, being whole, sound or well," from Proto-Germanic *hailitho*, from PIE *kailo-* "whole, un-injured, of good omen" (source also of Old English *hal* "hale, whole;" Old Norse *heill* "healthy;" Old English *halig*, Old Norse *helge* "holy, sacred;" Old English *hælan* "to heal". All lovely connotations.)

All I can say is, life is better, dare I say 'holier' when you move your body. But if you're not there, trust me, all it takes to get on the path is to light a small fire in your belly that gets you moving. Tend that little

flame a bit every day and watch it grow until it will warm your entire psyche and light up your entire life. Let it cool, and your whole psyche will start to slow down, freeze up, go inert.

Humans are *made to move*. We're made to climb hills and till fields and run and dance for joy. And all that energy begets energy. The world feeds off energy. Minds spark brighter the more energy that courses into them. So turn it on baby. Light up the world.

GONZO ELDERHOOD!

What is Elderhood, but your big chance to be authentic?
To let your freak flag fly. To come out of whatever closet you're in.
Or if you're already out — to spread the gospel of the True Self.

BUT — here is the question — do you actually have what it takes to be an Elder?

Look, we're all coming from wildly different places as we approach our mid-life, whether that's 50 or 60 or more, and yet we're all facing a similar question — what are we going to make of our future, how will we continue to evolve in our later years? Maybe we've accomplished great things; maybe we've done a long career haul; maybe we've hopped from position to position, field to field; maybe we've spent much of adulthood raising a family... but wherever we're coming from, the same questions arise:

Who have I become? And what am I going to do with it? Where can I grow from here? What thwarted desires are rumbling at the gate? What visions have yet to be realized?

I interviewed a fascinating man for Realize Magazine — Dr. Bill Thomas, a geriatrician who called himself an Ambassador from Elderhood. He raised an interesting theory: that we have over-extended and over-valued *adulthood*. Meaning that our generation, the 'almighty' Boomers, now moving beyond adulthood, have turned the productive strengths of adulthood into the overarching virtue for the entirety of American society. And he sees this drive — toward being ever faster, more efficient, more productive — as a problem central to our condition in America today. Emphasizing speed and efficiency above all else has led to the sacrifice of other, more lasting virtues like family, community, and our planetary home.

Thomas believes, however, that if we can seize this idea and

reinvigorate the concept of elderhood, there may be hope. Consider the fact that traditionally, elders have been leaders, the guiding forces of their tribes, respected beings whose wisdom and experience bring balance and direction to their community. And yet the term has been so diminished in our society, the concept is now appropriated by terms like *eldercare* or used in lame old chestnuts like "Respect your elders!" (shouted in quavering voices by geezers waving canes). But this is where I believe our generation is making a shift — by seizing the day and proving that there is great power in aging, and that we intend to use it for good.

Now for Bill Thomas, one of the purviews of the Elder is the right *to go slow*... because therein lies reflection, contemplation, reason. But another purview of the Elder is *to connect*. To unify the generations coming up behind them. And this is an area I find filled with potential.

Because, as I've stated earlier, I personally am *not* ready to slow up. In a way I feel like I'm just getting started on a whole new journey with a knapsack full of ideas that have been building for a few decades. Because if it's true that our generation has in some ways precipitated the crises that we now face, it's also true that we can help defuse them. That, to me, is a solid reason for us to remain engaged. And, as must be clear by now, I believe the concept of elderhood can encompass many different stripes of elders.

Maybe someday I *will* turn into a geezer waving a cane... or maybe it will be a staff, with my freak flag blazing free!

THOUGHTS FOR
THE YOUNG

"I'd say colleges have to do much more to put certain questions on the table, to help students grapple with the coming decade of uncertainty."

Having run across this Op Ed piece by Paul Krugman in the New York Times in June of 2017, I must say I couldn't agree with him more, so I thought I'd offer answers to a few of his questions.

"What does it mean to be an adult today?"

A) How the fuck should I know? I'm not an 'adult'.

B) How the fuck should I know — *nobody knows!* We're all just stumbling, hands out like a bunch of blindfolded players in a game of Blindman's Bluff and reality is a wildly swerving semi truck with failing brakes heading downhill at us. Nothing is permanent, nothing is immutable. All is morphing and most of it is really not in our hands. But lighten up! It's always *interesting!* And you'll figure it out along the way.

"What are seven or ten ways people have found purpose in life?"

Really? I'll go with eight.

1) Everybody followed their gut and ran into it.
2) It takes time, dude. You'll get there but you can't rush it.
3) They fell into it while looking in another direction.
4) Being earnest and loving life along the way.
5) Thinking a lot.
6) Working on themselves and wondering.

7) Really being who they were.

8) *Believing* they would find their purpose.

"How big should I dream or how realistic should I be?"

Dream big, but learn from when those dreams don't work. And then dream again. *Always* dream big, do big, and live big.

"What are the criteria we should think about before shacking up?"

1) How widely different are your habits? Are you ready to compromise about their messes or your anal organization needs?

2) Who is their mother? You'd better get along. (Make her like you; it's easier that way.)

3) Talk about your separate approaches to money. This is a major issue in all relationships.

4) If the topic is on the table, talk about your philosophies of child-rearing. Watch other parents and their strategies and see if you two agree about them.

"What is the cure for sadness?"

Watching Pixar flicks? Walking your dog? Blowing up balloons for kids with cancer? Getting over yourself?

"What do I want and what is truly worth wanting?"

Asking what is truly worth wanting is misleading and ridiculous, nothing is worth wanting if *you* don't want it. So totally subjective. Wanna be a logger? Guys give up hedge fund jobs to do that. Wanna be a singer? Find a choir or a band or a street corner. Wanna do anything stupid, outrageous, meaningless, absurd? Go fucking do it so we can

do the same kinds of stuff too! We all want liberty — but that means confronting our fear of exposure, so how badly do we want it?

Last bit of advice: Elon Musk wants to send us to Mars and it even makes economic sense. So become an astronaut. I would if I were you.

Bonus: a cautionary (and ironic) reflection from Soren Kierkegaard, world famous philosopher:

Had I followed my pleasure and chose what I plainly have a decided talent for: police spy, I should have been much happier than I afterwards became.

L'IL
LEXIVORE

LITTLE MISS HETEROCLITE SAYS: GET A FUCKING VOCABULARY!

Speaking of which, they say that swearing is a sign of having a good vocabulary. I know, it sounds counterintuitive. If you have such a great compendium of words at your command, why use the most base, vulgar, and simplistic?

Ostensibly because it shows you appreciate the very usefulness of such words, the punch they pack. Consider an aficionado of art uttering the following:

"I saw a shitload of art while I was in New York."

Such a statement around a white-clothed table on the Upper East Side might cause shudders enough to crumble the botox and wet the boxers but, in fact, it is an apt turn of phrase, spinning the possibly effete affects of museum going into the excesses of a voluptuary.

If you have a swell vocabulary, and are known for it, then your use of words like *'fucking'* can puncture a hole in statements which might otherwise come off as a tad inflated.

In my opinion, everyone brought up in the English language has a duty to study it thoroughly. While it appears to us native speakers to be a birthright, in fact it comes with a bill attached. Ignore its power and you will most likely never find success, except possibly in the crime world, but even there you would never rise to the top, for you would lack the ability to connive, exploit, and bullshit with panache. Yet possessed of a strong vocabulary, you will find it easier to rationalize and romance, startle and confound, seduce and cajole, climb ladders and split hairs, put down and talk up, impress your superiors and dismay your competitors.

Here's the thing: English is the *World's Most Staggeringly Awesome Language.*

One of civilization's most splendid legacies, English is a creation of astounding proportions. Sadly, for many of its speakers, its origins and subtleties are wrapped in the obscurity of the quotidian. It is a language of near infinite parts, wildly combinatory and elastic, an adhesive amalgam of every language it has encountered throughout its history. The extent to which English is indebted to French is astounding: nearly 400,000 words entered the English vocabulary during and after the Norman conquest and of those, 150,000 remain in use to this day.

Yet some of the most elemental words in English are rooted in Old Norse. Nouns like sky, skull, awe, birth, mistake. Verbs like die, slaughter, give, take, and trust.

But there are marvelous additions from nearly every country on the planet. For example, the word goon comes from a Hindi word *goonda*, but then Indian culture has given us as well *guru*, *prana* and *karma*, and all the other words we now know if we do *yoga*. *Ketchup* is a version of a Malay word, originally for fish sauce but, through the borrowing by the Chinese, now a sweet tomato sauce. *Alcohol* and *algorithm, assassin, coffee, cotton* and *candy* come from the Arabic (and that's just A-C).

A study, published in 1973, offered this breakdown of the sources that have flowed into English: Latin — 28.34 percent; French — 28.3 percent; Old and Middle English, Old Norse, and Dutch — 25 percent; Greek — 5.32 percent; no etymology given — 4.03 percent; derived from proper names — 3.28 percent; all other languages — less than 1 percent.

※

Okay then. Let's start right now, with the word *heteroclite*. No, it ain't an adjective about sexuality, although, ironically, it could relate to gender politics. Its meaning, as of 1570, was 'irregularly inflected' and referred mostly to nouns. From the Greek heteroklitos: *hetero* 'different' and *klinein* 'to lean.' But, as of the 1590's, it adopted a figurative usage to describe 'persons deviating from the ordinary'. Of course we

all know that there is no longer any ordinary, so are we all heteroclite? Hmmm, I think not. Some of us still want to claim their ordinariness and many of us still want to proclaim our extraordinariness, our otherness, our leaning differently.

Webster's Third International defines Heteroclite: "One that deviates from the common forms or the common rules."

"Modern poetry is not only for the heteroclites." said the great poet Wallace Stevens. Whoopee!

I choose this particular word because, while not an everyday word, it shows the wonderful breadth of the English language. I also love it because it resonates with me. I seem to have evolved into somewhat of a deviant. Of course all artists are, to a certain extent, but I even deviate from the norm of what the artist is. There seems to be no particular category into which I can stuff myself, except that of the Heteroclite.

But this launches me into the realm of Language Itself — its purpose, its uses.

If it is true that language is not merely the method we use to describe, after the fact, our experience of the world, but is in fact the very framework within which we experience it, then all my struggles to arrive at some 'paramount truth' are also predetermined by the very existence of those words 'paramount truth'. And the whole idea of 'paramount truth' is really just an object of desire which serves to supplant our fixation upon the 'paramount truth' of death.

Of course there are millions of discrete 'truths' and their prolific intermingling breeds a state beyond immediate comprehension — a state of unpredictability. In other words, 'reality' is always 'getting out of hand'. And though it may be a fickle tool, language is the only tool we have to try to pinpoint our experience, articulate our visions, and define our inventions.

The human self begins as a cipher. In its inception it is a mere urge, whose prime quality is a magnetism that attracts to it myriad words and icons by which it can define itself. Never completely aware of its

own contours, it then proceeds to bumble and clank about, with all its various component concepts continually bashing into each other and yielding unexpected meanings. All of which builds into a kind of crazed unintelligible cacophony on top of which our medial prefrontal cortex desperately imposes a vision of a cohesive core, whose inevitable deviations never fail to surprise us. But valiantly we carry on, cogitate and blather, blunder through our neuronal networks, and blurt, "Eureka!" when we think we've arrived at a kernel of actuality. And how would we express any of that without language? Without a supremely flexible, adaptable medium eager to please?

Dictionary...
From the depths of your
Dense and reverberating jungle
Grant me,
At the moment it is needed,
A single birdsong, the luxury
Of one bee,
One splinter
Of your ancient wood perfumed
By an eternity of jasmine,
One
Syllable,
One tremor, one sound,
One seed:
I am of the earth and with words I sing.
— Pablo Neruda

L'IL LEXI

In the early nineties, as I was working on my word game Pandel-exium, I took a cue from the rappers, who were running the show in the music business. I wasn't bedding chicks and ruling the streets, but I did have my own, self-declared turf. Btw, boasting, as an art form, does wonders for the self-esteem…

L'IL LEXI

My mind it is an empire,
A city built of words,
Risen from the quagmire
On the wings of thunderbirds.
I'm a master of my language,
A queen of the quick of wit,
From LA back to Cambridge,
I cut through the thick of it.

My vocabulary will astound you,
Inspiration will surround you,
My words enlighten
Or confound you,
Depending on my whim.

The way I use my English
Makes the boys all tinglish.
My brain it gets quim*-quivery
Fiddling with my lingo.
My rapid-fire delivery
Makes 'em holler Bingo!

My mind it is a spitfire.
Its ammo is my words.
Get caught in the crossfire
and suffer the fate of the herds.

Cuz I know my definitions,
I abandon inhibitions,
accomplish my ambitions.
On the stage of the world,
The red carpet gets hurled,
My intelligence unfurled,
Your plans get tilta-whirled.

Listen, I articulate
On matters evanescent
Or particulate.
I can dilate on every state
From the Roman to the Steady.
Armed linguistic, so futuristic,
For all phenomena I'm ready.

Yeah, I'm a lexicographer,
Magician of the verbal.
Can introspect on nano-tech
or the cortex of the gerbil.
I poeticize on anything,
The noosphere to wormholes.
Words my wings as I careen through
Loop-de-loops 'n' barrel rolls.

So if my style you'd emulate,
Learn how to discriminate,
Between the words delineate.
Cuz this is how we will create
The 21st century.

Let Webster turbocharge your brain.
Your thoughts you'll learn to train.
You'll take those little dogs
And turn 'em into pedagogues!

Understand the lexicon.
It's like possessing silicon.
Opens up the kingdom's door
Like the magic tales of yore.

But use your words judiciously.
Tantalize deliciously.
Think so surreptitiously.
Persuade oh so propitiously.
And predicate auspiciously.

Now chuck off that flibberty-gibberty
And achieve some five-star liberty.
From all earthly bonds be sprung,
By mastering your Mother Tongue!

 * **Quim** - a very succinct term for lady parts. Forgive our cheekiness
for including this rhyme from the Wanton Lass (Anonymous, 1879):

>*Her beau was plain, banal and dim.*
>*But one thing she could say for him,*
>*He did know how to amuse her quim.*

MY 100 FAVORITE WORDS
(at least at the moment)

Being a compendium of words divine, puerile, absurd, vulgar, and altogether wonderful. Words that are either awesome to roll across the tongue, or startling to consider as to their meaning or curious etymology. Or all of these things. I've even included a few neologisms and a few foreign words I'd like to popularize.

I include only the list here, sans definitions and etymologies, for the pure enjoyment of the words themselves, for a moment of raw marveling at what is, IMHO, the most amazing language on Earth. But if you're interested, I will slowly release the meanings, etymologies and amusing quotations on my website. (www.ellaryeddy.com)

Addlepated
Antediluvian
Asterisk
Axiom
Anxigenic*
Authentic

Buckaroo
Blimp
Blackguard
Boondoggle
Borborygmus

Cuckoo
Callipygian
Cattywampus
Consilience

Capricious
Dang
Delphinium
Dastardly
Deviltry

Ellipsis
Exhilarate
Epiphany
Elixir

Floozy
Flabbergasted

Giggle
Gargantuan
Generatrix

Hiccup
Hellion
Hoopla
Higgledy-piggledy
Halcyon

Imp
Id
Itty-bitty
Imbroglio

Jackanapes
Jazz
Jubilation

Juggernaut
Kitsch
Karma

Lambent
Luscious
Libidinal
Lepidoptery
Labyrinthine
Logodaedely

Mellifluous
Mesmerize
Mumbledy-peg

Nadir
Nookie
Nihilist
Nasturtium
Nincompoop

Osculate
Oops
Oblivion
Ornery

Poltroon
Phalanx
Penumbra
Prattle
Parakeet
Puckquify*

Quaquaversal
Quiddity
Quixotic
Quim

Resplendent
Riparian
Ravish

Serendipity
Sycophant
Sidereal
Susurrous
Shindig
Spanghew
Schnittpunkt

Truculent
Troglodyte
Topsy-turvy
Tintinnabulation

Ubiquitous
Umbelliform
Ululate
Ursprung

Wimple
Whiffle-ball
Wanton
Woebegone

Yippee

Zany
Zilch
Zephyr
Zugzwang
Zounds

* These words are neologisms of my own invention…you can find their meaning on my website, along with definitions, etymologies, and quotations for the entire list to be rolled out over time.
www.ellaryeddy.com

THE THING IS...

There is a world of things. We don't really think about things qua things. And yet, thing-bound are we.

Things cling to our psyches
Things get in our way
Things obscure our vision
Things stand as a screen
maybe even a wall
between us
and the utter,
complete
strangeness of existence.
Our utter strangeness.

For instance — the body, our main thing —
is it an automatic vehicle (which we could call a thing, in the ordinary sense of the word)?
We don't think of our bodies as things. Too many moving parts.
Too much subjectivity. Oh, way too much of that.
But we move it around like a thing, feed it because it's a living thing, and often have no real idea what it is up to (just as we don't know what things are up to). And we certainly treat it as a thing when we berate it or abuse it.
The Brits used to call people whose names they'd forgotten 'thingie'. Not to mention the fact that we treat ourselves like objects all the time — that self we refer to as an other: "I've got to cut myself some slack."

But whatever you call a thing, we fool ourselves with them.
They appear so very solid.

Consider walls.

We surround ourselves with them, then fill the space they enclose with all sorts of things and call it home.

Just as we clothe ourselves in fashion, in accomplishments, in connections, and call it Self.

But back to the screen, which can also act as a metaphor for our minds (which once upon a time comprised the series of stories we told ourselves but now is a bath of noise… a jumble of infinite things in which we are always close to drowning).

"Do your Thing, Baby"

My thing?

How the hell did anyone create this meme?

Is it a reification? (Which means "to convert into, or regard as a concrete thing: to make something real or bring something into being". In Gestalt psychology, reification means the perception of an object as having more spatial information than is present.) Well, it's definitely not a synecdoche (a figure of speech in which a term for a part of something refers to the whole of something or vice versa, like calling a woman a 'skirt.')

But is it a metonym? Hardly — since that is when one thing is closely linked to another thing, ie. "The pen is mightier than the sword."

Egad, a thing linked to another thing… Thing again!

But Thing is not related to anything (in particular) but to everything, or rather anything (as in all things).

This is exhausting.

But in a good way, like great sex!

But back to your 'Thing' — is it a wishful linguistic packaging of what we do — which really can't be explained or defined precisely? Or is it a radical reduction, one performed when the speaker (think stoned hippie dude) is too lazy to elaborate? "Yeah she's doing her thing."

So now Thing becomes an article of identity!
We are our thing! That thing which we do, or love to do, or can be seen doing a lot. But we don't do things really, we perform actions, which are wildly different than things! Am I driving you mad yet?

And now to drive one straight into the looney bin, there's a new iteration, which is the phrase, "Is that a thing?" This has caused some consternation in the literary press, but seems to have joined the gang of dubious nominalisations, albeit as an outlier. For instance; "Yeah, she is into parakeet whispering." "What? Is that a thing?"

I am my Thing.
The Thing and I. (My next book title?)
But, I stammer, "My Thing is many Things". No, that sounds weird — "She's doing her things." So I've got to get a Thing, one Thing. But if Seuss could create Thing One and Thing Two… Oh, I'm dying up here.

One last question:
When is a Thing not really a thing?
Most of the time!
(My apologies here to referencing the Uncertainty Principle, which has been much abused as a metaphor for the disreality of the world of actual things, seeing as how the stuff of which they're constituted can be waves as often particles.)

Okay. Time for a smoke.
(Actually I don't smoke, but right now I wish I did.)

Not sure what else to say here, except Chow for Niao. And thank you, if you've actually gotten this far, for having done so. Correspondence is welcome. And for that, cruise to my personal website where you can find all my favorite words and my blog and tons of pictures and rants and playlists and general mayhem.

www.ellaryeddy.com

Excerpts and news about readings and press regarding the book can be found at my book website: www.herargument.com

Cheers!

Made in the USA
Monee, IL
05 February 2020